Dictionaries of Civilization

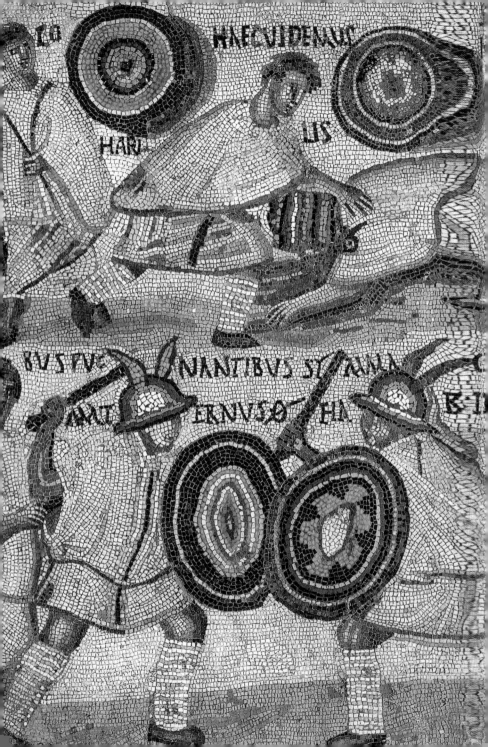

Rome

Ada Gabucci

Translated by Jay Hyams

University of California Press
Berkeley Los Angeles London

Dictionaries of Civilization
Series edited by Ada Gabucci

University of California Press, one of the most distinguished university presses in the United States, enriches lives around the world by advancing scholarship in the humanities, social sciences, and natural sciences. Its activities are supported by the UC Press Foundation and by philanthropic contributions from individuals and institutions. For more information, visit www.ucpress.edu.

University of California Press
Berkeley and Los Angeles, California

University of California Press, Ltd.
London, England

© 2005 by Mondadori Electa S.p.A., Milan
English translation © 2006 Mondadori Electa S.p.A.

Cataloging-in-Publication Data for this title is on file with the Library of Congress.

ISBN-13: 978-0-520-25265-3 (pbk.: alk. paper)

Manufactured in Spain

16 15 14 13 12 11 10 09 08 07
10 9 8 7 6 5 4 3 2 1

Art direction
Dario Tagliabue

Graphic design
Anna Piccarreta

Layouts
Sara De Michele

Editorial direction
Caterina Giavotto

Editing
Maria Grazia Luparia

Picture research
Elena Demartini

Technical coordination
Andrea Panozzo

Quality control
Giancarlo Berti

English-language translation
Jay Hyams

English-language typesetting
Michael Shaw

Page 2
Mosaic with amphitheater scene, detail,
4th century, Museo Arqueológico
Nacional, Madrid

Contents

Introduction

Illustrating the civilization of the Romans in a single volume is an undertaking both ambitious and, in all probability, also impossible, making necessary the establishment of chronological and geographical boundaries. As for the chronological boundaries of this book, the decision was made to use the period between the traditional date of the foundation of Rome (754 BC) and the date of the fall of the Western Empire (AD 476). Recent archaeological studies have lent a measure of validity to the myth of Romulus and the birth of Rome, and today we can with certainty date the voluntary creation of the first urban settlement on the Palatine Hill to shortly after the middle of the 8th century BC, and we know that this act probably involved marking off a sacred and inviolable space (the pomerium). The date chosen for the end of the empire, 476, is the year in which the last emperor of the West, the boy Romulus Augustulus, was deposed by the Goths and the imperial insignia were sent to Constantinople. This date was chosen in the full awareness that, while freighted with meaning today, it did not mark an epochal change at the time; in fact, by 476 the West had been in the hands of powerful generals of barbarian origin for several decades, generals who ruled in the place of puppet emperors, and Rome's culture and tradition endured for almost another century after 476, up until—following twenty years of Byzantine-Gothic struggle—the Lombards arrived in Italy. The geographical boundaries are quite narrow, coinciding with the city of Rome and its immediate suburbs in order to illustrate the rise and fall of the Roman civilization as it occurred in the heart of the empire.

Even while staying within the these boundaries, it has proven necessary to make choices, and the subjects dealt with in this volume are nothing more than a sampling, a collection of illustrative examples that makes no claim to being in any sense exhaustive. The book is divided into short entries grouped in chapters that take into consideration some of the major themes of any civilization, ancient or modern, and the individual entries should be considered not so much separate elements as tesserae drawn from a single large mosaic. Each entry includes a general overview in which the essential elements of the subject are presented and then several pages of illustrations with commentary presenting salient aspects of the

life, culture, and society of ancient Rome through the examination of the tangible evidence that has survived to our time, using the methods of archaeological research. The craft of archaeology involves the reconstruction of the past by way of the reading of ancient sources combined with the analysis of material remains—from majestic public buildings and the refined works of art made for the ruling elite to evidence of what the daily life was like for the less affluent classes, which best reflects the society of an epoch—resulting in the assembly of a complex mosaic.

Since it presents the social and economic situation in the empire's capital, the vision of life in ancient Rome presented in this volume is of necessity partial. There is no information here on what life was like in Rome's military encampments or on how its agricultural workers lived, for those subjects will be dealt with in the volume dedicated to the peripheral areas of the empire, including the areas where the legions were stationed and the lands that produced the grain, wine, and oil that were consumed in the capital. There is, however, an indication of the highly articulated and efficient machine, directed by the central power in Rome, that oversaw the collection and distribution of an adequate quantity of foodstuffs for a city that, at the moment of its greatest expansion, numbered at least 1 million inhabitants.

As far as possible, the effort has been made to follow the evolution of each theme over the course of time, from the centuries of Rome's rapid ascent to the long period of its prosperity to the period of its decline, but often the archaeological evidence does not present the same amount of information for the different periods. For example, the way a Roman monument looks today is almost always a result of late restorations, as in the case of the Pantheon, which was built by Agrippa between 27 and 25 BC but was radically restructured by Hadrian, who changed even the orientation of the façade.

This book includes a brief chronology that presents the most important events in the history of the Roman world, with attention focused on the capital of the empire, and a brief bibliography that includes many of the most recent works on ancient Rome. These references are designed to assist those readers who, stimulated by the information presented in this volume, wish to study the subject in greater depth.

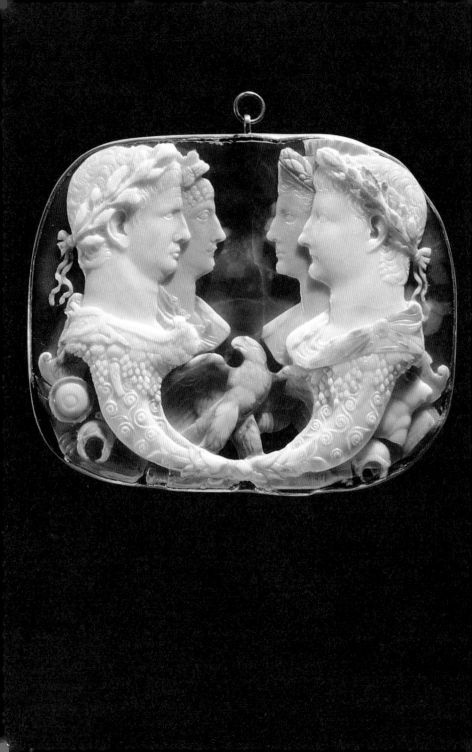

People

◄ The *Gemma Claudia*, mid-1st century, Kunsthistorisches Museum, Vienna.

"Since, after a tempest that suddenly arose in the thirty-seventh year of his reign, he was no longer to be seen, he was believed to have been translated to the gods and was accordingly deified [with the name Quirinus]" (Eutropius)

Romulus and Remus

The story of Romulus and Remus, long held to be little more than a fable devised to serve political and ideological purposes, turns out instead to be an ancient indigenous myth that dates to the beginning of the 6th century BC, or even earlier, and that began as a popular myth, later officially recognized, that arose around the royal figure of the founder of the city, whoever that was. An important element in support of this theory is the myth itself, which was more an ideal weapon of anti-Rome propaganda than an exaltation of Rome's origins, since it shows the founder to have been a fratricide who resorted to kidnapping to procure brides (the Sabines) for himself and his followers. Over the course of the centuries the Romans tried to tone down or rework some of the cruder aspects of this tradition (Remus had been killed, but it had been unintentional and had not involved Romulus but one of his companions; the Sabines, all of them unmarried, had maintained their virtue until the day of their fully proper weddings), but in truth the Romans never managed to free themselves from the tale.

The foundation of Rome as a deliberate act performed by a priest-king to give a prehistoric settlement an organized, stable, and definite

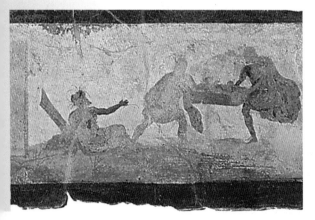

form from both the territorial and the religious points of view was given support by the discovery, on the slopes of the Palatine, of the traces of a wooden palisade, walls, and ditches, the material remains of the first efforts to give the city definition and datable to around 725 BC, a date not too distant from the traditional one of 754/753 BC.

The seated figure holding a branch may be a personification of the Palatine, the hill at the foot of which the all-important discovery of the twins took place.

The eagle, emblem of Jupiter, is symbolically located atop the sacred cave, the Lupercal, to indicate the divine protection given the figures in the scene.

The two figures that seem to flee the scene are probably Faustulus, swineherd of the good king of Alba Longa, Numitor, and his brother Faustinus, who cared for the flocks of the usurper, Amulius.

Aeneas founded a city and named it Lavinium in honor of his wife; his son founded the city of Alba Longa. After many generations and numerous rulers, at the death of King Proca, his sons, Numitor and Amulius, divided their inheritance: to the first went the throne, while the second chose the fabulous treasure Aeneas had brought from Troy.

Amulius, not satisfied with his wealth, managed to usurp the throne from his brother and forced his niece, Rhea Silvia, to become a Vestal Virgin in order to ensure her perpetual chastity, but the young woman was seduced by the god Mars and gave birth to the twins.

In the attempt to eliminate the newborn twins, the perfidious King Amulius had them thrown into the flooding Tiber; but the basket that held them floated and came ashore. A she-wolf heard the cries of the infants and nourished them until the arrival of the shepherd Faustulus, who raised them as his own sons, naming them Romulus and Remus.

The personification of the Tiber is identified by his crown of algae, an overturned urn, and the reed he holds.

◀ Painted frieze from the Esquiline, with scene of the abandonment of the twins on the banks of the Tiber, 30–20 BC, Palazzo Massimo, Rome.

▲ Altar to Mars and Venus, rear face, from the portico of the Piazzale delle Corporazioni at Ostia, ca. 100–130, Palazzo Massimo, Rome.

"Who, Great Pompey, after your victory over Mithradates, your recovery of the seas from piracy, and your three triumphs . . . would have believed that you were destined to perish on Egyptian shores?" (Manilius)

Pompey

106–48 BC

Important dates
76–72 BC: war in Spain against Sertorius
71 BC: first consulship, with Crassus
67–62 BC: special three-year command in the Mediterranean to eliminate pirates and extension of his power to the Asian provinces; subjugation of Pontus, Armenia, and Syria
60 BC: First Triumvirate, with Caesar and Crassus
55 BC: second consulship, with Crassus
52 BC: after violent disorder in Rome, Pompey receives sole consulship
49–48 BC: Civil war against Caesar
48 BC: defeated at Pharsalus, Pompey flees to Egypt, where Ptolemy XIII has him killed

After Pompey's triumphs in Asia, construction activity in Rome went through an important transformation, becoming an expression of the apparently limitless generosity of politicians, who used it as a means to gather popular support, thus setting in motion a system of political propaganda that was to be used by all the leading exponents of the senatorial class. Between 61 and 55 BC, Pompey had an enormous complex built in the Campus Martius that included, aside from his private residence, a theater and a portico decorated with statues made by Greek artists. A large rectangular portico, decorated with a statue of Pompey, extended along the side opposite the theater and was used by the senate when it held meetings outside of the *pomerium*; this portico was later the site of the assassination of Caesar.

Pompey's grandiose construction projects included Rome's first permanent stone theater, built in *opus reticulatum* with seating for 15,000 spectators. A temple dedicated to Venus Victrix was erected

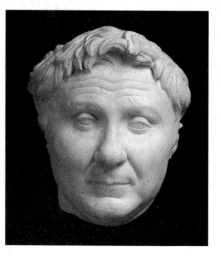

over the auditorium in keeping with the tradition, common throughout Italy for more than a century, that closely related stage performances with worship. Making the auditorium look like access stairs to the sacred building also made it possible to circumvent the censors' ban that until then had prohibited the building of theaters in stone inside the city.

▶ Pompey the Great, copy of an original that depicted him at age fifty, ca. 60–50 BC, Ny Carlsberg Glyptothek, Copenhagen.

The selection of the statues to decorate the theater was overseen by Atticus, a close friend of Cicero and a connoisseur of art, and was limited to subjects related to the theater and the worship of Venus.

The width of the shoulders looks correct only when the statue is viewed from a particular vantage point; it otherwise seems disproportionate in relation to the statue's size.

The large complex built in the Campus Martius also included a sumptuous villa where Pompey stayed when in Rome; since he held proconsular power almost continuously, in fact, he was not permitted to enter the pomerium.

Meetings of the senate that required the presence of Pompey were held in the curia annexed to the complex, and thus for the first time the senators met on the property of a private citizen.

▲ Seated Muse, from the Theater of Pompey, mid-1st century BC, Centrale Montemartini, Rome.

The sculpture was designed to be viewed from below and slightly to the side, since only from that perspective is it possible to appreciate the play of the folds of the drapery on the left side and see the crossed feet with their light sandals correctly.

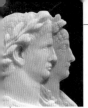

"On the day of his Gallic triumph, the axle of his triumphal chariot broke, and he nearly fell; but afterward he ascended to the Capitol between two lines of elephants, forty in all, which acted as his torch bearers" (Suetonius)

Caesar

100–44 BC

Important dates
63 BC: Caesar is elected pontifex maximus
61 BC: Caesar is governor of Farther Spain
60 BC: First Triumvirate, with Pompey and Crassus
59 BC: first consulship
58–51 BC: campaigns in Gaul
51 BC: publishes his commentaries on the Gallic Wars
49 BC: crosses the Rubicon, beginning the civil war against Pompey
48 BC: victory over Pompey at Pharsalus
46 BC: definitive defeat of the followers of Pompey at Thapsus
45 BC: adoption of his nephew Gaius Octavius
44 BC: Caesar, dictator for life, is assassinated in a plot on March 15

After defeating Pompey at the battle of Pharsalus, Caesar became the de facto ruler of Rome and the unquestioned director of building activity in the capital. After undertaking an extension of the Forum Romanum, he built a new complex, the Forum Julium, the first of the Imperial Fora. This was a long, rectangular, porticoed court that ended in a temple to Venus Genetrix, the legendary founder of the *gens* Julia. The project required the purchase of the land behind the Curia Corneli and the destruction of numerous homes that had been built during the late republican period; it was also necessary to tear down a stretch of the ridge that connected the Capitol to the Quirinal.

Death prevented Caesar from undertaking the most ambitious

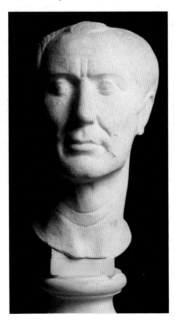

▶ Portrait bust of Julius Caesar from Tusculum, copy of an original from ca. 45–44 BC, Museo di Antichità, Turin.

of his projects for urban construction, a plan that included deviation of the course of the Tiber, the transformation of the Vatican Hill into a new monumental center, and the enlargement of the urban residential zone toward the Campus Martius. In the years immediately after his death, the activity in the monumental worksites Caesar had set in motion went ahead without major variations, divided up equally among the triumvirs Octavian, Marc Antony, and Aemilius Lepidus.

"Across from the Forum Julium is a bookstore, the entrance to which, both to the right and left, is covered by advertising posters" (Martial).

Work on construction of the forum went ahead slowly and was completed only by Augustus after the death of Caesar, who had, however, managed to

inaugurate the Temple of Venus in 46 BC, which he had built to keep a vow made before the battle against Pompey at Pharsalus in 48 BC.

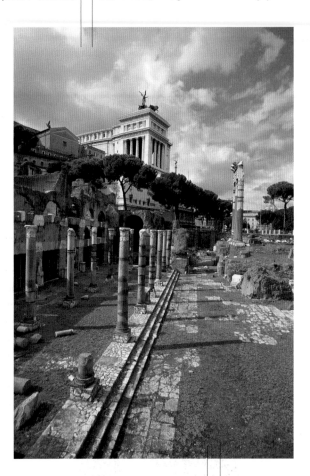

▲ Forum Julium.

"In the Pontic triumph, one of the decorated wagons, instead of a stage-set representing scenes from the war, like the rest, carried a simple three-word inscription: 'I came, I saw, I conquered!' This referred not to the events of the war, like the other inscriptions, but to the speed with which it had been won" (Suetonius)

Caesar was made dictator for life and assumed other privileges typical of the royalty of the Hellenistic and eastern type and undertaking, along with major urban projects, numerous important political and social reforms.

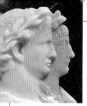

Augustus and Livia

Augustus: 63 BC–AD 14
Livia: 58 BC–AD 29

Important dates
43 or 42 BC: marriage of Livia and Tiberius Claudius Nero
39 BC: Livia divorces and marries Octavian
31 BC: battle of Actium and defeat of Cleopatra
27 BC: Octavian is named Augustus
21–15 BC: subjection of the Alpine peoples
17 BC: celebration of the Saecular Games for the end of the war
12 BC: Augustus is made pontifex maximus
12–8 BC: the Roman Empire reaches the Danube (provinces of Pannonia and Moesia)
AD 6: creation of the province of Judea
AD 14: Augustus dies at Nola on August 19, by his will Livia receives the title Augusta
AD 29: death of Livia

The apotheosis, or deification, of Caesar was a major element of the propaganda in support of Augustus, since he based the legitimacy of his rule on the fact of being Caesar's adoptive son; with the divination of his father, to whom he dedicated the Temple of the Divus Julius in the Forum Romanum—the first temple erected in Rome to a deified mortal—Octavian had the right to call himself *divi filius* ("son of god").

Thanks in part to the considerable wealth made available by the victory over Cleopatra, Augustus was able to undertake an immense building program in Rome. This involved, first of all, the large-scale restoration of many sacred buildings, a reflection of the emperor's religious policies. He restored certain republican institutions as well as religious practices that had fallen out of use. He also undertook a large urban transformation in the Campus Martius. Augustus's most important contribution, however, was the administrative reorganization of the city, which by then had a population of at least 700,000. He divided Rome into fourteen districts, each entrusted to a magistrate annually

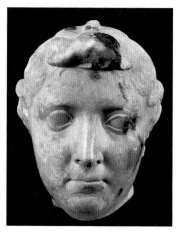

▶ Portrait head of Livia, white marble, end 1st century BC, Palazzo Massimo, Rome.

chosen by lot. These districts, which covered an area far larger than that enclosed within the old republican walls, became the basis for the system of urban maintenance and the direction of services. The traditional magistracies were rearranged, and new offices were created, such as night watchmen to guard against fires, and laws were enacted that codified building regulations in the city, as, for example, limiting the height of street fronts to 70 Roman feet, equal to a six- or seven-floor house.

"I was given the title of Augustus by decree of the senate, and the doorposts of my house were covered with laurels by public act, and a civic crown was fixed above my door, and a golden shield was placed in the Curia Julia, whose inscription testified that the senate and the Roman people gave me this in recognition of my valor, my clemency, my justice, and my piety" (Augustus)

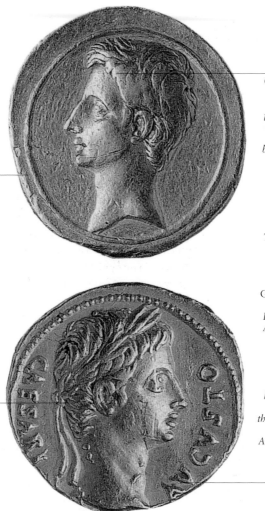

Octavian, just over thirty years old, appears in this portrait as a young man without royal insignia of power but recognizable by the characteristic thick hair dressed in locks and the aquiline nose.

The emperor wears a crown of laurel, symbol of royalty, and his features, at age forty-five, are still those of a young man; the treatment of the hair is more schematic than in older portraits and calls attention to the regular, almost forced arrangement of the locks.

The major political manifesto of the Augustan age to survive to modern time is the Res Gestae Divi Augusti ("Deeds of the Divine Augustus"), Augustus's political testament, which he wanted to have posted at the entrance to his mausoleum. It is known thanks to a copy inscribed on the walls of the cella of the Temple of Augustus and Rome erected at Ancyra (Ankara) between 25 and 20 BC.

▲ Aureus of Octavian, 32–29 BC (obverse), Palazzo Massimo, Medagliere, Rome.

▲ Aureus of Augustus, issued in Spain in 18 BC (obverse), Palazzo Massimo, Medagliere, Rome.

Rather than a separate house, it seems likely that the House of Livia was an apartment set aside inside the palace that Augustus, as early as 36 BC, made by uniting a group of older homes.

In 3, when Augustus's house burned down, many people offered to contribute money to the rebuilding, in some cases large sums, but according to the historian Dio Cassius, "He accepted nothing but an aureus from entire communities and a denarius from single individuals."

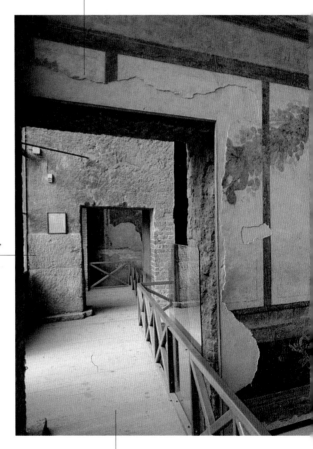

▲ Home of Livia on the Palatine.

The House of Livia, excavated in 1869 by Pietro Rosa in the service of Napoleon III, was identified on the basis of lead water pipes that—in keeping with building regulations—bore the name of the building's owner, Iulia Augusta.

Running along the upper part of the wall is a frieze with a yellow background that constitutes a highly important example of the refined landscape art of Rome; places of worship and exotic constructions, ritual scenes, men and animals follow one another without interruption, sketched using a technique of shading and highlighting.

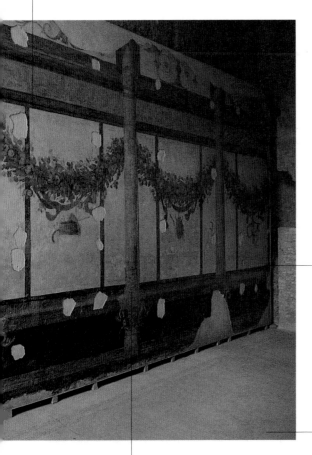

Suetonius reports that Augustus "moved to the Palatine, but again to a modest house, belonging to Hortensius, and neither large nor elegant; in fact, there was only a short portico with columns in Alban stone and rooms without marble or mosaic floors by special artists. There he slept in the same bedroom all year round, winter and summer, for over forty years."

The reconstruction of the House of Augustus emphasizes the distinction between the private areas, with small, very simple rooms, and those public, to the east of the Temple of Apollo, in which the rooms are large and elegant, decorated with stuccoes and marbles; this area was later incorporated in Domitian's palace and came to be called the Domus Augustana.

Depicted along the side walls is a portico with Corinthian columns and lush festoons composed of flowers, leaves, and fruit tied by colored ribbons from which hang various objects related to rustic cults.

"From this place the mules deposited their pack-saddles at Capua betimes [in the morning]. Maecenas goes to play [tennis], but I and Virgil to our repose: for to play at tennis is hurtful to weak eyes and feeble constitutions" (Horace)

Virgil and Maecenas

Virgil: 70–19 BC
Maecenas: ca. 70–8 BC

Important dates
42–37 BC: Virgil writes the *Eclogues* and enters the literary circle of Maecenas
41 BC: Virgil lives near Naples
37 BC: Maecenas and Virgil travel to Brindisi in the company of Horace and other artists
37–31 BC: Virgil writes the *Georgics*
36–33 BC: Octavian, far from Rome, entrusts his business affairs to Maecenas
31–29 BC: Octavian entrusts Maecenas and Agrippa with the direction of the business of Rome
29–19 BC: Virgil writes the *Aeneid*
19 BC: Virgil sets off on a three-year trip to Greece but falls ill and dies.

Maecenas was for decades the trusted friend and adviser of the emperor Augustus and performed a fundamental role in shaping the emperor's political agenda. Great connoisseur and patron of the arts, a refined and learned man, Maecenas understood the important roles played by art and literature in winning approval for the new ruler. A crowd of intellectuals and men of letters gathered around Maecenas, and he helped them with gifts and financial assistance and spurred them on toward ever more elevated goals, hoping to achieve that "great literature" that requires a variety of genres but that begins with the epic poem. The artistic patronage of Maecenas—whose name now stands for a wealthy and generous patron of the arts—along with that of other intelligent and influential figures was a fundamental aspect of the intellectual climate of the period. It seemed that the common efforts of artists would finally contribute to the birth of a new recognized figure, that of the poet as a useful member of society.

Poets were called upon to make proposals, to express hopes, and to present models, as Virgil did in his *Georgics*, which presents a sort of outline of morality. The *Aeneid*, Virgil's masterpiece, although composed in accordance with the archaic model of the Homeric poems, is a modern work in which the stuff of legends is reformulated organically to consecrate the figure of Aeneas as the founder of the family of Caesar and thus also the founder of the family and the power of the Romans.

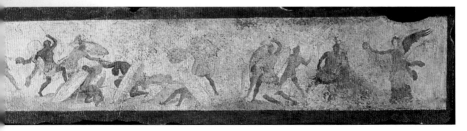

One of the basic elements supporting the legitimacy of the predominance of the gens Julia in the government of the state was establishment of its divine and heroic ancestry, which was accomplished through a certain reading of the origins of Rome.

Mars is presented as the divine father of Romulus and progenitor of the Roman line. This is the main face of the altar; the rear face illustrates the myth of the twins suckled by the she-wolf, as seen on page 11.

Venus, divine mother of Aeneas and thus divine ancestor of the people that were to found Rome, is accompanied by a young man, perhaps Hymen, and by a cupid in flight, reflections of the celestial marriage.

In Book VI of the Aeneid, Aeneas descends to the underworld and hears the solemn prophecy of his father, Anchises, who describes the glorious fate of their progeny and Rome, destined to rule other peoples: "Rome! 'tis thine alone, with awful sway, to rule mankind, and make the world obey: disposing peace and war thy own majestic way. To tame the proud, the fettered slave to free, these are imperial arts, and worthy thee."

Virgil enjoyed so much success among his contemporaries that as early as 26 BC his works were being studied in upper schools.

◀ Frieze painted on the Esquiline, scene of the battle of the Numicus River and the apotheosis of Aeneas, ca. 30–20 BC, Palazzo Massimo, Rome.

▲ Altar to Mars and Venus, from the portico of the Piazzale delle Corporazioni, Ostia, ca. 100–130, Palazzo Massimo, Rome.

Traces of water pipes have been found indicating that this space was used as a nymphaeum, a monumental fountain embellished by plants, flowers, and water sprays.

The building is composed of a rectangular hall, widening toward the front in an apsidal shape in which there are five niches over a semicircular stairway with seven steps, which must have been covered originally by slabs of cipollino marble.

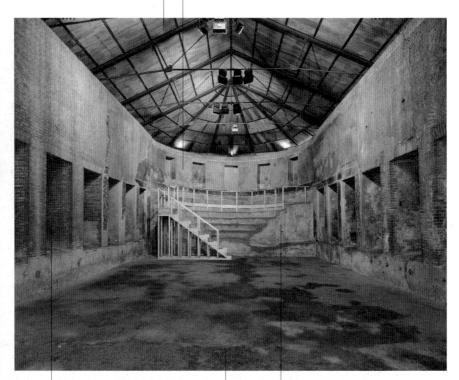

On the long walls, in the part toward the apse, are visible six niches on each side. Analysis of the structure suggests that it dates to between the last years of the republic and the very start of the imperial age.

It is possible that the great nymphaeum, located inside the gardens of Maecenas and known today as the Auditorium of Maecenas, is where the poets of his circle met for private recitals of their works.

The large nymphaeum must have been part of the villa that Maecenas built around 30 BC on the Esquiline and where Tiberius went to live on his return from his voluntary exile at Rhodes.

▲ Auditorium of Maecenas.

"Who was unaware of the ferocity of Nero? Having killed his mother and brother, nothing remained but to add the murder of his teacher and master" (Tacitus)

Seneca and Nero

Nero is known for planning ambitious projects that were never undertaken, such as cutting a canal through the isthmus of Corinth and connecting Ostia to Rome by canal, but he left enduring signs of his reign in the capital of the empire, the "new Urbs" that he intended to build following the Great Fire of 64, which very probably marked the point of departure for the major urban undertakings of the following centuries. For the first time Rome was given an orderly plan that regularized—in part by reviving old laws that had fallen out of use—building activity in the various quarters with instructions often related to fire prevention, such as the limitation on the height of buildings, the obligation of using tiles as roof coverings, and the obligation to leave an open area around every house.

Nero's best-known undertaking was quite different, however, and involved a series of unpopular measures that included

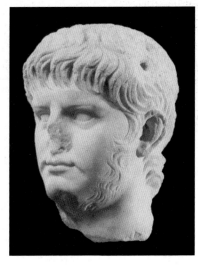

the demolition of public buildings and the confiscation and expropriation of private homes in order to create the immense space necessary for construction of his *Domus Aurea* ("Golden House"), his new palace in the heart of the city. This building, divided into private and public rooms richly decorated and often constructed with daring architectural methods, had a vast lake at its center.

Seneca: 4 BC–AD 65
Nero: 37–68

Important dates
AD 41: Seneca is exiled to Corsica for presumed adultery with Caligula's sister
49: Seneca is recalled to Rome by Agrippina and named tutor to the young Nero
54: Nero is proclaimed emperor by the Praetorian Guard and Seneca becomes his political adviser
55: Nero has Britanicus, the young son of Claudius, poisoned
59: Nero has his mother killed
62: Seneca, fallen into disgrace, retires to private life, leaving his enormous patrimony to Nero
64: Great Fire at Rome
65: plot of the Pisoni; Seneca is forced to commit suicide
68: on June 9 Nero, declared a public enemy by the senate, commits suicide

◀ Portrait bust of Nero, dated to between 59 and 64, Museo Palatino, Rome.

In the so-called Hall of Masks pictures with landscape scenes are inserted in a complex decoration involving painted architecture from which garlands hang; there are delicate superimposed views on a wall decorated with many different motifs among which stand out the masks that give the room its name.

The paintings in the Domus Aurea *inspired such artists as Ghirlandaio, Pinturicchio, Perugino, and Filippino Lippi, whose signatures are still visible on the frescoed walls. The style they took away came to be called "grotesque" in part because of the appearance of the fanciful and sometimes distorted decorations in the chambers, or* grotte, *of Nero's palace.*

Ancient historians have handed down the name of one of the artists who decorated Nero's palace, a certain Famulus, who seems to have painted only a few hours each day, with great seriousness and always dressed in a toga, even when on the scaffolding.

The landscapes in the pictures were created using broad, soft brushstrokes that created large areas of shadow and light, using only a few colors, brown, blue, and gray, aside from the white that was used to give luminosity to the composition.

▲ Landscape paintings from the Hall of Masks in the *Domus Aurea.*

Seneca was born at Cordova, in southern Spain, and was brought to Rome by an aunt. Little is known of his life before his early exile to Corsica and his nomination as the tutor to the young Nero, while we know that for nearly eight years, between 54 and 62, he and the Praetorian prefect Afranius Burrus were the most powerful men at the imperial court.

In his Annals, Tacitus relates the death of the great philosopher, forced to kill himself by order of his former student: "Each with one incision of the blade, he and his wife cut their arms. But Seneca's aged body, lean from austere living, released the blood too slowly. So he also severed the veins in his ankles and behind his knees."

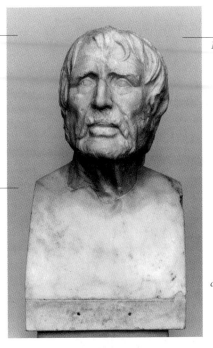

Many of Seneca's writings are still widely read today, including his many teachings and wise sayings: "Virtue is . . . lofty, exalted and regal, un-conquerable . . . Virtue you will find in the temple, in the forum, in the senate house— you will find her standing in front of the city walls dirty and stained and with calloused hands."

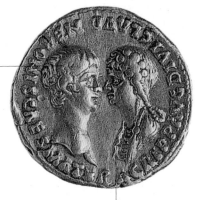

The ruler at only eighteen, in the year of his ascent to the throne. During Nero's reign the tax burden on Romans, primarily a result of the increasing cost of the bureaucracy and the army, became so intolerable that, in 64, Nero enacted a reform program that included reduction in the weight of the aureus and the denarius.

Agrippina II, eldest daughter of Germanicus and Agrippina I and sister of Caligula, married her uncle Claudius, in 49, and persuaded him to adopt Nero, her son from her first marriage. In the first years of his rule she enjoyed great power, but she was later exiled and ultimately assassinated, in 59, on Nero's orders.

▲ Pseudo Seneca, Roman copy of a Greek original of the 3rd century BC, Palazzo Nuovo, Museo Capitolino, Rome.

▲ Aureus of Nero, issued at Rome in 54 (obverse), Palazzo Massimo, Medagliere, Rome.

"When Titus complained that the tax Vespasian had put on the contents of the city's urinals was unseemly, Vespasian held a gold coin under his nose and asked, 'Does it stink?' Titus said no, to which he said, 'Yet it comes from urine'" (Suetonius)

The Flavians

69–96

Important dates
69: on December 22, the senate recognizes Vespasian as legitimate emperor
70: Vespasian's son Titus conquers Jerusalem
75: enlargement of Rome's *pomerium*
79: Vespasian dies and is succeeded by his son Titus
80: a fire in Rome destroys the Temple of Capitoline Jupiter; a plague rages; inauguration of the Colosseum
81: Titus dies and is succeeded by his brother Domitian
83–85: German war
87: plot against Domitian
96: Domitian is killed in a palace plot

During his reign, Vespasian worked hard to return to the city the enormous expanse that Nero had occupied with construction of his *Domus Aurea*; the sumptuous palace was dismantled and part of its structure was put to public use, such as for the baths later rebuilt by Titus. However, Vespasian's greatest undertaking was the building he erected atop the lake in the middle of Nero's palace: an amphitheater, the Colosseum. The city needed a new one, since the first permanent one, built by Statilius Taurus, had been destroyed by the Great Fire in 64.

Also dating to the period of Vespasian is construction of the Templum Pacis (Temple of Peace), erected to celebrate the Roman victory in Judea and the achievement of a new period of peace. Many of the works of art that Nero had taken from temples in Greece were placed in the temple, along with outstanding pieces from the spoils taken from Jerusalem.

There is unquestionable evidence that the Flavian age was a period of substantial urban renewal, also in terms of city administration and the reorganization of Rome's land registry, indicated in part by the expansion of the borders of the *pomerium*, the religious precinct of the city. Domitian was responsible for the definitive reconstruction of the Flavian palace on the Palatine Hill, which with the exception of occasional rebuilding and reworking was to remain the official residence of the emperors until late antiquity.

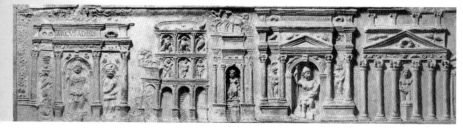

The statue, smaller than life size (it is only 130 centimeters high), portrays Julia at slightly more than twelve years of age, probably in the year of her father's death.

The girl's round, almost puffy face is crowned by a mass of curls collected in a bun at the back of her head, following a style typical of the Flavian age.

Julia wears a long tunic gathered under her chest that falls in soft folds to reveal her slightly bent right leg; over that is a stola *with a wide neckline; the mantle—the* palla—*draped over her left forearm goes around her entire body; on her feet she wears women's sandals.*

Julia was born around 68 in Titus's second marriage, and when very young was given in marriage to a cousin who, falling in disgrace, was put to death around 84. The young widow later lived with her uncle, the emperor Domitian, as his lover; after her death, in 91, she was deified.

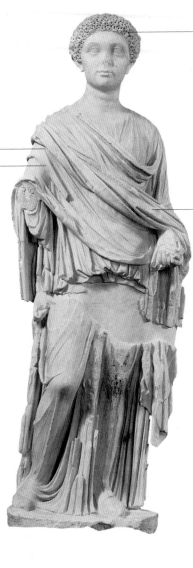

◀ Relief from the Tomb of the Haterii, ca. 70–100, Musei Vaticani, Rome

▲ Julia, daughter of Titus, from the Tiber Island, ca. 81, Palazzo Massimo, Rome.

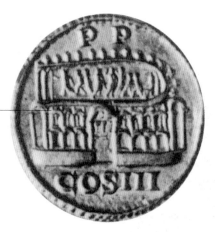

The stadium of Domitian depicted on a sesterce issued by Septimius Severus in 202–3, on the occasion of the return to Rome of his son Caracalla. Without doubt, the reason for presenting Domitian's stadium on the coin was that it had been used for the performance of the games to celebrate the marriage of Caracalla and Plautilla.

The stadium, 275 meters long and more than 10 wide, could hold up to 30,000 spectators; the surface of the arena was unobstructed, and the main entrances were located at the center of the long sides. The stadium's decoration probably included the statuary group with the so-called Pasquino that now stands in Rome's piazza of that name.

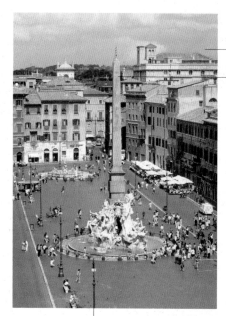

The obelisk that Bernini placed at the center of the square in 1651 came from the Circus of Maxentius on the Via Appia, although in all probability it had been originally located in some other monument.

▲ Sesterce of Septimius Severus, 202–3, British Museum, London.

▲ Piazza Navona, Rome.

Piazza Navona is an outstanding example of the urban continuity between ancient Rome and the modern city. Its highly elongated rectangular shape, with one of the short sides curved, exactly repeats the shape of the stadium that Domitian built around 86 to host Greek athletic games.

omitian's profile is well known from the coins struck during his reign; marble portrait busts of him are quite rare because after his assassination he was ubjected to damnatio memoriae—official condemnation of his memory—and a great many of the busts were destroyed.

The damnatio memoriae was an act of the senate that ordered the cancellation from public memory of those who were considered guilty of behavior that went against the interests of the state. Images of such persons were destroyed, and their names were erased from inscriptions.

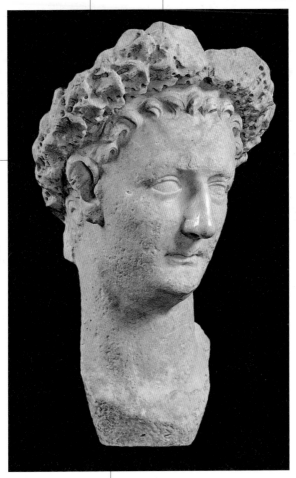

The final years of Domitian's reign were marked by his severe repression of all perceived opposition; not even the members of his family were spared, accused of conniving with the Jews and Christians in Rome. It seems that in the end even the emperor's wife was involved in the plot that brought an end to his rule.

▲ Portrait bust of Domitian, from the area of Lago di Fogliano, end 1st century, Palazzo Massimo, Rome.

The historians and intellectuals of the period had a harsh view of Domitian, probably in part because toward the end of his reign he unleashed his rage against them too, exiling many from Rome.

Trajan and Apollodorus

Trajan: 53–117
Apollodorus: ?–129

Important dates
98: Trajan, legate of Upper Germany, succeeds his adopted father, Nerva
99: Trajan arrives in Rome
101–2: First Dacian War
103: construction of Trajan's bridge over the Danube at Drobeta, on a design by Apollodorus
105–6: Second Dacian War
113–117: campaigns in Armenia, Assyria, and Mesopotamia
117: August 1, while returning to Rome with his wife, Plotina, Trajan dies at Selinus in Cilicia
129: Apollodorus is exiled and then killed by Hadrian, offended by criticism he had made of his architectural designs

▶ Posthumous portrait bust of Trajan, from the lime kiln of the Caseggiato del Serapide, Ostia, ca. 119, Museo Ostiense, Ostia Antica.

Trajan hoped to use the enormous wealth of the spoils brought back from the conquest of Dacia to undertake a large-scale urban project designed to become the true center of the state, creating, in an area already densely built up between the Forum Romanum and the hills behind it, a new monumental forum and a large commercial complex. The principal economic activities of the city were to be located in terraced shops on several floors under the direct control of the officials of the Annona, thereby establishing centralized management and firm administration of the supplies of grain and of goods that arrived in Rome from the new port at the mouth of the Tiber. Trajan had made a sheltered basin at Fiumicino with a port complex designed to finally solve the problems of the difficulties of access to the river port.

The Forum of Trajan was built between 107 and 113 on a design by Apollodorus of Damascus, the most famous architect of

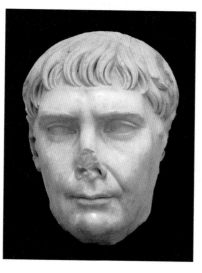

the period, who personally oversaw the work of building Trajan's Column, the Basilica Ulpia, and probably other buildings in the forum and markets. The great architect was highly admired by Trajan by fell into disgrace under his successor, Hadrian, for daring to criticize Hadrian's design for the Temple of Venus at Rome. Apollodorus was first exiled and then executed.

Marcus Ulpius Trajanus was born at Italica, in southern Spain, in 53; after a long military career that took him to every corner of the empire, he was made consul in 91 and governor of Upper Germany in 97; while there he learned of his adoption by Nerva.

Recent excavations carried out thanks to the Alda Fendi Foundation in the eastern apse of the Basilica Ulpia led to the discovery of a stretch of pavement in colored marble slabs (the white with purple veining known as pavonazzetto; the yellow from Tunisia called giallo antico, and African green), the existence of which had always been only supposed.

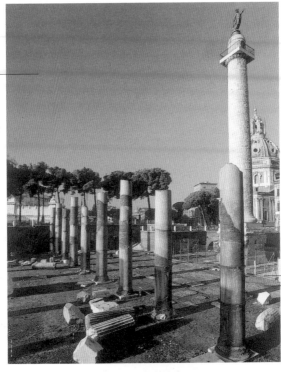

Trajan used coins to remind the Roman people of his munificence and of the greatness of his building projects, reproducing his most important monuments on several coins.

The statue of Trajan that originally stood atop the column disappeared during the Middle Ages and was replaced in the 16th century with the statue of St. Peter in place today.

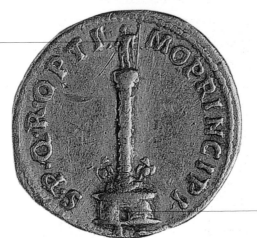

Over the door in the base of the column is an inscription stating that the principal reason for the monument was to indicate the original height of the hill excavated to make room for construction of the forum.

▲ Basilica Ulpia.

▲ Aureus of Trajan, issued between 112 and 114 (reverse), Palazzo Massimo, Medagliere, Rome.

Apollodorus of Damascus is credited with the final rebuilding and enlargement of the Baths of Titus.

The bath complex extended over an area of more than 100,000 square meters, a little less than half of which was occupied by the central building, and remains of the impressive structure are still spread over the park on the Oppian Hill.

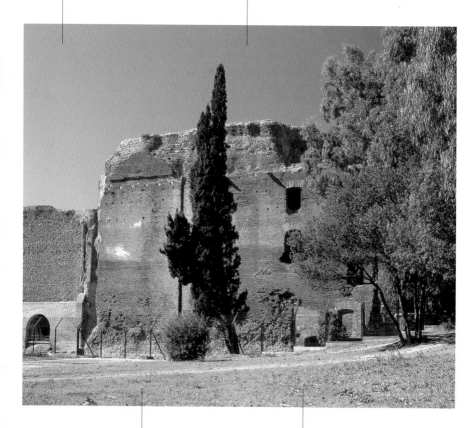

▲ Baths of Trajan.

Apollodorus of Damascus wrote several works on military engineering, only one of which, Engines of War, survives.

In his design for the Baths of Trajan, Apollodorus applied an innovative idea, adding an exterior enclosure with an exedra to the main building and thus creating a model destined to become standard in later bath complexes.

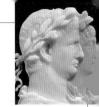

"O fleeting soul of mine, my body's friend and guest, whither goest thou, pale, fearful, and pensive one? Why laugh not as of old?" (Hadrian)

Hadrian and Antinous

Since he abandoned the expansionist policies of his predecessor, Hadrian did not have the income necessary for the creation of large-scale building projects, but his many urban architectural undertakings in the city are still emblematic of the capital of the empire. Between 118 and 125—as we know from the makers' marks impressed in the bricks—he rebuilt the Pantheon of Agrippa, totally changing the original building, and in 121, using his own design, began construction of the Temple of Venus in Rome. The enormous building, the largest temple ever erected in Rome, rose on an artificial podium built upon what had formerly been the site of the vestibule of Nero's *Domus Aurea*, following its orientation and even partially reusing its foundations.

On the right bank of the Tiber Hadrian built an impressive circular mausoleum (today's Castel Sant'Angelo) for himself and his successors, basing it on the model of the tomb of Augustus and connecting it to the city by a bridge—the Pons Aelius— still in use. But Hadrian's passion for architecture found its greatest expression in construction of his villa near Tivoli, in which he wanted to create references to the most famous monuments of the empire's Greek and eastern provinces, but made with innovative technical solutions and design schemes.

Hadrian: 76–138
Antinous: ca. 110–130

Important dates
100: Hadrian marries Vibia Sabina
117: Trajan leaves to Hadrian conclusion of the war in Mesopotamia; Trajan dies and Hadrian is hailed as emperor by the army at Antioch.
118: Hadrian returns to Rome
120–134: Hadrian makes long trips with short stays in Rome
130: Antinous dies, drowning during a trip along the Nile
134: Hadrian returns to Rome definitively
137: death of Sabina
138: after a complex series of adoptions, Hadrian dies on July 10

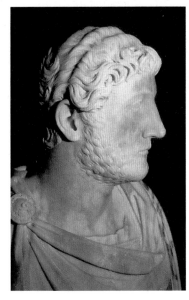

◄ Portrait of Hadrian, replica of an original of ca. 137, Cassa Depositi e Prestiti, Rome.

To make room for construction of the large temple, what remained of the vestibule of the Domus Aurea was demolished; using a wagon drawn by twenty-four elephants, the colossal statue of Nero was moved from its original site and, with its head replaced, was turned into a statue of the Sun.

The contemporary appearance of the monumental remains of the temple, with the vaulted apsidal cellae, is almost certainly a result of restoration work performed under the emperor Maxentius after a fire in the early 4th century.

Hadrian became angry with Apollodorus primarily because the great architect found fault with the proportions of the Temple of Venus and Rome, most of all disapproving of the lack of a high podium to support the building.

According to Dio Cassius, "Apollodorus found fault with the disproportion between the statues and the size of the cella, stating that, 'If the goddesses wish to get up and go out, they will be unable to do so.' When he wrote this so bluntly to Hadrian, the emperor was both vexed and exceedingly grieved because he had fallen into a mistake that could not be righted."

The temple, surrounded by a colonnaded portico, had two adjacent cellae facing opposite directions designed to hold the cult statues, that of the goddess Rome in the side facing the forum and that of Venus in the side facing the Colosseum.

▲ Temple of Venus and Rome.

Hadrian's Mausoleum is composed of a square podiumlike base on which stands a circular drum with a diameter of 64 meters and a height of 20. It was used as the imperial tomb for nearly a century, until the age of Caracalla.

Hadrian's Mausoleum became the Castel Sant'Angelo during the Renaissance, deriving its new name from the statue that was placed at its top in place of the statue of the emperor.

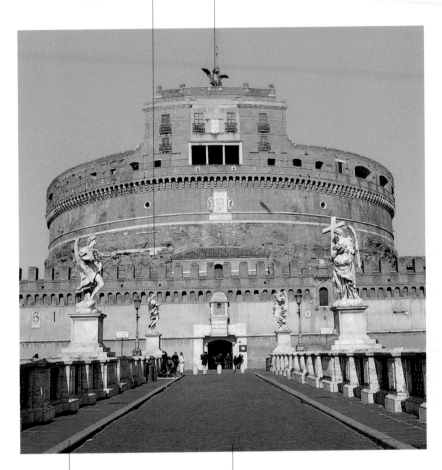

Transformed into a fortress during the Middle Ages, the monument became the main bastion in the Vatican's defensive system and was also used as a prison.

The entire structure was dressed in marble and travertine and was covered by a tumulus of earth planted with cypress trees and surrounded by statues; at the top stood a bronze four-horse chariot with the statue of Hadrian.

▲ Castel Sant'Angelo.

Hadrian and Antinous

The areas once believed to be ancient seem to have been made using a technique identical to the one used for the restoration, and the scratches and signs of wear seem almost to have been made intentionally.

The face of the young man who was Hadrian's favorite is the result of an integration from the modern age (the sculpture has been in the Ludovisi collection only since 1794), and recent studies lead to the suspicion that the entire work is a skilled imitation of an antique.

After the death of his favorite, Hadrian had him deified and founded the city of Antinoöpolis on the site of his death. The cult was most popular in the eastern regions of the empire, but also spread to Rome, where an obelisk was erected in his honor that today is on the Pincian.

The cult of Antinous did not survive Hadrian's death, and all the portraits of the Bithynian youth date to the few years between his death and that of his protector.

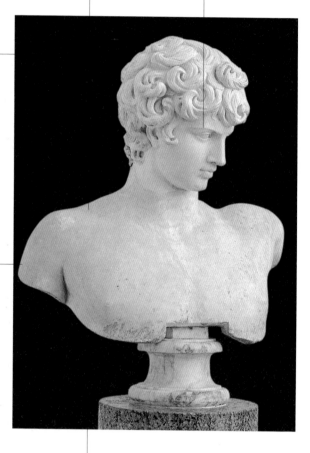

▲ Bust of Antinous, ca. 120–138, Palazzo Altemps, Rome.

Antinous, the youth that Hadrian loved, making him his favorite, was born around 110 in Bithynia, a region of modern-day Turkey facing the Black Sea. At age twenty, while traveling in Egypt with the emperor, he mysteriously drowned in the Nile.

Work on construction of the Hadrianeum probably began in 139, the year of his deification, and was completed six years later. All around the cella stood a series of pilasters on which were carved personifications of the provinces of the empire; the surviving reliefs are preserved in Rome's Musei Capitolini.

Almost the entire length of the right side of the temple is still visible today, with eleven fluted columns preserved along their entire length (15 meters); although sections of the entablature and the frieze are in part ancient, they have been restored many times.

▲ Hadrianeum in Piazza di Pietra.

Preservation of the Hadrianeum was made possible by its constant reuse over the course of the centuries and by the work of Francesco Fontana, who, in 1695, transformed it into the Dogana di Terra, inserting the surviving parts of the temple in the harmonic façade of the palace.

The 17th-century palace has maintained unchanged its original use and is today the headquarters of the Exchange.

"At the present time, neither Roman citizens nor any other persons who are under the empire of the Roman people are permitted to employ excessive or causeless severity against their slaves" (Gaius)

The Antonines

With the ascent to the throne of Antoninus Pius, originally from Gallia Narbonensis but closely tied to Italian traditions, the Roman Empire entered a long period of peace, longer, perhaps, than any the Roman world had known and sadly mourned when it had ended. The reign of Antoninus Pius is known for its progress toward more humanitarian laws, most of all in terms of slaves; for its prudent handling of the economy; and for the flowering of an erudite culture based primarily on study of the past, an outstanding member of which was the Greek Pausanius, author of a sort of tourist guide to Greece. Since the reign of Marcus Aurelius, however, there had been many rebellions and invasions to confront, as well as two tragic outbreaks of bubonic plague. The succession of Commodus brought an end to the happy period of adoptions. The new ruler withdrew, leaving power in the hands of the Praetorian prefect, surrounding himself with a court willing to adore him, and showing no concern whatsoever for the fate of the empire.

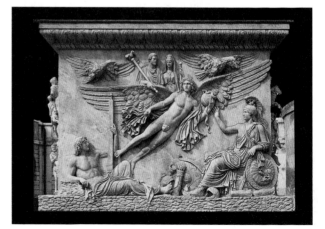

In the narration of events on the column, dramatic episodes alternate with genre scenes; a figure of Victory divides the history into two sections that most probably correspond to the campaign of 172–173 and that of 174–175.

In 1589 Pope Sixtus V had the statue of Marcus Aurelius that stood atop the column replaced by one of St. Paul; at the same time, he had the high base, decorated with a frieze of Victories and a scene of the submission of barbarians, demolished.

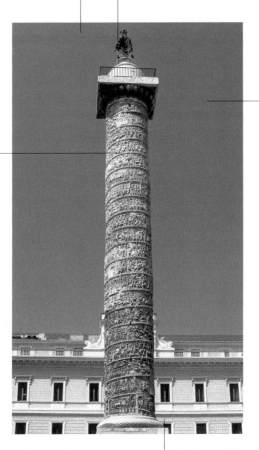

The shaft of the column—on the model of Trajan's Column—is composed of nineteen circular blocks that bring the monument to a height of 100 Roman feet, just under 30 meters.

The monument was raised between 180, year of the death of Marcus Aurelius, and 196, year in which, as is known from inscriptions, the custodian in charge of the column, a certain Adrastus, was authorized to use the wood from the scaffolding to build himself a home.

The column celebrates the deeds of Marcus Aurelius against the Germans and the Sarmatians in a carved narration that winds around the shaft, beginning with scenes of the Roman army crossing the Danube.

◄ Base of the Column of Antoninus Pius with the apotheosis of Antoninus and Faustina, immediately after 161, Musei Vaticani, Rome. ▲ Column of Marcus Aurelius.

The statue is today in the museum, where it was moved following a complete and complex restoration carried out about twenty years ago.

The statue of Marcus Aurelius has survived because during the Middle Ages it was believed to be a statue of Constantine, an emperor considered a Christian and thus treated with respect; for this reason it escaped being melted down, the fate of almost all the bronze works of antiquity.

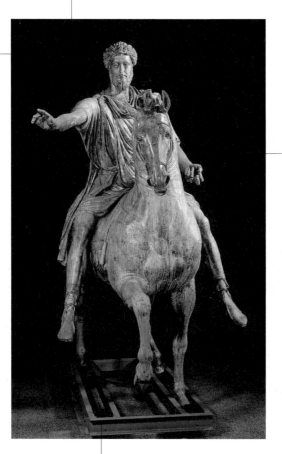

The emperor is depicted past middle age, with his right hand raised in a sign of peace as though calling to a halt some warlike event. The statue was probably part of a triumphal monument and was probably gilt in antiquity.

The Piazza del Campidoglio, as we know it today, was designed in 1538 by Michelangelo, acting on behalf of Pope Paul III. As the symbolic beginning of the project, the pope had the equestrian statue of Marcus Aurelius removed from the Lateran, where it had been preserved for centuries, and brought to the new square, where it became the centerpiece of the entire design.

▲ Marcus Aurelius, 170–180, Musei Capitolini, Rome.

Between the 7th and 8th centuries, the Temple of Antoninus and Faustina was transformed into the church of S. Lorenzo in Miranda and thus was preserved, although the transformation did not prevent the systematic plundering of the building's decorations between the 15th and 16th centuries.

The temple was dedicated to the memory of Faustina and, after his death, also to Antoninus, as can be seen on the architrave, on which the line about Antoninus was clearly added later.

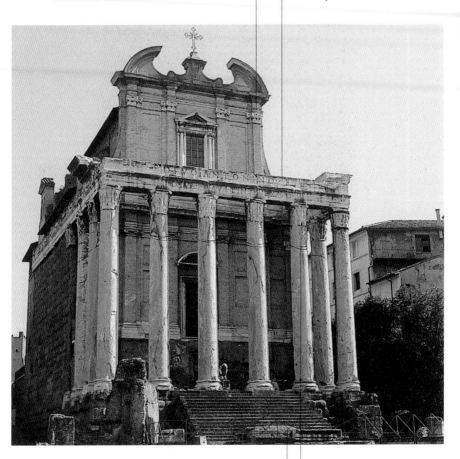

▲ Temple of Antoninus and Faustina in the Forum Romanum.

The access stairs to the temple on its high podium have been heavily restored in modern times, using brick; even so, the base of an altar still stands at the bottom of the stairs. In ancient Rome, altars were often placed in front of places of worship rather than inside them.

Still visible on the upper areas of the shafts of the columns are marks made by cables when an attempt was made—fortunately in vain—to pull them down.

"Severus always called the Antonines his children and . . . ended all his letters with these words: 'Greet the Antonines, my children and successors'" (Aelius Spartianus)

The Severans

193–235

Important dates
193: the senate proclaims
Septimius Severus
augustus (emperor)
197: Septimius Severus is
in Rome and nominates
his son Caracalla caesar
(subemperor)
198: Caracalla is emperor
with his brother Geta as
caesar
211: Severus dies at
Eburacum (York); he is
succeeded by Caracalla
and Geta
212: Caracalla grants
citizenship to all subjects
of the empire; he has his
brother killed
217: Caracalla is killed
near Carrhae (Haran);
Macrinus, prefect of the
Praetorian Guard, is
proclaimed emperor by
the soldiers
218 Macrinus is killed;
Elagabalus proclaims
himself emperor
222: Elagabalus and his
mother are killed; his
cousin Alexander
Severus becomes
emperor under the
control of his mother
and grandmother
235: Maximinus is
proclaimed emperor at
Mainz, and Alexander
Severus and his mother
are killed

Perhaps in part to legitimize his new dynasty, Septimius Severus chose a site in the heart of the monumental center, the Forum Romanum, for an arch celebrating his victories over the Parthians. This was the Septizodium, a massive columnar screen that extended up the slope of the Palatine toward the Circus Maximus. He built an encampment on the Alban Hills for the II Legion *Parthica*, stationing legionary troops in Italy for the first time. His government was prudent, and on his death there were wheat supplies sufficient for seven years and enough oil to serve the needs of Rome and Italy for five years. His son Caracalla had a complex of public baths built on a vast area of the slopes of the Aventine. The complex was of a size until then unimaginable, and to make it possible a special branch of the Aqua Marcia was needed, the Aqua Antoniniana, which ran over the Via Appia on what is today known as the Arco di Druso. Aside from building a

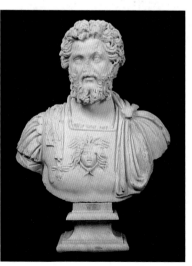

gigantic sanctuary on the Palatine, Elagabalus restored numerous aqueducts, baths, and public places and created public storehouses in each of the fourteen regions, probably as part of a reorganization in the system of grain supply that was going to replace monthly distributions of grain with the daily distribution of bread, pork and wine.

Clearly visible in the fourth line of the long dedicatory inscription on the attic is the cancellation of the name of Geta, the younger son of Septimius Severus who was killed on orders from his brother Caracalla, who then decreed his damnatio memoriae.

The top of the arch, as is known from its depiction on a coin, was originally decorated by a bronze chariot drawn by six horses and flanked by equestrian statues, a clear reference to the triumph celebrated by the emperor.

The friezes over the smaller bays present scenes of a triumph with the transportation of the spoils and trophies of war, including carts full of plunder, soldiers, prisoners, and a large seated statue symbolic of the conquered province.

The narration is probably based on pictorial models from the east, for it is known that along with news of his victory the emperor sent to Rome several large paintings showing the story of his deeds and that the senate had them displayed for popular admiration.

Erected in 203 by the senate to celebrate Septimius Severus's victories over the Parthians, the arch stood in the northeast corner of the Forum Romanum at the point in which the Via Sacra begins its ascent toward the Capitol.

◀ Bust of Septimius Severus from Ostia, ca. 196, Palazzo Massimo, Rome.

▲ Arch of Septimius Severus.

Fragments of the map continue to emerge from stratigraphic investigations in various areas of the city, as in the case of a small section found a few years ago in a lime pit in the area of the crypta Balbi, *where it was destined to be transformed into limestone, together with many other marbles from ancient Rome.*

The slab, found in the barracks of the mounted Carabinieri, depicts the area of the Campus Flaminius. The Temple of Castor and Pollux is recognizable, as well as an enormous commercial building owned by a certain Cornelia and her associates.

The marble plan of Rome dates to the age of Severus and is known as the Forma Urbis; it presents an accurate view of the entire city designed on a scale of 1:240. The first large group of fragments of the plan was found in 1562 near the place where the map was originally displayed.

Attempting to match his father's successes in war, Caracalla organized a new expedition against the Parthians, but no sooner had he arrived in Asia, not yet thirty, than he was murdered in a military plot in 217.

Caracalla's name is linked in particular to an edict that ended a period: the Constitutio Antoniniana *(issued in 212)* extended Roman citizenship to all free people within the borders of the empire, putting an end to the age-old distinctions between Roman citizens and provincials.

▲ Fragment of slab from the *Forma Urbis,* from the Via Anicia, Museo delle Terme, Collezione Epigrafica, Rome.

▲ Caracalla, from a suburban villa on the Via Cassia, 212–15, Palazzo Massimo, Rome.

The articulated architecture of the background, with columns and an arch, presents a reasonably accurate depiction of the site where the scene took place, in 205.

The emperor welcomes senators who pay him homage on the day of the election as consuls of his very young children, the seventeen-year-old Caracalla and the even younger Geta, presented behind their father.

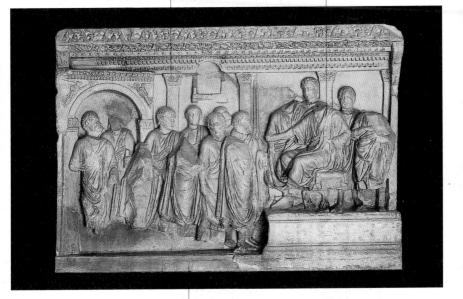

The sculpture of the Severan period is well documented in Rome and presents all the complexity of a learned art at the moment of passage from the classical designs of the preceding century, as in this relief from Palazzo Sacchetti, to those of late antiquity, in which the imperial figures are arranged frontally.

▲ Relief in Palazzo Sacchetti, early 3rd century, Palazzo Sacchetti, Rome.

The hairstyling of the portrait, a skullcap of short hair tight to the head, and the beard only barely indicated, are characteristic elements of the portraiture in late antiquity and can thus be taken as reflections of the style of the period.

After the brief rule of Elagabalus, nephew of the widow of Septimius Severus, Julia Domna, the last ruler of the dynasty was Alexander Severus, a thirteen-year-old boy who ruled together with his mother Julia Mamea from 222 to 235, when both of them were murdered in a military encampment on the Rhine.

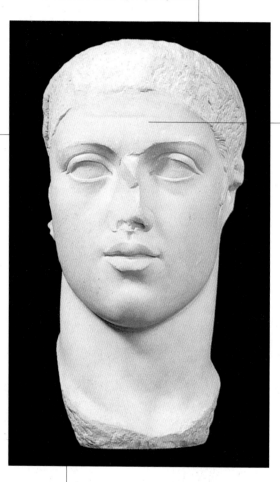

The colossal head of Alexander Severus is an important example of the stylistic changes that took place in imperial portraiture in the decades between the 2nd and 3rd centuries. The emperor is no longer given recognizable features but is presented frontally in an almost priestly pose without expression.

▲ Colossal head of Alexander Severus, from Ostia, ca. 222–35, Palazzo Massimo, Rome.

Alexander Severus's relationship to the rulers of the Severan dynasty was based not so much on his family ties to the widow of Septimius Severus as on a rumor, probably used as a pretext, that he was the son of Caracalla.

▶ Base of the Decennalia with animals being led to sacrifice, 303, Forum Romanum, Rome.

Diocletian

The age of Diocletian brought to completion a process that had been begun many decades earlier: Rome's emperors, constantly busy defending the frontier, spent less and less time in the capital, and it was the soldiers stationed in warmer regions that proclaimed the new emperors. Beginning in 286, Rome was no longer the capital of the empire, for Diocletian moved the political center to Nicomedia, where he ruled, while the imperial residence in Italy was moved to Milan. Even so, as indicated by the seals impressed on bricks, this was a period of new construction in Rome, which for more than a decade had been enclosed in a new and more powerful ring of walls. The curia in the Forum Romanum was rebuilt, and between 293 and 306 a new, gigantic complex of public baths—the Baths of Diocletian—was constructed in a location chosen to serve some of the most densely inhabited quarters of Rome. The baths were the only important alteration in the urban fabric, which otherwise saw changes only in the division of internal spaces and their uses, although these changes were often radical. In terms of private building, the opening decades of the 4th century saw the progressive disappearance of the multistoried *insulae*, which no longer met the needs of a city that was losing population and in which productive activities hardly existed. The old blocks were completely restructured and transformed into single-family homes decorated and furnished in a variety of ways.

the period 245/50–316

Important dates
284: Diocletian is acclaimed emperor
286: he appoints Maximian augustus and begins the administrative reorganization of the empire
293: establishment of the tetrarchy
301: monetary reform and edict on prices and wages
303: Diocletian visits Rome for the first time
303–6: edicts and persecutions of the Christians
305: Diocletian abdicates and retires to his palace at Spalato; Maximian is forced to abdicate

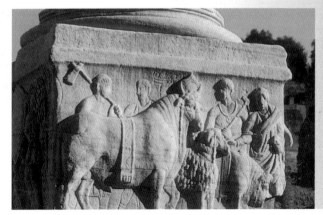

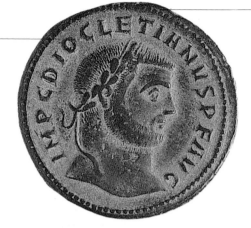

Diocletian effected a radical reorganization of the empire, abandoning the old direction of the state in which local administrations had dealt directly with the emperor and replacing it with a structure of intermediate offices.

The new organization was the first step toward creation of a bureaucratic apparatus designed to communicate the will of the central power to the people but also to control the actions of local administrations and impose respect for regulations. The new system, completely extraneous to the Greek and Roman world, was to have great importance in the future world.

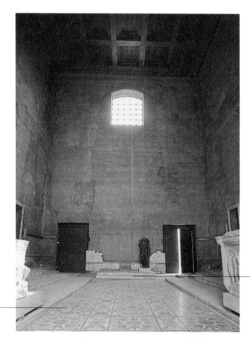

The sumptuous floor is composed of marble slabs with inlays in precious polychrome marble, such as porphyry and serpentine, which form a harmonious design: to the sides are steps that served as seats for the senators.

Still visible is the base on which stood the statue of Victory from Taranto, which Augustus had placed in the Curia Julia, or senate building; at the end of the 4th century the statue and its altar were the center of a heated dispute between Quintus Aurelius Symmachus, one of the last pagan senators, and St. Ambrose, who succeeded finally in having it removed.

▲ *Follis* of Diocletian, issued at Antioch in 297 (obverse), Palazzo Massimo, Medagliere, Rome.

▲ Interior of the Curia Julia.

*"By command of Constantine, the statues of Maximian . . .
were thrown down, and his portraits removed" (Lactantius)*

Constantine

With Constantine and his sons, the new arrangement of the central administration was fixed, destined to remain substantially unchanged until the end of the 6th century. The fundamental characteristic was the creation of a new social class composed of tens of thousands of state employees who came into existence as a result of the enormous increase in the power of the bureaucracy. The city of Rome, which Constantine rarely visited, came to be managed by officials designated by the emperor; the chief of these was the prefect of the city. Constantine's only construction in the old capital of the empire was a public bath not far from the Baths of Diocletian, but smaller and more refined. The principal activity of this period was the restoration and maintenance of old buildings in a city that was becoming an open-air museum visited by rulers most of all on state occasions or for the celebration of anniversaries. Constantine was responsible for important building projects in the religious field. He had the basilica of the Lateran erected, the first large Christian monument, building it on land occupied by the barracks of a military group that had fought against him in his struggle against Maxentius. He also began construction of several basilicas outside the city walls. Most importantly, he began work on St. Peter's, an enormous project completed only after his death for which part of the Vatican Hill had to be leveled and an important necropolis still in use filled in.

ca. 285–337

Important dates
306: Constantine becomes caesar (3rd tetrarchy)
307–11: 3rd and 4th tetrarchy and numerous usurpations
312: battle of Milvian Bridge (October 28) and defeat of Maxentius
Constantine remains in Rome until January of the following year
313: Edict of Milan proclaims the equality of rights of all religions
315: dedication of the Arch of Constantine for the decennial of the emperor's reign
315 and 316: Constantine is in Rome during the summer
330: inauguration of the new capital, Constantinople
337: Constantine dies near Nicomedia

◄ Sarcophagus of Helena, Constantine's mother, 336–50, Musei Vaticani, Rome.

The statue, datable to between 313 and 324, presented the emperor on a throne in a stately pose; the bare parts—head, hands, and feet—were made of marble, while the body was made with drapery in gilt bronze or in sheets of precious marble mounted on a wooden support structure.

Constantine brought to conclusion the construction of the Basilica of Maxentius. The remains of this colossal statue of him were found in 1487 in the western apse of the monument.

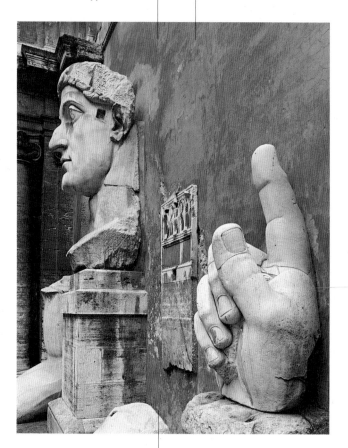

▲ Acrolith of Constantine, Musei Capitolini, Rome, courtyard of Palazzo dei Conservatori.

The oldest churches were built during the reign of Constantine, such as that of the Holy Cross in Jerusalem, a private church located in the home of the emperor's mother and created by adapting an existing large hall into a building for worship.

Constantine loaded his absolutist regime with religious aspects, and although he did not elevate Christianity to the level of state religion he obtained the support of the church for his new form of government, which abolished the collective principle on which the tetrarchy had been based.

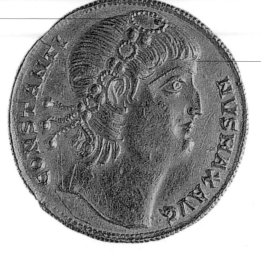

The Edict of Milan, issued by Constantine in 313, did not make Christianity the official state religion, but it affirmed a principle of tolerance and freedom of belief that put all the religions of the empire on the same level.

Constantine sought to provide for his succession by way of a new collective government, dividing the empire among his sons and nephews; but his death unleashed a wave of violence, and the court of Constantinople was shaken by the slaughter of his closest collaborators as well as almost all the male members of the imperial family.

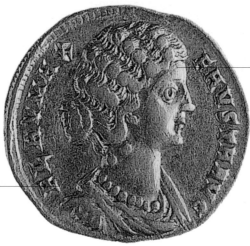

Maximian's daughter Fausta was Constantine's wife for many years. Following the celebration of Constantine's twenty years of rule, she was the primary figure as well as the victim of a mysterious event: for reasons that cannot today be explained, she and Constantine's son by his first wife, Crispus, were put to death at Constantine's order.

▲ Aureus of Constantine, issued at Thessalonica in 335 (obverse), Palazzo Massimo, Medagliere, Rome.

▲ Solid aureus of Fausta, issued at Nicomedia in 324–25 (obverse), Palazzo Massimo, Medagliere, Rome.

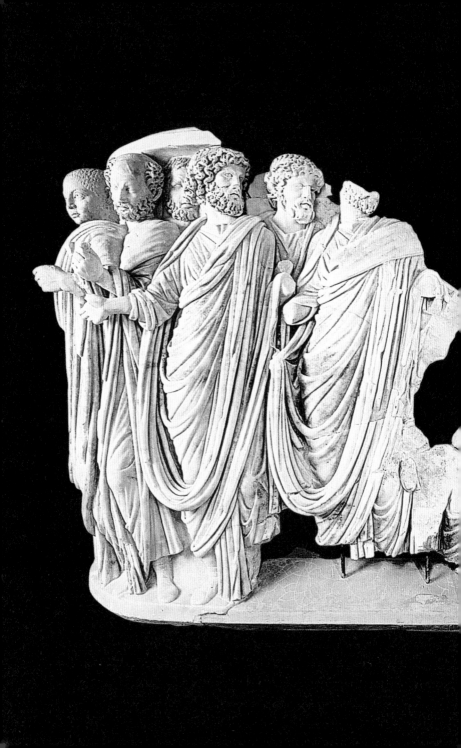

Power and public life

◀ Sarcophagus with procession
for the installation of a consul,
from Acilia, ca. 270–80, Palazzo
Massimo, Rome.

"A vast number of contracts . . . are given out by the censors for the construction and repair of public works . . . everyone is interested in these contracts, some people as purchasers, others as partners" (Polybius)

Cursus honorum

A political career in Rome was regulated by somewhat rigid rules that were derived from the custom of holding a series of magistracies in an order of growing importance, following a sort of hierarchy of positions. During the republican period, this codification of a political career (*cursus honorum*, the "course of honors"), initially unwritten, became increasingly less elastic and was gradually subject to regulations, such as that with which Sulla prohibited the omission of the position of censor in the succession of magistracies. The primary route leading to the highest offices began with the quaestorship—eventually followed by the tribuneship of the plebeians and then of public works—then the praetorship, the consulship, and finally the censorship.

The lesser magistrates occupied legal and administrative offices, such as the four superintendents of the maintenance of urban and extraurban roads. Among these officials were also those in charge of prisons and executions. In many cases the exercise of a magistracy served as the springboard for the youth who aspired to a political career; in particular the monetary triumvirs, the directors of the mint, profited from their position to carry out political propaganda, using minted coins almost as advertising posters. Thus, for example, M. Aemilius Lepidus, in 61 BC, presented on the reverse of a denarius the Basilica Aemilia, reminding people that one of his ancestors had helped build the impressive structure.

▼ Relief with depiction of a curule seat, from Torre Gaia on the Via Casilina, 50–30 BC, Palazzo Massimo, Rome.

The young magistrate is depicted in the act of beginning the races in the circus.

The figure's clothing and attitude clearly indicate his status at a very high level of the Roman society of late antiquity and help to establish his identification.

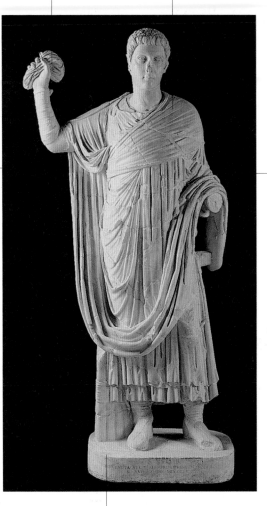

The Horti Liciniani *were the sumptuous residence of the emperor Gallienus, who often withdrew there with his court to take part in banquets and to relax in parks and pools; the villa was put to use long after the emperor's death and was enlarged enormously during late antiquity, becoming a residence comparable to the one on the Palatine.*

The statue was found in the 19th century in the area of the Horti Liciniani together with the statue of an older magistrate believed to be Quintus Aurelius Symmachus, praefectus urbi *in 384–85 and consul in 391; the young magistrate would thus be his son Memmius Symmachus, who became quaestor at ten and praetor at eighteen.*

▲ Young magistrate, from the *Horti Liciniani*, end 4th century, Centrale Montemartini, Rome.

Quintus Aurelius Symmachus *is the same figure who disputed with St. Ambrose over the altar and statue of Victory in the senate (see page 48).*

Built by Caesar in the middle of the 1st century BC as a stepped hemicycle, the Rostra replaced the speaker's platform that had been used during the entire republican period.

An extension of the tribune toward the Arch of Septimius Severus bears an inscription, still legible, explaining that it was restored around 470 by Lunius Valentinus in honor of a naval victory over the Vandals, for which reason it is today known as the Rostra Vandalica.

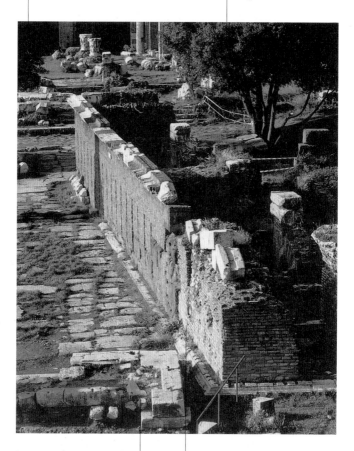

The Rostra was inaugurated by Caesar shortly before his death, in 44 BC, and a new inauguration took place following its reconstruction under Augustus after the battle of Actium.

▲ Imperial Rostra in the Forum Romanum, mid-1st century BC.

Augustus had the area radically rearranged, adding a rectilinear façade in which the large holes for the fastening of the bronze ships' beaks are still visible; the Rostra remained in use throughout the imperial age.

This cinerary altar was found several years ago in a cemetery along an urban stretch of the Via Appia.

The monument is divided in three parts: a base that has a celebratory character, the cinerary altar itself, on which the deceased is depicted busy at work, and the cover, decorated in turn with volutes around six-petaled flowers.

The deceased, the twenty-six-year-old Q. Fulvius Priscus, was a scribe who worked for the college of the curule aediles as indicated by the dedicatory inscription by his father, Q. Fulvius Eunius, and by the scenes related to the activity of scribes that decorate the monument.

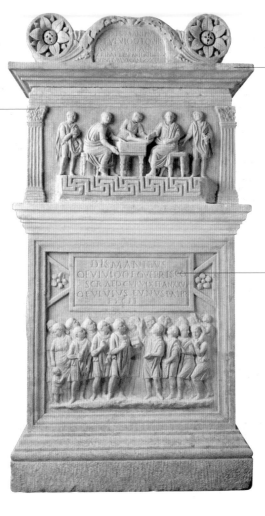

▲ Cinerary altar from the Via di Porta S. Sebastiano, 1st century, Museo delle Terme, Rome.

The formula used in voting remained unchanged over the centuries and offered two choices. When a new law was being proposed, A (antiquo) indicated the desire to maintain the old state of things while U R (uti rogas) approved the proposal; in public trials, L meant libero ("free") and D damno (there was also C condemno).

The assembly sat in an area divided into aisles and sections by barriers, and at the moment of voting each voter moved to the raised platform of the magistrate to deliver his vote; following the institution of the secret ballot, the voters deposited wooden tablets in a wicker box.

A voter inserts his tablet in the urn that will then be handed over to the officials for the count. Until 139 BC the vote was open and expressed verbally to an official who registered the will of the voters on special registers.

On this coin, the monetary magistrate P. Licinius Nerva refers to the moral actions performed by an ancestor in electoral consultations and, at the same time, calls attention to the program of electoral reform that the democratic party was proposing.

▲ Denarius of P. Licinius Nerva, issued at Rome in 113–112 BC (reverse), Palazzo Massimo, Medgaliere, Rome.

"There are many ways in which the senate can either benefit or indicate those who manage public property, as all these matters are referred to it" (Polybius)

Knights and senators

After the civil strife that shook Roman society between the 5th and 4th centuries BC, the essential dividing line remained economic, with the wealthy on one side and the proletarians on the other. Although numerically the preponderant class, the proletarians were not permitted to assume public office. The top of Roman society was composed of the *nobilitas senatoria*, composed of the old patrician order and members of the rich plebeian families, which represented a very solid economic force. To enter the senate one had to first hold the position of consul (after Sulla the quaestorship was enough) and good financial resources were necessary to attract the level of popular approval necessary for election. Despite the progressive increase in its members, from the original three hundred to the nine hundred of Caesar, the senate remained in the hands of a few dozen families that divided up the magistracies among themselves, making the Roman republic much like the oligarchies of the Greek cities. On the hierarchical scale, a step under the senators were the members of the equestrian order, of whom there were at least twenty thousand at the time of Augustus. Admission to the order was not hereditary but required a long military career, and in the imperial age it was subject to direct nomination by the emperor, and emperors tended to entrust knights with highly delicate missions, such that the knights became faithful supporters of the regime and thus a new force in the empire.

Related entries
The Severans, Annona, Army, Triumph, Markets and storehouses, Ports, Consular routes and roads outside the city, Forum and Markets of Trajan, Forum Boarium and Forum Holitorium, Sacred area of Largo Argentina, Ostia

▼ Colosseum, large slab in pavonazzetto with inscription concerning the *loca senatorii* in the most recent series, 5th–6th century.

An equestrian, wearing a short tunic and olive crown, makes a gesture of greeting, while an attendant holds his horse by the reins; another figure stands behind the knight, half-hidden by the horse, holding a headdress near the knight's head.

Close study and comparison with other reliefs have led to the conclusion that this slab is from the dressing of a funerary monument to a person of patrician rank who belonged to the college of the Salii priests, whose principal attribute was a leather headdress.

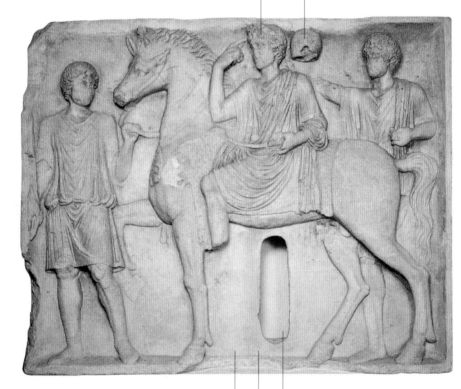

The scene probably refers to the annual ceremony that took place at the installation of the young knights, who rode along the Via Sacra, stopping in front of the temple of their tutelary deities, the Dioscuri, before reaching the Capitol.

The large oval hole beneath the belly of the horse was originally not thought to be antique, but it is now seen as a source of light for the sepulcher.

▲ Funerary relief, end 2nd century, Palazzo Altemps, Rome.

After the great conquests of the 3rd and 2nd centuries BC, the knights, most of whom were landowners, also became businessmen, traders, and bankers, specializing in activities that, at least formally, the senators were prohibited from engaging in.

The inscription indicates that the sarcophagus was being reused about one hundred and fifty years after its creation, between the end of the 3rd and beginning of the 4th century, when it was used for the burial of Flavius Valerius Theopompus Romanus, a youth of the senatorial elite and a candidate for the post of quaestor.

The sarcophagus, the front of which presents cherubs in flight over a crowded assortment of animals, is datable on a stylistic basis to the decades immediately before the middle of the 2nd century. The cover is decorated with garlands and ox's skulls in keeping with a somewhat widespread style.

During the period of late antiquity many of the major public posts, the special privileges of the senatorial class, did not lose their desirability but did completely lose their political functions, becoming mere honorific titles and thus given most often to very young men.

The position of senator was not hereditary, but the members of the great senatorial families enjoyed enormous advantages in elections.

▲ Sarcophagus from the Via Latina, Museo delle Terme, Rome.

*"He [Augustus] created new offices dealing with the upkeep of
public buildings, roads, and aqueducts; the clearing of the Tiber
channel; and the distribution of grain to the people"* (Suetonius)

Annona

Related entries
Cursus honorum, Fleet,
Ports, Forum and
Markets of Trajan,
Forum Boarium and
Forum Holitorium,
Sacred area of Largo
Argentina, Ostia

▼ Funerary urn with
inscription, second half 1st
century, British Museum,
London.

Every region of the ancient world tended to be self-sufficient,
and the trade in foodstuffs served primarily to make up for fluc-
tuations in supply caused by the influence of climatic variations
on harvests and also to help rural populations through difficult
times. As early as the republic, however, Rome reached a size
that was completely anomalous for its period, making it neces-
sary to oversee and manipulate the agricultural production of a
vast area of the Mediterranean to obtain an agricultural surplus
capable of satisfying the needs of the capital. This operation of
control, made possible only by Rome's over-
whelming power, required rigid control in
the planning of transportation and in the
management of reserves in order to guar-
antee a certain regularity in the distribu-
tion of grains and cereals to the population.

The year's food supply was given
mythological personification in Annona,
and during the republican period, the
administration of the supplies was
entrusted to aediles; Augustus created a
prefect of the Annona directly answerable
to the emperor. This prefect had to purchase
sufficient grain, make contracts for its
transportation, direct its storage, and con-
trol its retail price so that variations in pro-
duction and levels of supply would not
weigh heavily on Rome's citizenry. In the
service of the prefect was a bureaucratic
and administrative apparatus that became
increasingly sophisticated and specialized.

The Porticus Minucia, the portico built by M. Minucius Rufus in 110 BC, served as the center for grain distribution until the middle of the 3rd century, when the related magistracies were eliminated. A few decades later, under Aurelian, the free distribution of bread was instituted, in part because of the activity of the city's mills.

The Porticus Minucia had numerous offices open to the public, able to distribute grain to the many dozens of people who presented themselves with the requisite wooden tablet bearing the owner's name, the number of the arcade of the portico at which he was to present himself, and the day of the month reserved to him.

The only requirements for receiving the grain distribution were Roman citizenship and residence in the capital; it is estimated that at least two hundred thousand had the right during the Augustan age.

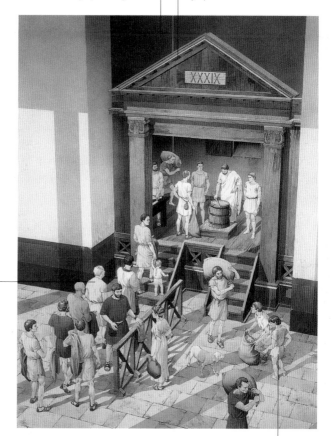

The Annona was the primary means of winning the favor of the urban poor. Although operating within a vast and crowded urban area, the Annona was so well organized that it succeeded in making up for the rare instances of food scarcity and completely prevented true famines.

▲ Reconstruction of a scene of grain distribution.

The second figure, holding in her right hand an Annona tablet, is easily identified as Annona. The term annona, *derived from* annus ("year"), *refers to the annual harvest of every kind of crop acquired by the state and stored in public storehouses to be given away at no charge in times of famine.*

The personification of Portus bears a lighthouse in her right hand.

The officials of the Annona who oversaw the supplies of foodstuffs were also directly responsible for storing them, and most of the foodstuffs destined for Rome were kept in storage areas concentrated almost exclusively on the plain behind the river port.

▲ Sarcophagus of a prefect of the Annona, from the Via Latina, ca. 270–75, Palazzo Massimo, Rome.

The figure of Abundantia, clearly recognizable by her cornucopia and apron full of fruit, leans against a rudder to indicate the happy conclusion of a maritime journey and the consequent provisioning of Rome, also indicated by the two containers at her feet full of ears of grain.

The last figure is a personification of Africa, as made clear by her headdress composed of parts of an elephant.

At the center is a scene of marriage (dextrarum iunctio; see page 207), the main figure is the deceased, a prefect of the Annona who probably lived during the age of Aurelian.

On the upper floor of a building—perhaps the Porticus Minucia or the Forum Julium—state officials pour alms for the people from small coffers.

The figures presented in the upper level are personifications of the rigid bureaucratic and hierarchical apparatus that represented the new element in the way emperors ruled.

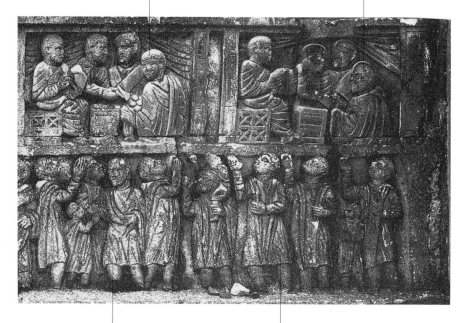

The people, a crowd of anonymous figures awaiting the tribute, would ideally be located in front of Constantine, but in the horizontal presentation they appear instead to his sides.

The scene depicts the final moment in the struggle between Constantine and Maxentius, when the emperor, by then victorious, on January 1, 313, offered tribute to the crowds acclaiming him.

▲ Arch of Constantine, detail of frieze with the distribution of tribute, early 4th century.

Farnacus, captain of the ship, stands at the stern and grasps the tiller of the rudder while waiting for his ship to be loaded before setting sail up the Tiber to Rome.

The creation of the port infrastructure and the construction of storehouses for foodstuffs made Rome able to handle such problems as delays caused by storms at sea or the cutting off of distant production areas. The citizens of Rome thus enjoyed a level of security in terms of the availability of food.

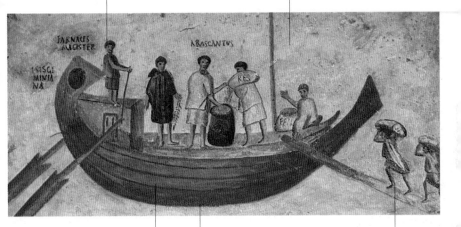

The ship, a classical river vessel almost certainly adapted for the transportation of goods from the port of Ostia to Rome's river port, was named, as indicated by the inscription, the Isis Giminiana.

Workers load sacks of what seems to be grain; aboard the ship a member of the crew named Abascantus or Arascantus checks the goods.

The food supply overseen by the magistrates of the Annona depended on an efficient system of maritime and fluvial transportation since water routes, with their greater facility and rapidity of movement, were far more economical than land routes.

▲ Painting on a funerary monument at Ostia, Biblioteca Vaticana, Sale delle Nozze Aldobrandini, Rome.

"He stationed garrisons of soldiers nearer together . . . and established a camp for the barracks of the Praetorian cohorts, which until then had been quartered in isolated groups in various houses" (Suetonius)

Praetorian Guard

Related entries
The Severans, Army

In 27 BC Augustus created a bodyguard for himself, the Praetorian Guard, composed of nine cohorts, each composed of a thousand men enrolled in central Italy; he stationed them at Rome. These special troops received a salary triple that of the other soldiers, and their term of service was only sixteen years instead of twenty; their headquarters, built in 23, was a large barracks conceived as a military encampment. Some of it is preserved today because it was made part of the Aurelian Walls, of which it formed a powerful defensive bastion, and is today known as the Castrum Praetorium. The Praetorians were the only soldiers permitted to stay within Italy, which was otherwise strictly off-limits to armies, and they were put under the command of a pair of knights, the Praetorian prefects, highly powerful men who, together with their troops, were often arbiters of the state, capable of deposing or acclaiming emperors. It was the Praetorians who, after taking part in the killing of Caligula, acclaimed Claudius emperor, and the imperial guard was at the center of complex events following the assassination of Commodus in a plot involving his mistress, Marcia, and the Praetorian prefect Quintus Aemilius Laetus. To put an end to the excessive power of the Praetorians, Septimius Severus, as soon as he reached Rome, discharged the guard en masse and replaced it with foreign soldiers recruited most of all from among the Illyrian legions; in 312 Constantine definitively dissolved the Praetorians.

▼ Sarcophagus of a young knight, from the fifth mile of the Via Tibutina, ca. 250–75, Museo delle Terme, Rome.

"He took the census of the people street by street, and that the people might not be so often [disturbed] to receive the distribution of grain, his intention was to distribute it three times a year" (Suetonius)

Treasury and archives

Public documents existed in Rome from the period of the republic; these were compiled and preserved in various ways, but were given no systematic organization. Registers of magistrates (called *Fasti*) have survived from that period, as well as information concerning censuses and documents written by priests. Beginning around the end of the 4th century BC Rome's state archives rapidly presented a fuller picture, and the documents relating to financial administration, such as contracts for public works and lists of people employed by the state, were preserved in the Temple of Saturn on the slopes of the Capitol, which since the 5th century BC had been the location of the office of the treasury of the Roman state.

In 78 BC, a new and impressive structure was built on the Capitoline, the Tabularium, destined to be Rome's central archive in which all the official acts of the state were collected, from the laws written normally on bronze tablets, to decrees, acts relating to real estate, and all the archives of the government offices. In the second half of the 2nd century the emperor Marcus Aurelius sought to create a true registry of all the citizens of Rome and the empire's provinces, collecting the documents in the offices of the Tabularium.

Related entries
Mint and bank

▼ Cinerary altar, from the Via di Porta, S. Sebastiano, ca. 70–120, Museo delle Terme, Rome.

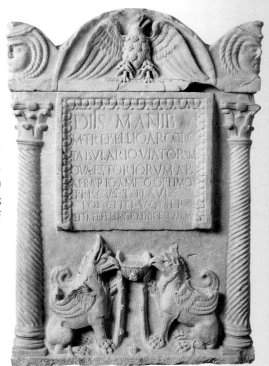

69

The arcade of the Basilica Julia is recognizable in the background among other buildings in the Forum Romanum.

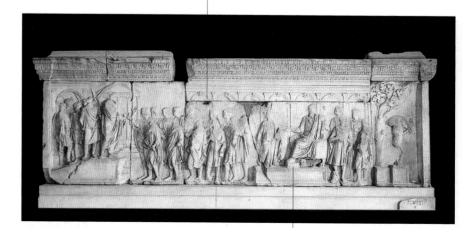

Trajan is presented in the act of instituting the alimenta, *a program of financial assistance for needy Roman children. He is depicted seated on a podium surrounded by men in togas; to his side, a personification of Italia bears a child on her arm.*

▲ Plutei of Trajan, from the Forum Romanum, period of Trajan, Curia, Forum Romanum.

In the presence of the emperor, attendants carry out and burn the wooden tablets listing the debts owed to the state by citizens. The pardon was made possible by the enormous spoils from the conquest of Dacia.

The pair of marble reliefs depict two outstanding events from the rule of Trajan, both of which took place in the Forum Romanum, and the backgrounds of the reliefs include recognizable depictions of some of the buildings in the forum.

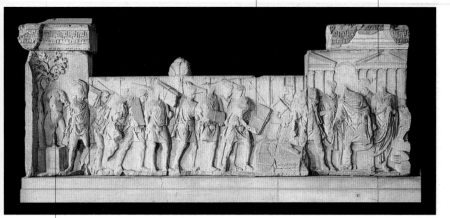

The statue of Marsyas that appears in both reliefs was a popular work; having been paid for with money earned from fines imposed on usurers, it was placed in the Forum Romanum early in the 3rd century BC, where it soon became symbolic of freedom from enslavement for debt.

The Tabularium gets its name from the bronze tablets on which the laws and official acts of the city were written, but no ancient literary source mentions this impressive building, the construction of which must have involved an entire city district.

The archive was identified thanks to the discovery, in the 15th century, of an inscription—today lost—that recorded its official approval in 78 BC by the consul Quintus Lutatius Catulus; it seems most likely that it was built immediately after the fire that devastated the Temple of Capitoline Jupiter in 83 BC.

Over the course of the centuries, the enormous building was incorporated in the structure of the senatorial palace, and today it is difficult to discern its original appearance. During the Middle Ages it was used as a storehouse for salt and was later used as a kitchen, stalls, prison for those awaiting trial, and in general as service rooms for the senatorial palace.

A vaulted gallery that was once a public passageway between the two ends of the Capitol is still open and usable.

▲ The Tabularium.

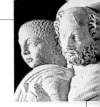

"So many of our armies were lost in Moesia, Dacia, Germany, and Pannonia through the rashness or cowardice of our generals, when so many of our officers were besieged and captured" (Tacitus)

Army

Rome's armies, the first true professional armies in history, long enjoyed unquestioned superiority over all their adversaries, and despite long periods of almost total inactivity they continued to evolve technically and to maintain a level of training that enabled them for many centuries to effectively handle new threats. On the death of Augustus the army numbered twenty-five legions; by the time of Septimius Severus there were thirty-three. At that time the army is estimated to have numbered about four or five hundred thousand soldiers under the command of

Related entries
Cursus honorum,
Knights and senators,
Praetorian Guard

▼ Bone tablets with depictions of soldiers, from the necropolis of the Colombella Palestrina, 4th century BC, National Archaeological Museum, Palestrina.

about five thousand centurions and five or six hundred officers. These officers were nominated directly by the emperor and most often were amateurs who performed their military service for a limited time as a necessary step toward promotion to the career of a magistrate. For ordinary soldiers and officers of lower rank, the period of service lasted about twenty-five years, during which they were prohibited from marrying, although soldiers very often lived with local women, setting up families that lived in the villages that grew up around military barracks or encampments. At the end of their terms of service such veterans almost always remained on the site, living with their women and children.

As chest protection, the figure wears a lorica, a short bronze cuirass that in later times was made of leather and was attached by way of straps and buckles.

Richly decorated loricas were evidently used for parades and state occasions. Numerous marble statues have survived of figures wearing such loricas, but only a very few bronze examples—and these only fragmentary. The creation of the bronze versions must have fully expressed the skills of the artists and artisans involved.

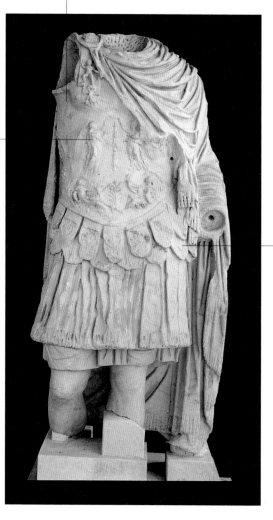

The lorica ends with a belt that holds it at the waist; hanging from the belt are two overlapping layers of scales.

▲ Statue of figure wearing a lorica, Julio-Claudian age, Palazzo Massimo, Rome.

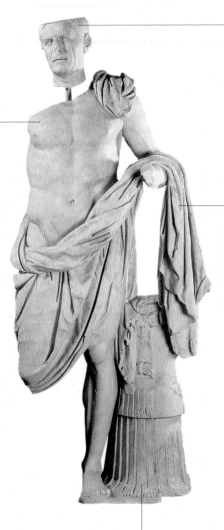

The body is presented following a heroic ideal, but the face is sharply realistic, with deep wrinkles along the forehead, cheeks, and neck and very small, sunken eyes.

The dating of this statue is the subject of debate, various schools of thought placing it between the 2nd century BC and the early 2nd century. It seems most likely that it was made between 90 and 70 BC, a period to which other statues date that portray similar figures in heroic nudity.

The figure is draped in a mantle wrapped over the left shoulder that winds around and up toward the stomach, partially covering the legs, to be gathered up on the left forearm.

▲ The Tivoli General, from the ruins of the substructure of the Temple of Hercules Victor, 1st century BC, Palazzo Massimo, Rome.

The support the figure rests against is a cuirass composed of two parts, with a double row of long scales, a belt tied at the waist, and a gorgoneion on the chest; the presence of the cuirass indicates the high military rank of the man presented in heroic nudity.

Aside from the cuirass and helmet, the equipment found in the tomb of the Warrior of Lanuvium included a belt of bronze mail, an iron spear point, and a sword, indicating that the deceased was a cavalryman.

The anatomical breastplate, composed of two pieces, puts the musculature in relief and served to protect the chest and back, leaving the arms free to move.

The helmet, made of bronze with large traces of gilding, was embossed and presents the upper portion of a human face rendered with the technique of damascening (using different metals to ornament certain parts) and with the insertion of apotropaic eyes—designed to avert evil—in vitreous paste.

Aside from the weapons, the tomb contained three aryballoi (vases for creams and ointments) in bone, a strigil (an instrument used by athletes to clean themselves) in iron, and a small hoe, also made of iron, that was probably used to smooth the ground before a competition, leading to the belief that the warrior was also an athlete.

The tomb of the warrior, discovered by accident in 1934, contained a monolithic sarcophagus of peperino bearing the supine skeleton of a man. The sarcophagus was destroyed, probably during a bombardment in February 1944 that caused serious damage to the city of Lanuvio and to its civic museum.

▲ Helmet and cuirass, from the tomb of the Warrior of Lanuvium, ca. 470 BC, Museo delle Terme, Rome.

The Lacus Curtius ("lake of Curtius"), or Curtian Pool, is an area at the center of the Forum Romanum that remained swampy for a long time and was finally reclaimed in the Augustan age with the construction of a well. The name was probably derived from a consul who, in the middle of the 5th century BC, had a fence built around an area that had been struck by lightning, a memorable omen.

According to the legend immortalized in a late republican relief that was found in the area in 1553, Curtius was a Sabine leader who fell with his horse into a chasm in the forum during clashes with the Romans in the age of Romulus.

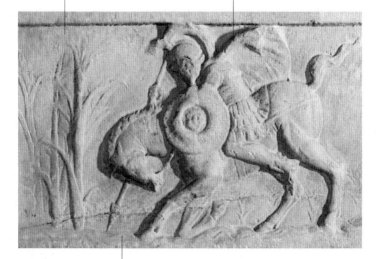

Stylistic analysis of the relief in Greek marble suggests that it might be a product of the same workshop of sculptors that made the frieze in the Basilica Fulvia-Aemilia, probably from the age of Sulla.

▲ Relief in marble from the Lacus Curtius in the Forum Romanum, first half 1st century BC.

The soldier is armed with a short sword (gladium) *and wears a crested helmet that probably has a vertical neckguard.*

The somewhat large circular shield has a central metallic boss; close analysis of the shields visible in the frieze on the Arch of Constantine suggests that they were about 80 centimeters in diameter.

The soldier is dressed in a tunic belted at the waist that reaches his knees; its style is similar to that of the tunics worn by the legionaries depicted on the frieze on the Arch of Constantine.

The catacomb in the Via Latina, discovered in 1955, was probably a private sepulcher belonging to a single family or to a group that has remained unknown. Buried together in the catacomb, although in different rooms, are both Christians—who constitute the largest group—and pagans.

▲ Fresco with figure of soldier from the catacomb in Via Latina, second half 4th century.

The empire's war machine maintained its high level of efficiency for centuries, its soldiers masterfully trained and armed with the most technically advanced weaponry, in part because the legions could almost always count on their own workshops for the fabrication of weapons and, in general, for all necessary furnishings.

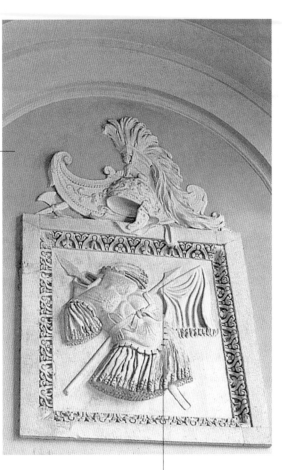

▲ Relief with trophy of weapons, from Piazza di Pietra, walled into the stairs of Palazzo Altieri al Gesù.

The custom of raising a memorial on the field of battle, or during the ceremonies that followed victory, composed of armor or arms taken from the enemy and mounted on a long pole, began in the Greek world but took on great importance in Rome's triumphal art beginning in the 1st century BC.

A military career meant moving to a different unit with each promotion: a centurion, having enrolled as a regular soldier, might have to serve in ten legions before achieving the rank of primus pilus, the chief centurion of a legion.

Roman soldiers attacking a fortress occupied by Dacians protect themselves by locking their shields together over their heads and at their sides to form the testudo ("tortoise").

The historian Dio Cassius presents a case apart, for although he openly scorned the military life, at the beginning of the 3rd century he became governor of Upper Pannonia, with its line of fortresses and military encampments along the Danube.

The senior officers were nominated directly by the emperor and sometimes performed their services for a limited time, only as a necessary step to a promotion in a political career; it thus happened that men bereft of tactical sense or even adequate military knowledge found themselves ruling a province.

▲ Trajan's Column, detail.

"The sole hope of the empire of the Roman people, Cincinnatus, cultivated a field . . . across the Tiber . . . opposite the place where the dockyards are at present" (Livy)

Fleet

For several centuries the Romans did not have a true military fleet, and at the outbreak of the First Punic War their inferiority compared to the Carthaginians was so clear that, according to legend, they built their first hundred ships by taking as model a Punic quinquereme that had sunk during a storm off the Calabrian coast. Over the course of the conflict the Romans sought to change sea battles into land battles, taking entire armies aboard their ships and fitting the ships with movable decks to make it easier to board enemy ships. During the early republican period Rome's military port, large enough for several dozen ships, was located more or less on the site of today's Regina Coeli prison; in the 2nd century this site was abandoned and the port relocated downriver, apparently without leaving a trace.

Since earliest times the Romans had had commercial fleets suitable for river navigation and composed of various kinds and sizes of ships, shallow-draft with flat bottoms. Some of these could sail on their own, with oars or minimum sails, while others were pulled from the banks with long cords. So it was that the Tiber, in reality a very small river, came to perform the fundamental role of connecting Rome to the sea and thus to the rest of its empire, and it must have been constantly animated by intense mercantile traffic.

Related entries
Traffic and means of transport, Ports

▼ Beam decoration, from the first of the ships of Nemi, ca. 37–41, Palazzo Massimo, Rome.

The figures are barely more than silhouettes and can be distinguished only by hints at armor or dress; the landscape, too, is suggested by rapid brushstrokes using a technique typical of an artist named Tadius—or Ludius or Studius, the reading is uncertain— cited by Pliny the Elder.

The large turreted building shows how the battle is taking place both on land and at sea at the same time.

The Villa of the Farnesina, which stood in a precarious position on the banks of the river, was inhabited for a brief period after which all the furnishings and fittings were moved to another place, as indicated by the total absence of statues and of sculptural elements in general.

The rich suburban home, datable to between the late republican period and the early imperial age, came to light between 1879 and 1885 during work on the banks of the Tiber, but it was only partially excavated because of the continuous flooding; the mosaics, wall paintings, and stucco vaults, still in position, were detached and saved.

▲ Landscape painting from Ambulacrum G, Villa Farnesina, ca. 19 BC, Palazzo Massimo, Rome.

The construction of the villa probably dates to the period immediately after the battle of Actium, while the pictorial decorations, just as they are seen today, were almost certainly commissioned on the occasion of the marriage of Julia, daughter of Augustus, to Agrippa, in 19 BC.

Found on the slopes of the Palatine, this relief in Greek marble was part of a public monument that can no longer be identified, but that was most probably made in the period immediately after the battle of Actium.

The hull is decorated with a very refined bas-relief that presents a series of dolphins and tritons. Archaeological research has established that Roman ships were almost always furnished with bilge pumps and other devices for emptying water from ships in case of leaks or fires.

The ship has a dense series of long oars, the central sections of which are unfortunately broken; the parts that remain visible are where the oars exit the hull, which seems to be protected by a covering to reduce friction, and where the long poles enter the water.

The prow of the ship is protected by a three-pointed rostrum and by a figure-head depicting the snout of an animal no longer recognizable; on the deck, closed by a barrier, can be seen traces of the feet of soldiers and sailors.

The characteristics of ships were often determined by the type of goods they carried. Ships carrying livestock, for instance, required large side doors to facilitate the loading and unloading of animals.

▲ Relief of the prow of a ship, from S. Gregorio al Celio, ca. 30 BC, Museo Palatino, Rome.

The scenes presented in the mosaics reflect the central importance of maritime commerce to Ostia, sometimes involving far-off ports, as in this view of the delta of the Rhone with the port of Arles.

Archaeological finds have provided little information on the sails used on Roman ships, although mosaic depictions make clear that ships with several masts were used. It has happened, however, that in excavating wrecks one or more coins have been found in mast housings, placed there as votive offerings.

Together with the macellum (the food market), the center of economic life at Ostia was the Piazzale delle Corporazioni, a vast square surrounded by an arcade, at the center of which was the Temple of Cybele on a high podium surrounded by statues of notables, the bases of which, with their inscriptions, remain today.

Around the square were sixty-four offices of maritime and mercantile agents, small offices in which employees probably kept the account books. In front of most of these was a mosaic illustrating the activity of the proprietor.

▲ Floor mosaic from the Piazzale delle Corporazioni, Ostia.

The sign for the office of the navicularii Sylectini with the depiction of two ships crossing a sea full of fish to arrive in a port. The Ostia mosaics, from between the 2nd century BC and the 4th AD, are made almost exclusively in black and white and often present scenes of daily life.

A group of soldiers with
their weapons probably
waiting to disembark.

Anchors were a fundamental element in a
ship's fittings, of course, and every ship had
more than one. Numerous anchors have
been found in the excavation of wrecks as
well as on their own, and they are of two
basic types. One type is made entirely of
iron, and one has the shank and flukes in
wood weighted down by a lead block.

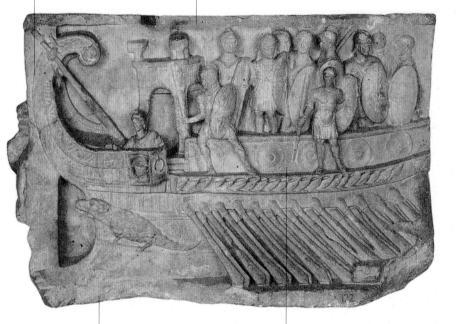

With the exception of ferries, such
as that between Brindisi and
Durazzo (Durrës, in Albania),
passenger ships did not exist, and
anyone who needed to cross a sea
had to make use of a merchant
ship traveling the necessary route.

The ship is accurately described
down to the smallest details of
its bronze fittings.

▲ Relief of a warship, from
Palestrina, ca. 40–30 BC,
Musei Vaticani, Rome.

"Caesar's triumphs were the Gallic—the first and most magnificent—the Alexandrian, the Pontic, the African, and lastly the Spanish. Each differed completely from the others" (Suetonius)

Triumph

Related entries
Cursus honorum,
Army, Capitoline triad,
Victory, Sacrifice,
Capitol

▼ Aureus of Domitian,
issued by the mint of
Rome in 88/89 (reverse),
Palazzo Massimo,
Medgaliere, Rome.

To earn the right to celebrate a triumph one had to bring a war to an end, enlarge the borders of the Roman state, kill at least five thousand of the enemy in battle, and have had an independent command as magistrate.

The triumphant general entered the city from the Porta Triumphalis followed by his soldiers calling, *"Io triumphe"* ("Hurrah, triumph!"), and proceeded to the Capitol. He sat upon a gilt chariot drawn by four white horses and was often surrounded by his children, while relatives and clients followed the chariot wearing the *toga candida*. The triumphant general wore the *tunica picta* and a crown of laurel, while behind him on the chariot a public slave (who belonged to the city, not to a private individual) held a crown of gold over his head and called in his ear, *"Hominem te esse memento"* ("Remember, you are a man"). Parading in front of the general were wagons bearing the spoils of war, bearers with placards giving the names of the defeated peoples and representations of the cities of the countries conquered; there followed illustrious prisoners and their relatives in chains, who were thrown into prison (the Mamertine) during the parade, before ascending to the Capitol. Behind the prisoners came the victims for Capitoline Jupiter and immediately in front of the chariots were lictors bearing fasces crowned with laurel. The army intoned chants to the victorious general in which ribaldry was mixed with praise *(carmina triumphalia)*. For one day the triumphant general was compared to a god.

Bearers with placards on which were probably written the names of conquered cities.

A group of bearers with the most significant objects from the rich spoils taken from Jerusalem, the seven-branched candelabrum, symbol of the Hebrew people, and silver trumpets.

The arch topped by two quadrigas depicted on the far right of the composition is the Porta Triumphalis, located in the Forum Boarium. Since that is where triumphal processions began, the cortege presented on the arch is moving into position for the beginning of the ceremony.

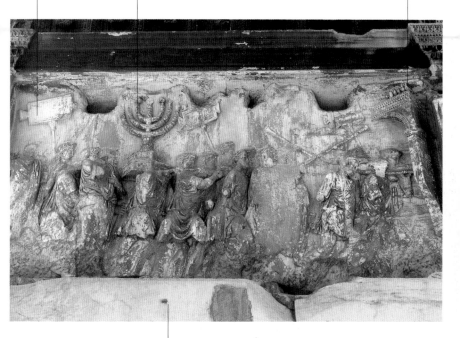

The arch, which was erected by the senate and people of Rome in memory of the emperor after his death, in 81, commemorates the triumph celebrated by Titus and his father, Vespasian, after the conquest of Jerusalem in 71.

▲ Arch of Titus, interior panel with scene of the triumph of Vespasian and Titus.

A trophy of weapons is borne atop a litter; seated beneath the weapons are two bound prisoners, probably important members of the defeated people fated to be paraded behind the victor before being executed.

Sacrificial slaughterers lead beasts for sacrifice in front of the Temple of Jupiter Optimus Maximus on the Capitol.

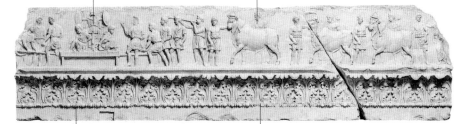

Nothing remains of the oldest triumphal poetry, but there are fragments from more recent periods, such as those from Caesar's Gallic triumph recorded by Suetonius: "Men of Rome, protect your wives; we bring home the bald adulterer. All the bags of gold you lent him went to pay his Gallic tarts."

The frieze with triumphal procession was made for the lavish decoration of the cella made to hold a statue of Apollo.

▲ Frieze from the Temple of Apollo Sosianus, second half 1st century BC, Centrale Montemartini, Rome.

Behind the emperor, who appears here as a triumphant general, a small figure of winged Victory crowns him.

Riding a chariot drawn by four horses and dressed in a toga, Marcus Aurelius is presented about to pass through a triumphal arch, preceded by a lictor and a tuba player.

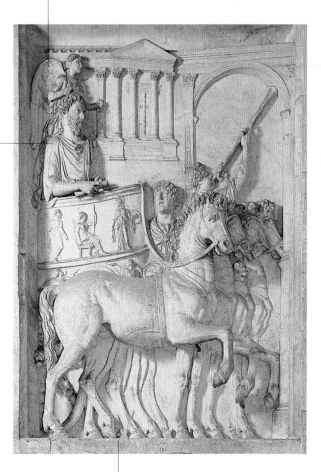

▲ Relief from a monument in honor of Marcus Aurelius, ca. 176–80, Musei Capitolini, Palazzo dei Conservatori, Rome.

Together with another two panels, this panel has been located on the stairway in Palazzo dei Conservatori since 1572–73. The three were probably part of the same series of reliefs as the eight panels reused in the decoration of the Arch of Constantine (see page 340).

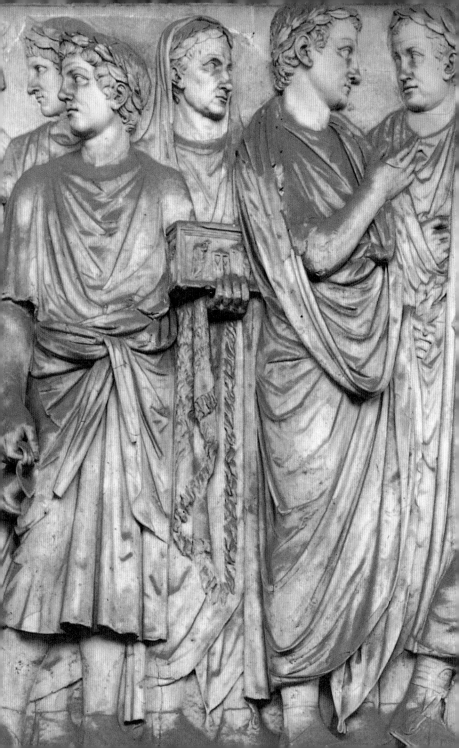

Divinities and religion

◄ *Ara Pacis*, procession
of priests, detail.

Capitoline triad

Jupiter, Juno, Minerva

Related entries
Capitol

▼ Head of Zeus, first
half 2nd century, copy of
a Greek original datable
to the end of the 5th and
beginning of the 4th
century BC, Palazzo
Altemps, Rome.

As early as the period of the Etruscan kings—according to ancient
sources during the reign of Lucius Tarquinius Priscus, the first ruler
of Etruscan stock—the foundations were laid for the great temple
dedicated to the Capitoline triad. The sanctuary, in which Jupiter
Optimus Maximus, Juno, and Minerva were worshiped, was des-
tined to become the most important center of worship in the
Roman state and the site of the most important official ceremonies.
The main divinity of the triad was Jupiter, the Latin correspondent
of the Greek Zeus, father and ruler of the sky, upon whose will
depended the fates of peoples, and pro-
tector of the Roman state, which he had
chosen to rule the world. At his sides
were Juno, queen of the sky and of
the gods, and Minerva—the Greek
Athena—a goddess associated with war
but most of all a divinity of wisdom, the
protector of many arts and crafts as
well as of female and domestic chores.
The three divine figures were also wor-
shiped individually in numerous other
shrines in which they often assumed
different characteristics based on
indigenous tradition, as is the case with
Jupiter Veiovis (young Jupiter), a some-
what mysterious Italic divinity, perhaps
related to the underworld and a protec-
tor of runaways. His worship, very
popular in the republican period, was
celebrated in a temple that stood on the
slopes of the Arx, on the site where the
Tabularium would later be built.

The first cult statue of Jupiter Optimus Maximus, almost certainly a terracotta sculpture of Etruscan derivation, was placed in the Capitol—according to literary sources—by Lucius Tarquinius Priscus and was destroyed by fire in 83 BC.

Jupiter the Thunderer, seated on a throne, bears a lightning bolt in his right hand, the symbol of his power. The Thunderer was primarily an agricultural divinity of eastern derivation with little diffusion in the West except for a small sanctuary in the Villa of the Quintili.

"Jupiter Capitolinus approached him [Augustus] in a dream and complained that his worshippers were being taken from him, and he answered that he had placed the Thunderer hard by to be his doorkeeper: and accordingly he presently festooned the gable of the temple with bells, because these commonly hung at house doors." (Suetonius)

▲ Jupiter the Thunderer, end 2nd–early 3rd century, Antiquarium, Villa of the Quintili.

The oldest cult statue in the Temple of Veiovis (young Jupiter) on the Capitol was a simulacrum in cypress wood described by both Ovid and Pliny the Elder, while the colossal sculpture still visible in the subterranean area of the square was carved from a single block of marble, probably in the age of Sulla.

93

In 133 BC, during an assembly being held near the temple dedicated to the Capitoline triad, the tribune Tiberius Graccus was killed; a statue worshiped like that of a divinity was later erected at the spot where he fell, perhaps at the top of the stairs leading down toward the Campus Martius.

In 391 BC, while Furius Camillus besieged the Etruscan city of Veii, a wooden statue of Juno Regina was taken from the Etruscan city and brought to Rome, since it was considered an auspicious act to invite the tutelary gods of an enemy city to set themselves up in Rome.

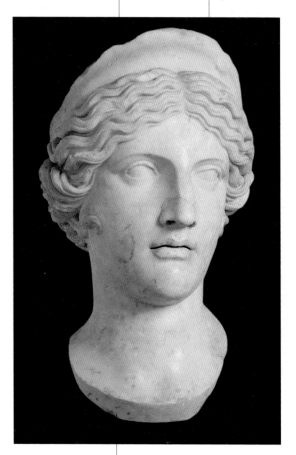

▲ Head of Hera, Palazzo Altemps, Rome.

The face has been identified with Juno on the basis of its close resemblance to similar depictions of the Greek Hera based in turn on models based on Polyclitus from the 5th century BC. There is much disagreement on dating of the head, the theories varying from the 2nd century BC to the 2nd century AD (the age of Hadrian).

The Athena Parthenos ("Athena the Virgin") was the subject of a famous statue by the Greek sculptor Phidias.

In the innermost area of the sanctuary of Vesta in the Forum Romanum, accessible only to the Vestals, were preserved not only the tutelary deities of the city but also the Palladium, a simulacrum of Minerva that, according to tradition, Aeneas had saved form the burning Troy together with the Penates and the sacred fire.

The splendid intaglio on red jasper depicting the bust of Athena Parthenos is a masterpiece signed by Aspasios, an artist who must have been acquainted with Athenian neoclassicism.

▲ Intaglio gem by Aspasios, 1st century BC, Palazzo Massimo, Rome.

The statue's original face and neck were lost and have been replaced by a plaster cast of another portrait of Minerva.

The goddess's hair, made of basalt, falls in long waves along the sides of her face; a diadem is just visible on her head, half-hidden by the edge of her mantle.

The aegis with the gorgoneion (image of a Gorgon face) on the chest makes certain the identification of the goddess as Minerva.

The image of Minerva seated on a throne is quite different from the classical depiction of the warrior goddess who was part of the Capitoline triad and seems instead to approach the simulacrums of the Magna Mater.

The statue probably presents Minerva as the patron of artisans and protector of students, whose feast was celebrated on March 19; on that date students brought a gift to their teachers that was called, in fact, a minerval.

▲ Seated Minerva, from the foundations of a palace in Piazza dell'Emporio, Augustan age, Palazzo Massimo, Rome.

The altar, which was found together with another very similar one bearing an inscription to Lucina, must have once supported an object sacred to the divinity.

MINERVAE

The altar is decorated with a large, heavy floral garland including various types of fruit. This type of ornament became somewhat common on cylindrical altars in the Hellenistic age.

On the back of the altar, above the garland, is a carved *patera*, a flat area with raised borders that was used for libations to the gods.

▲ Circular altar from the *Domus Tiberiana*, second half 1st century, Museo Palatino, Rome.

"He built the Temple of Apollo in the part of his palace . . . struck by lightning. . . . It housed Latin and Greek libraries; in his declining years Augustus held meetings of the senate there" (Suetonius)

Apollo

Related entries
Augustus and Livia,
Diana, Muses, Palatine

▼ Slab in terracotta with
girls decorating a symbol,
from the Temple of
Apollo on the Palatine,
end 1st century BC,
Museo Palatino, Rome

Among the Romans, just as among the Greeks, Apollo, son of Jupiter and Latona (Leto), was a god of wisdom whose oracles manifested the will of his divine father and who had the gifts of poetry, song, and playing the cithara. Apollo was one of the leading gods, and his cult was so universal that, according to tradition, as early as the period of the Etruscan kings the Romans had organized an expedition to his oracle at Delphi. In reality, the worship of Apollo was introduced to Rome probably between the end of the 6th and beginning of the 5th century from the colony at Cumae, site of the Cumaean Sibyl; like all foreign divinities, Apollo was confined to an area outside the *pomerium*, in his case

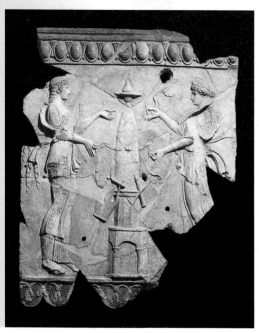

the Apollinar, an open-air sanctuary with an altar for sacrifices. Following a serious plague, in 431 BC, a temple was dedicated to Apollo Medicus, a divinity offering protection from contagions; the shrine was restored several times over the course of the centuries and entirely rebuilt in 34 BC by C. Sosius, thus taking the name of the Temple of Apollo Sosianus.

Augustus was especially devoted to Apollo, most of all after winning the battle of Actium near the shrine of Apollo Actius, which tradition held had been erected during the mythological expedition of the Argonauts, and he dedicated a new temple to Apollo in the public part of his new home on the Palatine, thus bringing the god inside the *pomerium*.

After the destruction of Carthage, Scipio Aemilianus brought the cult statue from the Temple of Apollo to Rome and set it in a shrine near the Circus Maximus; at the end of the 1st century BC, C. Sosius erected a statue of the god in cedar wood, from Seleucia, in the Temple of Apollo near the Circus Maximus.

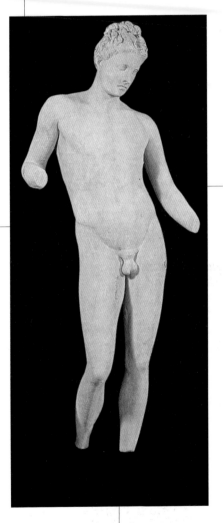

In the Temple of Apollo on the Palatine the god—an original sculpture by Skopas—appeared to the faithful flanked by his mother and sister. The statues of the two goddesses were also Greek originals by famous artists, Diana by Timotheus and Latona by Cephisodotus.

The statue of Apollo is a marble copy from the Roman age of a Greek sculpture datable to the second half of the 4th century BC, probably made in a workshop related to the Athenian sculptor Praxiteles.

▲ Apollo, from the Anzio–Ardea highway, 1st century, Palazzo Massimo, Rome.

The original model was probably made of bronze; although no trace of it remains, it can be recognized in other replicas from the Roman age.

"It is Venus who paints the year in flowers . . . who pushes the growing rosebuds into the swirling wind . . . It is Venus who has ordered that all the morning roses cover the heads of virgins" (Pervigilium Veneris)

Venus

Related entries
Caesar, Augustus and Livia, Virgil and Maecenas, Hadrian and Apollodorus, Mars

▼ Bust of Venus, copy from the 2nd century of an original by Praxiteles from ca. 360 BC, Palazzo Altemps, Rome.

Aphrodite, daughter of Jupiter, born according to Hesiod out of sea foam off the island of Cyprus, was the goddess of love and beauty who surpassed all other female divinities of Olympus in grace and beauty. At an unidentified time during the republican period, the Romans identified the Greek divinity with their Venus, a goddess of orchards, nature, and springtime. Perhaps one of the earliest signs of this assimilation is the Temple of Venus Erucina, built between 184 and 181 BC and later incorporated in the *Horti Sallustiani*, although sources indicate that a temple of Venus Murcia and another of Venus Verticordia existed at least a century earlier, erected in one of the far corners of the Circus Maximus. Not a trace of these remains.

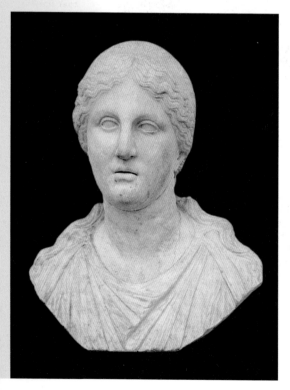

The worship of Venus assumed increasing importance during the passage from the republican to the imperial age, thanks in part to Virgil's evocation of the related myths. The *Aeneid* narrates how Aeneas, son of Venus, fled the flames of Troy to arrive on the coast of Latium after a thousand adventures to become the progenitor of the Roman people and in particular of the family of Caesar and Augustus. Venus thus became the dynastic divinity of the Julio-Claudian family and, more in general, an important aspect of the imperial cult.

The idea that the famous statue is a portrait of Cleopatra results from close anatomical study; the small stature, the robust structure of the legs, and the signs of a recent maternity are important elements, particularly when united to the presence of a cobra, an early symbol of pharaonic power.

Caesar had the statue made during Cleopatra's visit to Rome and to his estate in Trastevere between 46 and 44 BC, almost certainly by the leading Greek artist active in Rome at that period, Stephanos, a pupil of Pasiteles.

The statue was found along with other masterpieces in a basement area of the imperial villa, where in all probability they had been stored by Maxentius during a restructuring of the building that was brought to a sudden halt by his death at the battle of Milvian Bridge (312).

▲ Esquiline Venus, from the *Horti Lamiani*, mid-1st century BC, Centrale Montemartini, Rome.

Thanks to her small body, Cleopatra had been able to present herself to Caesar for the first time, in 48 BC, wrapped in a rug case.

"*The gates of the Temple of Janus, which had been closed twice since the foundation of Rome, Augustus closed three times . . . a sign that the empire was at peace on land and at sea*" (Suetonius)

Janus and Quirinus

Related entries
Romulus and Remus,
Mars

▼ Relief with the
Temple of Quirinus
on the Quirinal,
Museo Nazionale
Romano, Rome

Janus, one of the most important Roman divinities, was without a parallel among the Greek pantheon. He was the god of entries and transitions, of doors to homes and cities, the protector of entrances and exits; for this reason he was presented with a head with two faces, one looking inward, the other outward. His temple at Rome, a small building with the cult statue at its center, stood along the road that led from the Forum Romanum to the Subura district and was an important place of worship since opening its doors meant a state of war, while their closing indicated a period of peace, as Augustus himself reminded the Romans.

Quirinus, too, is not comparable to any Greek divinity, although his functions are very similar to those of Mars. He was a god of Sabine origin whom the Romans identified with the figure of Romulus and to whom a sanctuary was dedicated in 293 BC,

built on the Quirinal by Lucius Papirius Cursor with earnings from his campaign against the Samnites. Augustus had the temple entirely rebuilt, but it is known today only from a fragmentary relief and its description by Vitruvius.

The worship of Quirinus must have come to an end quite early, but its memory remained in the name Quirinus, shared by both Janus and Augustus.

"There is also more than one Diana; first the daughter of Jupiter and Proserpine, mother of the winged Cupid, secondly a more famous one whom we know as the daughter of the third Jupiter and Latona" (Cicero)

Diana

Diana, the bringer of light and life assimilated from the Greek Artemis, was the ancient protector of the Latin peoples and was venerated in a shrine located in a sacred grove on the shores of Lake Nemi, which was also the religious center of the Latin League. According to tradition, during the period of the Etruscan kings Servius Tullius had dedicated a temple to Diana on the Aventine surrounded by a large portico with two rows of columns, probably built on the model of the temple at Ephesus, which we can today only imagine thanks to its depiction on a fragment of the Severian marble plan of Rome. Beginning in 431 BC Diana was probably worshiped, as a companion of Apollo, in the temple erected near the Porta Carmentalis, near the site of the Theater of Marcellus, and in 179 BC a temple to Diana was dedicated by the consul M. Aemilius Lepidus in the area of the Circus Flaminius.

Related entry
Apollo

Diana, daughter of Jupiter and Latona and sister of Apollo, was primarily a protector of women, a fact that is reflected by the presence in her shrine of many votive offerings related to fertility and childbirth. Diana the Huntress is an exclusively Greek creation, completely excluded from Italian traditions, though recurrent iconography presents her as an agile huntress in short clothing bearing a bow and quiver.

► Torso of Diana, from the area of the Circus Maximus, copy from the Antonine age of a Hellenistic original, Museo Palatino, Rome.

The cult of Artemis had enormous importance at Ephesus from as early as the kings of Lydia, and her sanctuary survived and prospered into the Roman age.

The iconography of Artemis Ephesus is very particular, with the multiple rows of breasts, which reflect her importance as a goddess of fecundity, located beneath a large necklace, the fantastic animals that decorate her clothes, and the head covered by the kalathos, a tall, richly decorated headdress.

The Artemis of Ephesus is one of the great goddesses of Asia Minor and the unparalleled protector of wild animals, as indicated by the two lions she bears under her arms. The symbolism of the goddess reflects the spread of her image in the Hellenistic period.

The lower part of her body is wrapped in a sort of sheath decorated in relief with bovine figures.

▲ Ephesian Artemis, 2nd century, Villa of the Quintili, Antiquarium, Rome.

The kalathos that the goddess wears as special attribute was in some cases topped by a tetrastyle temple or by a construction with three pediments.

The statue was found in 1996 in the Baths of Caracalla, where it was being used as a large paving stone in a restoration of the subterranean galleries probably datable to the 5th century.

The goddess, which today is headless, is in a standing position and wears a short chiton. Since 1997, it has been on display in the Octagonal Hall of the Baths of Diocletian together with other sculptures found in the Baths of Caracalla.

▲ Artemis, from the Baths of Caracalla, 5th century, Museo delle Terme, Rome.

The statue is a Roman replica of a late-classical Greek original.

"Augustus had vowed to build the Temple of Mars during the Philippi campaign of vengeance against Julius Caesar's assassins" (Suetonius)

Mars

Related entries
Venus, Imperial Fora

In ancient times, Mars was a divinity closely tied to nature. He protected the countryside from unfruitfulness and the flocks from disease and the attacks of wolves. Later assimilated to the Greek god Ares, he became a god of war and battle. Many feasts were celebrated in his honor over the course of the year. Among these, those held in March must have been a sort of propitiatory rites for military campaigns, while the autumn rites must have been to placate the divinity and convince him to put down his arms during the winter.

In 42 BC, before the battle of Philippi against the murderers of Caesar, Augustus vowed he would construct a temple to Mars Ultor (the Avenger), and it was built in the new Forum Augustum. The building, closely associated with the events of the wars of the Roman state, soon became the site in which the senate decided on questions of wars and triumphs and the site from which magistrates set off to their provincial commands. Created as an emblem of the revenge taken against the killers of Caesar, the Temple of Mars the Avenger became the site for Rome's vindication against all adversaries, and from 20 BC on, the insignia of the Roman legions won back from the Parthians were displayed in the exedra along with the statues of Mars and Venus.

◄ Colossal statue of Mars, from the Forum of Nerva, Flavian age, Musei Capitolini, Rome.

Varro, *in his treatise* Antiquitates rerum humanarum et divinarum, *a great history of the customs, traditions, and institutions of the Roman people, reports that in earliest time a rod was worshiped as an image of Mars, this being proof that the oldest Roman religion did not include the worship of statues.*

Mars, *considered the progenitor of the Roman line for having fathered Romulus and Remus, enjoyed great popularity. Since he was an armed divinity, his temples were usually located outside the* pomerium, *and he was worshiped in two different places in the Campus Martius, one in his military role, the other in his agrarian.*

This statue, along with a sculpture that portrayed Minerva, must have formed a group that decorated the temple of the goddess. The likeness of Mars is most probably a reworking of the type of Mars Ultor made by Augustus for the temple in his forum.

▲ Marcus Aurelius and Faustina as Mars and Venus, end 2nd century, Musei Capitolini, Rome.

The Roman Mars, an indigenous divinity highly venerated by the Italic peoples most of all as their patron in war, had a far more complex personality than did the corresponding Greek divinity, Ares.

"The consul who was given . . . the honor of the consecration was also put in charge of the administration of the Annona, responsible also for assembling a corporation of merchants" (Livy)

Mercury

The cult of Mercury—the Roman version of the Greek Hermes—was introduced to Rome at the beginning of the 5th century BC, probably through the influence of the Greek mercantile world. There is no indication of the existence of a primitive indigenous cult of this god, and his mythology—as in the case of other divinities taken from the Greek world—coincides almost completely with that of his Greek counterpart. The divinity, whose primary role was that of messenger and herald of the gods, is almost always depicted as a nude youth with a pair of wings on his feet and with a characteristic headdress also furnished with small wings. Mercury was also the protector of commerce, traffic, and in general of everything related to roadways and travel. He indicated the correct route to wayfarers, but at the same time he protected thieves and was also the guide of souls to Hades. A temple was dedicated to Mercury in 485 BC near the Circus Maximus, in a zone that lay outside the *pomerium*, as was fitting for a foreign divinity. No trace of this temple remains, but it must have been related to the formation of the corporation of merchants; on May 15 of every year the merchants celebrated a splendid feast in the temple.

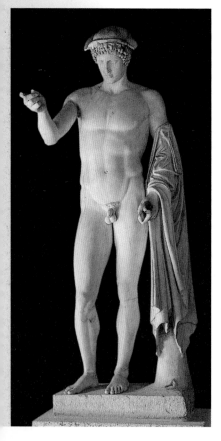

◀ Hermes Logios, end 1st–beginning 2nd century, based on a Greek original of the 5th century BC, perhaps by Phidias, Palazzo Altemps, Rome.

"A pestilence raged in the city and country districts alike . . . the sacred books were consulted . . . it was ascertained that Aesculapius must be sent for from Epidaurus" (Livy)

Aesculapius

Early in the 3rd century BC a pestilence raged at Rome. The Romans consulted the Sibylline books and were advised to send a mission to Epidaurus, site of Greece's most important shrine to Aesculapius, the Greek god of medicine. A senatorial decree ratified an expedition of ten envoys, and under the command of Quintus Ogulnius they set off. While awaiting a response from the god, a snake, symbol and also personification of Aesculapius, slithered out of the temple and went aboard the Roman ship, where it stayed until the return to Rome. While the ship was sailing up the Tiber the snake leapt off and swam to the Tiber Island, going ashore and disappearing; at that moment the pestilence ended. The episode was seen as a manifestation of the god's choice of that island as the site on which to erect a temple, the first dedicated to a divinity imported from Greece.

The Temple of Aesculapius was built on the model of the Greek temples, and its interior was the site of intense health-related activities, as indicated by inscriptions dating from the 2nd century BC to the Antonine age and also by the many votive offerings found there, most of all at the end of the 19th century during work on the flow of the Tiber. It seems probable that the site was chosen for hygienic reasons and also because of the presence on the island of a spring of water believed healthful.

Related entries
Omens and divination,
Ex-voto, Medicine

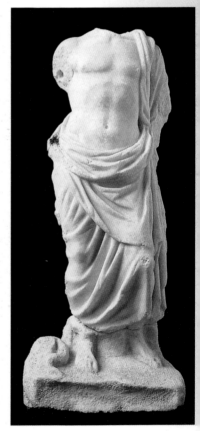

▶ Aesculapius, from the Villa of the Quintili, end 2nd century, Villa of the Quintili, Antiquarium, Rome.

The Pons Aemilius (Ponte Rotto) was built when the Via Aurelia was opened, perhaps after the middle of the 3rd century BC. *From the 13th century on, the bridge suffered a series of collapses caused by the deviation of the river's current to facilitate river mills, and it was finally destroyed and abandoned following a flood in 1598.*

▲ Tiber Island.

Although worship of Aesculapius had been abandoned even before the spread of Christianity, Tiber Island has maintained its association with health over the centuries, and in the 16th century the religious order of the Fatebenefratelli built a hospital on the island that is still in operation.

In the 1st century BC, in memory of the miraculous arrival of the snake of Aesculapius, Tiber Island was given the appearance of a ship with the construction of two structures, today visible only from downriver.

It seems possible that Tiber Island was the site of an even more ancient cult, that of the god Tiber, a river god also in possession of healing abilities.

The Greek inscription on a marble slab datable to the early 3rd century reports cures effected in the Tiber sanctuary; one can assume that these were not seen as miraculous events but as simple suggestions from the god to perform various magical acts or to make use of natural remedies, such as honey and wine.

During the imperial age the custom arose of abandoning sick or worn-out slaves on Tiber Island; to put an end to this, Claudius ordered that all slaves so abandoned were to be granted their freedom. And if they recovered, they were not to be returned to their master.

Aesculapius was considered a doctor (iatrós) and a savior (sotér), the son of Apollo and the student of the centaur Chiron, who had taught him the art of medicine.

The sick awaiting healing were brought to special rooms near the area of the statue of the god; there they went to sleep in the hope that Aesculapius would appear to them in a dream and indicate the therapy to use or would directly cure their sickness while they slept.

The god is depicted here in accordance with his most common iconography, as an older man wearing a mantle that leaves the upper part of his body bare, using a staff with an entwined snake—which in the case of this statue serves a support purpose—bearing a scroll in his left hand, and wearing sandals.

Perhaps the priests themselves impersonated the divinity, but it is also possible that they administered drugs or induced a kind of self-hypnosis in the ill by way of individual or group psychotherapy. In their medications, the priests made use of medicinal herbs and other natural substances, well aware of their therapeutic virtues.

▲ Aesculapius, perhaps from the Quirinal, 2nd century, Palazzo Altemps, Rome.

"Here once was a cave . . . where dwelt the awful shape of half-human Cacus; and even the ground reeked with fresh blood, and, nailed to its proud doors, faces of men hung pallid in ghastly decay" (Virgil)

Hercules

According to Virgil's account, Hercules, while returning to Greece with the cattle of Geryon, the fruit of his tenth labor, arrived at the Forum Boarium, where the cattle were stolen from him by Cacus, a monster that lived in a cave probably located on the slopes of the Aventine. Hercules killed the deformed being, making himself a hero to the Arcadians, the inhabitants of the Palatine, and to their king Evander. To celebrate the undertaking an altar was dedicated to the hero, known as the *Ara Maxima*, on the site where the church of S. Maria in Cosmedin stands today; on August 12 every year, sacrifices were performed near the altar in honor of the hero, following a ritual of Greek tradition. The monument, or at least what is almost certainly a reconstruction of it that does not date to before the 2nd century BC, is identified with a large foundation in *tufo* from the Aniene River visible today in the back area of the church, thanks to indications given in inscriptions of the praetors who performed the rites.

There were several temples dedicated to Hercules in Rome. A temple to Hercules Custos was erected near the Circus Flaminius in 220 BC, in 187 BC Marcus Fulvius Nobilior dedicated a temple to Hercules and the Muses between the porticoes of Octavia and of Metellus, and also in the 2nd century BC a merchant who had made himself rich with commerce in oil gave thanks to Hercules, the patron saint of the oil producers, by building the Temple of Hercules Victor, known as Hercules Olivarius, entrusting the creation of the statue to a Greek artist, Skopas Minor.

Related entries
Forum Boarium and
Forum Holitorium

▼ Sarcophagus with the Labors of Hercules, detail, ca. 240–50, Palazzo Altemps, Rome.

A recent hypothesis suggests that this sculpture is a copy directly based on a Greek bronze of the 4th century BC very near the style of Lysippus.

Hercules is also a protector of health and agricultural property and is thus treated as an agricultural and fertility god.

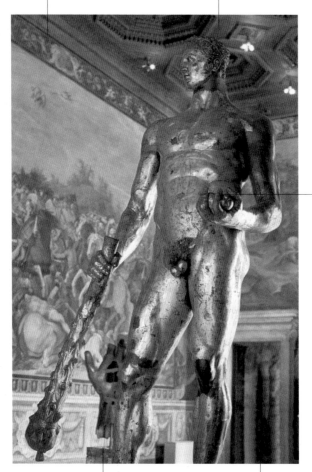

According to tradition, the statue in the temple founded by Scipio Aemilianus holds the apples of the Hesperides in his hand.

▲ Hercules, from the Forum Boarium, 2nd century BC, Musei Capitolini, Rome.

The colossal statue in gilt bronze—nearly two and a half meters high—was found during the pontificate of Sixtus IV in the 15th century near the church of S. Maria in Cosmedin, the area in which the Ara Maxima stood.

Various dates have been proposed for the statue—which has been heavily reworked—but the most credible connect it to the foundation of a rotunda temple dedicated to Hercules by Scipio Aemilianus.

"Within ten days from the time that this letter is delivered to you, you should see to it that those places of Bacchic worship, if there are any in your region, are destroyed" (Senatus consultum de bacchanalibus)

Bacchus

Related entries
Magna Mater,
Satyrs and sileni

Among the divinities imported from Greece, Dionysus—Bacchus to the Romans—was the one that least fit with the austere character of Roman society. It seems likely that the celebrations held in honor of the god were originally simple rural festivals, but with the passage of the centuries the ceremonies and rites tied to Bacchanals assumed an orgiastic character and a wildness unacceptable to the rigid and severe concept of life of Roman society early in the 2nd century BC. Even so, it seems probable that the senate's decision to officially suppress the performance of the festivities, in 186 BC, was the result of the cult's secrecy, for it attracted most of its initiates from the lowest levels of the population, including slaves; the ruling class feared that the religious practices were being used as the

▼ Mosaic with bust of the young Dionysius, from the Via Flaminia, mid-2nd century, Palazzo Massimo, Rome.

cover for the organization of subversive activities. This did not mean the disappearance of the cult, only the drastic limitation of its occult and orgiastic aspects; the cult was given a further reorganization under Caesar, who introduced regular Bacchanals. A small sanctuary dedicated to Bacchus and Cybele that stood in the Forum Romanum is known from a passage in Martial and from a medallion from Antoninus Pius that depicts it as a circular temple inserted in an exedra, perhaps the one still visible alongside the Basilica of Maxentius.

According to tradition, Dionysus, accompanied by the drunken Silenus and a train of nymphs, satyrs, and maenads, and riding upon a chariot drawn by tigers (or panthers), traveled across all of Greece and on into Asia to reach India, teaching men the art of viticulture.

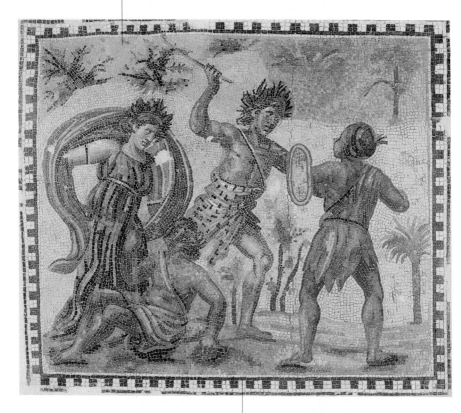

The Villa della Ruffinella was the residence of Lucien Bonaparte—Napoleon's brother—1st prince of Canino, a passionate archaeologist who did much excavation work in Etruria, most particularly at Vulci.

▲ Floor mosaic with Dionysus and Indians, from the Villa della Ruffinella, first half 4th century, Palazzo Massimo, Rome.

The god's characteristic long hair is divided in two bands knotted at the neck and falls to his shoulders. His head is adorned with a crown of vines and is framed by two large bunches of grapes; traces of gold-leaf decoration are still visible on his face and hair.

Holding a two-handled cup (kantharos) *in his right hand, Dionysus rests against a support in the shape of a tree trunk decorated by a vine with leaves and bunches of grapes that wraps around it.*

Made of Luna marble, the statue was found in 1908 in the Syrian shrine on the Janiculum, inside the eastern cella, probably a room set aside for initiation ceremonies. The temple dates to the middle of the 4th century but was found to contain numerous other sculptures made in earlier times.

▲ Dionysus, from the sanctuary on the Janiculum, second half 2nd century, Palazzo Altemps, Rome.

The head shows the face of a man of advanced years with a thickly curling beard and an elaborate hairstyle composed of thick locks collected behind the head to fall to the shoulders.

The standing god is dressed in a long chiton, the width of which is made clear by rich folds. He is also wrapped in a heavy mantle that covers his left shoulder and arm. He probably held an attribute in his right arm.

The statue, which had been found in 1928, was removed from the Museo Nazionale Romano by Nazis in 1944 and taken to Weimar, where, however, it was never displayed. Only in 1991 was it finally returned to Italy.

The name Sardanapalus is derived from an inscription found on a replica of this statue in a Roman villa and today in the Musei Vaticani. The owner of the statue had the name engraved because he associated the god with the mythical wealthy king of Assyria, known for his dissipated habits and feminine style of dress.

▲ The "Sardanapalus" Dionysus, from the Via Appia, Roman copy of an original from ca. 310–300 BC, Palazzo Massimo, Rome.

"There are temples of Wealth, Safety, Concord . . . and Victory, all of which, being so powerful as necessarily to imply divine governance, were themselves designated as gods" (Cicero)

Victory

It is possible that in earliest times the divinity that led the Roman people in their victorious undertakings was Vica Pota, but as early as the Samnite Wars there was a shrine dedicated to the goddess Victory on the Palatine on the route of the Clivus Victoriae. This first shrine stood near the site on which the Temple of Victoria Virgo was later to stand. Later, in a period of great difficulty during the course of the Second Punic War, the tyrant of Syracuse, Gelon, sent a gold statue of Victory to Rome that was solemnly placed in the Temple of Jupiter on the Capitol, in the hope that the goddess would prove benevolent to the Roman people.

A fundamental moment in the worship of Victory came in 29 BC, with the consecration of an altar inside the Curia Julia, with which act Octavian sought to indicate the indissoluble union between the state and the divinity, presented as a statue upright atop a globe, following an iconography that would remain unchanged over the centuries.

Also in Rome, following the Greek model, the divinity appears winged and her attributes were the crown and palm branch, but sometimes also the trophy and the shield to indicate success in war; when instead she appears with a cornucopia and an olive branch, the goddess is the bringer and dispenser of peace and happiness.

Related entries
Triumph, Imperial apotheosis, Forum Romanum, Caelian Hill, Capitol

▼ Victory holding a crested helmet, detail from the vault of the Villa Farnesina, ca. 19 BC, Palazzo Massimo, Rome.

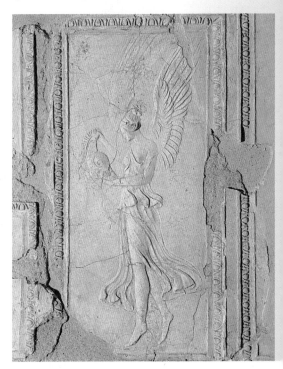

The goddess, seated on a throne in a frontal position, holds in her right hand a statuette of winged Victory that in turns holds the vexillum and globe, in a typical image that usually presents Victory alongside greater gods that concede success and the achievement of dreams of glory.

Seated on the shoulders of the goddess are two winged figures that have been interpreted as Amor and Psyche, thus contributing to the identification of the goddess as Venus, a hypothesis first put forward by Winckelmann, against the theory that saw the figure as the goddess Roma.

The panel, found in a room near the baptistery of St. John Lateran, was moved to Palazzo Barberini in 1655 and was donated to the Italian state in 1935.

▲ The "Roma Barberini," from the Lateran, first quarter 4th century, Palazzo Massimo, Rome.

The majestic figure of the goddess is dressed in a white tunic over which she wears a sleeveless gilt gown decorated with violet bands; she is wrapped in the soft folds of a purple mantle, and her face is adorned with earrings and a necklace with pendants.

The figure was largely reworked in oil paint by a 17th-century painter who reconstructed the upper part of her head, adding a helmet that served to strengthen the traditional hypothesis of an identification with the goddess Roma.

Victory, an exact copy of the Greek Nike, the propitiatory goddess of victory, worshiped primarily by armies and their commanders, soon became a true symbol of the empire.

The statue in gray marble is without attributes that might clarify its identification, although the quality of the stone used might indicate a divinity, perhaps Isis, to whom a site of worship had been dedicated on the Caelian Hill as early as the end of the 2nd and beginning of the 1st century BC.

Ancient sources relate that a violent dispute arose concerning the altar of Victory that Augustus had placed in the senate house and that the emperor Gratian had removed; the struggle ended with the defeat of Symmachus and the destruction of his home on the Caelian, along with its furnishings, including a famous statue of Victory in gray marble.

▲ The so-called Victory of Symmachus, from the area of the military hospital on the Caelian Hill, late Hellenistic age, Centrale Montemartini, Rome.

Magna Mater

Cybele

Related entries
Bacchus

▼ Magna Mater enthroned, from the *Domus Tiberiana*, Antonine age, Museo Palatino, Rome.

The first eastern cult imported to Rome and admitted within the *pomerium* was that of Cybele, the Great Mother (Magna Mater), brought to Rome in 204 BC. Cybele was a Phrygian divinity worshiped primarily at Pessinunte in the form of an aniconic black stone (probably a black meteorite). When Rome found itself in difficulty during the Second Punic War, the Sibylline books advised bringing the cult to Rome, so a request was made to the king of Pergamum, in whose territory the sanctuary of Pessinunte was located. The ruler, who had no interest in making enemies with the Romans, ceded the cult stone, which was transported to Rome aboard a ship. The stone was given a provisional home in the Temple of Victory on the Palatine, but was later given a suitable home, and when the war with Carthage ended a temple was built on the Palatine and dedicated to her in 191 BC. The Ludi Megalenses were instituted in her honor, games for which the dramatists Plautus and Terence wrote some of their best works.

Cybele was a goddess of nature and, together with her divine consort Attis, symbolized the generative principle and the perennial cycle of vegetation. The cult had an orgiastic character that awakened distrust among the authorities, but it became widespread, most of all during the imperial age, and remained popular until the 4th century.

The goddess is depicted as a statuette that wears a turreted crown on its head and wears a pectoral and a mantle; in front of Cybele is a small Mercury holding the caduceus and a purse of money.

"Those who are born to woe . . . find affliction even after death. The Galli of Cybele used an ass when out begging alms. When he died from overwork and from the constant beating, they made drums out of his hide. . . . He thought he'd find peace in death, but his misery knows no bounds, for his back still resounds with their blows." (Phaedrus)

Direction of the cult of Cybele and Attis was entrusted to Phrygian priests called Galli who reached states of mystical exaltation and emotional frenzy during their ceremonies; the Galli were eunuchs who had castrated themselves, and they slashed themselves during ceremonies. These rites were repugnant to the Roman mentality, but the lower classes were highly attracted to the promise of eternal life.

The chief Gallus of Ostia (archigallus coloniae ostiensis) performing a sacrifice to Cybele, taking fruit from a bowl and placing it on a sacrificial column.

▲ Funerary bas-relief from the necropolis of the Isola Sacra, first half 3rd century, Museo Ostiense, Ostia Antica.

The priest wears a sleeved tunic under which he also wears breeches; he is wrapped in a mantle and wears a crown with imperial busts.

Two divinities are carried in procession; on the litter to the right is Magna Mater, preceded by her running lions; behind her is probably a statue of Amor.

The litters seem to be somewhat heavy and are borne by eight men each, some of whom seem to bend from the effort; visible in the background are two tuba players.

Ancient sources relate that when the ship bearing the black stone from Pessinunte reached the mouth of the Tiber it ran aground, and soothsayers announced it could be freed only by a chaste hand. Claudia Quinta, a matron whose modesty and virtue had been called into question, pulled the ship free using her own belt, thus proving her modesty and innocence.

The senate respected the powerful goddess that had freed Rome from the danger of Carthage, but chose to isolate the new cult and prohibited Roman citizens from becoming priests of Cybele.

▲ Section of sarcophagus, 3rd century, S. Lorenzo fuori le Mura, Rome.

"Let the farmer offer the first ears of grain to Ceres and the harvester ... crush the grape, and the crowd ... applaud the generous master who offers ... games at the cross-roads" (Calpurnius Siculus)

Ceres

Ancient *Italian* divinity of grain, vegetation, and fields, Ceres was being identified with the Greek Demeter as early as the beginning of the 5th century BC, and her worship was associated with, and sometimes confused with, Tellus Mater, the Roman goddess of the earth. The iconography of Ceres crowned with ears of grain, as she appears on numerous coins, probably took form between the 4th and 3rd centuries BC, while no image exists of the older goddess. A temple was dedicated to her in 493 BC, almost certainly after consulting the Sibylline books, near the Circus Maximus; the sacred building, which soon became the center of activity of the urban plebeians, must have

▼ Clay bust of Demeter, from Ariccia, end 4th–first half 3rd century BC, Museo delle Terme, Rome.

been closely tied to the Annona importations of grain for the urban plebeians and it was related to the Ludi Cereales, games instituted in honor of the goddess that constituted a typical aspect of her feast.

According to accounts from both Livy and Pliny the Elder, in 485 BC, at which time the statues of many other gods were still in clay, a bronze image was dedicated to Ceres using the goods confiscated from Spurius Cassius, one of the first consuls cf the newborn republic, who had aroused the ire of his fellow patricians by proposing that land donations be distributed equally among the Roman and the Latin peoples.

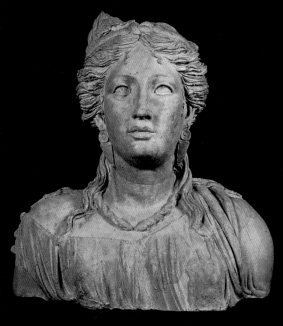

"You also believe that the mark in the rock resembling a hoof print, to be seen at the present day on the shore of Lake Regillus, was made by Castor's horse?" (Cicero)

Dioscuri

Castor and Pollux were heroic twins, sons of Leda, wife of the Spartan king Tyndareus, and Zeus, who joined with her in the form of a swan. The introduction of their cult to Rome is connected to an event said to have occurred during the battle of Lake Regillus, when the divine twins appeared to lead the Roman cavalry against the enemy (the Latins); immediately after the victorious battle, Castor and Pollux appeared in the Forum Romanum, watered their horses at the spring of Juturna, which was located near the Temple of Vesta, and announced the victory to the crowd. To secure the everlasting memory of these events, the dictator Aulus Postumius Albinus vowed to erect a temple, and it was completed by his son in 484 BC.

The twins were known in Greece as the Dioscuri, and they long maintained iconography established in the Hellenistic age. They were a somewhat frequent subject in the decoration of sarcophagi in the imperial age, with their twin figures often used to frame a scene. The funerary character of their cult, based on the alternation of mortal and immortal, life and death, that is part of their nature, increased progressively between the 2nd century and the age of Constantine.

▼ Relief with the Dioscuri and a procession of worshippers, from the Via Buonarroti, beginning 4th century BC, Palazzo Altemps, Rome.

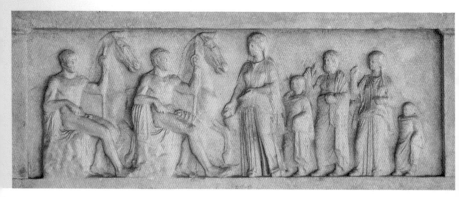

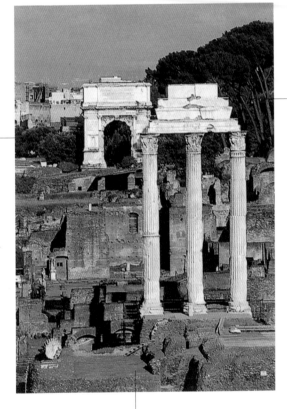

"In the Latin War, at the critical battle of Lake Regillus between the dictator Aulus Postumius and Octavius Mamilius of Tusculum, Castor and Pollux were seen fighting on horseback in our ranks." (Cicero)

According to some legends, Leda laid two eggs, one from Zeus and the other from her husband. From the first was born Pollux and Helen, from the other Castor and Clytemnestra. So it was that the divine twins had different characteristics, one immortal, the other mortal.

▲ Temple of Castor and Pollux in the Forum Romanum.

The Temple of Castor and Pollux was restored several times over the course of the republican period. The last restoration dates to the period immediately after a fire that broke out in 14 BC; the new building was dedicated in AD 6, and to it belong the monumental remains still visible today.

"If Minerva can prescribe medicines without need of a doctor, why cannot a Muse give in a dream the ability to write, or read, or exercise any of the other arts?" (Cicero)

Muses

Related entries
Apollo, Music and dance, Theater

From the days of Livius Andronicus, in the first half of the 3rd century BC, the Romans identified the Muses with the Camenae, ancient Italic divinities, perhaps nymphs of springs and wells, who foretold the future. These ancient aquatic divinities, which were honored with libations of water and milk, lived in a forest outside the Porta Capena near a fountain from which the Vestals drew water every day and where there was a shrine. When this small building was struck by lightning, the shrine was moved to a temple that had been built in the Campus Martius around 187 BC in honor of Hercules and the Muses; here, according to Pliny the Elder, Marcus Fulvius Nobilior, probably on the advice of the poet Ennius, placed a group of statues of the Muses that had been taken as spoils of war from Ambracia, capital of Aetolia. Also according to Pliny, another group of nine Muses, the work of a Rhodian artist, had been placed in the Temple of Apollo near the Portico of Octavia.

According to the most widespread version, there were nine Muses, daughters of Zeus and Mnemosyne, and they were the patrons of the arts and sciences and could be readily identified by their attributes but also on the basis of their attitudes or hand gestures. Their images appear on the visible sides of a large group of urban sarcophagi, sometimes accompanied by Apollo with his cithara and Minerva with the aegis, helmet, and lance.

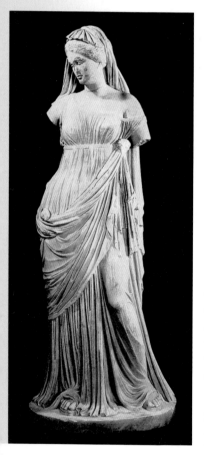

◄ Melpomene, from the Via Aventina, Roman replica from the 1st century BC of a Hellenistic original, Palazzo Massimo, Rome.

Terpsichore, Muse of the dance, was usually identified by the presence of a lyre.

Thalia, Muse of comedy and satire, holds a comic mask in her left hand; she is often presented with a crown of ivy while holding a shepherd's staff; she was also held to be the patron of rustic feasts and banquets.

Melpomene, Muse of tragedy, holds a tragic mask in her right hand and perhaps originally wore a crown of ivy.

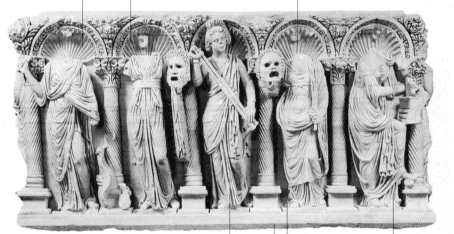

Euterpe, Muse of lyric poetry, holds the aulós, a wind instrument very similar to a clarinet or oboe; her hairstyle is not a Greek type, and the features of her face seem to indicate the intention to create a portrait.

Erato, Muse of love poetry and mime, holds the cithara with which she accompanied her verses.

The series of nine Muses is completed by scenes presented on the short sides of the sarcophagus; on each of these a bearded philosopher is busy speaking with two Muses, Urania and Polyhymnia on one side, Clio and Calliope on the other.

The figures of the Muses are inserted in niches marked off by spiral columns and decorated by seashells; the spaces between the niches are filled by vegetal decoration, and crowns of acanthus leaves can be seen on the lintels of the niches.

▲ Sarcophagus with Muses, from S. Paolo fuori le Mura, ca. 280–90, Palazzo Massimo, Rome.

Urania was the Muse of astronomy
and didactic poetry and was
sometimes depicted with stars.

The statue was heavily restored in
the neoclassical period with the
addition of all the upper area, the
arms, and the attributes, which are
made of a different marble.

It seems likely
that the statue,
seated on a rock
and dressed in
a chiton and
mantle, was part
of a group of
nine Muses that
drew inspiration
from models
created by the
sculptor Philiskos
of Rhodes
between 150
and 130 BC.

This young girl is
identified as
Urania on the
basis of the
attributes she
holds—a stylus
and a globe—
which were added
in the neoclassical
period; close
iconographic
study of the
original parts
suggests instead
that this began as
a statue of
Calliope or Clio.

The iconographic type of the Muse,
which enjoyed so much fortune in
the Roman period, enjoyed renewed
success during the Renaissance, and
16th-century collectors of ancient art
sought to possess as complete as
possible a series of Muses.

▲ Urania, 1st century,
Palazzo Altemps, Rome.

The head and neck are results of
period restoration work, while the
forearms and the attributes of the
Muse—the stylus and wax tablet—
in gray marble were added in more
recent times.

Calliope, with
her beautiful
voice, was the
Muse of epic
poetry.

The young
woman sitting on
a rock wears a
chiton, its sleeves
held up by a
series of small
buttons, its
volume held in
by a belt under
the breasts; a
broad mantle
covers her legs.

▲ Calliope, Hadrianic period,
Palazzo Altemps, Rome.

The most recent studies tend to
identify the Greek original of this
statue with a work made by Lysippus
around 317–07 BC for the eastern
acropolis of Megara.

With its decorative frame, this mosaic emblema *is inserted in a floor decoration composed of at least thirty-two panels with scenes depicting widely different subjects, including mythological groups, marine animals, the seasons, and the loves of Jupiter.*

Clio, the Muse of history, is usually depicted holding a scroll or book.

Stylistic analysis of the subjects depicted on the villa's floor suggests that the composition dates to the Severan age and was made by reusing polychrome emblemata *from different periods.*

▲ *Emblema* with a depiction of Clio, from the Villa di Baccano, Severan age, Palazzo Massimo, Rome.

"As for myself, may the 'sweet Muses,' as Virgil calls them, bear me away to their sacred places where their streams flow, far from anxiety and care and free from the obligation to perform some task every day that goes against my will." (Tacitus)

The most commonly accepted version, based on Hesiod, speaks of nine Muses, but one myth speaks of only three, Melete, protector of thought, Mnemosyne, patroness of memory, and Aoide, who presided over song. In his verses, Homer sometimes refers to a single Muse and sometimes to several, without being precise about names or numbers.

Polyhymnia was the Muse of pantomime and lyric poetry.

▲ Polyhymnia, from the *Horti Liciniani*, Roman copy of a Hellenistic original, Centrale Montemartini, Rome.

Satyrs and sileni

Related entries
Bacchus

▼ Torso of a satyr, Hadrianic age, Palazzo Altemps, Rome.

The satyrs, woodland creatures that accompanied the maenads during Dionysian rites, were known for their pointed ears, horse's legs, hooves, and small horns on their heads. Extremely lascivious creatures, they personified the spontaneous fertility of nature and spent most of their time chasing nymphs, with which they hoped to satisfy their lust. The sileni, sons of Pan and a nymph, had a hairy body, snub noses, goat's legs, and the ears and tail of a horse; bald and paunchy, they were often depicted atop mules. Always depicted as somewhat elderly, the sileni too accompanied the maenads, joining them in their Dionysian rites.

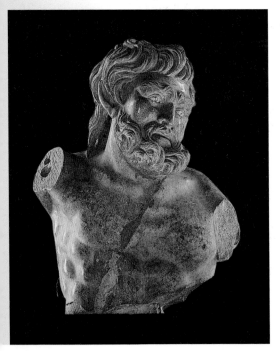

With the passage of time, the overtly animalesque aspects of satyrs and sileni slowly disappeared from representations of individuals, and in many statues only the pointed ears, brutish skin on the back, or dense hair recalled the traditional iconography, while their features and attitudes became completely human.

A well-known legend tells of a drunken silenus that King Midas had captured in order to ask him the secret of human life. Brought before the ruler the silenus responded that for man the best thing is not to be born, and the next best is to die as soon as possible.

The right arm down to the shoulder and part of the chest are the work of a 16th-century restorer; the bunch of grapes that was put in the satyr's hand at that time served to emphasize the ties to the Dionysian cult.

The model for this satyr pouring wine into a cup was without doubt a famous bronze statue made by Praxiteles that the Greek geographer Pausanias was able to see along the Street of Tripods at Athens in the 2nd century.

The crown of ivy leaves he wears on his head is a clear indication that this is a satyr; other telltale attributes are the items on the support covered by a sheepskin: a syrinx—a panpipe, the flute of Pan—and the typical hooked staff of the shepherd.

Numerous replicas of the Praxiteles work have been found in Italy since the subject of a satyr pouring made an excellent decoration in the parks of luxurious Roman villas.

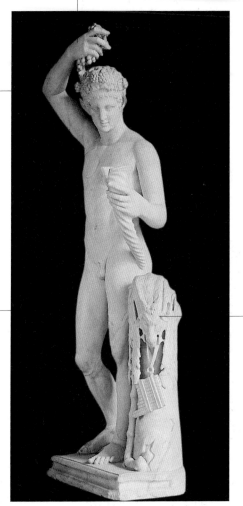

▲ Satyr pouring, second half 2nd century, Palazzo Altemps, Rome.

"My urgent desire was to offer my prayers to the supreme power of Queen Isis . . . who from the site of her temple in Rome is called Isis of the Field and is the subject of special veneration" (Apuleius)

Oriental cults

Most of the oriental cults imported to Rome were brought by soldiers, traders, and slaves, for which reason they spread most rapidly among the lower levels of the population, those most readily drawn to picturesque rituals. The oriental religions could boast an elevated sense of morality and, most of all—unlike the official state religion of Rome—they promised an afterlife in which everyone would find justice: the good their merited reward, the wicked their just deserts.

The principal sanctuary of the Egyptian cult in Rome, the Temple of Isis and Serapis in the Campus Martius, was probably erected by the triumvirs in 43 BC, but the cult was harshly persecuted under both Augustus and Tiberius, who had the building destroyed and the cult statues thrown into the Tiber. Rebuilt by Caligula, the temple was destroyed, along with the rest of the district, by fire in AD 80 and was rebuilt in a magnificent style by Domitian; it was largely rebuilt again under Alexander Severus. The statues must have been colossal; their remains can probably be identified with the enormous foot visible today on the corner of Via del Pie' di Marmo and the large female bust known as Madama Lucrezia located today in a corner of Piazza S. Marco, which can be identified as a statue of Isis by the knot at its chest (see page 152).

▼ Fragment of slab with Isiac scene, from Ariccia, 100 BC, Palazzo Altemps, Rome.

Mithras was always presented in Persian dress, with a Phrygian cap on his head and a short, loose chlamys, and is almost always depicted in the act of sacrificing the bull.

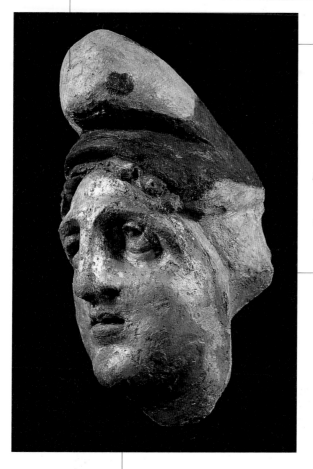

Worship of the Persian god Mithras was probably introduced to Rome by the soldiers of Pompey returning from the campaign in the east; the cult reached its highest level during the 3rd century, when it enjoyed favor even among emperors, including Caracalla and Diocletian.

Mithraism was reserved exclusively to men and was practiced in small groups of initiates that almost always met in underground spaces designed to look like caves, thus recalling the myth of Mithras who killed a bull in a cave to generate the universe.

▲ Head of Mithras, from the Mithraeum of S. Stefano Rotondo, 2nd century, Museo delle Terme, Rome.

The head, made of gilt stucco, was part of a relief depicting Mithras killing the bull that was located at the center of the Mithraeum during the first phase of the building's life.

The small male figure in bronze bears clear traces of gilt; its head is covered and its body veiled by a thin fabric, and it is wrapped in the coils of a serpent with a dragon's head. A hole under the feet suggests that it may have been displayed in a vertical position, perhaps during special celebrations.

The small bronze idol may well be an image of the Egyptian divinity Osiris, a nature god who is born and dies every year, thus symbolizing the initiation of new adepts—a ceremony that may have been performed in this cella—who experience an allegorical birth to a new life.

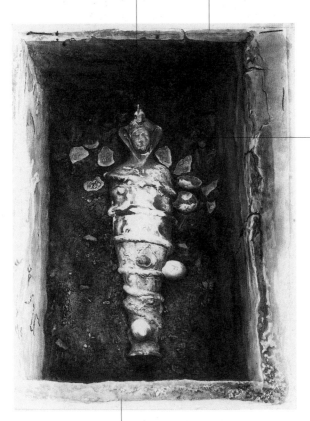

The oriental gods differed from the old divinities of the Greek and Roman pantheon by being able to suffer and die and be resurrected, thus caring for the salvation of their faithful without distinction of race or social state.

▲ "Janiculum Idol," from the sanctuary on the Janiculum, second half 2nd century, Museo delle Terme, Rome.

The statuette was found in a cella of the Syrian sanctuary, under a triangular altar, placed supine in a horizontal position inside a grave along with seven eggs and traces of flowers and seeds, probably votive offerings connected to fertility rites.

Cautes and Cautopates are usually depicted to the sides of Mithras, with whom they form a triad; or they are located within niches almost always near the entrance to the Mithraeum.

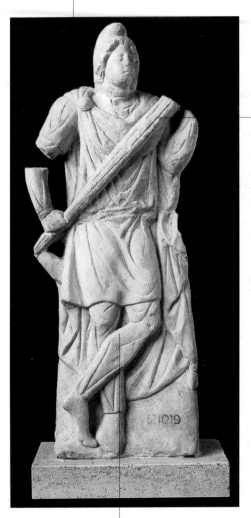

The uplifted torch held in the right hand is the symbol of Cautes, considered the guardian spirit of the rising sun. Related to the worship of the god Mithras, Cautes was paired with Cautopates, the spirit of the setting sun, who thus holds his torch downward.

▲ Cautes, from the Villa of the Quintili, 3rd century, Villa of the Quintili, Antiquarium, Rome.

Cautes wears an oriental costume similar to that of Mithras, with a sleeved tunic belted at the waist, short tight breeches, a mantle over his shoulders, and a Phrygian cap.

The relief, found together with statues of other oriental divinities during excavations in 1929 in the so-called Oriental Sanctuary of the villa, remains a unique work for Rome.

Astarte, identified by the four pairs of wings, holds a lotus flower in her right hand and wears a hawk-shaped Egyptian headdress topped by a solar disk framed by cow horns.

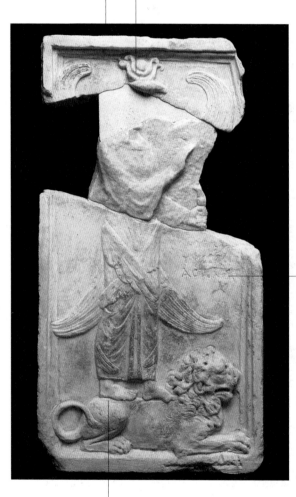

A dedicatory inscription in Greek, partially worn away but still legible, identifies the goddess as "Astarte the Highest."

▲ Relief with Astarte, from the Villa of the Quintili, 2nd century, Villa of the Quintili, Antiquarium, Rome.

The divinity is presented standing atop a crouching lion, an animal that often appears with the Syrian-Phoenician goddess, who sometimes rides it.

The sculpture, found in 1741 in a room in the substructures of the Poikile, was donated to Pope Benedict XIV for his collections.

The unmistakable trait of the divinity is his hairstyle composed of thick curls that fall to his shoulders and that are partially gathered over his forehead in a knot that was meant to resemble the crown of Lower and Middle Egypt.

Harpocrates is presented in his usual pose, nude and standing with one leg slightly bent and the index finger of his left hand held to his lips. The gesture serves to remind the faithful of the need to not divulge the secrets involved in the initiation rites of Isiac mysteries.

▲ Harpocrates, from Hadrian's Villa, Hadrianic age, Musei Capitolini, Rome.

The young divinity rests his weight on the trunk of a fruit-bearing palm, visible behind his left leg.

Christianity

Related entries
Constantine, Catacombs

Although in constant expansion, Christianity found itself on the margins of Roman society during the 2nd century, most of all because of its rejection of Rome's civic ritual and imperial cult, an attitude that became an expression of opposition to power. The faithful met wherever doing so was possible, very often in the homes of well-to-do private citizens who made sufficiently large spaces available to the community. By the 3rd century the number of Christians in Rome must have approached tens of thousands, and the new religion had penetrated every level of society, most of all because unlike paganism it offered a strong sense of community, such that Christians knew that wherever they went they could attend the same church and could find help and comfort from other Christians and thus feel at home. Given the dramatic conditions of Roman society at the time, such experiences cannot have failed to have a powerful influence.

In the middle of the 3rd century and early in the 4th, various imperial edicts unleashed violence against the Christians, with episodes of cruel mass persecution that reached their height only a few years before Constantine, in 313, granted legitimacy to all the religions professed in the empire. In 391–92 the emperor Theodosius I reversed the situation, issuing a series of edicts that prohibited all forms of pagan worship.

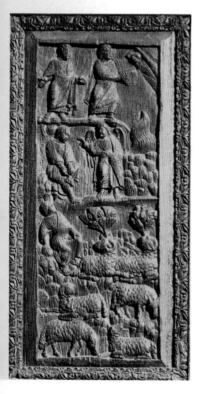

◀ Panel from the wooden door of the church of Santa Sabina, ca. 420, Rome.

Two similar scenes are presented to the right. In the first Christ rests his hand on the head of a kneeling figure who has perhaps asked to be healed; in the second Christ helps a lame man rise to his feet. A woman can be seen behind the two figures of Christ.

The central scene depicts an episode of the Sermon on the Mount: Christ, seated on a rock and wrapped in a mantle that leaves his right shoulder bare, addresses six small figures seated in a circle in front of him.

Christ holds a scroll in his left hand and places his right on the head of a kneeling woman, perhaps to heal her; in front of him a fragmentary figure seems to be reading from a scroll.

▲ Slab with scenes from the New Testament, 3rd–4th century, Palazzo Massimo, Rome.

The slab, bearing clear traces of polychrome decoration, was part of the front of a large sarcophagus; there are too few elements to reconstruct the scenes in the upper register, but it seems likely that they refer to another episode of Christ's sermon, with several seated figures turning their heads upward.

The process of the conversion of the West to Christianity was somewhat rapid; at the beginning of the 4th century Christianity could have been considered widespread only in Africa, but no more than a century later most of the population of the Western Empire had been converted.

Without doubt, the statue was modeled on the images of seated divinities and philosophers, and its identification as the teaching Christ is based on its appearance on numerous classical-style sarcophagi datable to the late period of Constantine.

▲ Teaching Christ, mid-3rd century–mid-4th century, Palazzo Massimo, Rome.

Pliny the Younger, in a letter to Trajan, wrote of the habits of Christians: "They meet on a fixed day before dawn and sing a hymn to Christ as to a god . . . and bind themselves by oath, not to some crime, but not to commit fraud, theft, or adultery, not to falsify their trust, nor to refuse to return a trust when called upon to do so."

The statue presents a seated youth with long, shoulder-length curly hair dressed in a tunic and mantle; he holds a scroll in his left hand.

The conversion of Constantine served to accelerate a process that was by then irreversible. Although Constantine openly favored the Christians, his successors were somewhat neutral, with the exception of the reactionary reign of Julian the Apostate, who did not promote persecutions but gave his favor to the old pagan cults.

"I asked them if they were Christians . . . those who persisted I ordered executed. . . . their stubbornness and inflexible obstinacy surely deserved to be punished. . . . It was their custom to assemble to partake of food . . . I discovered nothing but depraved, excessive superstition." (Pliny the Younger)

▲Funerary slab of Priscus dedicated to his brother, provenance unknown, second half 4th century, Museo delle Terme, Rome.

"But the Christians, what wonders . . . do they feign! That he who is their God, whom they can neither show nor behold, inquires diligently into the character of all, the acts of all, even into their words and secret thoughts . . . they make him out to be troublesome, restless, even shamelessly inquisitive . . . and everywhere present." (Minucius Felix)

"I would call on the man who saw Drusilla's soul on its way to Heaven; he will swear that he saw Claudius taking the same road, 'with halting gait'" (Seneca)

Imperial apotheosis

▼ Arch of Titus, detail of the vault with imperial apotheosis, Forum Romanum, Rome.

The sources relate with abundant details the solemn and grandiose funeral of Augustus, who was cremated on a pyre from which an eagle rose in flight, quickly winging its way skyward; another eagle had appeared before the death of the emperor, while he sacrificed to Mars, flying around him and then coming to rest on the letter A in Agrippa on the inscription on the façade of the Pantheon, indicating that the temple was destined to be the dynastic sanctuary of the imperial family. The origin of the eagle's symbolic appearance remains unclear, but it is certain that it became a constant in imperial funeral ceremonies, and the ritual flight was repeated each time that an apotheosis was decreed. It was up to the senate to decree the apotheosis of a dead emperor, and it seems unlikely that such acts were supported by public opinion. There is the case of Claudius, perhaps the only emperor of the Julio-Claudian line whose apotheosis

was met with mockery by the people, as indicated by Seneca in his *Apocoloncytosis,* in which he celebrates the transformation of the dead emperor into a divinity "with the shape of a pumpkin."

The deification of the dead emperor was always an important political act since it gave his successor the opportunity to call himself "son of god," thereby attributing to himself a series of divine prerogatives.

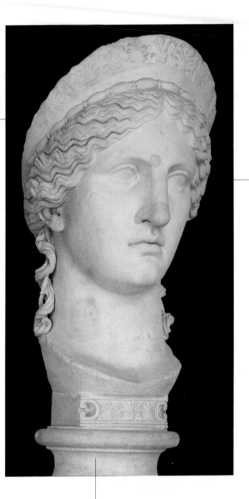

Antonia, youngest daughter of Marc Antony and Augustus's sister Octavia, married Drusus, eldest son of Livia and brother of the future emperor Tiberius; the marriage had three children, Germanicus—father of Caligula—Livilla, and Claudius.

Antonia was celebrated as an unsurpassed paradigm of maternal devotion and conjugal virtue (she was not yet thirty when Drusus died, in 9 BC, but refused to remarry). In this portrait, probably posthumous and commissioned by her son, she is presented with the idealized features of youth.

▲ Ludovisi Juno, Claudian age, Palazzo Altemps, Rome.

This colossal marble portrait bust has been identified as Antonia Augustus, mother of the emperor Claudius and deified by him after her death, in 37. The sculpture, one of the most highly praised of all time, is described by Goethe in his Italian Journey: "No words can give any idea of this work."

The diagonal division of the composition—much like that of the base of the column of Antoninus Pius, with the apotheosis of the imperial couple (see page 38)—is an imitation of the classical-style rhythm employed by Attic workshops.

Hadrian's wife Sabina is lifted from the flames of the pyre and carried skyward on the wings of a Nike.

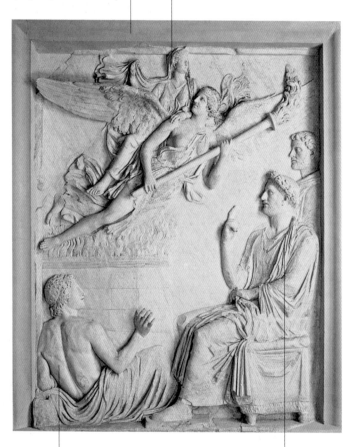

The figure of the reclining youth is a personification of the Campus Martius, the site where the funeral of Augusta took place.

The enthroned emperor observes the event.

▲ Apotheosis of Sabina, Musei Capitolini, Palazzo dei Conservatori, Rome.

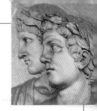

"Whatever the augur declares to be unjust, ill-omened, vicious, and accursed, let them be forsaken as prohibited and disastrous, and whoever will not obey . . . let him suffer capital punishment" (Cicero)

Omens and divination

No Roman would undertake an important enterprise without first taking the auspices by studying the flight of birds, following precise rules that established the arrangement of the area of observation, the act of observation, and its interpretation. In very early times an area was set aside in Rome for the activity of the augurs and for their divination of the flight of birds. This was the *auguraculum*, an area along the Via Sacra, and its creation required the removal of all the buildings that blocked the field of view. During the ceremony the augur divided the expanse of the heavens to be observed by marking off its corners with a *lituus*, a crooked staff without knots, and he then observed the flight and direction of the birds, as well as the sound of their wings and song. Augurs were consulted for both political and military decisions, and the public augurs followed a very precise hierarchy.

With the passage of time, observation of the flight of birds was abandoned in military campaigns, its place taken by divination based on the eating habits of birds. Thus, immediately before an action, the commander would summon the keeper of the sacred birds, who would scatter food and free the birds; if they ate, the signs were favorable, and the commander could order the attack. Along with the official augurs there were others who observed natural phenomena, including the weather predictions made by sailors and farmers.

▼ Relief with the announcement of an oracle, from the Temple of Hercules, Ostia, first half 1st century, Museo Ostiense, Ostia Antica.

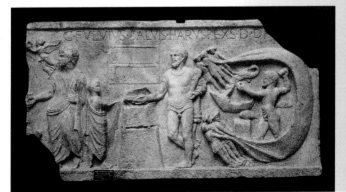

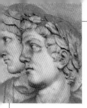

Priests and colleges of priests

Related entries
Sacrifice, Forum
Romanum

▼ Head of a Vestal,
Antonine period, Museo
Palatino, Rome.

Numa Pompilius is traditionally considered the founder of a Roman religion closely based on the Etruscan tradition and full of a variety of colleges of priests, among them the Vestals, the Pontiffs, the Flamines, the Augurs, and the Arval Brothers. Cicero undertook a complete examination, almost a refoundation, of the Roman religion. He entered the college of augurs in 53 BC and one year later drew up a sort of legal picture that regulated the various worlds of the priesthood and the religious practices.

In Rome one could become a priest between the ages of fifteen and thirty, and the term of a service varied, although it was always for a predetermined length of time. The priesthood was an honorific office without pay, but it offered prestige and was considered compatible with the performance of public offices, so much so that most of the consuls during the republican period also held important posts in Rome's religious life. The priesthoods were regulated by state laws, sacred laws, and traditional doctrine, and the positions most strictly regulated were those of the Vestals, who had to serve for thirty years, and the Flamen Dialis, the priest of Jupiter, who could leave office only if his wife died, since the position required him to be married.

"He increased the number, prestige, and privileges of the priesthood, being particularly generous to the Vestal Virgins. When a Virgin's death caused a vacancy, and many citizens sought to keep their daughters' names off the list of candidates, Augustus took an oath that if any of his granddaughters had been of eligible age he would have proposed her." (Suetonius)

The face still presents certain realistic features, such as the wrinkles on the forehead—at the time of the portrait, Augustus must have been nearly sixty—along with the high cheekbones that characterized the emperor's face but that gradually disappeared from later official portraiture.

The emperor is portrayed with his head veiled by his toga, as fitting a priest about to perform a sacrifice. It thus seems probable that he held a cup in his right hand and in his left a lituus, the crooked staff used by augurs derived from Etruscan tradition.

The toga was the most traditional dress for a Roman citizen, and Augustus, as part of his overall policy of restoring ancient customs, had made its use obligatory in public places and during ceremonies.

When Augustus became pontifex maximus, in 12 BC, on the death of Marcus Lepidus, he did not move into the house of the pontifex maximus, as had been customary, but transformed a part of his residence on the Palatine into a public space.

▲ Augustus Pontifex, from the Via Labicana, end 1st century BC, Palazzo Massimo, Rome.

"He also revived some of the ancient rites which had gradually fallen into disuse, such as the augury of Safety, the office of the Flamen Dialis, the Lupercalian festival, the Saecular Games, and . . . the festival of the Compitalia." (Suetonius)

The woman has puffy cheeks because she was probably playing a wind instrument—perhaps a double flute—that she held in her hands, which have been lost along with the instrument.

The priestess wears a foot-length tunic and a large mantle that covers her head and wraps around her chest, its two ends knotted to form the classical voluminous Isiac knot.

The priestess is probably depicted while participating in a processional cortege related to the celebration of a rite; aside from musicians, the cult of the goddess required the presence of special female musicians and dancers.

The cult of Isis, from Egypt, took hold at Rome beginning in the late republican period and spread somewhat rapidly, most of all thanks to its promises of salvation and eternal life, for which it attracted people from all social levels.

▲ Priestess of Isis, from Via Tripoli, 2nd century, Palazzo Altemps, Rome.

The shaved head and the scar, rendered as a vertical furrow, are immediately visible indications that this is a priest of Isis; along with white linen garments, these were the elements that distinguished the priests from the faithful.

The cella in the Temple of Isis was reserved to the priests and to initiates, who were not supposed to divulge the mysteries of the goddess to others. In his Golden Ass (or Metamorphoses) the 2nd-century writer Apuleius gives a long and colorful description of the initiation ceremony, as described by his main character, Lucius, who is introduced to the cult of Isis.

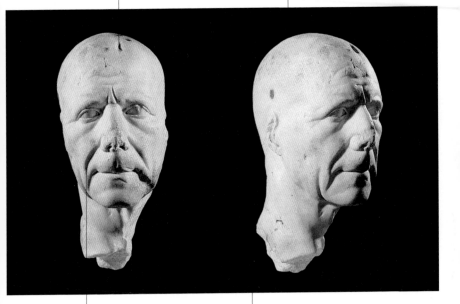

The bust of the priest is rendered in a highly realistic manner and presents the face of a man already somewhat old, with numerous deep wrinkles, a square jaw, small eyes, and thin lips.

▲ Portrait of a priest of Isis, from the bed of the Tiber, early 1st century BC, Palazzo Massimo, Rome.

According to myth, Isis sought and found the pieces of her husband and brother, Osiris, whom the jealous and perfidious Set had enclosed in a coffer and thrown in the Nile and then—when the coffer was found— cut into fourteen pieces scattered far and wide. After reassembling the body of Osiris, Isis restored the murdered god to life and with him generated their son Horus.

"No change should be made in the prescriptions . . . as to the offerings appropriate for each of the gods, as to which should receive full-grown victims, which sucklings, which males, and which females" (Cicero)

Sacrifice

Related entries
Triumph, Aesculapius,
Omens and divination,
Priests and colleges of
priests, Ex-voto,
Medicine

▼ Detail of the relief on
the *Ara Pietatis*, Claudian
age, Villa Medici, Rome.

Animal sacrifice was a constant element in Roman religion, although in more ancient times it had not been rare to sacrifice humans. Shortly before 225 BC, in order to placate the gods and stave off the imminent danger posed by an approaching army of seasoned Gauls, the decision had been made to sacrifice a pair of Greeks and a pair of Gauls by burying them alive in the Forum Romanum.

The rituals that accompanied the sacrifice and the choice of the site depended on many factors, such as the reason for the festival, the number of participants, the season, or the relative expense. The chosen animal, of the same sex as the divinity to whom it would be sacrificed, had to be healthy, well nourished, free of defects, and never yoked. After a series of propitiatory ceremonies, the victim was stunned by the blow of a hammer and its throat was cut; as soon as it was dead it was bled, its body was opened, and its internal organs were examined while still inside the abdominal cavity; if these were perfect, the sacrifice was successful and the entrails could be cooked in a special pan or roasted on a spit, otherwise another victim was necessary. The cooked entrails, cut up and cooled with wine, were placed in one or more plates with pieces of bread and salt and were burnt on the altar as an offering to the divinity.

The believers were permitted to eat the remains of the animal, which were roasted and distributed in accordance with fixed rules. The remaining meat could be sold to butchers and the hide to tanners.

Sale of the remains of sacrifices often represented a good source of income for shrines.

Those who were to participate in the sacrificial ritual had to first perform a lustratio, or purification, washing themselves or only sprinkling themselves with water.

All those who were participating in the ceremony gathered around the altar, the officiant with his veiled head, other priests and members of the cult, flute players, and those who were there to witness the ritual. In the case of private sacrifices the entire family participated, including the servants and groups of friends.

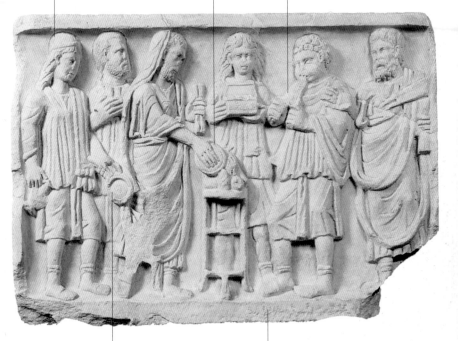

The officiant was assisted by helpers, members of the cult or family members, who stood beside him ready to hand him the objects necessary for the performance of the ritual.

The sacrificial ceremony called for an initial propitiatory phase during which various divinities were invoked and presented with offerings of incense, wine, and bread. The forehead of the victim was bathed with wine and spread with barley meal mixed with salt; the animal was then symbolically marked with a stripe from its head to its tail and was dedicated to the divinity with the recitation of a prayer.

▲ Relief with scene of sacrifice, second half 3rd century, Palazzo Massimo, Rome.

Ex-voto

Related entries
Aesculapius, Medicine

The ex-voto ("in fulfillment of a vow") is a timeless religious practice: a gift offered to a divinity in the hope of obtaining a grace or in gratitude for a prayer answered. There have never been limits to the kinds of gifts offered as ex-votos, from large temples, altars, and votive chapels to those less costly and more ordinary, including a variety of objects made of metal or terracotta. Most of these are anatomical votives, parts of the human body almost always roughly modeled in clay by artisans who had limited knowledge of anatomy, sold in shops or from stands located near temples. Some of these represent organs bearing obvious signs of disease, such as breasts deformed by tumors, but there are also apparently healthy parts of the body that could in reality suffer unseen illness, such as rheumatic pain or migraines. Many ex-votos are in the shape of female genital organs and were offered in hope of obtaining a felicitous outcome to maternity, from childbirth to breastfeeding.

The practice of offering ex-votos was widespread between the 4th and 1st centuries BC. Sanctuaries became so full of them that it

▼ Ship ex-voto from Ostia, Museo delle Terme, Rome.

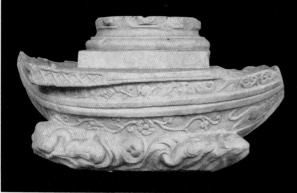

was often necessary to set aside the older ones in order to make room for new arrivals. Given their sacred character, ex-votos could not be destroyed, so special pits were dug near temples into which they were dumped. From these pits archaeologists have brought to light many hundreds of these votive offerings.

The disease was often attributed to an offense, whether voluntary or not, and the votive offering assumed the role of replacing the sick part of the body. Such replacement offerings were soon joined by propitiatory offerings.

In his treatise on medicine, Celsus lists numerous substances of animal origin suitable for the preparation of therapeutic remedies. Thus ox bile had laxative properties and swallow's blood made a purge, butter could be used to cure ulcers, and cobwebs were to be used to check the bleeding of abrasions.

Ex-votos are often in the form of bare feet resting on a surface, but in some cases footwear is also visible. The molds, often made directly from human feet, were in two halves, and examples have been found that broke along the mold line.

The Catholic Church has prohibited the depiction of internal organs in ex-votos, but even in somewhat recent years such offerings have been made, such as a silver uterus or lung given in Italy's Val d'Aosta and various genital organs in Sardinia.

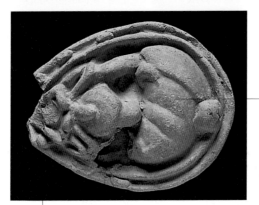

The Bible relates that the Philistines, suffering a disease of the anal region, offered golden emerods (hemorrhoids) to the god of Israel, whom they feared to have offended by profaning his ark.

▲ Ex-votos in terracotta, from the Tiber, 3rd–2nd century BC, Museo delle Terme, Rome.

"Private rites are perpetual. Render to the gods-Manes that which is their due. They are men who have departed this life; hold them for divine" (Cicero)

Domestic cults

Lares, Manes, Penates, *Genius*

Related entries
Temples and sacred buildings

The most ancient religious practices in Rome were performed by the *paterfamilias* for his family and were closely tied to the land and the rustic setting. The house itself was entrusted to the protection of animistic forces: the cupboard or pantry in which food was kept was protected by Penates; the domestic hearth was under the care of Vesta; the door to the house was protected by Janus. Lares guarded the house in general, and every family had its Manes, spirits protecting dead ancestors. Lares, Manes, and Penates were private family divinities, and in the same way each male individual had his *genius*, a sort of guardian spirit—like today's guardian angel—that accompanied him and watched over him from his birth until his death.

Inside his home the *paterfamilias* performed priestly functions, and it was his office to perform the private rites that marked off the life of the family, which included the slaves.

According to the occasion, such ceremonies could be very simple, nothing more than offering a drop of a beverage that was about to be consumed, or more complex, requiring special implements. Children assisted their father in performance of the most simple rites, handing him the necessary implements, whereas more important rituals called for specialized personnel, such as sacrificial slaughterers.

▶ Dancing Lar, Musei Capitolini, Rome.

The vicomagistri—*there were four such wardens for each* vicus *("district")—were elected every year and saw to the organization of the ceremonies and the* sacrifices *connected to the cult of the Lares Compitalia, to which a pig was usually offered, and those of the* genius *of the emperor, to whom a bull was given.*

The inscription recalls that the altar was dedicated in the ninth year since the reorganization of the cult of the Lares by Augustus.

The four magistrates, with their heads veiled to indicate their function as priests about to perform a sacrifice, celebrate the rite at the sides of an altar, while musicians beside them accompany the ceremony.

At the bottom of the altar are two handlers of sacrificial animals, each with his animal ready for sacrifice.

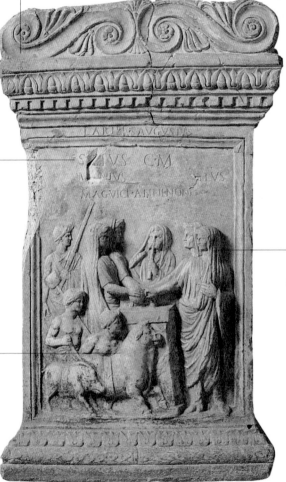

▲ Altar of the *vicomagistri* of the *Vicus Aesculetus*, 4 BC–AD 2, Musei Capitolini, Palazzo dei Conservatori, Rome.

"Why does astrology say that the star of Jupiter or Venus in conjunction with the moon is auspicious for the birth of children, while Saturn or Mars are inauspicious?" (Cicero)

Folklore and magic

The oldest Roman religion was at heart animistic, and early cults and creeds were closely associated with magical practices; the purpose of most rituals was the propitiation of superhuman forces, either winning their favor or holding them at bay in order to avoid their harmful influences. Magic was considered the art of dominating the forces of nature by way of special rituals and without the intervention of a supreme being, and for the Romans superstition and magical practices were part of their normal relationship with divinities, which might send signs and warnings indicating their will. Then as today people turned to the occult arts for the resolution of romantic difficulties, such as getting the desired person to respond favorably by having him or her drink a love potion, and also for purposes of revenge, sticking pins into a clay or wax simulacrum of the offending person while reciting some special magical formula in the hope of seeing that person dead or maimed. Oriental astrologers, often known as Chaldeans, enjoyed great fortune in Rome for their supposed ability to read the future in the stars and numbers. Although expelled from Rome en masse in 139 BC, astrologers continued to operate there, consulted by simple people who were often cheated by unscrupulous charlatans, but also by the learned. The emperor Tiberius would do nothing without first consulting his personal astrologer, Trasillus.

▼ Hermetic containers in lead, from the fountain of Anna Perenna, Museo delle Terme, Rome.

Reading defixiones ("curse tablets") reveals the innumerable motives that drove people of all social levels to seek the assistance of infernal divinities to satisfy their lust for revenge, often manifesting their hatred in very crude phrases; unfortunately their signs and drawings cannot always be interpreted.

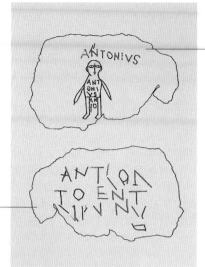

A certain Antonius is depicted on this tablet, albeit in a rough and stylized manner. His name is repeated several times, probably in the hope of eliminating errors, making sure that the malediction would not miss the hated person.

The presence of a fragment of bone has been noted between the base of the head and the neck. Similar fragments have been found in other figurines of the same type.

The anthropomorphic male figurine, made of a soft mixture with a wax base, was found inside a lead container composed of three cylinders placed one inside the next; the figurine, with its clearly indicated genitals, fingers, and toes, was placed in the container with its head downward.

The fountain of Anna Perenna, a very ancient Roman deity, was found in 2001 during construction of an underground garage in Rome's Piazza Euclide; the identification with the divinity was established by a dedicatory inscription.

▲ Magical objects, from the fountain of Anna Perenna, Museo delle Terme, Rome.

Daily life

◀ The toilette of Aphrodite, detail,
from the Villa Farnesina, ca. 19
BC, Palazzo Altemps, Rome.

"Take some green dates or remove the nuts from mature dates and fill them with walnuts or pine nuts and ground pepper; salt, fry in cooked honey, and serve" (Apicius)

Food and dining

In the Roman world the only meal worthy of the name, the only one for which a table was set, was the evening meal consumed between the eighth and ninth hour (the early afternoon); the other meals were brisk affairs involving the rapid and frugal consumption of something cold. During dinner the diners used plates and glasses but not tableware, for the food was served already cut into bite-size pieces; when needed there was a spoon. At the center of the table were serving plates, fruit bowls, and cups with marinated white or green olives in brine; the wine was always strong and thus diluted with water, warm or cold according to the season, and was sometimes mixed with honey.

Throughout the archaic age the primary food in the Roman diet was a kind of polenta made with millet or barley, while bread did not become a common food until the 2nd century BC, at which time the first bakeries came into being. The Romans ate an abundance of legumes and vegetables and were fond of dried fruit, which was also used as an ingredient in many sweets; cooked fruit with honey and spices was served as a side dish for meat, most often birds and pork. Fish, whether fresh or pickled, was usually eaten with *liquamen* (also called *garum*), a sauce made with salted and fermented fish with the addition of aromatic herbs, and in general fish preserves were among the basic components of the Roman table.

▼ Detail of fresco with still life, *Domus Aurea*, Rome.

Sheep-raising seems to have been tied principally to the production of wool, milk, and cheese.

Apicius's cookbook provides highly useful information on what well-to-do Romans ate; particularly striking is the enormous variety of birds, including the peacock, pheasant, and even the crane, for which Apicius provides six different recipes.

"On workdays I never ate anything but potherbs with a hock of smoked bacon. And when a friend came to visit or my welcome neighbors came to dine . . . we ate well, not on costly fishes fetched from town but on a pullet and a kid: then dried grapes, nuts, and figs, and that was all my feast." (Horace)

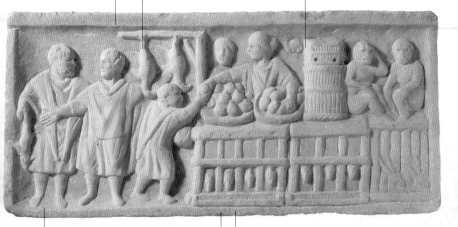

The Romans considered wheat a normal food already in the 5th century BC. In this regard, the historian Dionysius of Halicarnassus relates how the population of Rome had looked on the millet and spelt that arrived in Rome from Etruria during a famine in 492–91 BC as unusual foods.

During the republican period, it was against the law in Rome to kill cattle, in order to preserve them for agricultural work. Thus only the old or those unable to work in the fields were used for food.

"Yet, if a peacock be served, I shall hardly root out your longing to tickle your pallet with it rather than with a pullet. You are led astray by the vain appearance, because the rare bird costs gold and makes a brave show with the picture of its outspread tail. . . . Do you eat the feathers you so admire? Does the bird look as fine when cooked?" (Horace).

▲ Marble relief from Ostia, 2nd century, Museo Ostiense, Ostia Antica.

In late antiquity—as indicated by Diocletian's edict on maximum prices (AD 301)—the price of meat declined such that it was included in free food distributions.

Vegetables, both those cultivated and those wild, played an important role in the Roman diet.

The various sumptuary laws issued during the 2nd century BC to prevent extravagance and luxury also lashed out against excesses in foods.

The cookbook by Apicius—a gourmet who lived during the reign of Tiberius—clearly demonstrates the variety and refinement of the meals eaten by those on the higher levels of Roman society.

The eating habits of the Romans changed radically between the 3rd and 2nd century BC when Rome's expansion and the conquest of rich territories resulted in an extraordinary availability of different foods; the result was a great disparity between supply and demand, and the taste among the wealthy for refined and high-priced foods.

In imagining the meals eaten by ancient Romans one must not forget that certain foods, most especially those from the New World, did not yet exist in Europe, including such modern staples as tomatoes, potatoes, and various beans.

▲ Pot in bronze, from the fountain of Anna Perenna, Museo delle Terme, Rome.

The mosaic, made with tiny tesserae of vitreous paste, decorated the basin in a bathing complex in a private home; numerous species of sea creatures are presented across a landscape.

Olives were much used in Roman cooking, whether whole, cut up, or reduced to a paste, and they were served throughout the meal, from appetizers to after-dinner treats.

Using fingers instead of forks meant Romans needed to wash their hands frequently during meals, and ancient authors mention slaves bearing cups from which they poured perfumed water over the hands of diners.

▲ Details of a mosaic with marine scenes, from the area of S. Lorenzo in Panisperna, end 2nd century–early 1st century BC, Musei Capitolini, Rome.

"In many parts of Italy no man puts on a toga until he is dead. Even on festival days . . . the aediles are content with white tunics. In Rome, everyone dresses smartly and above his means" (Juvenal)

Dress

Related entries
Hairstyles and makeup,
Funeral

▼ Bust of Pupienus,
wearing a *toga
contabulata*, ca. 238,
Musei Capitolini, Rome.

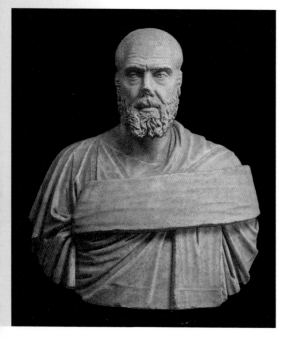

The ancient Romans made clothing primarily from wool, which was highly economical and was produced in various regions of the empire; the best woolen material came from Miletus and the province of Gallia Belgica (Belgium), famous most of all for heavy, rough fabrics suitable to the cold climates of northern Europe. Only the wealthier classes could afford clothing made of cotton, linen, or a very thin fabric from Kos that, according to Pliny the Elder, made women look as if they were naked. Chinese silk was being imported to Rome as early as the 3rd century BC. It arrived raw and had to be dyed and woven before being offered in the Punic markets of Tyre and Berytus (Beirut). Silk was such a precious commodity that even the emperor Aurelian had forbidden his wife to buy a mantle of purple silk because it was too costly, and Diocletian's edict on prices in 301 fixed the cost of a kilo of rough silk at 4,000 gold coins.

With the passage of time the counterfeiting of precious fabrics became increasingly normal, unstitching old materials and reweaving them together with threads of other fabrics to increase the volume. During the reign of Justinian two missionaries smuggled silkworm eggs out of China to Constantinople, where they were bred for the production of silk, eventually ending the monopoly that Oriental markets had enjoyed on commerce in the highly costly fiber.

The toga of the republican age (toga exigua) was shorter and tight fitting; it was composed of a semicircular piece of wool, and the two angular ends were called laciniae.

The statue, probably of a funerary character, is almost certainly one of the latest examples of sculpture from the republican period.

The toga of the imperial age was based on an elliptic piece of material and required a notable quantity of material, with the line of the fold running as much as five meters in length, and adjusting it properly was a complex operation.

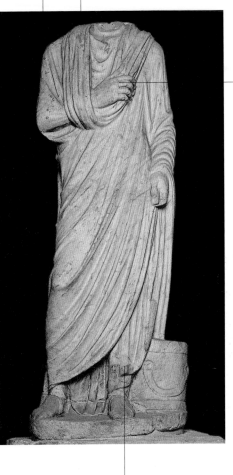

The right arm, held across the chest, extends from the folds of the toga so the hand can grasp the balteus, the straight side of the material. The toga could be draped in different ways according to the requirements of movement; the arrangement on this statue, in fact, does not permit any movement to the right arm, more or less blocked at the chest.

The toga made an uncomfortable and awkward article of clothing for daily life; there was the further problem that the material had to be kept absolutely white, and the folds had to be done properly since appearance and decorum were integral aspects of the toga.

The lacinia, arranged in orderly parallel folds, descends to cover the ankle and to partially hide a basket on the ground.

▲ Statue in toga, end 1st century BC, Palazzo Altemps, Rome.

This sculpture was long thought to be the figure of a Dacian because of its resemblance to the statues of Dacian prisoners that decorated the Forum of Trajan before being moved to the attic of the Arch of Constantine. Recent studies have raised the dating of the work by more than half a century, making its identification impossible.

The statue, in giallo antico marble, has been largely restored, including the addition of the bare-skin parts in black English marble (touchstone marble) and of portions of the legs, arms, and trunk in giallo antico; the cap is also the result of restoration work.

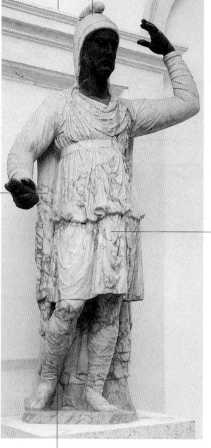

The cloak, which drops straight to the ground, probably served as a support for the statue as well as a surface to rest against a wall; this hypothesis is supported by the summary treatment of the back of the cloak.

The figure wears oriental-style clothing, a sort of pants (bracae) and a short tunic held under the chest by a band, creating a long drop; a heavy mantle hangs over the right shoulder.

▲ Statue of Dacian, Julio-Claudian age, Palazzo Altemps, Rome.

In the Antonine period, not only Roman soldiers but also Roman citizens who moved to areas in northern Europe began wearing pants, which were comfortable and better suited to cold climates than togas.

The quinarius, issued by Hadrian between 119 and 132, provides what archaeologists call a terminus post quem, *a means of dating the "moment after which" the burial occurred.*

The reverse of the coin is practically upside down by 180 degrees compared to the obverse; there is almost always a degree of difference between the axis of the obverse and that of the reverse of coins, for which reason coin catalogs provide an indication of the deviation between the axis of the reverse and that of the obverse.

The collection in which the pendants were found also included a ring, a pair of simple gold earrings, and two styluses in gilt bronze.

The quinarius was a silver coin worth half a denarius; compared to bronze coins, the quinarius was worth two sesterces and five asses.

▲ Small pendant with coin of Hadrian, from the necropolis of the Via Ostiense, near the basilica of S. Paolo fuori le Mura, mid-2nd century, Palazzo Massimo, Rome.

A tunic was composed of two rectangles of material sewn together and held at the waist by a belt. Around the 3rd century, tunics similar to cassocks became popular among the wealthy classes. These reached the heel and were richly decorated. In cold weather a mantle was worn over the tunic with a hood that tied under the chin.

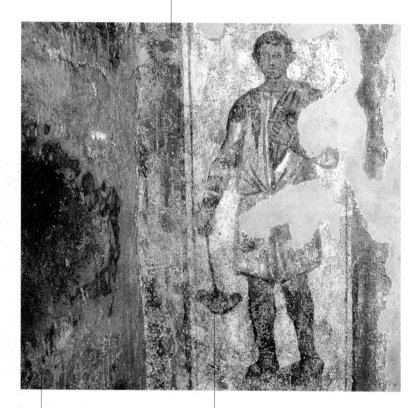

When indoors people wore only a tunic; women also wore a sort of ancestor of the bra, a strip of cloth, sometimes padded, that wrapped around and supported the breasts.

▲ Fresco, second half 4th century, catacombs of SS Pietro e Marcellino, Rome.

The figure depicted on the fresco is a funeral worker—a grave digger—and in his right hand he holds a shovel, the indispensable tool for his work.

"For nothing she scratches her handmaid's face, seizes a needle and stabs her arm, and the maid curses and weeps and while blood-stained and crying combs her mistress's hated hair" (Ovid)

Hairstyles and makeup

Roman matrons made large use of cosmetic products: colored earths were used for makeup and beauty masks, while a black powder, similar to Egyptian kohl, was used to embellish eyes, and hair and wigs were tinted with such substances as henna imported from Egypt and sapo, a red dye made by blending goat's fat with beech ash produced in Germany. Oils and perfumed ointments were certainly luxury goods, even if various city cultivations served local and regional needs at lower prices, and well-to-do families used their own grounds for the production of perfumes for personal use.

For many centuries, men had worn their hair long and left their beards unshaven, but in the 3rd century Roman men adopted the Greek style of short hair and shaved cheeks. By the end of the republican period male hairstyles were becoming more elaborate, and the work of barbers increased sensibly when men began to adorn short hair with the *calamistrum*, an iron that was warmed on coals and used to make curls or ringlets. A new style was adopted in the 2nd century when the philhellenic emperors, from Hadrian on, returned to beards, and some of them began to dye themselves blond, leading to the excesses of Commodus, who powdered himself with gold dust.

Related entries
Dress

▼ Portrait of a Julio-Claudian noblewoman, Neronian age, Palazzo Massimo, Rome.

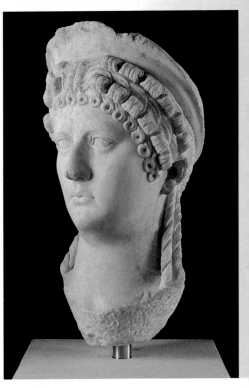

The habit of spreading oil and ointments over the body and abundantly perfuming clothing was deeply rooted in Roman society and dated to the first importations of perfumed substances from the Orient in the period immediately following the war against Antiochus of Syria.

The woman is carefully pouring perfume from a small pitcher (askos) into a tiny amphora.

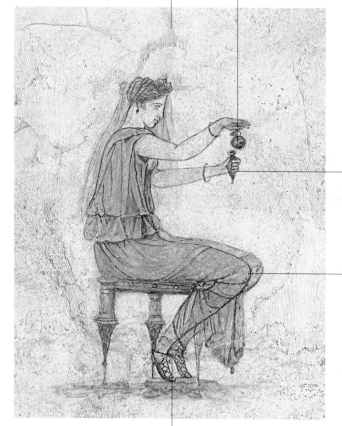

Unlike the processes in use today, odorous essences were extracted by means of maceration in fatty substances to which were added the additives necessary to slow the process of evaporation.

Only the wealthy classes could afford garments made of cotton, linen, or the thin fabric from Kos.

Calcei *were a sort of unisex footwear, short boots composed of a shoe upper and four strings that were wrapped around the ankle and up around the leg; the sandals worn indoors were not suitable for going out. Women obtained high heels through the simple expedient of thickening the soles.*

▲ Female figure pouring perfume, detail, from the Villa Farnesina, ca. 19 BC, Palazzo Massimo, Rome.

The first typically Italian hairstyle came into being at the end of the republican period, the so-called Octavia style, with a soft, thick ringlet above the forehead and braids gathered in a chignon on the back of the head. The style was adopted by women of all ranks and ages.

In his Art of Love, Ovid recommends that his female readers make themselves beautiful and that they disguise all the operations of makeup and cosmetics so as to appear desirable to their lover.

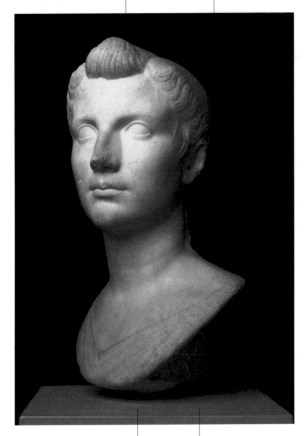

In earlier epochs the hair had been styled with great simplicity and with only the most limited use of ointments and perfumes.

▲ Portrait of woman, Augustan age, Palazzo Massimo, Rome.

During the republican period Roman women saw beauty as a reflection of the virtues and the qualities needed to care for the domestic hearth, and the face and hair were meant to reflect that fully.

During the Flavian period it became stylish to add hairpieces to one's own hair so as to frame the face in abundant curls; these towers of high-piled ringlets only increased in volume and endured into the Trajanic period.

Blonde hair was enormously popular in Rome although it was considered more suitable to courtesans than to respectable matrons.

At the end of the 2nd century Tertullian complained that "Some women are anxious to force their hair into curls, some to let it hang loose and flying, not with good simplicity . . . some affix I know not what enormities of subtle and textile perukes, now after the manner of an undressed hide."

The habit of dying hair to disguise gray spread during the early imperial period, probably in part to compete in beauty with the women arriving in Rome from conquered provinces.

▲ Portrait from the Flavian age, Musei Capitolini, Rome.

The care of clothing was entrusted to servants who had the chore of realigning the many folds in men's and women's clothing every evening.

Roman clothing styles were somewhat monotonous and uniform, but women's clothes in particular were given great vivacity through the use of a variety of colors, making it possible to achieve chromatic contrasts. According to their financial means, women also had access to numerous accessories and ornaments with which to embellish themselves.

Lucilla was born around 148 to Marcus Aurelius and Faustina; at sixteen she was given in marriage to Lucius Verus, her father's adoptive brother and colleague. When her husband died, in 169, her father, against her will, had her remarry. She plotted unsuccessfully against her brother Commodus and was exiled to Capri before being murdered.

The noblewoman is dressed in a wool tunic (stola) held tight under the chest by a belt and is wrapped in a mantle that covers her head. Such was the only protection Roman women had against the cold.

▲ Lucilla, second half 2nd century, Museo delle Terme, Rome.

177

The mass of hair with its thick waves parted in the middle is, in fact, a wig. The hairstyle was typical of the period and is how Julia Domna appeared during the early period of her husband's reign.

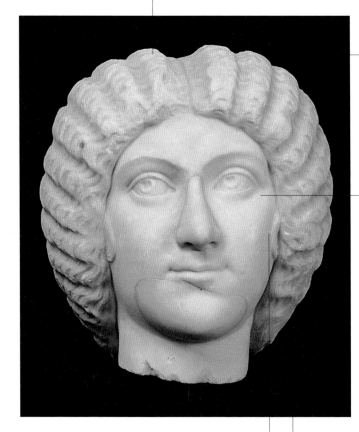

Most Roman women did not wear hairpieces and dressed their hair quite simply.

The facial features, although of a generic classical style, accurately present the oriental appearance of Julia Domna, with the high cheekbones, aquiline nose, and large eyes with heavy eyebrows.

The two short curls on the cheeks are probably tufts of real hair, artfully arranged to look as if they have slipped free of the wig.

▲ Portrait of Julia Domna, end 2nd century, Palazzo Massimo, Rome.

Julia Domna, Syrian from Emesa (Homs), was the second wife of Septimius Severus, who was himself a native of Leptis Magna in Africa; an intelligent and ambitious woman, she had a strong influence on political life during the reign of her husband and that of her son Caracalla.

The back of the mirror bears relief decoration depicting the myth of Phrixos and Helle, daughters of Athamas and Nephele: when Ino, their father's second wife, sought to kill them, their mother had them flee on a golden-fleeced ram.

Mirrors were common, standardized objects, often without decoration, most often in bronze with only the reflecting side silvered. They were round or, more rarely, square, with handles in a variety of styles or without handles, although according to a line from Ovid, women turned to their mirrors for advice.

During the flight Helle fell into the sea at the point later named in her honor: Hellespont. Phrixos reached Colchis safely, and there he sacrificed the ram and hung its fleece in a wood sacred to Ares. The fleece was later stolen away by Jason and the Argonauts.

▲ Mirror in silver, from a woman's tomb on the estate of Vallerano, Antonine age, Palazzo Massimo, Rome.

Roman women made use of many artifices to dress their hair, sometimes gathering it and holding it in place with hairnets made of gold wire that were attached to the head with hair bands or ribbons.

Gold hairnets can be seen in frescoes from Pompeii and in encaustic portraits on sarcophagi from the oasis of Fayyum in Egypt.

The net is composed of several strands of gold thread, made by spinning microscopic threads of metal that were then twisted to obtain a circular thread with a diameter no greater than one-tenth of a millimeter.

Roman matrons took great care of their hair since a woman was not considered elegant if her hair was not carefully dressed.

▲ Hairnet in gold,
Palazzo Massimo, Rome.

According to Ovid, "An oval-shaped head asks for a plain part . . . a round face demands a small knot on the top, leaving the forehead free, showing the ears . . . another girl may throw her hair over both shoulders."

Beginning in the Severan age the custom spread of a hairstyle characterized by a central part and dense, wavy hair reaching the neck, hence the name "helmet," a style that was adopted by empresses, noblewomen, and matrons over the course of the 3rd century.

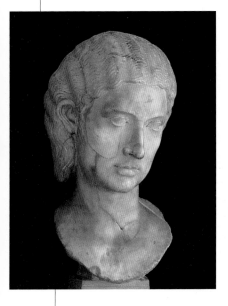

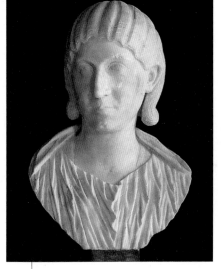

Until marriage, Roman girls wore their hair simply, divided in a part down the middle and gathered in a pony tail or braids, often with bangs on the forehead.

During the imperial age, the emperors' wives and ranking matrons dictated the hairstyle to be worn, and the style was then spread primarily by way of the portraits of empresses on coins, which were carried to every corner of the empire.

▲ Portraits from the Severan age, Musei Capitolini, Rome.

Etruscilla also appears on coins with this characteristic "helmet" hairstyle composed of a very thick and flat arrangement pulled back to the top of the head.

The diadem makes certain the identification of this woman as an empress, probably the wife of Decius, who spent much of his short reign (249–51) battling the Carpathians and Goths. He was a proud supporter of Roman traditions, believing that only respect for those traditions could safeguard Romans from danger.

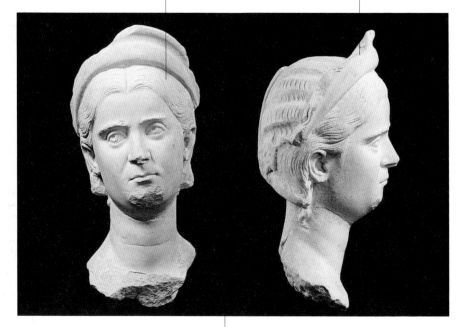

Decius issued an edict ordering all of Roman society to pray to the gods to bring their favor to the fate of the empire, thus beginning the first, although short, great persecution of the Christians since he ruled that anyone who refused to sacrifice to the gods should be severely punished.

▲ Portrait of Etruscilla, from the Via Appia Nuova, mid-3rd century, Palazzo Massimo, Rome.

"The deceit of men and cunning profiteering led to the invention of the quack laboratories, in which each customer is promised a new lease on his life, at a price" (Pliny the Elder)

Medicine

For many centuries in Rome, medicine fell within the sphere of the magical-religious, and the treatments employed, all of them useless, were the prerogative of the *paterfamilias*. Only after the conquest of the Greek provinces did actual doctors arrive in the capital, but their knowledge did not bring an end to the magical-religious healing practices. For a long time Rome's central government showed no concern for public health, and only in the imperial age were efforts made to slowly organize a sort of health service that saw to the needs of the less wealthy classes, those who could not count on private treatments, not even on the charitable associations that came into being with Christianity.

The first public doctors in Rome did not appear before the 4th century, when a figure similar to today's general practitioner was instituted. Fourteen chief physicians, one for each city district, treated the less well-to-do classes at no charge, provided certificates of illness, made reports in case of fatal accidents, gave the authorization for burials, and were mobilized in response to epidemics or catastrophes. The candidates had to take a sort of exam, judged by a commission composed of the college of serving chief physicians, and once accepted they received a fixed salary and enjoyed certain privileges.

Related entries
Aesculapius, Ex-voto,
Folklore and magic

▼ Trajan's column, detail with scene of treating wounded soldiers.

Relief in gilt terracotta depicting a scene of childbirth with the use of a midwife's stool as prescribed by Soranus, a Greek physician probably born at Ephesus, who lived during the reigns of Trajan and Hadrian and wrote several treatises. Several of his works have survived, including a treatise on diseases of women that remained an influential work until the 16th century.

The profession of midwife (obstetrix) was practiced almost exclusively by women, and doctors were consulted during childbirth only in the case of unforeseen complications. Midwives could be called on in divorce cases to establish the term of a pregnancy.

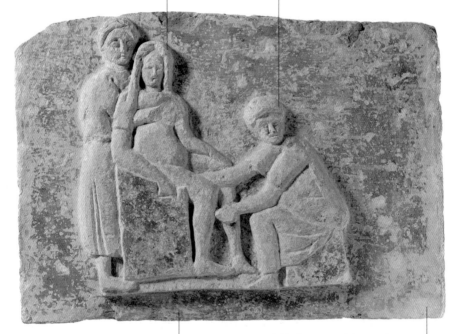

Aside from general doctors there were also specialists, such as surgeons who treated external wounds and eye doctors. Information is not always available on the treatments they administered, but in some cases the ancient sources have handed down invaluable notations.

▲ Funerary slab of Scribonia Attice, from the necropolis of Porto, ca. 140, Museo Ostiense, Ostia Antica.

In the eighth book of his treatise on medicine, Celsus, an erudite of the 1st century, explains with great precision and thoroughness how to cure the eyes with washes and medicines and also how to perform surgery on the lens.

Rome got its first reputable schools of medicine only with the arrival of Galen, according to whom the proper education of a doctor required at least two years of the study of logic and philosophy followed by another four of anatomy and physiology. In 200 Septimius Severus instituted a sort of state examination required for the exercise of the profession.

Roman emperors had personal physicians who held the title of "doctor to the house of Augustus." The most famous of these was Galen, who was born in Pergamum and became the personal physician to Marcus Aurelius. He was a skilled preparer of medicines, for which he used plant extracts; he sold them from his laboratory on the Via Sacra.

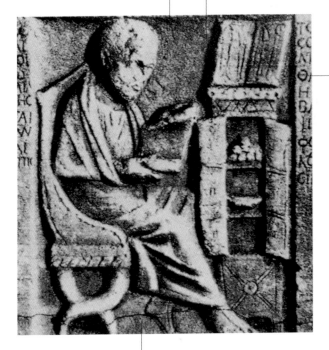

There was no state control in Rome over the preparation of medicines until the 3rd century, nor was there any oversight on the proper practice of medicine.

Aside from being unable to afford the care of doctors, members of Rome's lower classes were often unable to follow the most elementary measures of prevention and either fell into the hands of quacks or were left to hope for divine intervention.

▲ Reader with scroll, detail from a sarcophagus with the figure of a doctor-philosopher, Museo Ostiense, Ostia Antica.

"Above all else we must take care that a child who is not yet old enough to love learning should not come to hate it . . . Let his lessons be fun, let him volunteer answers" (Quintilian)

School and teaching

Related entries
Virgil and Maecenas,
Imperial Fora

The first teachers, most of them slaves from the recently conquered Greece, appeared in Rome in the homes of prosperous families in the 3rd century BC; Rome's first public schools opened a little later. Here the *grammaticus* taught young Romans the works of the principal Latin authors and, most of all, the laws of the Twelve Tables, which the youths had to learn by heart as the cornerstone of their morals, their civic virtue, and their love of country. Older boys took lessons from a *rhetor* to learn the theory and practice of eloquence. The sons of the most wealthy families rounded out their educations with a visit to Greece. This final step in the instruction of young Romans usually involved study at some famous school of philosophy or rhetoric, such as that of Athens or Rhodes, and was the equivalent of a university education.

There was a public school in Rome under the portico of the Basilica Argentarius in the Forum Julium. Still visible on the rear wall of this school are graffiti dating to the 2nd century that offer a glimpse of the curriculum followed: Latin and Greek alphabets, an exercise in writing Greek, an exercise in declensions, and numerous notes on Virgil—the opening verses of the first book of the *Aeneid* appear seven times. Other schools were probably located in the Forum Augustum and in that of Trajan.

▼ Small abacus, Museo Nazionale Romano, Rome.

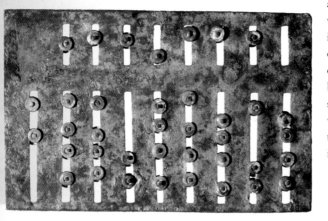

The deceased is surrounded by materials related to reading and writing; the box to his right probably held books.

The object should probably be considered a sort of desk set that would have contained a stylus and whatever else was necessary for the performance of what had been the activity of the deceased.

Among the projects Julius Caesar did not live to accomplish was the creation of a Greek and Latin library that was to be supervised by Varro.

At the lower left of the figure is a container for papyrus scrolls, above which is visible a closed scroll.

An open volume rests on the floor, with another two to the right of the deceased, who holds a codex open in his lap.

▲ Arcosolium from the hypogeum of Trebius Justus, 4th century.

In the choice of texts that the students had to copy and memorize, preference was given collections of moral sayings. These would provide the young men with a store of pithy knowledge that would be useful to them throughout their lives.

The small student is depicted in the act of writing with a stylus on a tablet.

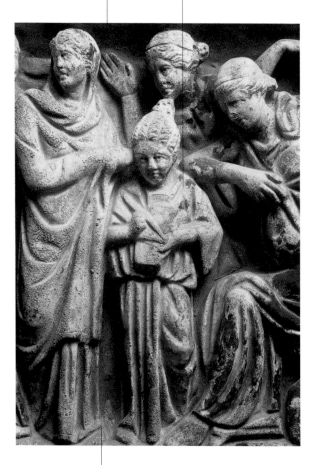

▲ Detail of sarcophagus, 3rd century, Museo Nazionale Romano, Rome.

Tutors were a luxury that only wealthy families could afford, while the lower classes made use of the public schools (but not state schools) that had probably been providing elementary instruction in Rome as early as the 4th century BC.

The upper school in the Forum of Trajan remained active until at least the end of the 4th century, an indication of the intellectual vitality in the city during a period when the empire was in decline. The vicinity of the two libraries made the Forum Augustum and that of Trajan special sites in the cultural life of Rome.

Teachers did not earn much. A good indication is the edict on prices that Diocletian issued in 301, which established that an elementary teacher could earn 50 denarii per student per month; at that rate, the teacher would need to have a class with 30 students to earn the salary of an artisan.

Teachers in middle and upper schools were better treated. Diocletian established salaries that ranged from 200 to 250 denarii per student.

▲ Sarcophagus with school scene, Museo Ostiense, Ostia Antica.

The Roman mentality was against the remuneration of appointed posts, but Augustus saw that paying teachers a salary would give dignity to a position that, although essential to the formation of future citizens, was at the bottom of the social ladder. He thus entrusted the education of his children to Marcus Verrius Flaccus, a freedman known for his teaching skills, and paid him a high salary.

"Mansions once known for the cultivation of liberal studies reecho with the sound of singing. You find a singer instead of a philosopher; a teacher of arts in place of an orator" (Ammianus Marcellinus)

Music and dance

Related entries
Muses, Theater

▼ Cylindrical base with dancers, Augustan age, Palazzo Altemps, Rome.

For many centuries in the Roman world music and dance were tied exclusively to important public and private events, such as solemn ceremonies or funerals, and only in the 2nd century BC, with the spread of Greek culture, did music become a separate form of art. It soon became customary to have musicians and dancers at banquets and private feasts, and two new performance genres came into being, based on the skills of soloist actors, the mime and the pantomime. Dance was primarily a female art, and we know that Syrian women excelled in the art of dancing to the music of an instrument very similar to a harp, while the girls of Kos, wrapped in the fine fabric produced on their island, performed a kind of veil dance, and the Spanish dancers performed to the music of the *crotalum*, a kind of ancestor of castanets.

Many actors and musicians became famous, true divas of the ancient world. There was also a great number of traveling artists who performed in the streets and squares for a public of common people that repaid their efforts with modest bronze coins at the end of the performance. There were also numerous members of the nobility who delighted in playing the lyre or the aulos and took part in competitions and contests, much as Nero loved to do.

Among the many numerous figures that crowd the scene on the great sarcophagus is this horn player, who grasps the crossbar with his left hand. The instrument was used primarily by armies in battle, but also made its appearance during religious ceremonies and funerals.

The cornu *was a wind instrument made of bronze and shaped like a curved trumpet; it was characterized by the presence of a crossbar that served to rest the instrument on the shoulders to make its use more comfortable.*

In the Roman world many events in the community life were accompanied by singing and the playing of musical instruments, most especially wind instruments, unlike the situation in the Greek world, where the predominant musical instrument was the lyre.

▲ The "Grande Ludovisi" sarcophagus, from the Vigna Bernusconi near Porta Tiburtina, mid-3rd century, Palazzo Altemps, Rome.

Similar to the horn was the bucina, *which differed by being made of animal horn instead of metal. First used by armies only to signal orders inside encampments, it was later also used in battle.*

Twice a year, on the occasions of the festivals in honor of Mars (March 23) and Vulcan (May 23), the tubas were purified (lustratio).

The long straight trumpets taken from the temple of Jerusalem were called tubas. Wind instruments with a long metal tube as much as a meter in length, they had a separate conical mouthpiece made of horn or bronze.

The tuba gave a sharp sound believed to inspire fear and was used in battle to signal attack or retreat. Tuba players were also used during the performance of triumphal parades and religious ceremonies.

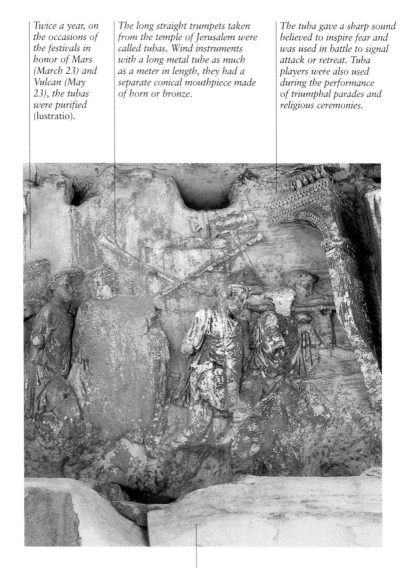

▲ Arch of Titus, detail.

Ancient sources relate that the tuba players in each legion formed an association that distinguished them from the rest of the soldiers, even if, as seems likely—as indicated on the Column of Trajan—they wore the same uniform as the other legionaries.

The cithara had a wooden sound box with two arms united at the ends by a horizontal crossbar; strung between the sound box and the crossbar were a variable number of strings made of gut or hemp.

The first concert of Greek music was offered in Rome in 167 BC by the praetor Lucius Anicius on the occasion of his victory over the Illyrians.

The strings were held raised by a bridge and were fixed to the crossbar with rolled leather straps that also served to tighten or loosen the strings to tune the instrument. The number of strings varied—up to eighteen in the latest examples— but the standard type of cithara had seven strings.

One played the cithara either seated or standing, with the instrument held against the body at a slightly inclined angle. The strings could be plucked with the plectrum, but true masters used only their fingers. The left hand probably held still the strings that were not supposed to sound, and the vibrations could be damped to achieve special effects.

▲ Apollo Citharoedus, Roman copy of a Greek original from the mid-2nd century BC, Musei Capitolini, Rome.

The lyre was a very similar instrument to the cithara, from which it differed by having its sound box in the form of a turtle shell—a real shell in the most ancient times—over which was stretched an ox hide in imitation of the first lyre invented by Hermes.

Music was first greeted in Rome with a certain degree of suspicion, but with the passage of time it came to occupy an increasingly large space. The first Christian songs appeared between the 1st and the 2nd century, and although these first revealed the strong influence of Greek and Roman music, they soon acquired an autonomous form.

The tibia—which corresponded to the Greek aulos—was a double flute, the length of which varied according to the number of finger holes. The examples with four holes, about 15 centimeters long, had an extension of a single octave, but the invention of metallic or ivory rings similar to the keys of the modern clarinet brought the dimensions of the tibia to 60 centimeters.

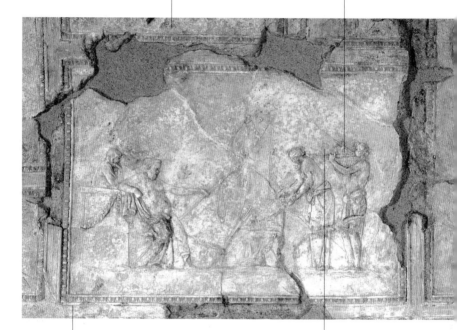

The artisans that made tibias used different woods and materials according to how the instrument would be used: boxwood, for example, was preferred in the production of tibias for use during religious ceremonies, while for spectacles the choice fell on lotus wood, or also on donkey bone or silver.

If the two reeds of the tibia were of the same size, the tibia was called Phoenician; if they were of different lengths, with the holes arranged asymmetrically, the tibia was instead Phrygian.

▲ Relief in stucco, from the Villa Farnesina, ca. 19 BC, Palazzo Massimo, Rome.

Very popular in Rome were mime and pantomime, shows in which actors performed scenes with explanations provided by songs accompanied by a flutist or by gestures and dance.

The custom of having musicians and dancers enliven banquets dates to the 2nd century BC. Particularly popular were veil dances in which girls covered only by the thin, fluttering fabric of Kos swayed to the sound of crotals and cymbals.

Wearing a clinging dress of a soft material closed by a belt under her bare breasts, this dancing girl must originally have held an object, although all that remains visible is the large support. It was probably a musical instrument of a type that no longer can be identified, and while playing it she danced to its music.

The support in the form of a knotty trunk reveals that the original prototype for this sculpture must have been a bronze probably of the Hellenistic age; in the passage from bronze to marble it was necessary to provide a support to handle the far greater weight of the marble version.

▲ Dancer of Tivoli, from Hadrian's Villa, Hadrianic age, Palazzo Massimo, Rome.

"An innkeeper, a butcher, a nice bath, a barber, dice and a gaming board, a few books . . . give me these, Rufus, and you can keep Nero's baths for yourself" (Martial)

Toys and games

To distract and amuse infants, the ancient Romans used small trinkets dangling from a necklace along with a variety of rattles, including a small hoop with attached rings. Babies were given clay bottles, most often in the shape of animals, with a tiny hole through which to suck. As soon as children were walking, their amusements became contests of strength or agility and imitations of the adult world: they built miniature houses and animated them with dolls and figures of animals or tied mice to tiny carts or had themselves pulled about in carts drawn by goats or by other children. Games using tops were quite popular, as were hoops and amusements that highly resembled the gambling of adults, such as mora, odds and evens, heads or tails, and knucklebones.

▼ Detail of a fresco with children playing ball, from the columbarium of the Via Portuense, Museo Nazionale Romano, Rome.

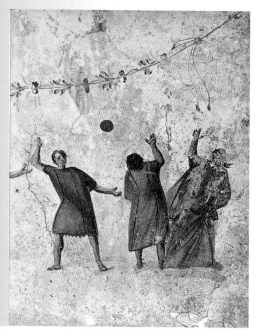

Roman adults were so fond of games that even emperors—notably Claudius—dedicated themselves whole-heartedly, often betting enormous sums, most of all on dice and even though playing at dice was officially illegal except during Saturnalia. Another game much loved by the Romans was a sort of "war game" similar to chess played on a board with sixty squares using rows of counters of different value; the goal was to block or capture your adversary's pawns. There was also a kind of backgammon, which became quite popular in the early 1st century, most of all among the wealthier class.

The game of the twelve lines had thirty-six squares arranged on three parallel lines divided by ornamental elements. Often the squares were composed of six words of six letters each that, together, formed a complete phrase, such as victori palma victus surgat ludere nescit ("to the victor the victory, the defeated, who doesn't know how to play, stands up").

The rows of repeated letters inscribed on the boards or tabletops on which the game was played probably served the purpose of helping beginners understand the direction in which the game was to be played; the counters were supposed to follow the route A–B–C–D–E.

Dice were usually made of bone or ivory and had six faces, very similar to those we use today. They were used in a variety of table games; they were cast, three at a time, using a dice-cup called a fritilla, in the hope of coming up with a different face on each die, the combination considered best by the Romans.

▲ Fragment of slab with *tabula lusoria* and gaming dice, Museo Ostiense, Ostia Antica.

This doll was found in the tomb of a young bride who died at the age of twenty around 170. The doll was probably a memory of childhood that she brought with her to her new role as wife. The doll is quite well made and has movable joints.

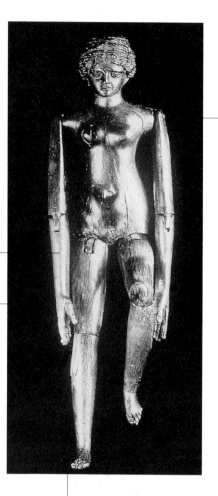

Alongside dolls in terracotta, bone, or ivory, there must have been those made in less costly and more perishable materials, most of all cloth. Such toys were always in the form of young women, for which reason it is believed that the primary game was that of identifying with the mother or imagining one's life as a married woman.

Ball games were also quite popular in Rome. The balls used were filled with pressed feathers, horsehair, or even sand; small children and the elderly played with a light ball inflated with air.

▲ Doll of ivory, from the tomb of Crepereia Tryphaena, ca. 150–160, Musei Capitolini, Rome.

The games played by children included many using walnuts, which could be kept in a sack. Walnuts could be thrown at a target, tossed into a basket, or used to play odds and evens. To the poet Martial, giving up playing with walnuts signified the sad end of the Saturnalia holiday: "Now the schoolboy puts away his walnuts and is ordered back to school by his bullying teacher."

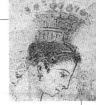

"Distinguished men of our state used to say that when gazing at the masks of their ancestors their heart was aroused most ardently toward virtue" (Sallust)

Portraits

The custom of funerary masks, along with the clear influence of Greek portraiture, was of great importance in the formation of the Roman portrait, an artistic genre marked by stark realism. During the late republican period, the faces of figures were described analytically, emphasizing any imperfection or characteristic trait, such as baldness, wrinkles, or big ears. Even so, the artists hired by Roman patrons tended to be Greek, with the result being a mediation between the art of the sculptor and the requests of the patrons, as is visible in certain sculptural works in which a realistic Roman portrait is superimposed on an athletic body drawn from the tradition of Polyclitus. During the last years of the republican period the dependence on Hellenistic models became increasingly evident in the public portraits of leading individuals. The portrait of Pompey, for example, shows nothing of the "verism" of the private portraits from the Sulla period, and instead recalls the dynastic images of Hellenistic rulers. During the imperial age the difference between the realistic portraits made for private use and the official portraits of the imperial family and, in general, of public figures became even greater. The fundamental element in the effigies of the emperors was a classical formal language that served to transmit a message more than a representation of an actual person.

Related entries
Ancestors

▼ Male portrait from Palestrina, 75–50 BC, Palazzo Massimo, Rome.

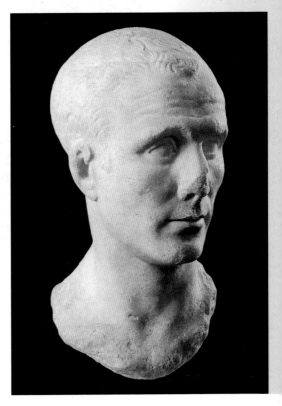

The oldest surviving indications of the style of dressing the hair with a front knot is a portrait of Octavia, sister of Augustus, on an aureus struck between 40 and 30 BC. The same style was later adopted by Livia, who appears with it in most of her official portraits.

The hair is dressed very simply in a style that did not require the assistance of an ornatrix (slave acting as hairdresser): the hair is smoothed and pulled back to be tied in a series of small braids joined at the back of the head in a bun, while the upper forehead is decorated with a knot of hair folded back to form a small pad (nodus).

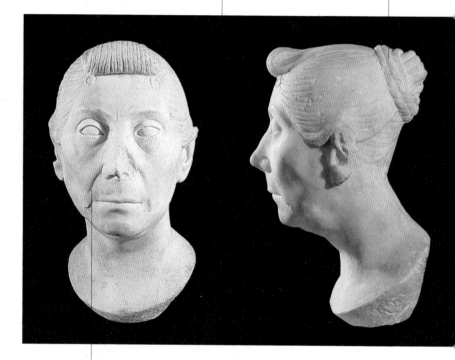

The deep wrinkles at the sides of the nose and around the mouth, together with the hair, which seems to be thinning, indicate that this is a woman of mature age.

▲ Portrait of an elderly woman, from Palombara Sabina, last quarter of the 1st century BC, Palazzo Massimo, Rome.

In some cases, such as the wife of Quintus Volusius Saturninus, we know of the existence of maidservants whose exclusive role was that of taking care of mirrors, keeping them ready and shiny for every need of the matron.

Along with the ornatrices *in the service of rich women, there were also beauticians who worked for women who could not afford a specialized slave. The* ornatix *had to have done at least two months of training in a recognized workshop.*

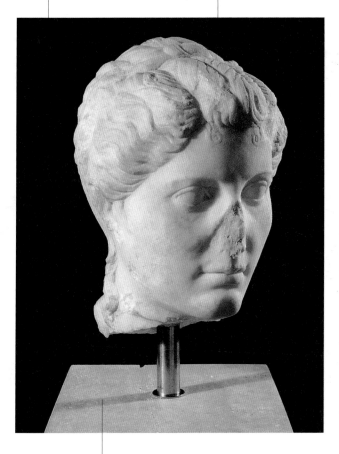

▲ Portrait of a young woman, from Formia, end 1st century BC, Palazzo Massimo, Rome.

All the ranking Roman matrons had an ornatrix, *a maidservant who occupied herself only with her matron's beauty, working as hairdresser and beautician. Along with the* ornatrix *there were the* cinerarii, *slaves trained in the use of the* calamistrum, *an instrument indispensable to curling hair.*

On the left is the figure of an older man with a full beard and hair dressed in small locks combed forward following a style typical of the Flavian age. He directs his gaze at the woman beside him, probably his wife.

This woman, of advanced age, has a hairstyle composed of a tower of curls rendered in the stone through the use of a drill, another style typical of the Flavian age, as seen in a portrait of Julia, daughter of the emperor Titus (page 27).

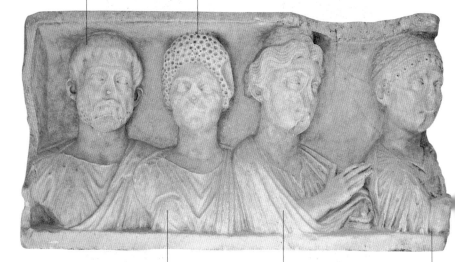

The women in the relief are dressed in chitons and mantles, while the man wears a tunic and a toga over his left shoulder. The attitudes of the figures in the relief indicate kinship ties, while the differing hairstyles reflect the differences in their ages.

The woman to the right in the composition is probably closely related to the woman behind her, who rests a hand on her shoulder; she was probably united in the typical matrimonial gesture of the dextrarum iunctio with the figure of a man that has been lost.

The hairstyle of the third figure is completely different; the hair is parted down the middle to fall softly around her face; small locks have been joined to form a bun on the top of her head. Similar hairstyles have been seen in portraits of Faustina Maggiore, wife of Antoninus Pius.

▲ Funerary relief, mid-2nd century, Palazzo Altemps, Rome.

The head has been assembled from several fragments, and part of the nose and part of the bust, including the shoulders, are the result of restoration work.

The statue portrays a somewhat young man with short, curly hair and a beard; his lips are fleshy, and he has heavy-lidded eyes.

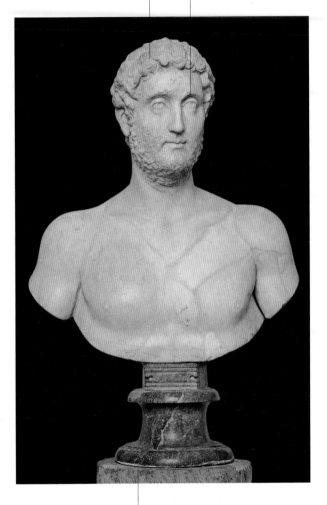

▲ Bearded portrait, ca. 200–30, Palazzo Altemps, Rome.

The dating of this portrait is the subject of debate. Although certain traits of the face recall portraits of Marcus Aurelius, closer analysis of the work indicates that it was made in the opening decades of the 3rd century.

During the 1st century the emperors combed their hair very simply, dedicating most of their attention to the formation of bangs along their foreheads.

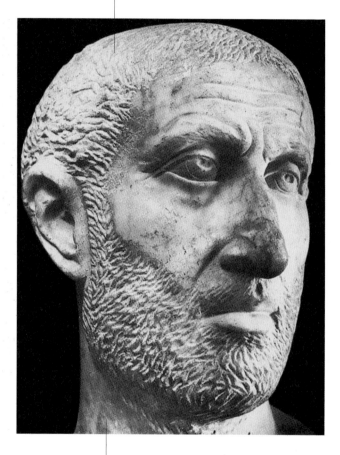

▲Male portrait, 3rd century, Musei Capitolini Rome.

The first time a young Roman male shaved was the occasion for a sort of religious rite for his entire family, with the hair consecrated to the gods.

Men paid close attention to their hair, curling it and making abundant use of hairpieces, most of all to disguise baldness, which was frowned upon as an unacceptable defect.

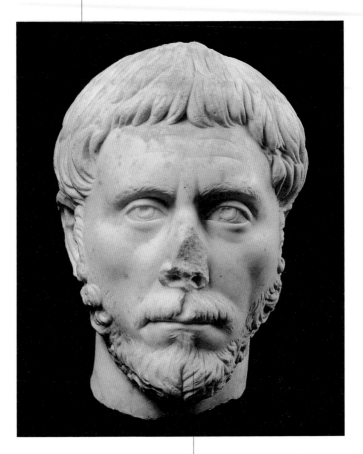

▲ Male portrait, from Ostia, ca. 250– 70, Palazzo Massimo, Rome.

Aside from introducing the custom of the short beard, which was a characteristic of Roman men until Constantine, Hadrian radically changed the style of men's hair, distributing his hair uniformly over his head, perhaps to cover his many scars.

"Whoever catches an adulterer with his mistress in the act, provided that he kills both, may go free. A son too may punish adultery on the part of his mother" (Seneca the Elder)

Marriage

▼ Funerary stele with married couple, 1st century BC, Musei Capitolini, Rome.

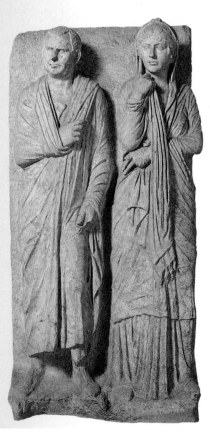

The bond of marriage recognized by the laws of the Twelve Tables, the matrimony *cum manu*, established that the woman entered the authority of her husband and the patrimonial regime of his family, much like a daughter. Her dowry and possessions became the property of her husband, and divorce, permitted only in the most serious cases, was extremely rare. A radical change took place during the late republican period with the rise of the matrimonial rite *sine manu*, which later became the classical Roman marriage and which established the legal independence and autonomy of the woman that today appear very modern. The bride remained under paternal authority and under the patrimonial regime of her family of origin, and on the death of her father became legally independent and could inherit, which was not infrequently the case among the daughters of rich families, who came into possession of large patrimonies. Roman law prohibited gifts between husbands and wives, and from the early imperial age wives were no longer obligated to furnish a permanent guarantee for the debts of their husbands. In that way the patrimonial regimes of married couples were far more similar to our modern concept of the separation of possessions than to that of traditional matrimony in which the family was recognized as a single financial entity concentrated in the hands of the male head of the family.

Between the two spouses is the symbolic figure of Concordia, while to the left of the man is the Genius Senatus; both allegories make a clear reference to the senatorial rank to which Flavius Arabianus—who must have been a knight to become a prefect of the Annona—had been raised on the basis of his merits.

The owner of the great sarcophagus had been prefect of the Annona, as can be deduced from the complex decoration of the monument. It is possible to identify the figure as Flavius Arabianus, who oversaw the office of the Annona under Aurelian, increasing, on the orders of the emperor, the ration of bread distributed to the urban plebeians by one ounce.

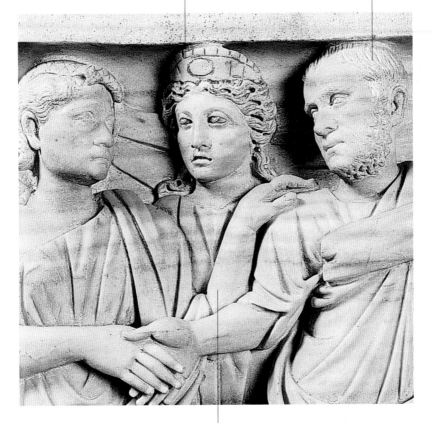

The woman places her right hand in that of her husband while resting her left hand on his shoulder in the typical gesture indicating the bond of marriage.

▲ Sarcophagus of a prefect of the Annona, detail, from the Via Latina, ca. 270–75, Palazzo Massimo, Rome.

The wedding ceremony was followed by a banquet. Toward evening the bride was taken to her husband's home, where he simulated a rape by pretending to tear the girl from the arms of her mother.

On her head the young bride wore a series of six pads of artificial hair separated by narrow bands, and over this a veil of flaming orange—thus called the flammeum—that hid the upper part of her face. Atop the veil was placed a wreath woven of marjoram and verbena in the time of Caesar and Augustus and later of myrtle and orange blossoms.

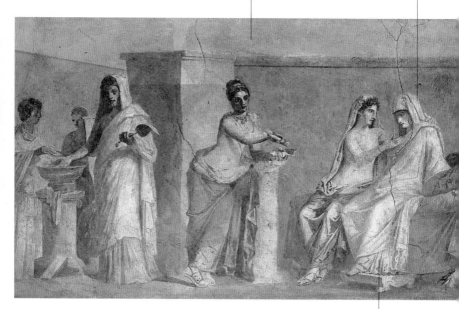

The bride wore a costume with precise characteristics: a white tunic without colored border secured at the waist by a double-knotted wool belt, and a saffron-colored mantle; on her feet she wore sandals of the same color.

▲ The "Aldobrandini Wedding," fresco from a house on the Esquiline, Augustan age, Musei Vaticani, Rome.

The day of the wedding the bride was washed, perfumed, dressed, and adorned. A sacrifice was performed to take the auspices for the marriage, after which the marriage contract was signed in the presence of witnesses. Finally the matron assisting the bride took the right hand of the bride and that of the groom and joined them.

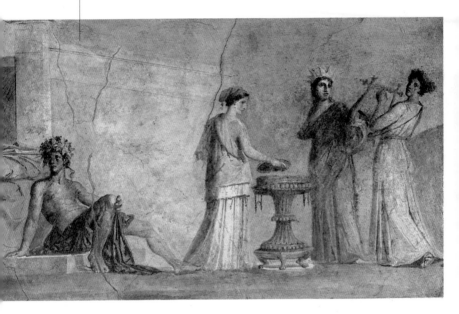

The veiled female figure on the left shakes hands with her groom in the binding gesture of the *dextrarum iunctio* while drying tears with the edge of her mantle. The woman's attitude seems to be that of a mourner bidding farewell to her husband.

The pair of holes immediately under the upper frame of the sarcophagus probably served for the insertion of brackets to fasten the cover.

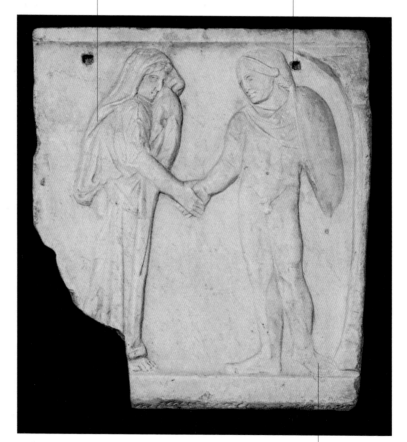

The man, presented in heroic nudity and armed with helmet and shield, seems to look on his wife sadly for the last time.

▲ Fragment of sarcophagus, Palazzo Altemps, Rome.

"Before dawn bakers disturb you, and the whole day the hammers of coppersmiths jar your nerves. Over here the moneychanger idly jangles Neronian coins on his filthy table" (Martial)

Arts and crafts

During the Roman age, literature and philosophy were held in high esteem and were nearly always practiced by members of the upper class, but the visual arts and artisan crafts were looked upon as manual labors and thus occupations unsuitable for the upper class. Roman art has the traits of an anonymous group activity in which the name of the patron had greater importance than that of the artist.

All workers—artisans, artists, professionals—could form associations or colleges, controlled by the state and divided into categories with the principal aim of ensuring the members a respectable funeral, achieved through a form of obligatory saving. With the passage of time, however, these associations, although they could never act as unions since they had no contractual power, began to concern themselves with other aspects of the lives of their members, organizing recreational activities and entertainment. Aside from operational expenses and the creation and maintenance of funeral monuments, the dues paid by members could be used to provide a small pension to surviving family members. The associations of artisans soon became powerful organizations that, in some situations, were considered possible sources of sedition and revolt, such that the central power sought to prevent their formation.

Related entries
Funeral, Columbarium

▼ Section of sarcophagus cover, 3rd century, Palazzo Rondanini, Rome.

The marble worker wears a dalmatic, a wide-sleeved kind of tunic originally from Dalmatia that became a popular article of clothing among all Rome's social classes. Diocletian's edict on prices, issued in 301, makes reference to dalmatics, describing the varieties of cloth they can be made from and their decoration.

The Romans were interested in works of art, but almost never in the personalities of artists. Emblematic of this is the fact that where the names of specific painters and sculptors are known it is almost always in relation to a curious anecdote, not to their talents.

The custom of decorating luxurious rooms with inlays of colored marble, following a technique known as opus sectile, began in the 4th century, although the earliest examples at Rome date to the period of Claudius. The technique was probably invented in Egypt, and it seems that panels made in Egyptian workshops were sometimes shipped off to Rome.

The artisan is depicted busily at work, perhaps in his shop, making inlaid decoration in a large slab of marble resting on sawhorses.

Pliny the Elder relates an amusing anecdote about two sculptors, Batrachus ("Frog") and Sauras ("Lizard"), who built temples at their own expense because they hoped to be honored by an inscription; when this was refused, they attained their object by putting carvings of a lizard and a frog on the molded bases of the columns.

▲ Slab depicting a marmorarius, second half 4th century, Museo delle Terme, Rome.

Aside from kitchen knives, the cabinet of Cornelius Atimetus holds other iron tools, such as small scythes and pruning knives.

Pliny the Younger to Trajan: "A desolating fire broke out in Nicomedia . . . it spread owing to the wind, the laziness of the citizens . . . [and because] there was not a single public fire engine or bucket . . . I would have you consider whether a fire company of about 150 men ought not to be formed. I will take care that no one not a genuine fireman shall be admitted and that the guild should not misapply its charter."

The scene depicts the deceased— L. Cornelius Atimetus—in his shop beside a cabinet that contains an orderly row of iron knives and other tools used in the kitchen for the preparation of food.

The associations of craftsmen, considered possible sources of uprisings and sedition, were common in northern and central Italy, Gallia Narbonensis, and the Danube provinces, but were rare in Spain and Britain and were completely unknown in the restless eastern regions.

▲ Relief depicting a cutler, second half 1st century, Musei Vaticani, Rome.

A pair of bricklayers busy at work on both sides of a wall, spreading mortar with trowels.

The scaffolding is supported atop a series of poles inserted in holes left in the wall; such holes are today visible in ancient structures but were originally hidden beneath a decorative dressing applied to the surface.

The scaffolding on which the bricklayer stands is very similar to those used in modern worksites with the difference that it is not a self-supporting structure but needs—at least for the upper part— to be secured to the wall.

The worker below uses a hoe to work the mortar that will then be poured in the pails that two of his companions load on their shoulders and carry to the scaffolding.

▲ Hypogeum of Trebius Justus, detail with bricklayers at work, 4th century.

The image of Rome's common people handed down by Roman authors is that of a mass of sluggards constantly playing games or filling seats at the amphitheater, theater, and circus. This malevolent vision is clearly a result of the disdain with which the upper classes treated the more humble members of the population.

In reality Rome's plebeians, the hundreds of thousands of free citizens without wealth, made ends meet through activity in a variety of activities, most of all in construction, small businesses, and in jobs serving the upper classes.

The tunic was the basic article of clothing for the Roman people. All Romans wore one, but only for the common people was it the single garment; others wore it as a kind of "underclothes." The images we have of artisans, merchants, and farmers portray men dressed only in a tunic.

▲ Slab of relief with workshop of shoemaker and rope-maker, Museo Nazionale Romano, Rome.

According to Isidore of Seville, Juno, near whose temple on the Capitol stood the mint, "is called Moneta because she warns not to alter the alloy and the weight of the metal."

Mint and bank

Related entries
Cursus honorum,
Treasury and archives

▼ Idealized reconstruction of scene of engraving coins, based on a design by Guido Veroi, Palazzo Massimo, Galleria dei Banchieri degli Zecchieri, Rome.

Throughout the republican period, the mint and the treasury, the place where the spoils of war were stored, were on the Capitol, near the Temple of Juno Moneta. Following a devastating fire in 80, Domitian relocated the entire activity to a new structure on the slopes of the Caelian Hill, beneath today's church of S. Clemente, in an area that had been the scene of intense building activity for several years.

The activity of Rome's first money-changing banks dates back to the end of the 4th century BC. These were set up in shops that faced onto the square of the forum. The *argentarii*—this was their name, from a word meaning "silver"—originally did nothing more than change money and check the weight and the alloy of coins, but they soon began to take part in auction sales and to loan sums of money to clients, also overseeing the writing of contracts on special registers. The roles performed by banking personnel multiplied, and soon the debt collector appeared along with the *nummularii*, responsible only for money exchanges and checking coins; they operated for the

most part in ports or near shrines, where they were more likely to encounter foreigners. With the beginning of the imperial age the *argentarii* opened shops in various parts of the city, wherever commercial activities were carried on. One of them, a certain Calixtus, slave of an imperial freedman, worked at the end of the 2nd century near a public pool in a far corner of the city. He became pope in 217.

The less well off argentarii *performed their work in the open, on mobile counters with room for a desk and enough money for a day, while those more well off rented shops from the state.*

The nummularii *used empirical means to check the metal of coins and their authenticity and exchanged money, while* argentarii *were more like today's bankers. The contracts of deposit established that the money returned would be exactly that deposited, and only in some cases was one permitted to render coins that were only identical to those deposited.*

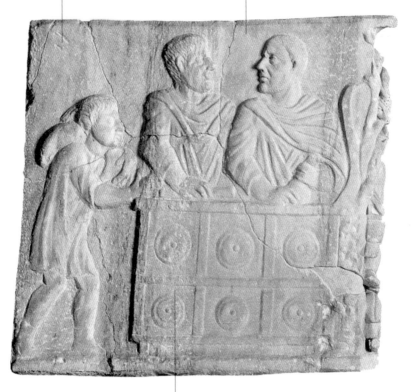

▲ Side of a sarcophagus, mid-3rd century, Palazzo Massimo, Rome.

The counter on which the money-changers work is somewhat high, closed on three sides, with the front reinforced with listels and metal bosses. Perhaps these served to make the counter more secure, transforming it into a kind of safe, although it is easy to imagine that most of their capital must have been kept in a more protected locale.

"The rich man will be carried above the heads of the crowd by his tall Ligurian litter bearers. . . . Inside the litter he will read or write or sleep, for a litter with the windows closed induces sleep" (Juvenal)

Traffic and means of transport

Related entries
Fleet, City streets, Ports, Consular routes and roads outside the city, Ostia

Rome's traffic was impossibly chaotic and congested as early as the end of the republican period: too many vehicles, too many buildings crammed into one space, and too many of the city's streets in serious need of repair. Despite the efforts of the aediles, many streets were unpaved and too narrow to permit the easy passage of vehicles. A law enacted by Caesar in 45 BC regulated the circulation of vehicles in the city, prohibiting carts during the day except for those transporting construction materials for public works, the carts of the Vestals and other priestly categories on the occasion of ceremonies, the chariots of triumphant generals, and those used in public games; also permitted were carts that had entered the city during the night and those hauling garbage. Areas for authorized parking spread immediately outside the city's gates, where it was also possible to find public coaches for trips outside the city. Despite the effort to limit the city's traffic, the situation seems to have remained unbearable, or so it would seem from the many laments from Roman poets, who complained of being kept awake at night by the din of carts in the streets, the curses of the drivers, the bleating from herds of animals.

There was also much traffic in the Tiber, used by a veritable fleet of ferries, barges, and transports, including boats hauled upstream by men and animals, all of them bearing goods and foodstuffs from the seaport to the city's river docks.

▼ Detail of the mosaic of one of the offices (*statio* 46) in the Piazzale delle Corporazioni, 2nd century, Ostia.

A canopy sheltered the passenger from the sun and poor weather and curtains kept him hidden from the crowds. In some cases the coverings were made of animal hide.

The litter, whether privately owned or rented, was carried by six or eight slaves who had to be strong and well dressed.

A thin mattress was fitted across the framework of the bed.

The passenger could lean back against feather cushions held up by a wooden rest, its ends trimmed in metal.

The poles of the litter end in metal rings into which were inserted the cylindrical poles that were used to lift and carry the litter; these poles were fixed to the shoulder of the bearer by leather straps.

▲ Reconstruction of a litter (Castellani litter), Musei Capitolini, Rome.

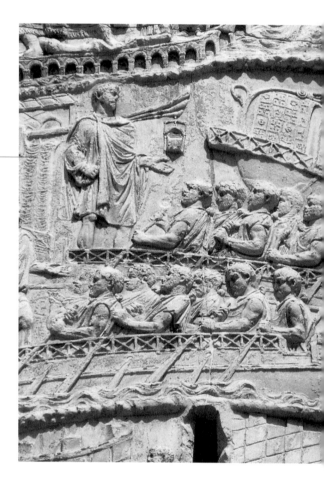

The reliefs on the column are unquestionably the result of a single overall design made by a single artist, and that person is conventionally called the Master of the Works of Trajan; this towering figure in the sphere of official Roman art is sometimes identified with Apollodorus of Damascus.

▲ Section of Trajan's Column with scene of ships.

It is probable that even the Great Trajanic Frieze, parts of which are today on the Arch of Constantine, was designed by the same artist who designed the decorations of the column.

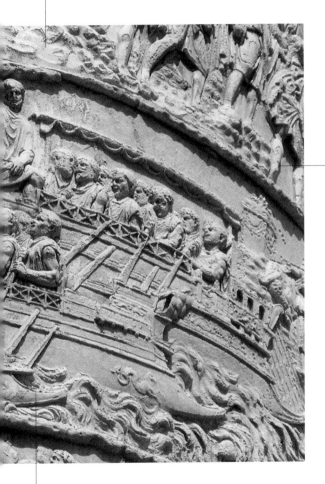

"The senate and people of Rome dedicate this to the emperor Caesar Nerva Trajan . . . pontifex maximus, in his seventeenth year in office as tribune, having been acclaimed six times as emperor, six times consul, pater patriae, *to demonstrate the great height of the hill that was removed for these great works"* (dedicatory inscription on the Trajan's Column).

The scene depicts the departure of Trajan's army from Ancona on its second expedition to Dacia in the spring of 105.

> *"Caesar reformed the calendar, which . . . had fallen into such disorder . . . that the harvest and vintage festivals no longer corresponded with the appropriate seasons"* (Suetonius)

Measuring time and the calendar

The Romans divided the day, no matter the season, into twelve parts, so that a day's hours varied from 45 minutes at the winter solstice to 75 minutes at the summer solstice; the night was also divided in twelve parts, put in groups of three to mark the watches. The weekly cycle, based on the recurrence of market days, was nine days, seven for work, one for the market day, and one for rest, during which one was not supposed to begin a new project but was permitted to complete one already begun, so one could tend a garden but not plant new trees. If one committed an error, it was possible to put things right by way of a purifying sacrifice; sacrificing a pig one could seed, harvest, and shear sheep. The Romans followed lunar months marked off by sacrifices performed on the Ides, the middle, and the Kalends, the end. To keep up with the solar year, a month was intercalated of 22 or 23 days in February. Even so, by the end of the republican period the official year was running three months shorter than the solar year. Thus Caesar, in 46 BC, acting as pontifex maximus, created an artificial year of 445 days and then adapted the Egyptian solar year to Roman needs. The Julian calendar, reformed by Pope Gregory XIII in 1582, is the one we still use today.

▼ Sarcophagus with season-cherubs, mid-2nd–3rd century, Palazzo Altemps, Rome

Auspicious days are marked on the calendar with the letter F (faustus).

The letters from A to H correspond to the passage of the week based on market days.

The letter K indicates the Kalends of every month, the first day in the lunar cycle.

The letter N (nefastus) indicates unfavorable days.

The Nonae correspond to the first quarter of the waxing moon.

Religious festivals are noted on the calendar, as are certain anniversaries, such as, for example, July 18, date of the defeat suffered by the Romans in 390 BC on the Allia River, in the Sabine territory, which resulted in the sack of Rome by the Gauls.

The Horologium Augusti, a giant sundial created for the emperor Augustus, stood in the Campus Martius. As its gnomon it used an obelisk set on the edge of a paved area "in a remarkable way, namely, to cast a shadow and thus mark the length of days and nights" (Pliny the Elder). Today the obelisk stands in Rome's Piazza Montecitorio.

The Ides are the day of the full moon.

The Horologium Augusti functioned for only about thirty years. Clocks in general met with little success in Rome, in part because synchronizing them proved so difficult. As Seneca said, it was "easier to get philosophers to agree among themselves than Rome's clocks."

▲ Graphic presentation of the Fasti Anziati, from Anzio, 84–55 BC, Palazzo Massimo, Rome.

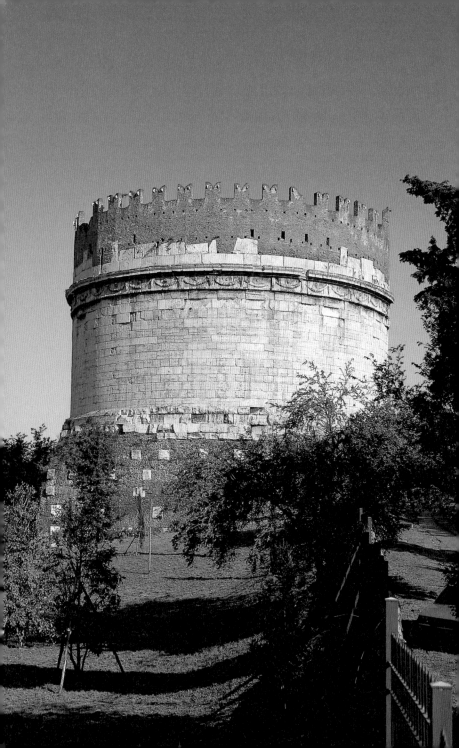

The world of the dead

◄ Mausoleum of Caecilia Metella.

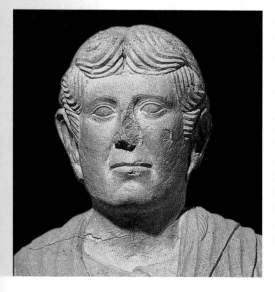

"The body of Poppaea was not cremated in the Roman fashion, but was stuffed with spices and embalmed in the manner of foreign potentates.... She was buried in the mausoleum of Augustus" (Tacitus)

Funeral

Related entries
Dress, Arts and crafts, Sarcophagi, urns, reliefs

▼ Funerary statue of a woman, end 1st century BC, Museo Archeologico, Aquileia.

The ceremonies that accompanied the dead on his final journey followed a codified ritual clearly described in ancient sources. The corpse, carefully cleaned, spread with aromatic substances, and dressed, was usually displayed in the atrium or vestibule of his home, with his feet toward the entrance; the body was surrounded by flowers and incense, which also served the purpose of mitigating the odors of decomposition.

Relatives and friends assembled for a long wake marked off by the laments of women, which often included hired mourners. At the end the wake, which could last as long as several days, the funeral procession took place. The route taken by the procession depended on the public or private character of the ceremony, but included a stop at the forum, where a relative of the deceased recited the funeral oration.

To transport the body to the burial site the less wealthy had to make do with simple grave diggers, but upperclass families could afford a far more elaborate retinue, including horn players and flutists, whose music blended and alternated with the wails of the hired mourners. Despite numerous attempts to keep down excesses, between the middle and late republic period Roman funerals became opulent and ostentatious, most of all in the case of public celebrations, such as the funeral ceremony organized by Pompey in honor of Sulla.

The Greek historian Polybius, who arrived in Rome among the 1,000 Greek notables sent as hostages after the battle of Pydna in 168 BC, left a detailed description of Roman funeral ceremonies and the rites that accompanied burial.

The scene of the farewell to the deceased is located between the two side pilaster strips with molded capitals that support the frame.

The bearded male figure is depicted reclining on the funeral bed, his chest bare and his body wrapped in a mantle; the horse in the background may indicate the social status of the deceased, but it is also a clear reference to the journey the man is about to begin toward the afterlife.

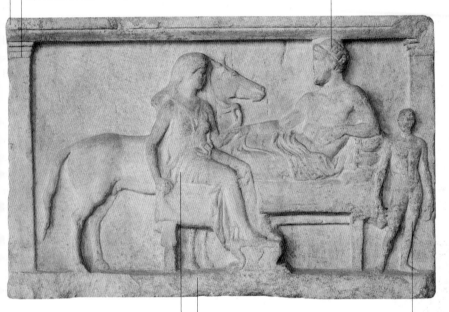

The seated female figure rests her feet on a low three-legged stool; she is dressed in a light chiton, and her head is covered by a veil that she holds in her left hand.

The reduced-scale figure to the right is a person of secondary importance to the scene, a cup-bearer holding a pitcher in his right hand and a patera in his left, indispensable objects for ritual libations.

▲ Relief with funeral banquet, early 4th century BC, Palazzo Altemps, Rome.

The marble relief follows the Greek style of funeral monuments, and the woman's hairstyle and the sculptor's way of handling drapery indicate that it is probably related to the products of Magna Graecia, most especially those from Tarentum.

The burial ceremony was followed by a funeral banquet for which special foods were prepared. The meal was usually held near the site of the burial, and some of the food was placed on the tomb as a meal for the deceased; nine days later a second banquet took place.

Tombs were often fitted with a tube to keep open a connection between the deceased and the external world so that relatives could repeat the offerings of food on the occasions of feasts and anniversaries.

Christian burial ceremonies differed little from those pagan, although the Christian rite prohibited cremation. The tradition of the funeral banquet survived and became a moment of gladness for Christians, who celebrated death as the day of the birth to a new life.

The rite of burial spread once again—and most of all among the wealthier classes—between the end of the 1st century and the beginning of the 2nd, probably in part because of the influence of the rules dictated by Judaism and Christianity.

▲ Scene of funeral banquet, from a columbarium in the Via Laurentina near Ostia, mid-3rd century, Museo Gregoriano Profano, Musei Vaticani, Rome.

"The funeral was noteworthy for its long procession of ancestral effigies—Aeneas . . . all the kings of Alba Longa; Romulus, founder of Rome; the Sabine nobility . . . finally the rest of the Claudian house" (Tacitus)

Ancestors

Ancestors participated in funeral processions, or at least wax masks of ancestors worn by actors who dressed in historical costumes and preceded the coffin. These images of dead relatives, exclusively male, were preserved in shrines or small wooden cabinets located in the most conspicuous spot in the house, to be honored, displayed during public sacrifices, and worn in processions when an important relative died. Since all descendents had a right to a mask of the deceased, several copies of the mask would be made, with others made each time a new family nucleus formed.

The right to preserve masks of ancestors was considered a privilege to be proud of and was initially an exclusive right of patrician families; at a later time it was extended to plebeians who had entered the senate. Possession of a great number of masks, enough to make possible the construction of a true genealogical tree, was a sign of old nobility. Those who committed a crime might lose the right to acquire and possess images of ancestors and also to become an image for descendents. Both Suetonius and Tacitus, for example, report that the emperor Nero, making up excuses to kill off Roman nobility, accused a lawyer named Cassius Longinus of keeping a mask of Gaius Cassius, one of Julius Caesar's murderers, attached to his family tree.

Related entries
Portrait, Sepulcher

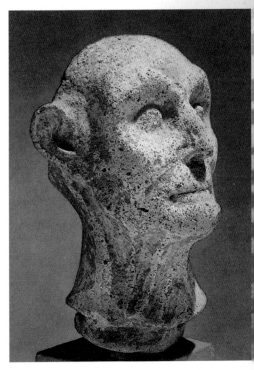

▼ Portrait in terracotta based on a funeral mask, 1st century BC, Louvre, Paris.

"This image is a mask made strikingly similar to the facial features and expression of the deceased . . . the family takes the images or masks to the funeral . . . It would not be easy to find a more splendid sight. . . . For who would not be moved by the sight of the images of men renowned for their excellence, all together in one place, portrayed as if still alive and breathing?" (Polybius).

The head is an ancient portrait unrelated to the statue, to which it was added during the 17th-century restoration of the statue desired by the Barberini family immediately after finding the sculpture.

This image of a grandfather is a portrait probably made between 50 and 40 BC, following a somewhat naturalistic style that brings out the characteristic features of the face.

The image of the father, a portrait presumably made between 20 and 15 BC, already shows the classicism of the Augustan age.

From the funeral oration of Scipio: "With my conduct I increased the virtues of my family; I have generated sons and have sought to equal the deeds of my father. I have maintained the praise of my ancestors such that they can be pleased at having given me life. The positions I have held have ennobled my family."

▲ The "Togato Barberini," Augustan age, Centrale Montemartini, Rome.

Scipio is clearly proud to see himself as a part of a larger whole, of belonging to a line, a family, his gens. He sees his ancestors as judges and is clearly eager to win their approval.

"'A dead man,' says a law of the Twelve Tables, 'shall not be buried or burned inside the city' . . . the words 'or burned' proves that a cremated body is not considered buried, only one which is laid in the earth" (Cicero)

Sepulcher

The Romans believed life continued after death, although in other forms, but they also saw proper burial as essential for the soul of the deceased to find peace. Concern for the final resting place was thus a constant in the Roman world, and those who could afford it built tombs for themselves and for their families while still alive. Since Roman law strictly forbade burial within the city's walls or its urban perimeter, special areas were set aside—necropolises—where burial lots were arranged in a sort of hierarchical division, as we know from inscriptions that relate the measure of a piece of ground belonging to a single burial. Romans greatly dreaded the profanation of tombs, and doing so was a criminal offense, but it must have happened regularly, as is revealed by the constant reuse of sarcophagi in later burials and their use as building material. The misappropriation of tombs also awakened great concern, and in some cases the owners of a tomb provided fines for heirs that sold the tomb or used it for the burial of other family members. Some Romans are known to have left bequests in their wills to guarantee care for their tombs after their death, and most of all for the performance of the necessary ritual sacrifices, libations that were poured in special tubes set in the ground that led to the inside of the tomb.

▼ Cinerary altar of Statlius Aper, Hadrianic age, Musei Capitolini, Rome.

The obelisk that stands between the statues of the divine twins was originally located to one side of the entrance to the Mausoleum of Augustus, the other side being occupied by the obelisk that is today located in front of the apse of the church of S. Maria Maggiore.

Special ships were built for the transportation of obelisks; for the obelisk in the Circus Maximus, Augustus had a ship built that was then left unused in the port of Pozzuoli, while the ship that Caligula used to transport the obelisk to the Circus Vaticanus (today in St. Peter's Square) was later used by Claudius as the nucleus of the central breakwater for the new port.

"Augustus during his sixth consulship had built his tomb between the Via Flaminia and the banks of the Tiber and had surrounded it with groves and walkways which he opened to the use of the public . . . [he left] a record of his reign, which he wished to have engraved on bronze and posted at the entrance to the mausoleum." (Suetonius)

The statues of the Dioscuri must have been found in the area, and it seems likely that they belonged to the great Temple of Serapis that Caracalla had built on the hill of which today some remains are visible in the Colonna gardens. The sculptural group has been at the center of the piazza since 1589.

Rome's emperors were buried in the Mausoleum of Augustus until Trajan, who wanted his column to be his tomb, and from Hadrian to Commodus the emperors found eternal rest in the great Mausoleum of Hadrian.

▲ Obelisk in Piazza del Quirinale, Rome.

When the site was made into a castrum, it became a true fortified village inside which were houses, a church dedicated to the blessed Nicholas, and a palace for the noble family; at that time the mausoleum was raised on bricks and was given a battlemented structure so as to transform it into a defensive tower protecting the outskirts of Rome.

The cornice of the tower bears a frieze decorated with garlands of flowers and fruit interwoven with ritual bands and ox heads; over every garland is a patera. These are symbols related to sacrificial ceremonies, and they appear on funerary and votive altars.

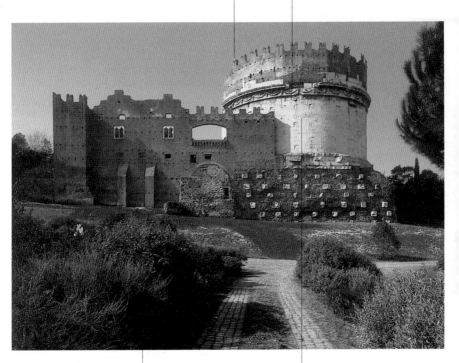

▲ Tomb of Caecilia Metella, on the Via Appia.

In 1303, the mausoleum was incorporated into the construction of the Castrum Caetani, many remains of which are still visible today. Well preserved is most of all the noble residence, which was set against the walls and which, over the course of the centuries, has lost its roof and the floors of its various stories, but still rises impressively with its battlements and mullioned windows.

The monument was erected between 30 and 20 BC for Caecilia Metella, daughter of Quintus Caecilius Metellus Creticus and wife of Crassus. The only information we have on the person the tomb was made for is given in a brief inscription that does not do justice to the impressive size and richness of the tomb, which has been known since 850 and is considered an outstanding symbol of the Via Appia.

The large, circular construction is composed of a barrel-vaulted ambulacrum that winds around a raised drum supported by twelve pairs of columns and covered by a dome. Set in one of the niches inside was the sarcophagus, made of red porphyry and decorated with cupids and vines. It is today in the Musei Vaticani.

The mausoleum—today the church of S. Costanza—was erected on the Via Nomentana for one of Constantine's daughters, Constantina, who married Constantius Gallus; the construction of the sepulcher, and most of all its attachment to the nearby basilica of S. Agnese, was part of a larger project financed by the imperial family for the creation of a large basilican complex.

Another rotunda had been built at the gates of Rome at the will of Constantine as a mausoleum for his mother, Helena, later proclaimed a saint; its ruins are today known as the Tor Pignattara (roughly, "pot tower").

During the Renaissance the mausoleum was known as the Temple of Bacchus because of the Bacchic motifs that appear in the decoration of the vault and the cherubs harvesting grapes depicted on the front of the sarcophagus of Constantina, originally located inside the church.

▲ Mausoleum of Constantina.

L. Scipio Barbatus, consul in 298 BC, was a leader in the fighting in Samnium and Lucania, as related in his funeral inscription; Livy's report that he was a commander in Etruria seems less reliable.

Ancient sources indicate that the tomb of the Scipio family was located to the left of the Via Appia before the S. Sebastiano Gate; it was there that the hypogeum, already opened in 1616, was excavated beginning in 1780; the original inscriptions were removed by the discoverers and are today in the Musei Vaticani; in 1926 copies were made of the originals and set in place.

The Sepulcrum Scipionum, family tomb of the Cornelii Scipiones, was begun by Scipio Barbatus or by his son and was used until the middle of the 2nd century (except for Scipio Africanus, who was buried near his villa of Literno). The tomb was later enlarged, perhaps by Scipio Aemilianus, and remained in use until the early imperial age.

The sarcophagus, the only one inside the sepulcher, is composed of a casket with tapered molding below and decoration above that includes a Doric frieze with metopes adorned with rosettes; at the ends of the lid are curling volutes.

▲ Sepulcrum Scipionum, copy of the sarcophagus of Scipio Barbatus.

The sarcophagus still in place in the Cornelii Scipiones family tomb is a copy; the original is in the Musei Vaticani.

"Care, fatigues, prizes, honors for duty performed, leave me, from now on torment other lives. A god calls me far from you. Having completed this life, I bid you farewell, hospitable earth" (Seneca)

Columbarium

Related entries
Arts and crafts,
Sarcophagi, urns, reliefs

During the final years of the republican period, in addition to open-air necropolises Romans began using columbaria, a more rational and economical means of burial also better suited to the demands of a metropolis in the course of enormous demographic growth. Columbaria are communal burial chambers, composed of one or more rooms built on the surface or dug into the ground, that can hold hundreds of cinerary urns in small niches, or loculi, arranged in rows along the walls. The bodies of the dead were cremated in spaces set aside for that purpose *(ustrini)*, and the ashes, collected in marble or terracotta urns or in simple jars, were arranged in the loculi, which were then sealed shut with a slab that most often bore an inscription, much like a modern headstone.

A columbarium often held the remains of the members of a group, such as the servants or freemen dependents of a large Roman family or the members of a funeral club, who paid an initiation fee and monthly dues to defray the costs of a respectable burial. Many columbaria are visible today in Rome, and many others were destroyed or are no longer reconstructible; among these is the columbarium of the servants and freemen of Livia, found in 1725 on the Via Appia and today no longer legible. This must have been an impressive structure since it contained the mortal remains of nearly three thousand servants of the wife of Augustus.

▶ Slab closing a
shelf-niche (loculus),
columbarium of
Vigna Codini.

The loculi were dug into the wall wherever it was thick enough to permit them, eventually occupying the entire burial chamber. Most of the loculi were vaulted, making the structure resemble a dovecote and giving the columbarium its name (from columba, "dove").

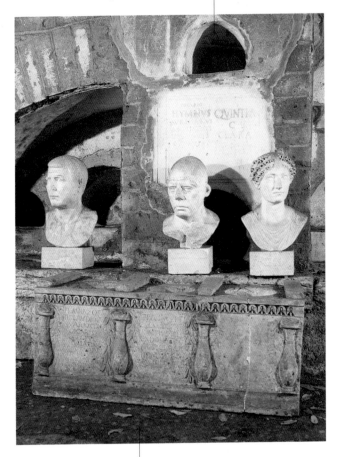

▲ Interior of one of the columbaria in Vigna Codini.

The first columbaria were built in Rome around the middle of the 1st century BC, and their greatest spread took place under Augustus and Tiberius; there do not seem to have been any new constructions following the reign of Claudius.

The hypogeum was discovered by Pietro Campana in 1831 in the park between the Via Appia and the Via Latina, a short distance from the Aurelian Walls.

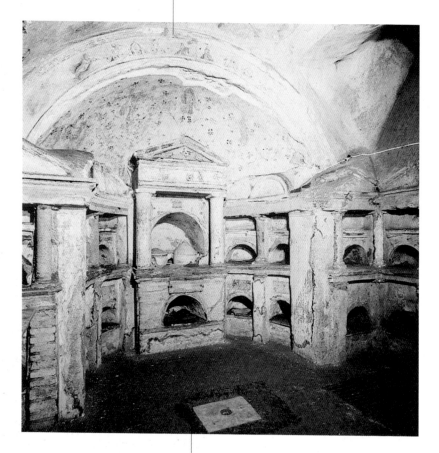

▲ Columbarium of Pomponius Hylas, 1st century, Rome.

With its somewhat complicated architectural structure, the small columbarium—roughly 3 meters by 4—is richly decorated with stuccoes, paintings, and a large mosaic panel of vitreous paste framed by a band of seashells.

"Having collected the bones of Polycarp . . . we laid them to rest in the appointed place in exultation and joy . . . the Lord will allow us to celebrate the anniversary of his martyrdom" (Martyrium Polycarpi)

Catacomb

The first Christian communities buried their dead in open-air necropolises alongside the dead of other faiths. Only over the course of the 2nd century did the custom develop of burial in catacombs, the characteristic underground cemeteries that, according to the legendary version, served as hiding places for Christians during persecutions. In reality, there were not very many large-scale persecutions of Christians, and they were concentrated primarily between the middle and the end of the 3rd century; furthermore, it would have been difficult for Rome's thousands of Christians to have found shelter by crowding together in a network of dark and airless tunnels.

The first catacombs almost certainly came into being from the donations of lots of land by private citizens who made their possessions available to the entire Christian community; they also served to help the faithful in more precarious financial conditions, those unable to afford a dignified burial.

In some cemeteries, there was particular concentration in the area near the tombs of martyrs, since the faithful wanted to be buried near them; these holy sites continued to be visited even when, over the course of the 5th century, the custom of burying in catacombs went out of use.

Related entries
Christianity

▼ Crypt of the popes in the catacombs of St. Calixtus.

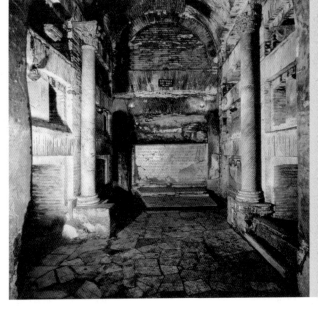

239

The expression "ad catacumbas" ("near the cavity") gave the name to the zone located between the second and third mile of the Via Appia, precisely between the basilica of S. Sebastiano and the Circus of Maxentius; this area was characterized by a depression, the result of the extraction of pozzolana.

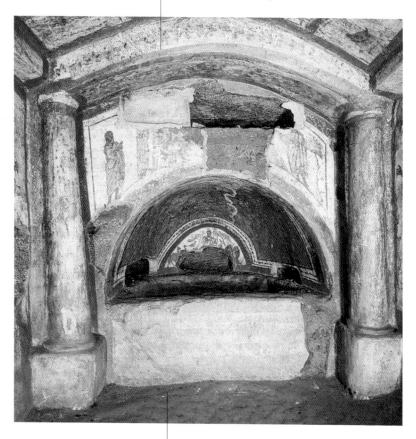

▲ Catacomb of Domitilla, cubicle of Orpheus.

The burials, most often in superimposed loculi, were shut with marble slabs, tiles, or blocks of tufo, sealed with lime, and plastered over. The name of the deceased was sometimes inscribed in the plaster.

The cemeteries were arranged on several levels, forming a dense and intricate network of galleries illuminated by weak light that filtered down through the few shafts opened at the time of the excavation (lucernari); the rest of the weak illumination was entrusted to oil lamps.

▲ Catacomb of S. Sebastiano.

The belief that these cemeteries served as hiding places for Christians during persecutions resulted from an erroneous opinion formed in the modern era.

Sarcophagi, urns, reliefs

Related entries
Funeral

▼ Urn of Tiberius Claudius Melitonus, doctor of Germanicus, first half 1st century, Museo delle Terme, Rome.

Until the 2nd century, the primary practice was cremation, direct or indirect. The more humble classes used the more economic direct cremation: the pyre was prepared directly over the grave, and the burnt bones were left in the ground along with the carbonized remains of the funeral bier; any objects to accompany the dead were placed on the pyre or set beside the grave. In the more common method of cremation, the body was burned in a special crematory set up inside the sepulchral area and arranged in a complex and at times picturesque manner, with a tall pyramid of wood hung with draperies and garlands. The entire catafalque was sprinkled with perfumes and aromatic substances in homage to the deceased, but probably also to disguise the exhalations resulting from cremation; evidence of this practice, described by ancient authors, is the thousands of small glass containers found among tomb furnishings. At the end of the ceremony, the carbonized remains were collected in a stone or marble urn, although these were sometimes made of glass, terracotta, or wood, and buried in the ground or deposited in the loculus of a sepulcher. Between the 2nd century and the middle of the 3rd, burial very slowly took the place of cremation, and for a long time both practices existed side by side. The deceased was placed in a wooden coffin or in a sarcophagus of terracotta, stone, or marble, often richly decorated; the poorest were lowered into the ground naked, wrapped only in a winding-sheet.

The young man lies stretched out in a relaxed position, his head resting on a pillow, his body partially wrapped in a broad mantle.

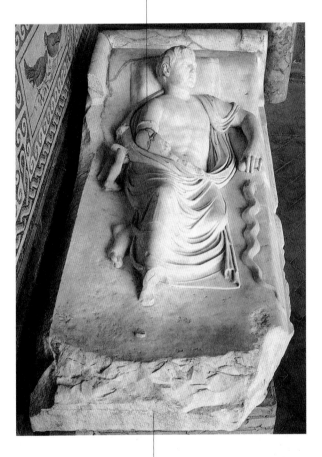

▲ Cover of a *kline* sarcophagus, early 1st century, Museo Nazionale Romano, Rome.

The covers of sarcophagi carved so as to simulate a couch (kline) are of Greek derivation.

The upper level presents only victorious Romans, most of them mounted, accompanied by a cornu player who probably announces victory (see page 191).

At the center of the complex scene, the victorious general on horseback, with his right arm raised and hand open in the typical attitude of the imperator *and his forehead marked by the sign of the cross, serves as the center of the scene, which although apparently random is in fact arranged on three descriptive levels.*

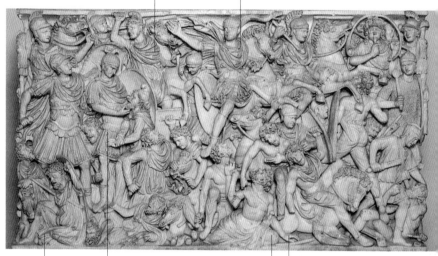

The middle level—the widest— presents the true scene of combat between the legionaries and the barbarian army in a confusion of bodies and weapons in which, however, Roman supremacy seems always to appear.

The sarcophagus, carved from a single enormous block of Proconnesian marble, presents a complex and highly articulated scene of battle between Romans and barbarians characterized by a great mass of figures in action around a commander, perhaps the son of Decius, who died in 251 together with his father.

In the lower level the artist has presented the defeated and overcome army, a mass of horses and human bodies identified by the clothing and hair as belonging generically to a Gothic people.

The production of monumental relief-decorated sarcophagi developed between the 2nd and 4th centuries in the artisan workshops of Rome and in those of Athens and the east; the decorative motifs could be simple but also complex narrations of the Italic tradition, in which scenes of battles and mythical episodes took place alongside great biblical themes.

Despite its brevity (Via Sacra aurivestrix), the inscription beneath the name on the cover informs us that the deceased, Sellia Epyre, had a dressmaker's shop along the Via Sacra where she made clothes decorated in gold.

The luxurious clothing that Sellia Epyre created for her rich clients was undoubtedly made with precious fabrics imported to Rome from the Orient.

The urn held the ashes of the deceased after cremation, which was almost the only funeral rite during the first half of the 1st century. An emblematic case of the persistence of this rite during the slow passage to the custom of burial is a double sarcophagus found in Emilia that contained the mortal remains of a buried husband alongside those of his cremated wife.

Although skill at weaving remained one of the talents most valued in a Roman matron, many fabrics were mass-produced by specialized "industries" and were bought by clothing stores that probably functioned much like modern dressmakers.

◄ The "Grande Ludovisi" sarcophagus, from the Vigna Bernusconi near the Porta Tiburtina, mid-3rd century, Palazzo Altemps, Rome.

▲ Urn of Sellia Epyre, first half 1st century, Museo delle Terme, Rome.

The external surface of the shield that serves as frame to the portrait is embellished with a braid, a bean motif, and a crown of pearl shapes.

Imago clipeata *portraits could depict only heads, but most often portrayed half-bust figures, as is the case with these two figures from Ostia, a youth and an elderly man.*

Imago clipeata *images are portraits framed by a shield or circular medallion following a model created in Greece in the painting of heroic subjects.*

Imago clipeata *images could be painted, embossed on metal, or carved in marble; almost all those that have survived are in marble. The style was most often used to portray heroic figures and also divinities.*

▲ *Imagines clipeatae*, from the Baths of Mithras at Ostia, ca. 100–10, Museo Ostiense, Ostia Antica.

Anteros, with his face slightly turned toward his wife, has a skullcap hairstyle, as was common in the Augustan age, and has a thin face on which can be seen the signs of advanced age.

The inscription legible along the upper border of the relief—A[ulus] Pinarius A[uli] l[ibertus] Anteros Oppia [muliebris] l[iberta] Myrsine—establishes the social status of the deceased couple, both of them freedmen who had probably reached a discreet level of prosperity.

The portraits of the two deceased are inserted in the relief like busts, while during the republican period similar reliefs presented figures framed almost to the height of their waist.

Myrsine's broad face has sharp features and large ears, and her hair is gathered on the back of her head in two braids that fall to her shoulders, following the typical "Octavia" style characteristic of the period.

▲ Funerary relief of Anteros and Myrsine, from the area of S. Maria sopra Minerva, last quarter 1st century BC, Palazzo Altemps, Rome.

The wife, with a variant of the "Octavia" hairstyle, wears a tunic that leaves her forearms bare and is wrapped in a mantle that she grasps at her chest with her left hand.

The third figure, whose head is covered by a veil held by a large circular stay and whose face is framed by wavy locks, is perhaps the mother of the bride, or perhaps also their patron, the woman who had been their owner before their manumission, their freedom from slavery; numerous similar reliefs are known to have been possessed by freedmen.

The two figures on the left are clearly indicated as a married couple by the gesture of the dextrarum iunctio and by their faces—most of all the woman's—turned slightly to one another.

Because of the absence of an inscription, the names of the people are unknown. The man is dressed with a tunic and a toga that he holds with his hands on his left shoulder; the wrinkles on his face indicate that he is no longer young, and his hair is combed to form a skullcap.

The relief is made in Luni marble, today's Carrara marble, extracted from the quarries opened in the age of Caesar and widely used beginning in the Augustan period; the quarries were made imperial property under Tiberius.

▲ Funerary relief, ca. 40–30 BC, Palazzo Altemps, Rome.

A Corinthiarius *was an artisan who produced objects in bronze and probably also in precious metals; another member of the same Aufidius family was a goldworker. The bronze-worker's workshop must have been to the south of the buildings of Lucius Cornelius Balbus, near the Tiber, where the* Forma Urbis *may indicate the presence of a row of workshops facing the road.*

The inscription, datable to between the late Julio-Claudian age and the early Flavian, relates that Lucius Aufidius Aprile performed his activity as bronze worker near the Theater of Balbus, which was inaugurated in 13 BC but made temporarily unusable by a flooding of the Tiber.

The rooms of the complex that was built atop the Crypta Balbi during the Middle Ages have been restored and are now the site of a museum that illustrates Rome in late antiquity and the early Middle Ages along with the transformation over time of the urban area occupied by the complex of the theater and the Crypta Balbi.

The large marble altar, 140 centimeters high, was found in 1965 near a large circular mausoleum along the Via Flaminia.

Annexed to the Theater of Balbus was a vaulted passageway also known from a fragment of the Forma Urbis. *Known as the* Crypta Balbi, *it was considered lost until being rediscovered in 1981; it was the subject of careful archaeological research until 2000.*

The altar, richly decorated in relief and of excellent workmanship, clearly indicates the social position and financial means of the deceased.

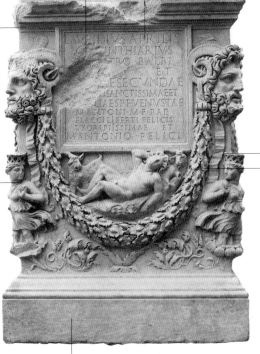

▲ Funerary altar of L. Aufidius Aprile, from the Via Flaminia, ca. 60–80, Museo della Crypta Balbi, Museo Nazionale Romano, Rome.

The theater near which Aufidius Aprile worked had been built by Lucius Cornelius Balbus with earnings from the spoils he had won in his expedition against the Garamantes, a people of Libya he had defeated in 19 BC. Remains of the theater are still visible inside the block that includes the Caetani and Mattei palaces.

The female figure wears a frock and a large mantle that wraps her entirely in a rich drapery that she holds in her left hand.

The woman holds a small bouquet in her left hand in which ears of wheat and poppies can be recognized, attributes of the cult of Ceres, of whom the deceased had perhaps been a priestess.

▲ Female funerary statue, from the Via Latina near Porta Furba, Museo delle Terme, Rome.

This is a copy from the Hadrianic age of a Hellenistic original datable probably to around 160 BC.

The stele still bears a pagan dedication to the Manes—recognizable by the letters D M ("Dis Manibus")—but it appears along with the Christian formula ἰχϑὺς ζώντων, "fish of the living," reinforced by the image of two fish facing each other divided by an anchor.

D M

IXΘYC · ZWNTWN

LICINIA·AMIATIBE
NEMERENTI VIXIT

▲ Funeral stele of Licinia Amias, from the area of the Vatican necropolis, beginning 3rd century, Museo delle Terme.

The formula "fish of the living" is derived from the fact that the Greek word for fish, IXΘYΣ, is an acronym for the saying "Jesus Christ God's Son Savior" (Ἰησοῦς Χριστός Θεοῦ Υἱός Σωτήρ). The living are the Christians who have been reborn in baptism and entered a new life.

The city

◄ View of the Forum Romanum
with the Temple of the Dioscuri
in the foreground.

"If you can tear yourself away from the chariot races in the circus . . . you can buy an excellent house [in the country] for what you now pay at Rome to rent a dark hovel for one year" (Juvenal)

The city

"I prefer even Procida to the Subura. For what have we ever looked on so wretched or so lonely that you would not deem it worse to be in constant dread of fires, the perpetual falling-in of houses, and the thousand dangers of the cruel city, and poets spouting in the month of August? . . . Who dreads the collapse of a house at cool Praeneste or at Volsinii seated among the well-wooded hills, or simple Gabii, or the heights of slopping Tibur? We, in Rome, inhabit a city in great measure propped up by flimsy boards. The manager of your apartment building stands in front of the collapsing structure, and while he plasters over the old and gaping crack he bids you sleep well—even though a total cave-in is imminent! I want to live in a place where there are no fires, no nightly alarms. Here, one neighbor discovers a fire and shouts for water while another moves out his shabby possessions. The third floor, where you live, is already in a blaze—but you don't even know it! Downstairs there is panic, but you, upstairs, where the gentle pigeons lay their eggs, where only thin tiles protect you from the rain, you will be the last to burn. There are other perils of the night from these. How high is it to the lofty roofs, from which roof tiles fall and hit you on the head? . . . How often cracked and broken pots fall from windows . . . you might well be accounted remiss and careless about sudden accidents if you were to go out to supper without having first made your will. For there are just as many chances of death as there are open windows where you are passing. Pray, therefore . . . that they may be content with throwing down only an open basin." (Juvenal)

▼ Italo Gismondi, plastic model of Rome in the age of Constantine, detail with the Circus Maximus, Palatine, and Colosseum, 1937, Museo della Civiltà Romana, Rome.

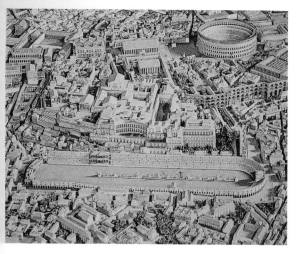

"During his aedileship, Caesar filled the Compitium, the forum, and its adjacent basilicas with a display of works of art he possessed, building temporary colonnades for the purpose" (Suetonius)

Basilica

The basilica was a large covered space designed to serve the performance of the legal, political, and financial functions that were typical of the forum and to provide shelter, in poor weather, for all the exchange activities that normally took place in the open square. The interior space of the building was divided into aisles by straight rows of columns that also served as supports for the roof; the central aisle (the nave) was usually higher than the side aisles to permit the opening of large windows that brought in light. A basilica had been built in the forum as early as the end of the 3rd century BC, and a few decades later Marcus Porcius Cato bought land between the Capitol and the curia on which to construct the Basilica Porcia, a rectangular building of which nothing remains today that was flanked by columns and galleries that could be used for commercial activities and also for promenades. In a short time another three basilicas arose; two of these have left no trace, but the remains of the Basilica Fulvia-Aemilia survive in the form given them by restorers of the imperial age. Almost a century and a half later, in the central part of the forum, Caesar began work on construction of the Basilica Julia, a new and larger building that occupied the space marked off by the two main routes that led from the Tiber to the forum; it was completed fifty years later by Augustus.

Related entries
Caesar, Forum
Romanum

▼ The Basilica Julia seen from the Capitol.

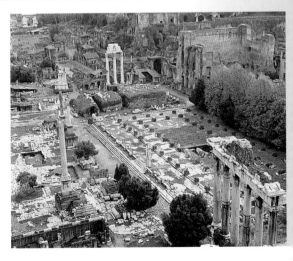

"After viewing our modern villas, as large as cities, it is worthwhile to contemplate the temples our ancestors, a devout race, erected to the gods . . . our forefathers adorned the temples of the deities with devotion" (Sallust)

Temples and sacred buildings

The oldest type of sacred monument erected by the Romans was the altar on which sacrifices and libations were offered to the gods. Whether simple blocks of stone or highly elaborate monuments, altars appeared everywhere, in front of temples and in private homes, in public places and at crossroads. Shrines were more complex architectural structures. Most often inserted in the walls of temples, both inside and outside, these were made to hold the images of divinities or heroes. Shrines also could be autonomous structures like miniature temples, such as those

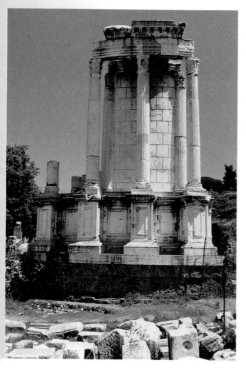

▼ Temple of Vesta in the Forum Romanum.

located at crossroads dedicated to Lares Compitales, the tutelary divinities of the locale; the category of shrines also includes those dedicated to a family's Lares. The term *temple* was applied to a delimited space, ritually inaugurated, on which a structure was built and dedicated to one divinity or more. There were an infinity of reasons for vowing to build a temple, from the hope of surviving a storm at sea or a natural calamity to the desire for peace after a bitter struggle, as is the case with the Temple of Concordia. Temples were almost always promoted by consuls and could be built at public expense or with the spoils of war, while the state saw to the expense of their maintenance and administration. The temple was inaugurated by a magistrate, and the day of its dedication became the festival day of the divinity.

In the background, the impressive mass of the temple dedicated to Jupiter, supreme deity of the Roman pantheon, can be seen as it must have appeared after its reconstruction in the age of Domitian. The building is easily identifiable by the decoration of its pediment.

The emperor Marcus Aurelius, his head veiled as was required for an officiant, sacrifices to Capitoline Jupiter on an altar placed in front of the entrance to the sacred building.

A ritual slaughterer with his tools leads a bull to sacrifice, while a musician plays in front of the altar.

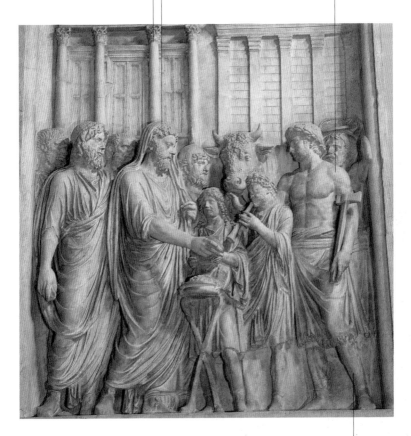

▲ Relief panel from a monument erected in honor of Marcus Aurelius, from the church of SS Luca and Martina, 176–180, Musei Capitolini, Palazzo dei Conservatori, Rome.

The relief is one of a series of three panels—probably completed by a fourth today lost—that symbolically depicted Clementia (Marcus Aurelius on horseback receiving defeated barbarians), Victory (the emperor on his triumphal chariot), and the Pietas Augusti (his pious sacrifice before the temple).

*"Within your threshold there's a broad drive for your carriage
... You enjoy deep sleep and a stillness disturbed by no voices;
the daylight never shines in unless you let it"* (Martial)

Domus

Related entries
Villa, Garden, *Insula*,
Hadrian's Villa

▼ Mosaic floor from
the *domus* in Piazza dei
Cinquecento, first half
2nd century, Palazzo
Massimo, Rome.

During the early republican period, the Roman home—the *domus*—
was composed of an access hall that led to a central courtyard
(atrium) with a ridged roof designed to direct rainwater into a basin
connected to a cistern; the bedrooms *(cubicula)* and the main hall
(tablinum) were arranged around the atrium. Over the course of the
2nd century BC this basic structure was enlarged with the addition of
a second nucleus inspired by Greek models, a peristyle court—a
colonnaded portico—surrounded by rooms for public ceremonies,
such as dining rooms, sitting rooms, and reception rooms. The Hel-

lenistic style had a great influence on the
domestic architecture of Rome's ruling
class, and the rich aristocratic *domus* of
this period became a vast structure,
sometimes larger than the royal palaces
of the Hellenistic princes of the period.
Luxury was also introduced to the dec-
oration of homes, with mosaic floors
replacing simple pavements in *opus
Signinum* (plaster made of pulverized
tiles), and walls decorated with frescoes,
stuccoes, and marbles.

The style of Roman homes changed
during the imperial period, and the
term *domus* came to be used almost
exclusively for luxurious aristocratic
homes fitted out with private baths,
dressed in marble, and embellished
with statues. According to a catalog of
Rome's buildings, there were 1,790
such single-family residences in the
4th century.

All Roman lavatories, typically communal, worked the same way: along three walls of a room ran a series of regularly spaced seats in stone or marble set above a canal with flowing water that emptied into the nearest sewer.

The Roman lavatory included a small canal running along the base of the seats and filled with a stream of water in which were immersed handled sponges used to clean the area. Such sponges are mentioned by Seneca and Martial.

Impressed into the fistulae *(water pipes) was the name of the person who had been authorized to tap the main aqueduct system with the pipes or the name of the person who owned the site. This impression was made by the pipe manufacturer or by the water commissioner responsible for the concession; in no case has the name of the water carried in the pipes (the name of the aqueduct it came from) been preserved.*

The lead pipes were made of smooth sheets of lead wrapped around a wooden cylinder of the desired diameter; in order to simplify inspections and repairs, the maximum length for a segment of water pipe was 10 Roman feet (2.95 meters).

▲ Lavatory from the area of the baths in the Forum of Ostia.

▲ *Fistula* in lead, from Piazza del Gesù, Antiquarium Comunale, Rome.

The principal and most detailed source of information on Roman domestic architecture is Vitruvius, a military engineer under Caesar, whose De architectura, *published at the end of the 1st century* BC *and dedicated to Augustus, was a thorough architectural manual, full of advice for architects and builders.*

Vitruvius's treatise takes into consideration different building techniques, the division of interior spaces, and the function of individual rooms. It provides an exhaustive panorama of the homes of the upper class during the late republican period.

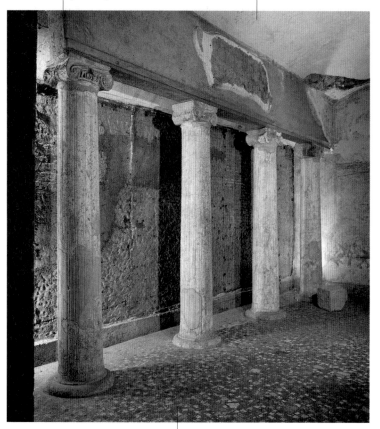

▲ *Oecus Corinthius* (columned triclinium) in the Casa Bellezza on the Aventine, 1st century BC.

Analysis of Vitruvius's work combined with study of the lavish homes in the cities near Vesuvius and the *insulae* of Ostia is the only way to compensate for the scarcity and fragmentary nature of the information available on architecture in Rome.

The linear style—completely white walls decorated by airy niches and motifs just barely sketched in—spread around the middle of the 2nd century and, over the course of the 3rd century, became a characteristic element of funerary painting, most of all in catacombs.

Over the course of time, the room has gone through at least three successive decorative styles, the overlapping traces of which are still visible. The oldest—chipped away to apply what is the best conserved style today—had a yellow ocher background with rows of panels painted in lively colors.

The most recent decoration has almost completely disappeared because of the poor resistance of the method used, the dry application of paint to a layer of whitewashing.

▲ *Domus* in Piazza dei Cinquecento, detail of the fresco of one of the rooms, end 2nd–early 3rd century, Palazzo Massimo, Rome.

Standing out against the white background are airy and elegant architectural motifs, just barely articulated, inside which are floral motifs and small human figures.

"Princely vestibules must have lofty atria and spacious peristyles, groves and extensive walks . . . libraries, galleries, and basilicas, luxurious and impressive, of similar form to those made for public use" (Vitruvius)

Villa

Related entries
Garden, Hadrian's
Villa

During the republican period, the Romans used the term *villa* for a country house almost always involved in agricultural activity or, in general, with rural activity *(villa rustica)*. According to Varro, author in 37 BC of an important treatise on farming, such a villa should combine productivity with pleasure. These large villas were composed of three distinct parts, the areas for the workers and agricultural activities *(pars rustica)*, storage areas *(pars fructuaria)*, and the owner's home *(pars urbana)*, so splendid and comfortable that he would never miss his city house. In fact, the ideal villa was not located overly far from Rome and offered sufficient comfort to tempt the owner to make frequent visits.

Luxury villas designed only for leisure and entertainment made their appearance during the last years of the republican period; among these were the many rich homes built in the shadow of Vesuvius beginning in the 2nd century BC. Having completely abandoned agricultural activity, these residences became increasingly sumptuous and refined, offering a refuge and place for entertainment to people in the public eye. Great villas soon appeared in the area around Rome, as well as its immediate environs, and in a short time these outdid city homes in luxury, being embellished with peristyles, gardens with nymphaeums with scenic splashing fountains and ponds, elaborate bathing installations, statues, and elegant wall and floor decorations.

▼ Hadrian's Villa, mosaic floor of one of the *hospitalia*, or guest rooms.

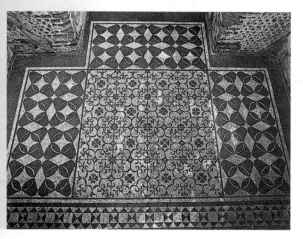

Tubuli—*hollow bricks*—were used in the system of heating rooms through walls. A layer of these bricks was inserted in the walls, and warm air was conducted into the cavity from a furnace.

The cavity created by the use of tubuli *was covered by a thick layer of plaster that served as protection and was also the support for the application of decoration. Roman heating systems also involved floors, which were raised from the ground on short masonry pillars to create the same sort of hollow space for the passage of heated air.*

The indirect heating of rooms by means of warm air, which was conducted into cavities in walls or floors, was introduced early in the 1st century BC *and led to a sharp improvement in the hygienic-sanitary conditions of bathers, since it guaranteed a constant temperature in the rooms.*

▲ System of heating in a room in the Villa of the Quintili.

There were heated rooms in all Rome's bathing complexes as well as in the private baths of the homes of the wealthy, in which other rooms were often heated. In the Forum Romanum, for example, on the upper floor of the house of the Vestals, the priestesses lived in comfortable rooms with heaters and had numerous heated baths available to them.

The flooring material—whether marble slabs or mosaic—was applied to a solid preparation, such as that shown here.

"Wherever I turn, I see evidences of my advancing years. I visited lately my country-place, and protested against the money which was spent on the tumble-down building. My bailiff maintained that the house was old. And this was the house which grew under my own hands. What has the future in store for me if stones of my own age are already crumbling?" (Seneca)

Domitian built a grandiose residence on the western slope of Lake Albano, with a series of terraces leading up the hillside. Aside from being a true home, the villa included a hippodrome and a theater.

The remains of Domitian's Villa—the cryptoporticus is still usable—are incorporated in the park of what has been the summer residence of the popes since 1597.

▲ Nymphaeum in Domitian's Villa, Castel Gandolfo.

'Meanwhile, praying unto all the gods, I looked about in every place to see if I could espy red roses in this garden" (Apuleius)

Garden

According to Cicero, the first garden *(hortus)* created in Rome belonged to Sulpicius Galba, at the beginning of the 2nd century BC. This was a park facing the spur of the Aventine, in which the poet Ennius loved to stroll. The taste for splendid gardens rapidly took hold, and soon all the leading figures of the late republican period longed to own not just a luxurious city home, but also *horti*, much as noble families did in the 16th century, from the Borghese to the Torlania to the Pamphili. Between the end of the republican period and the beginning of the imperial, the center of Rome found itself surrounded by a band of large parks full of trees, scenic settings embellished by small temples, statues, and water displays.

In addition to the *horti* of the leading aristocratic families, there were also public parks, most of them large enclosures framed by long porticoes, the first built by private munificence, those later the result of imperial will.

Water was the fundamental element of the Roman garden, although its role was by no means as overwhelming as it was to become in 16th-century parks. Water fell in cascades and gushed or dripped from fountains and nymphaeums. Agrippa seems to have been the first Roman to design a garden around a body of water, a lake 5.5 hectares in size that occupied the area between the Pantheon and Piazza Navona. It was big enough for a swim; Seneca, or so it seems, had the habit of diving into it to celebrate the first day of the year.

Related entries
Virgil and Maecenas,
Villa, Hadrian's Villa

▼ Fountain in the shape of a krater with the Marriage of Paris and Helen, from the Esquiline, 1st century, Centrale Montemartini, Rome.

265

Nymphaeums were monumental fountains based on architectural structures composed of niches and exedrae with elaborate decoration. In the gardens of the luxury homes of the ruling class, the nymphaeums served to enliven the view, in part because of their water displays.

Fountains and nymphaeums are typical elements of Roman civilization. Pliny the Elder reports that Agrippa alone had fifty fountains built in Rome and decorated them with three hundred bronze and marble statues and four hundred columns. Between the 4th and 5th century, Rome had 1,200 fountains and 15 urban nymphaeums.

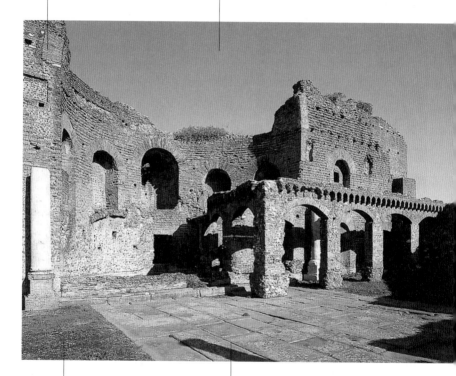

From the names that appear on water pipes, this large villa is known to have been the property of the brothers Sextus Quintilius Condianus and Sextus Quintilius Valerianus Maximus, both consuls in 151. The complex stood at the sixth milestone of the Via Appia, while at the third was the sumptuous residence of Herodes Atticus.

In 182–183 Commodus had the two brothers assassinated, accusing them—probably falsely—of having participated in a plot against him. On their death, all their belongings became imperial property, as was the case with the property of all those who were accused—rightly or wrongly—of opposing an emperor.

▲ Nymphaeum in the Villa of the Quintili.

In 1863, a small underground room was discovered in the Villa of Livia, located on the Via Flaminia; being underground, perhaps the room was used to keep cool in the summer. All four walls of this windowless room are decorated with a fresco depicting a luxurious garden.

Birds of different species appear everywhere in the painted garden, flying, resting, pecking at food; one small bird is enclosed in a metal cage set atop the marble balustrade.

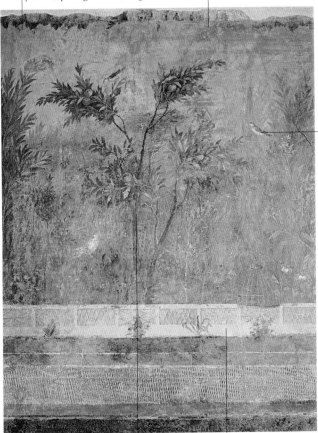

The villa is also known as Ad Gallinas Albas ("the white hens") because of a legendary event said to have occurred on Augustus's wedding day. An eagle dropped a white hen into Livia's lap; in its beak the hen held a branch of laurel with berries. The hen and its young were raised at the villa, and the laurel was planted there and became a grove, the branches being used in Rome's triumphs.

A notable variety of plants and trees is depicted, but the abundant fruits and flowers include seasonal discrepancies, such as chrysanthemums in flower at the same time that a peach tree is laden with fruit.

▲ Fresco from the Villa of Livia at Prima Porta, 30–20 BC, Palazzo Massimo, Rome.

The space of the garden is marked off by double walls, one in woven reeds or branches in the foreground and one in relief-decorated marble farther in; there are openings in the reed wall at the center of each of the room's short sides, opposite exedrae in the marble wall.

As early as the 1st century BC Vitruvius reminded influential people not to forget, when designing their homes, to match regal halls, atriums, and peristyles with pleasant woods and gardens suitable for pleasant strolls.

Numerous flower vases have been found at Hadrian's Villa in several areas of the gardens; a flowerbed was found along the Canopus, or scenic canal, in which a row of upside-down half amphorae was set. These had been used by the villa's gardeners as disposable flowerpots in the arrangement of the ornamental plants.

Little more than an orchard in the republican age, the garden was an essential component of any luxury home by the imperial age, with precise architectural rules that codified the types of plants and their arrangement in relationship to the various areas of the buildings.

There were usually three holes in each pot, located an equal distance one from the next; the holes were for the roots of the plant. In this way a plant could be set directly in the ground inside the pot in which, presumably, it had been grown.

▲ Flowerpots, from Hadrian's Villa, ca. 125–135, Hadrian's Villa, storehouses, Tivoli.

The statuette at the center of the fountain was probably part of the water display.

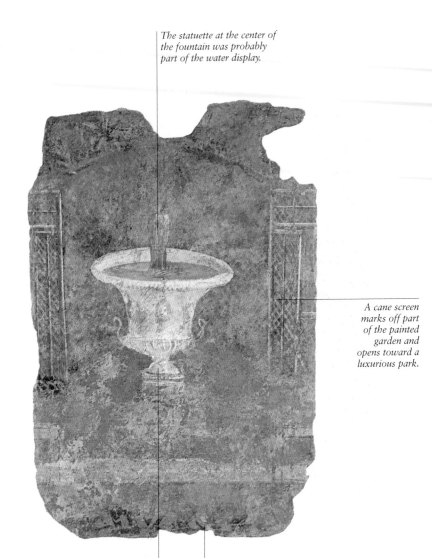

A cane screen marks off part of the painted garden and opens toward a luxurious park.

The decorations in the garden presented in the fresco include a marble fountain brimming with water that is very similar to the fountain that was found on the Esquiline (see page 265).

▲ Fresco with fountain from the Villa Farnesina, ca. 19 BC, Palazzo Massimo, Rome.

Detailed depictions of gardens were painted on the rear walls of actual gardens, but also on the walls of triclinia and cubicula so as to illusionistically increase their size, opening them onto pergolas, woods, and hedges apparently located just beyond a screen or balustrade.

The relaxing divinity holds a cornucopia in his right hand, traditional attribute of river gods for its allusion to the fertility that rivers with their abundant water give to the earth. This personification of the Tiber was found not long after the discovery of a sculpture presenting a personification of the Nile.

The oar the Tiber holds in his left hand is probably emblematic of the navigability of his course. The statues of the two river gods, the Tiber and the Nile, may have been located—perhaps together with a representation of the Ocean—opposite each other on the sides of the Euripus Channel.

▲ Tiber, from Hadrian's Villa, Hadrianic period, Antiquarium, Hadrian's Villa, Tivoli.

The detail of the curled-up wolf suckling the twins made immediately clear the identification of this statue as a personification of the Tiber. The sculpture was found in 1954 in the Euripus Channel, not far from the drainage canal.

It seems probable that the statues of river gods installed in the gardens of Hadrian's Villa were copies, reduced in size and simplified, of the colossal statues of the Domitian age that decorated the Isei Campensis, the temple of Isis that stood in the Campus Martius. The statues are today in the Louvre (the Tiber) and the Musei Vaticani (the Nile).

The sanctuary, erected by Elagabalus on an artificial terrace on the Palatine overlooking the Colosseum, included a vast portico enclosing a garden; at the center was the temple dedicated to the emperor identified with the Sun, a late attempt to introduce to Rome, as in the eastern provinces, the worship of the living emperor.

The temple of Elagabalus was the last building erected on the Palatine, by then crowded and congested with constructions. He wanted the temple to house all the objects most sacred to the Romans, such as the aniconic stone of Cybele, the fire of Vesta, and the Palladium, the effigy of Minerva that Aeneas had saved from the flames of Troy.

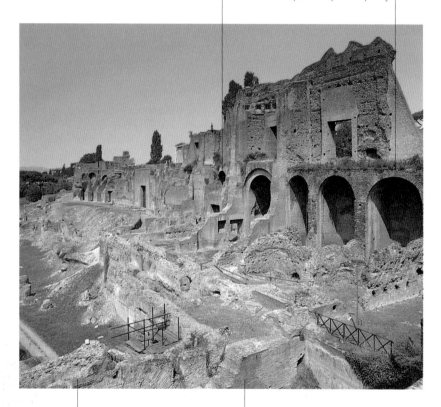

Among the largest and most famous gardens of Rome were the Horti Sallustiani, *which extended over a vast area between the Porta Salaria and the Porta Pinciana; the park became an imperial possession in* AD 20 *and was the favorite refuge for many rulers.*

Among the buildings in the Horti Sallustiani *was also a circus so large that the games could be held there when flooding made the Circus Maximus unusable.*

▲ Walls of terracing of the
Vigna Barberini on the Palatine.

"Here in Rome many sick people die from lack of sleep. Noise deprives them of sleep, and they develop indigestion . . . But what rented rooms ever allow sleep? In this city, sleep comes only to the wealthy" (Juvenal)

Insula

Related entries
Domus, City streets,
Ostia

Between the end of the republican age and the beginning of the imperial, the traditional structure of the Roman house underwent numerous transformations that reflected changes going on in Roman society. In terms of popular housing, the goal was the maximum exploitation of space at the lowest cost, leading to the creation of a new housing model in the imperial age, the apartment blocks called *insulae*. The old structure of the one-family *domus* of the republican age, with the collection of rainwater in the *impluvium*, gradually lost importance as Rome's numerous public aqueducts came into use, and the new home type, more rational and economic, took hold rapidly.

The large blocks of buildings in Ostia, presumably rental apartments, are an excellent example of the new building model. The four- or five-story buildings had independent apartments that faced the street or internal courtyards, were directly accessible by stairs, and were connected by wide galleries of external arcades; inside the apartments, which were illuminated by large windows, the space was exploited to the maximum, with partitions and intermediate floors, while the ground floor was taken up by a row of shops, most of them with back rooms or loft spaces that provided a small home for the shop manager. The more modest *insulae* formed a long, narrow structure on two parallel streets, while the finer blocks had an inner courtyard with fountains and flowerbeds.

▼ Model of porticoed palace and *insula* at Ostia, Museo della Civiltà Romana, Rome.

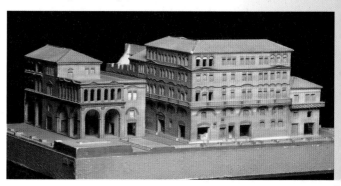

The façade of the second floor was decorated with narrow balconies that are still partially visible. The notable thickness of the ground-floor walls (about one meter) has been taken to indicate that the building had a considerable number of floors.

The House of Diana owes its name to a small terracotta relief inserted in the western wall that depicts the goddess hunting.

During the reign of Trajan the maximum height of buildings was reduced from 21 to 18 meters, but the rule was disregarded, with unlawful extensions disguised by setting them back slightly from the façade.

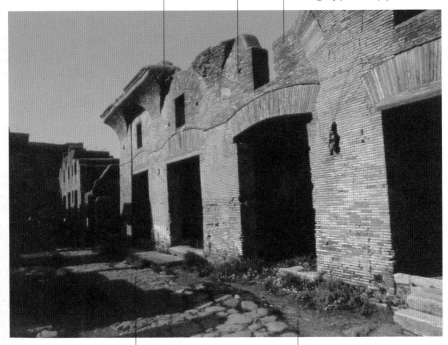

The Via di Diana is named for the building, which is a well-preserved insula *from the 2nd century that was excavated during the years of World War I by Guido Calza. On the opposite side of the street was a* thermopolium, *a sort of bar in which the service counters are still visible (see page 370).*

The first multiple-floor apartment houses were built in response to the increasing cost of building lots—which weighed most heavily on the construction of low-cost housing—and because of the need to increase the available living space in the center of a very large city without public transportation.

▲ Via di Diana, Ostia.

"Nowadays baths are called 'moth havens' unless they are designed to receive the sun all day long through very wide windows, unless people can get clean and get a tan all at the same time" (Seneca)

Baths

All Romans went to the baths, men and women, young and old, poor and rich. Indeed the rich, who could easily have afforded private baths, were among the most assiduous patrons of the public baths, where they went in the company of slaves and clients who assisted as they were rubbed down with oils and reinvigorated with massages. Even the emperor and the members of his family visited the public baths, mixing with the crowd. According to one's habits and physical condition, a bath could be a matter of cleanliness, a recreational activity, or a refined luxury. Beginning in the 2nd century BC women enjoyed access to Rome's public baths, using separate areas from those of the men or, when that was not possible, going at different hours; however, promiscuous use of public baths seems to have been a deeply rooted custom in Rome, as indicated by the several imperial decrees issued by Hadrian, Marcus Aurelius, and Alexander Severus to bring it to an end. Entrance fees were low or were waived, and the proper functioning of baths was the responsibility of the aediles, who saw to their cleanliness, temperature, and the proper performance of their suppliers. Aside from the manager or owner, every bath had doorkeepers, cloakroom attendants, employees in charge of the heating, massagers, and what we could call beauticians (specializing in depilation, ointments, etc.).

Related entries
Cursus honorum,
Baths of Diocletian,
Baths of Caracalla

▼ Central room of the *frigidarium* ("cold room") of the Villa of the Quintili.

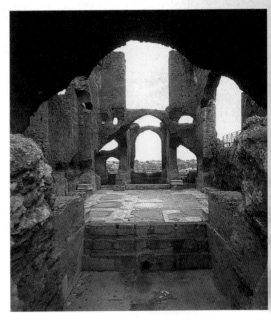

The caldarium ("hot room") had enormous arched windows overlooking the valley that were closed by panes of glass probably set in a metallic grid, although no traces of such grids remain.

The walls of the caldarium were dressed entirely in slabs of marble that were still visible in the middle of the 19th century. The ceiling was probably made of a cross vault covered in a mosaic made of dark and light blue and aqua green tesserae of vitreous paste; many such tesserae were found in the layers dating to the period when the structure was plundered.

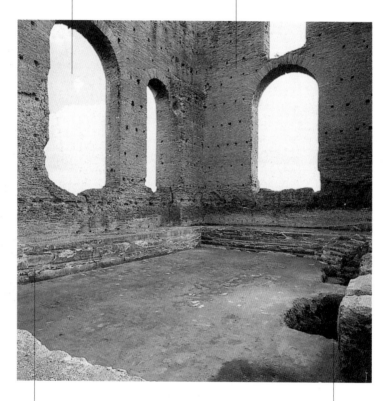

In the large warm-water swimming pool, which one entered from a heated vestibule paved in slate, the water reached the highest step.

These holes are the openings of the three furnaces (praefurnia) over which the large bronze cauldrons were mounted that served to heat the water of the pool. Warm air rose from the hypocaust, an underground space in which fir wood was burnt, the ashes being collected for the laundry; the warm air also circulated under the floors and through the walls.

▲ Caldarium, baths of the Villa of the Quintili.

In the city of Rome, the conduction and distribution of water were overseen by the state, while in towns it was in the hands of the local administration; used water was recycled to wash out lavatories or—as in the case of the water from the Baths of Caracalla—it was used to turn mills, after which it was emptied into sewers.

This large basin, which was found during excavations in the area of the Senate Building in 1979 and was placed in its current location in 1987, is from the Baths of Nero. It is carved from a single block of red granite 5.5 meters in diameter.

When restructured in the Severan age, the Baths of Nero included two columns that are today located on the left corner of the pronaos of the Pantheon, placed there in 1666 by Pope Alexander VI to replace the originals, which had been seriously damaged.

Remains of the Baths of Nero are visible under Palazzo Madama and in the basements of buildings nearby, while impressive structures are still preserved in Piazza Rondanini, the area of which probably coincides with the palaestra (exercise area).

Seneca may be referring to the Baths of Nero when he exclaims, "How many statues! How many columns that hold up nothing, but serve only as an ornament to attest to expense! How much water tumbling down a noisy waterfall! We have reached such a pitch of luxuriousness that only gemstones are good enough for us to tread on."

▲ Fountain in the Via degli Staderari, Rome.

This mosaic is an exceptional document since it is a unique case of an ancient depiction of the layout of a bathing complex; the building must have been of medium size—its side probably measured about 24 meters—and was probably a public bath operated by a private company.

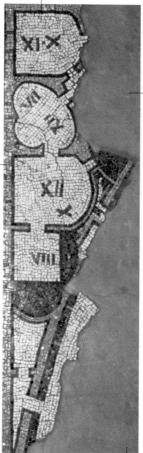

Public baths were essential since only the rich could afford private baths; the bathrooms in the homes of the less well-to-do were tiny spaces located near the kitchen to share its warmth.

A visit to the baths was a personal experience, the route taken was a matter of taste. Following what was perhaps the most common itinerary, you began at the dressing room, where you left your clothes and rubbed yourself with oil before performing gymnastic exercises in the palaestra; you then moved to the sauna (laconicum), in which you sweated profusely, then on to the hot-water room (caldarium) and a room with small pools of warm water (tepidarium); the last stops were a large unheated room usually richly decorated (frigidarium) and finally the covered swimming pool (natatio).

Agrippa built Rome's first public baths, opening them at no charge to everyone during his period as aedile. Seneca relates how the opening of each new bath made the others, even those recently opened, seem immediately old and obsolete.

▲ Mosaic in a building near the Via Marsala, with the layout in scale of a bathing complex.

The two wrestlers were found in the rooms of the Schola of Trajan, a large building identified as the site of the association of the Fabri Navales (shipwrights). Statues of athletes performing different athletics were often used to embellish the rooms of baths.

The pair of wrestlers presented in the final moment of their match has been mutilated and lacks the right hand of the wrestler about to be thrown; thus it is not possible to know if he is raising his arm to break the force of the fall or if this is a scene of pancratium, and he is about to punch his adversary in a final act of defense.

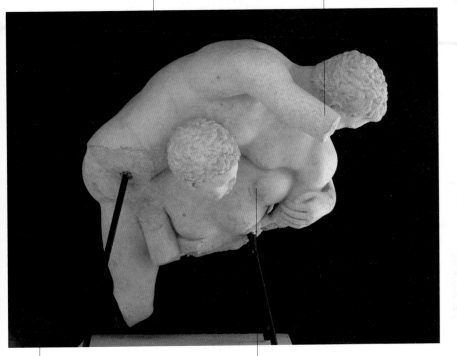

Pancratium was an originally Greek sport that mixed boxing and wrestling; the athletes who practiced it wrapped their hands to form boxing gloves.

The young wrestler has arched his back and is raising his adversary to throw him. The pair, of great artistic quality, was recently carefully restored.

▲ Wrestlers from the *Schola* of Trajan at Ostia, Hadrianic age, Museo Ostiense, Ostia Antica.

The head and torso have been so heavily reworked that it is not possible to propose a date for this sculpture; its current appearance is the result of modern manipulations.

The right arm and leg are the results of restoration work. The statue was in the Altemps Collection, listed as "a Lysippos," probably because that Greek sculptor was credited with having perfected statues of athletes standing with one leg lifted onto a rest.

Suetonius relates that Augustus "pampered his health, especially by not bathing too often and being usually content with an oil rub or with a sweat bath beside a fire, after which he took a bath of water either warmed or allowed to stand in the sun until it had lost its chill."

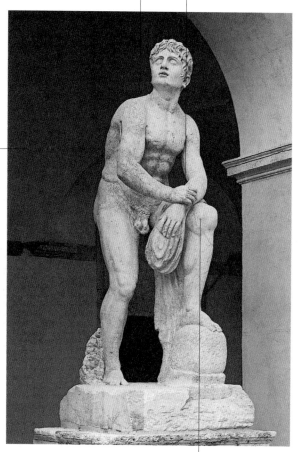

The pose of the figure resting one leg on a support—whether natural or artificial—is somewhat common in Greek art, on painted vases as well as in statuary.

▲ Resting athlete, Palazzo Altemps, Rome.

"What is more amazing . . . than people bold enough to sit in such treacherous, rickety seats . . . Here the entire Roman people, as if on board two frail boats, was supported by a couple of pivots" (Pliny the Elder)

Theater

Of theatrical performances it was comedies that enjoyed greatest success in Rome, most especially the Atellan farces, originally from Campania and introduced to Rome at the end of the 4th century. The most ancient Latin tragedies, based directly on Greek works, have mythological or historical subjects and date to the 3rd century BC, while the first mime performances took place in the 1st century BC. Women took part in these; indeed, they sometimes ended in a strip-tease.

For a long time during the republican period, the construction of permanent theaters in Rome was prohibited, so performances took place in mobile structures, perhaps similar to our circus tents. Among those structures was the highly admired theater/amphitheater of Scribonius Curio, who in 53 BC, to honor the memory of his father, who had died a year earlier, built two large theaters in wood facing opposite directions but hinged together. In the morning the two structures were kept separate and hosted two theatrical performances at the same time, but in the afternoon they were rotated to close and form the space of an amphitheater in which gladiatorial games took place. According to Pliny the Elder, it was possible to rotate the two theaters without making the spectators leave their seats.

The first permanent theater in the city was that built by Pompey inside the enormous complex he built in the Campus Martius; the curvilinear shape of its auditorium is still visible.

Related entries
Pompey, Muses, Music and dance

▼ Comic mask used as architectural decoration, Museo delle Terme, Rome.

The Theater of Pompey is still visible in the imprint it left in the urban fabric of the modern city since the outline of a part of the auditorium can be recognized in the curving shape of the houses in Via di Grotta Pinta, while its exterior face is highly visible in Via del Biscione.

Palazzo Righetti, which is located near Campo dei Fiori, is built exactly where the Temple of Venus Victrix stood and reuses its substructures. Traces of Roman walls in opus reticulatum—among the earliest examples of the technique in Rome—that were part of the structure of the theater can be seen in the basements of several buildings in the area.

Pompey built the theatrical complex on land he owned in the Campus Martius between 61 and 52 BC. Aside from the theater—the first built entirely in stone in Rome—the complex included an immense tree-lined portico decorated with statues and fountains and a curia.

In some of his letters, Cicero mentions that the inauguration of the theater, which had space for up to 17,000 spectators, was celebrated with sumptuous games. It seems possible that the theater was inaugurated in 55 BC during Pompey's sixth consulship, while the Temple of Venus located on top of the auditorium was not dedicated until 52 BC.

▲ Fronts of houses in
Via di Grotta Pinta.

The large sarcophagus was almost certainly made in Rome using a sort of album of models (fully 184 different scenes) based on the artistic world of the eastern provinces. It thus presents a kind of summary of all the eschatological ideas that appear in symbols reproduced on sarcophagi throughout all of the 3rd century.

The overall concept is that the human spirit is immortal and goes through life like an actor awaiting an after-life from which he will be able to communicate by way of love.

The large sarcophagus, made of Parian marble and discovered in 1955, is the work of Greek sculptors from Asia Minor and was probably made in a workshop in Rome.

The sarcophagus is divided in two bands; the upper band presents the Labors of Hercules, while the lower presents a series of scenes of life in Hades, a rural scene, and a sacrifice.

▲ Sarcophagus with the Labors of Hercules, from Velletri, second half 2nd century, Museo Civico, Velletri.

The masks are part of a decorative frieze in which they alternate with landscapes painted in rapid brushstrokes, much like that illustrated on page 317.

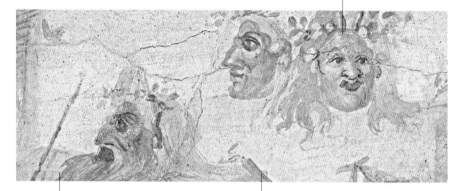

The masks were differentiated primarily by the color of the hair, which was also used to indicate age; the paler tones indicated female masks.

The prologue was usually a masked figure, wearing a tunic and pallium and bearing an olive branch, who appeared on stage and recited the introduction of the work to the spectators.

▲ Fresco from Ambulacrum G of the Villa Farnesina, ca. 19 BC, Palazzo Massimo, Rome.

Papposilenus is the result of a combination of the character Pappus, the old fool of Atellan farce, and the satyr of Greek drama.

The actor's face is covered by a mask, as is highly visible in the area of the mouth hole, though which the tongue and teeth are visible. The expression is scowling, the forehead is wrinkled, the nose is flattened and pug; also typical are the pointed ears.

In order to appear as the character Papposilenus, father of the satyrs and mentor of Dionysus, the actor wears a sleeved lambskin tunic that reaches his knees and a short mantle wrapped over his left shoulder and around his waist.

Satyr plays, introduced around the end of the 6th century BC at Athens, were performed by a chorus and dancers dressed as satyrs during the great Dionysian rites and followed in joking tone the typical plot of tragedy. They were introduced to Rome in the 3rd century BC, becoming integrated with the genre of the Atellan farces, an indigenous Italic form with set characters.

The legs of Papposilenus are covered by a kind of hairy stockings that seem made of goat hair.

▲ Statuette of actor, from the area of the Villa di Torre Astura, 2nd century, Palazzo Massimo, Rome.

The theater's façade, dressed entirely in travertine, originally had 42 arcades and three floors, for a total height of nearly 33 meters. There was room on the theater's steps for between 15,000 and 20,000 spectators.

During the Middle Ages the building was transformed into a fortress by the Savelli family, and it later became a residential palace of the Orsini. Its current appearance is a result of the work of Baldassarre Peruzzi.

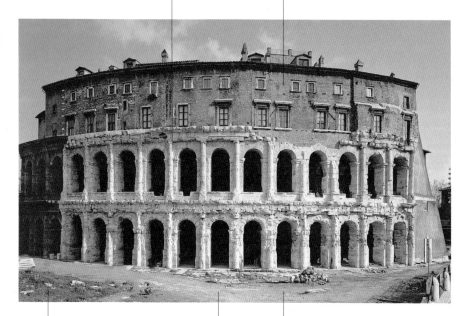

The Theater of Marcellus, begun by Caesar and completed by Augustus, stands on the same site where temporary theaters had been set up during the republican period. The building was dedicated in 13 or 11 BC to Augustus's young nephew—and chosen heir—who had died prematurely when not yet twenty ten years earlier.

The seats rest on a complex arrangement of semicircular and radial substructures, and the exterior presents a façade with several rows of arcades that acted as entrances and gave form to semicircular ambulacrums of various heights.

The distinguishing characteristic of a Roman theater was that it was built entirely of stone and could therefore stand anywhere, meaning it was completely free of the surrounding lay of the land.

▲ Theater of Marcellus.

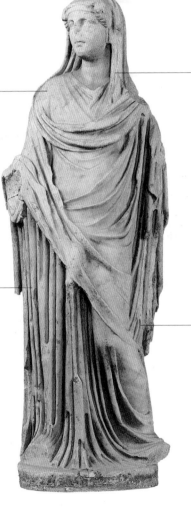

A theater in stone was probably built around the middle of the 2nd century BC, related to the Temple of Magna Mater, but the senators soon decided to destroy it. No signs of its structure have come to light during excavations in the area of the temple.

Hostility to theatrical performances on the part of the aristocracy contributed to the late appearance in Rome of a permanent theater; even so, it is possible that an ephemeral structure with a theatrical proscenium was installed as early as the first decades of the 2nd century BC.

Theatrical performances usually took place during the day, with actors who entered a narrow and wide stage from three doors; the curtain was introduced during the Augustan age. Made with rugs imported from Pergamum, it could be lowered to disappear in the pit in front of the stage.

The stage was equipped with increasingly complex theatrical machines: rotating platforms, stairs, pits, and trapdoors to facilitate appearances and disappearances, pulleys for the appearance of winged beings, and whatever else imagination and skill managed to devise.

▲ Statuette of actor, 2nd century, Palazzo Massimo, Rome.

Most of the action in both comedies and tragedies took place in outdoor settings; the figure of the narrator appeared to address the audience when it was necessary to relate indoor events.

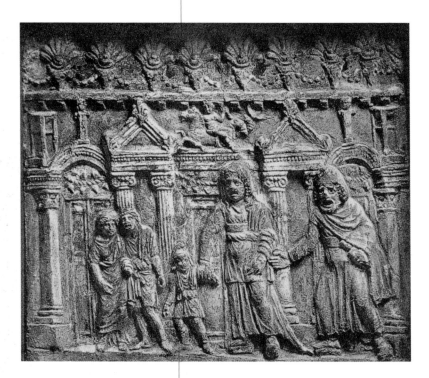

Little is known of Roman tragedy since only fragments have survived, but it most probably repeated the consolidated tradition of Greek tragedy, more or less paraphrasing the famous dramas of Euripides, Sophocles, and Aeschylus.

▲ Slab of terracotta from the sepulchral shrine of P. Numitorius Hilarius with the depiction of a tragic performance, Museo Nazionale Romano, Rome.

Amphitheater

The amphitheater was the scene of combat between men, of simulated hunts, of fights among animals, and even of gory exhibitions involving trained beasts; the popularity of these spectacles was a result of the astonished thrill of the spectators at seeing exotic animals, as well as the sudden appearance of scenery and natural backgrounds out of which beasts and hunters leapt.

Rome's gladiatorial games, offered to the people by the emperor, nearly always culminated in the death of the vanquished. Such was not the case in provincial towns, since many years were required to train a good gladiator, and the presenter of the games, who was almost always the owner of the champions, would not sacrifice them willingly. The battles staged between men condemned to death ended without survivors: the last man standing, exhausted by the battles, was dispatched by a gladiator who entered the arena well rested.

The movement to end the cruel spectacles that took place in the amphitheater became heated as early as the 3rd century, with the spread of Christianity, but not until 365 did Theodosia prohibit the condemnation of Christians to the arena. As late as the 5th century a monk named Telemachus was lynched by infuriated spectators when he ran onto the arena and tried to interrupt the games. Not long after that the gladiatorial events came to an end, but the animal hunts went on for a long time after that.

Related entries
Colosseum

▼ Relief with gladiatorial games, scene of the victor and the defeated, from the Via Arenula, end 3rd–early 4th century, Museo delle Terme, Rome.

The term venatio *("hunt") was applied to various kinds of spectacles that usually took place in the morning: battles among wild beasts, simulated hunts, exhibitions of exotic animals, performances by trained animals, and also battles between gladiators and animals and the executions of those condemned to death* ad bestias.

One servant holds open a cage while others drive animals (bears?) into it; the scene is framed above and below by a net probably intended to prevent the animals about to be captured from escaping.

▲ Mosaic with hunting scenes, from near the church of S. Bibiana, early 4th century, Centrale Montemartini, Rome.

The first bans on spectacles involving hunting date to 469 and the reign of Leo and Antemius, but two centuries later Justinian II was still trying to abolish them. Furthermore, on the basis of a watercolor by Bartolomeo Pinelli (1781–1835) we know that spectacles with bulls similar to modern corridas were being performed in the Mausoleum of Augustus, transformed into an arena.

The oldest account of a venatio *dates to 252 BC, and the animals in question were referred to as "Lucanian oxen." The Romans had first encountered these strange beasts, to their terror, a few years earlier, and the specimens in question had been captured in Sicily from the Carthaginian army, which commonly made use of them—known to us as elephants.*

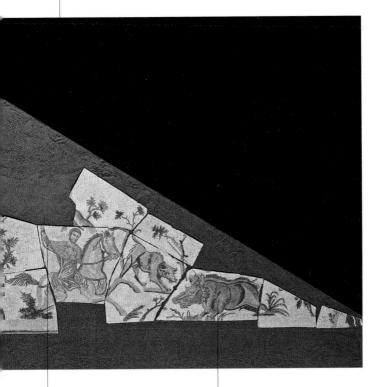

The figure on horseback with his hand raised, probably to hurl a spear at a running boar, may well be the leading figure of the story; he is distinguished by his dress and the care with which the details of his face have been rendered, including a short beard.

The mosaic depicts scenes of hunting bears, gazelles, and other animals to be used in the venationes *in the amphitheater; on the right is an episode of boar hunting.*

In 325 Constantine issued an edict in which he expressed his disapproval of the bloody spectacles that took place in the amphitheater, but he did not decree their abolition.

By the 4th century it had become so difficult to come by gladiators that the custom arose of directly recruiting them from the army, which continued until an imperial edict put an end to the practice, in 357. Around the end of that century the emperors Arcadius and Honorius had to intervene to prohibit senators from using gladiators as bodyguards.

Precisely when the gladiatorial games came to an end is unknown, but edicts issued in 414 and 417 authorized arena personnel to kill lions in the event of dangerous situations, for the first time putting the value of human life above the value of the spectacle.

One gladiator, dying, collapses to the ground while another, armed with sword and shield, awaits the attack of wild beasts.

An attendant drives a lion into the arena with a long lance.

▲ Section of a Campana frieze, mid-1st century, Museo Nazionale Romano, Rome.

"An inundation of the Tiber flooded the circus in the middle of the games, which produced unspeakable dread; it seemed as though the gods had turned their faces from men and despised what was done to appease them" (Livy)

Circus

The circus, the largest structure for spectacles in the Roman world, was used for the performance of the wildly popular chariot races (*circus* was the Roman word for "racetrack"). The course was divided down its main axis by a *spina* ("backbone"), a low wall, with pillars at the far ends—the turning posts, around which the course turned. There were seven laps in each race, the laps marked off with wooden eggs and bronze dolphins located inside the *spina*. The chariots, drawn by two or four horses, were extremely lightweight, and the charioteers needed great skill to avoid spills; of course, their ruinous falls constituted a primary thrill for the spectators. Like a modern-day sports arena, the Roman circus was surrounded by taverns, stalls, and shops, and while the spectators on their seats watched as many as a hundred races a day, they were prey to thieves, prostitutes, peddlers, and idlers of every sort.

Rome's oldest circus structures date to the period of the Etruscan kings, but construction activity in the valley between the Palatine and the Aventine hills really began only in 329 BC, with the construction of the starting gates for the chariots and the central *spina*; in 174 BC, the eggs used to count laps were put in place in the *spina*, and Agrippa added the bronze dolphins in 33 BC. The Circus Maximus remained in use throughout late antiquity, the last races being organized in 549 by Totila, last king of the Ostrogoths.

▼ Mosaic *emblema* with depiction of a charioteer, from the Villa di Baccano, early 3rd century, Palazzo Massimo, Rome.

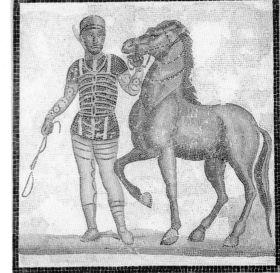

Augustus embellished the spina *with the obelisk of Ramses II—today in Rome's Piazza del Popolo—and Constantius II, in 357, added the obelisk of Thutmose III, today in the square of St. John Lateran.*

The charioteers and their horses were divided in teams, identified by different colors, that attracted wildly faithful fans; over time the teams took on the characteristics of factions and had great influence on political life.

▲ Circus Maximus.

Charioteers were idolized and stood to accumulate fortunes. Such was the case with Diocles, of Portuguese origin, who in the 2nd century competed for the Red team for twenty-four years, winning 3,000 times with the two-horse chariot and 1,462 with the four-horse; by the time he retired at age forty-two he had accumulated the fabulous sum of 3.5 million sesterces.

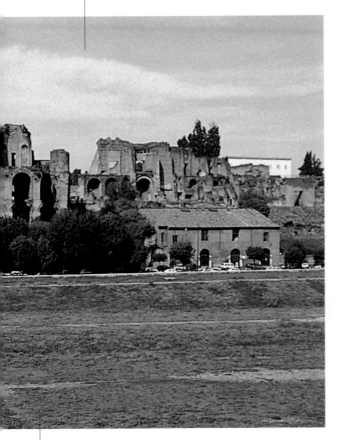

According to the estimates of Dionysius of Halicarnassus, during the age of Augustus the Circus Maximus had a capacity of 150,000 spectators; Pliny the Elder calculated that after its complete restoration by Nero—following the Great Fire of 64—its capacity reached 250,000.

Waxed-tablet diptychs, made of wood, ivory, or other precious materials, were composed of two hinged leaves with the interior face waxed and used for writing and the exterior face richly decorated. During the 4th century, such tablets became popular luxury gifts; a law passed in 384 restricted their use as gifts to consuls entering office.

The magistrate in charge of the games, probably a member of the Lampadii family, watches a quadriga race in the Circus Maximus.

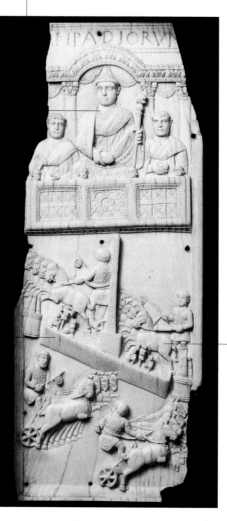

The skill of the charioteer consisted in taking the curves as narrowly as possible so as to gain distance; nearly any kind of roughness was permissible to block an adversary or force him to crash into a wall.

Four charioteers are competing, racing along the spina; the two turning posts are clearly visible, as is the obelisk in the middle of the spina.

▲ Diptych of the Lampadii, first half 5th century, Museo di S. Giulia, Brescia.

"The audacious retailers had appropriated the entire city; no threshold kept within its own bounds. You bade the narrow streets expand, Germanicus, and what had lately been a track became a road" (Martial)

Markets and storehouses

There were public markets in Rome for the distribution of food, artisan manufactures, and housewares; they were directed and managed by magistrates who oversaw their proper functioning and lawfulness. There were also weekly markets where farmers went to sell their vegetables, fruit, and other products and to purchase what they could not produce on their own. In various parts of the city there were shops where bread, legumes, vegetables, and other foods could be purchased, and peddlers set themselves up under the porticoes of squares, along streets, or under tents, usually in the most crowded areas, such as near the entrances to baths or the amphitheater. There were also numerous shops where prepared food was sold, in some cases true restaurants with one or more interior rooms or with a large marble counter with openings to hold containers for food and drinks.

The shops like bakeries, with ovens for bread and pastries, usually performed all the steps in the process, from grinding the grain to selling goods both wholesale and retail.

Storage and distribution always presented problems, and as early as the end of the 2nd century BC the first large-scale warehouses came into being—the *horrea*—such as the Porticus Aemilia, a building with 3,000 square meters of space, built in *opus incertum (caementicium)*—rubble with cement mortar—the first use of the technique in Rome. The storehouses, under the direct supervision and control of the officials of the Annona, were concentrated almost exclusively on the plain behind the river port.

Related entries
Annona, Fleet, Ports, Forum and Markets of Trajan, Forum Boarium and Forum Holitorium, Ostia

▼ Temple of Hercules Victor in the Forum Holitorium.

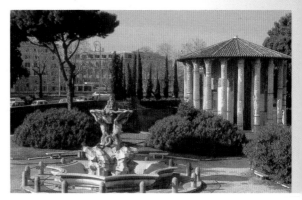

Fruits and vegetables are spread across the counter, displayed on overhanging shelves, collected in bunches, or stored in woven baskets.

According to Cicero, shopkeepers were to be distrusted, and "Those who buy to sell again as soon as they can are to be accounted as vulgar; for they can make no profit except by a certain falsehood." However, it seemed to him that the long waiting times involved in large-scale commerce justified the earnings.

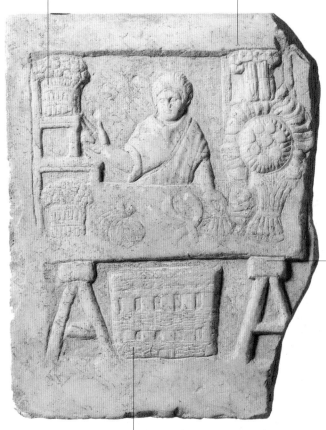

The counter, laid across saw-horses, seems a provisional and mobile structure, not unlike those that are found in open-air markets today.

The large basket on the ground beneath the counter was probably used to transport goods, and one can imagine that it was also used as a temporary storage place for whatever there wasn't room for on the counter and shelves.

▲ Fruit and vegetable seller, from Ostia, Museo Ostiense, Ostia Antica.

The inscription on the marble tablet set in the architrave over the main entrance—Horrea Epagathiana et Epaphroditiana—makes absolutely clear—and this is the only instance at Ostia—the use of the building as a storehouse for foodstuffs.

The main entrance to the storehouse is located on its northern end, and its door is decorated with two brick columns with capitals and architraves.

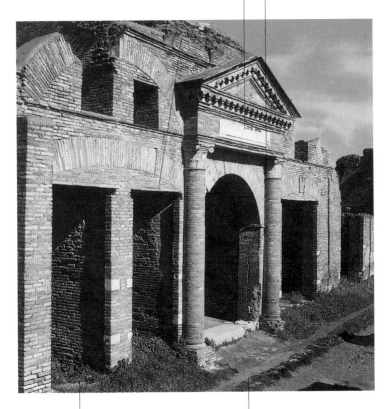

Inside the complex was a square courtyard surrounded by a portico paved with a black-and-white mosaic onto which opened rooms of various size; the largest of these rooms may have been the office. Two flights of stairs led to the upper floor, the layout of which was probably quite similar to that of the ground floor.

The two owners—Epagathus and Epaphroditus—were freedmen active around the middle of the 2nd century. The kind of products they stored is not known, but the many security systems—including many doors locked with wooden beams—suggests that they dealt in products of a certain value.

▲ Entrance to the *Horrea Epagathiana*, Ostia.

Testaccio is an artificial hill created by the systematic accumulation of thousands of fragments of amphorae that, emptied of their contents and broken up, were piled up in an orderly way, alternating layers of fragments with layers of lime, under the supervision of officials, who also oversaw the creation of the necessary works of containment.

Only amphorae that had held olive oil were used to make Monte Testaccio—such containers could not be reused because of the rapid alteration of any residual oil—from Baetica (Spain) and, to a lesser degree, from Byzacena (Tunisia).

The refuse heap, which remained in use for about 270 years, beginning in the period of Augustus, is today a precious mine of information, including study of the seals and inscriptions on the amphorae, which bear the names of producers and merchants, the varying capacities of the containers, control marks, and much other information.

▲ Monte Testaccio.

City streets

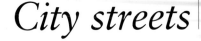

Rome's street network included many slopes, called *clivi*, along with flat streets, called *vici*; the intersection of the Clivus Argentarius, the Clivus Capitolinus, the Via Sacra, and the Vicus Jugarius was considered the center of the street network, the departure point for all the most important streets of the empire. The care of the city's streets as well as those in the suburbs, within a thousand paces of the city, was the responsibility of aediles, but maintenance of the streets was the responsibility of the owners of the buildings facing

Related entries
Traffic and means of
transport, *Insula*

▼ Via Biberatica.

the street; in the case of streets bordering a lot or building belonging to the public, the work done was paid for by the treasury.

Only with the expansion of the city toward the Campus Martius and Trastevere and, most of all, with the rebuilding following the Great Fire of 64 was an attempt made to rationalize the city's street network in accordance with an overall plan. The streets had to be wide enough to permit the easy passage of carts and had to have a slightly convex surface to facilitate the shedding of water. Streets were often flanked by sidewalks, set a little higher then the street level, and oval stones were set in the street to indicate pedestrian crossings, most often serving the entrances to homes or public buildings.

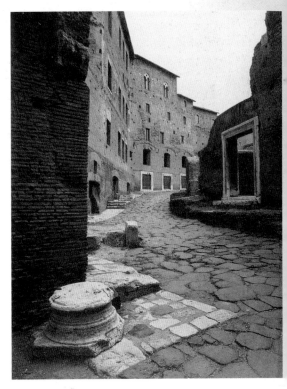

The street that climbs the Caelian Hill between the church of S. Gregorio al Celio and that of SS Giovanni and Paolo and that today bears the name of Clivo di Scauro follows the route of an ancient street that probably bore the same name; in fact, a Clivus Scauri has existed since at least the 8th century.

The arches over the street date to the Middle Ages but rest against walls that date to the imperial age. Those walls, which reach a notable height, have been incorporated in the construction of the religious buildings.

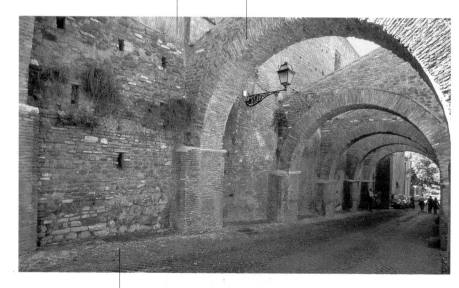

Much of Roman life took place in the street, and peddlers and vendors crowded the sidewalks and porticoes in such a chaotic way that Domitian issued an edict that prohibited blocking public property. Martial wrote that finally "The barber, the taverner, the cook, the butcher keep to their own thresholds. Now it is Rome; it used to be a big shop."

▲ Clivo di Scauro.

Keeping streets clean was a public service of primary importance to the health of Rome's citizens; the city's central administration saw to the collection and transportation to sewers of garbage, but nothing could be done to keep the people in private homes from throwing their waste into the streets during the night, a problem that continued until 1870.

Names of streets were often derived from their predominant commercial use, as in the case of the Clivus Argentarius, the street of the bankers. The name of Via Biberatica is attested to only from the Middle Ages, but given its probable derivation (bibere, "to drink"), it most likely recalls the presence of hostelries and wine shops in the Roman era.

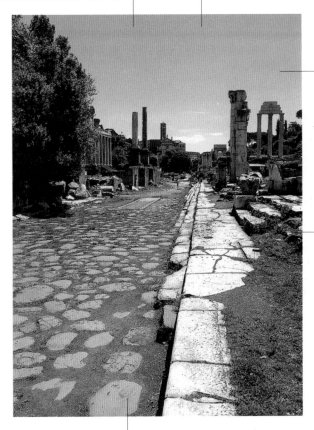

One could eat in a trattoria, of course, where it was also possible to find prepared food to take out; also for sale were fire and warm water.

"I was strolling by chance along the Via Sacra, musing after my fashion on some trifle or other, and wholly intent thereon, when up there runs a man I knew only by name and seizes my hand: 'How d'you do, my dearest fellow?'" (Horace)

Rome had many trattorias and hostelries, but also simple bars, composed of one or more rooms, that gave onto the street and had only a counter at which clients were served. These were for the most part dirty and hardly welcoming, but there was always the possibility of doing a little gambling in the back room.

▲ The Via Sacra in the Forum Romanum.

The frieze, roughly five meters long, must have decorated the entire side of the base of an altar or a colossal statuary group.

The Official slaughterers lead animals—a bull, an ox, and a cow—to sacrifice; some bear the tools of the sacrifice, a knife, an ax, and the malleus ("hammer"), while others push the animals forward.

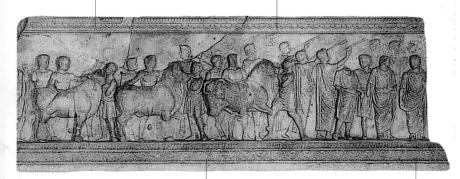

Leading the procession are two togaed figures, probably a pair of vicomagistri *in their first year in office; visible behind them are three lictors; next come attendants dressed in tunics and three tuba players.*

Following are a new procession of togaed figures with their heads crowned with laurel accompanied by musicians in the background, while in the foreground, presented in particularly high relief, are other figures, four in the dress of magistrates, much like the pair at the beginning of the procession.

▲ Base of the Vicomagistri, relief from the Palace of the Cancelleria, Tiberian age, Musei Vaticani, Rome.

"When the people complained about the . . . high price of wine, he [Augustus] said that his son-in-law Agrippa had made adequate provision for thirsty citizens by building several aqueducts" (Suetonius)

Water and aqueducts

So advanced was Rome's water-supply system that only modern industrial nations have succeeded in outdoing it. During the imperial age, the eleven aqueducts feeding the city had the capacity to deliver about 1 million cubic meters of water daily, more or less one thousand liters per inhabitant, a supply that was not equaled until recent decades. Running water was guaranteed only to public buildings and to the private homes of the wealthy and the influential. To avoid abuses and disputes, the owner's name was stamped into the lead water pipes *(fistulae)*; the inhabitants of the blocks of rental apartments got their water from the city's many public fountains. It seems that there were more than 1,300 such fountains in the 4th century.

The concession of water to private persons was regulated by very strict laws: water could not be drawn directly from an aqueduct, and instead the owner had to be connected to a distribution *castellum* using a *calix*, a short bronze tube to which the *fistula* was soldered, and the water commissioners checked that the quantity of water taken was in keeping with the authorization and that the attachments were in the right position, meaning perpendicular to the wall. This system was designed to avoid fraud since bronze, unlike lead, could not be expanded to increase the amount of water drawn. The *calix*, smaller than the lead pipes, with a diameter of 2.13 centimeters, had a capacity of more than 40 cubic meters per day.

▼ Section of the Claudian aqueduct in the Roman countryside.

According to tradition, construction of the Cloaca Maxima began under the Tarquins. That date would concur with the works of urbanization that followed the final consolidation of the city's structure in the years between the 7th and 6th centuries BC.

A well-preserved stretch of the Cloaca Maxima can be seen near the Arch of Janus in the Forum Boarium.

According to tradition, near the shrine of Venus Cloacina a girl named Virginia was killed by her father to save her from the lust of one of the decemvirs, Appius Claudius, and this event was the element that set off the popular revolt that led to the downfall of the decemvirs.

The Cloaca Maxima entered the forum near the steps of the Basilica Fulvia-Aemilia, at the site of a shrine dedicated to Venus Cloacina, an open-air enclosure in which stood two cult statues of the divinity, one as Venus and one as Cloacina.

▲ Cloaca Maxima.

Most of Rome's water was used to feed the city's public fountains, and what drained away was used to clean its sewers. Rome still has many fountains, and they are served by the same water supply.

The reliefs, datable to the Domitian age, were reused, probably by Alexander Severus, in the construction of an immense fountain that stood above the castellum of the Aqua Julia. In late antiquity the monument was called the Nymphaeum Alexandri.

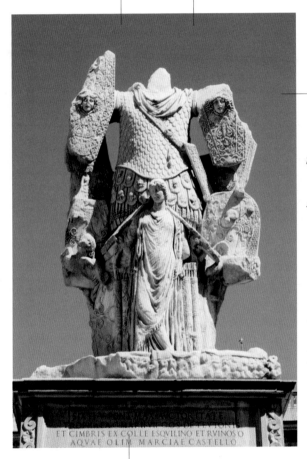

During the republican period, water was a good that belonged exclusively to the people; it was in the Augustan age that this changed, with water becoming something conceded to private persons by the emperor on the basis of a contract that ended automatically with the death of the concessionaire or with a change in the ownership of the property.

▲ One of the two reliefs of the so-called Trophies of Marius in Piazza del Campidoglio.

The two large monuments with presentations of trophies of weapons were located on the impressive brick structures that stood on the northern corner of Piazza Vittorio Emanuele and were moved to the Piazza del Campidoglio in 1590.

"The pile bridge almost provided the enemy with access to the city, but one man, Horatius Cocles . . . warned and ordered the Romans to destroy the bridge with iron implements, fire, or any instrument at their disposal" (Livy)

Bridges

Related entries
City streets, City walls
and gates, Consular
routes and roads
outside the city

The Romans built nearly two thousand bridges in the creation of their complex road network. Many of these bridges were feats of astonishing technical skill, and they remain the most conspicuous part of Rome's communication network. That so many have survived over the centuries attests to the skills of the Roman engineers, but also reflects the fact that they were maintained and rebuilt through the Middle Ages into the modern era. Indeed, setting the foundations for a bridge in water proved so difficult that no new bridges were built in Rome until 1886, when the pylons were built for a new bridge dedicated to Queen Margherita.

Rome had only four bridges during the republican period. The oldest of these, of which there are no traces, was the Sublicius, built in wooden beams joined without the use of iron so it could be destroyed in time of danger; the Aemilius, Rome's first stone bridge, was built in 179 BC and is known today as the Ponte Rotto. In 62 BC the Pons Fabricius was erected, and a few years later the Pons Cestius, both built to connect Tiber Island with the banks of the Tiber. Another five bridges were constructed during the imperial age, among them the Neronianus, of which a few traces remain alongside today's Ponte Vittorio Emanuele; the Neronianus was probably knocked down even before the 6th century since it stood outside the city walls and had become a weak spot in the defensive system.

▼ The Milvian Bridge.

Along with the city bridges, bridges were built on roads outside Rome, such as the Ponte Nomentano built over the Aniene probably between the end of the 2nd century and the early 1st century BC and fortified with a double portal and guard posts only when the danger of invasions became pressing.

To throw the pylons that were to support the structure of a bridge watertight forms made of oak logs bound together with chains were lowered into the water and solidly anchored to the riverbed. The interior of these forms was then emptied of water and filled with blocks of stone and concrete. The arches of the bridge could then be constructed using wooden centering.

Roman engineering creativity reached notable levels in the construction of bridges primarily by taking advantage of the application of arched spans, making it possible to erect increasingly large bridges without having to worry about the often irregular heights of the terrain.

The Ponte Salario, an ancient wooden structure that helped the Sabines reach the mouth of the Tiber, was fortified as a defense against the barbarians, but was destroyed in 547 by Totila and then rebuilt twenty years later under the Byzantine general Narses.

Various expedients were used to protect bridges from damage caused by debris carried on the current or by flood waters, including small openings in pylons and the construction of buttresses.

▲ Ponte Nomentano.

The Via dei Pettinari still feeds into the bridge, running over the exact stretch of the ancient road.

The Ponte Sisto was built by Pope Sixtus IV around 1470, perhaps incorporating the structure of the ancient bridge made by Agrippa.

Some sources claim that Agrippa built—and then rebuilt, in 12 BC, the year of his death—a wooden bridge that opened the way toward Trastevere. According to others, however, the bridge was built ex novo under Antoninus Pius.

▲ Ponte Sisto.

"When hostilities ceased . . . all hope of lightening the load of debt vanished since new debts were being contracted to meet a tax imposed for the construction of a stone wall, contracted by the censors" (Livy)

City walls and gates

Tradition holds that Rome's oldest walls were built by Servius Tullius, but the ponderous ring of walls today called the Servian Wall dates to the period immediately following the Gallic occupation; restored several times over a period of three centuries, these walls gradually fell into disuse and were deliberately torn down in the Augustan age. For nearly three hundred years Rome stood without fortifications, until Aurelian, in 271, thought it would be prudent to give the capital defenses to protect against possible barbarian incursions while he was away. Incorporating several existing structures in the perimeter simplified the work, most of which was probably completed by the emperor's death, in 275, leaving very little still to be done by Probus (ruled 276–82). These fortifications were restored and reinforced by Maxentius and, most of all, by Arcadius and Honorius who, in 401–2, to withstand the attacks of the Goths, doubled the height of the walls and replaced the open walkway at the top with a covered gallery and included the Mausoleum of Hadrian within the defensive system, which became a forward outpost on the right bank of the Tiber.

▼ A section of the Servian Wall near the Stazione Termini.

In Aurelian's design the main gates in the walls were twin entrances covered by arches and framed by semicircular towers; secondary openings were simply inserted in a stretch of wall between a pair of square towers. Arcadius and Honorius eliminated many of the double entrances and raised the towers, turning them into true self-sufficient fortresses.

The bronze statues of Gaius Cestius, today preserved in the Musei Capitolini, were made with money earned from the sale of several tapestries from Pergamum that could not be placed in the tomb because of a law against luxury issued in 18 BC.

An inscription on the eastern side of the pyramid of Gaius Cestius states that the monument was erected in fewer than 330 days in obedience to the instructions in the will of the deceased. Another two inscriptions recall some of the heirs of Cestius, among them Agrippa, Augustus's son-in-law.

The tomb of Gaius Cestius, who was perhaps involved in the construction of the older Pons Cestius, is datable to between 18 BC—date of the law against luxury—and 12 BC, year of the death of Agrippa.

For many centuries Rome had no ring of defensive walls since it was threatened by no dangers. The city had a border, however, the pomerium, the boundary that marked off the sacred precinct and that could not be crossed with weapons without violating the law and incurring the wrath of the gods.

▲ Aurelian Walls and Pyramid of Cestius.

The stretch of road today called Via di Porta S. Sebastiano, which leads from there to the Porta Capena, corresponds to the urban stretch of the Via Appia, meaning to that portion of the consular road that was incorporated in the enlargement of the pomerium.

Entering the city, engraved on the left wall of the gate is the figure of an angel and an inscription in medieval Latin that recalls that in front of the Porta S. Sebastiano the Romans fought a victorious battle against Robert of Anjou, king of Naples, in 1327.

Porta S. Sebastiano—or Porta Appia—is the largest and best preserved gate in the city's walls. Five successive phases of building are visible in its makeup.

▲ Aurelian Walls and
Porta S. Sebastiano.

The gate, which was originally called Porta Appia, after the name of the road that left from it, had a double door and portcullis that moved along a groove and was controlled from a room on the upper floor.

The two arches of the Porta Maggiore, built to carry the Aqua Claudia over the Via Praenestina and the Via Labicana, were incorporated and transformed into city gates. Under Honorius a bastion was built with gates to its sides; these were demolished in 1838. The inscriptions on the attic are originals from the age of Claudius.

The frieze, a continuous relief made using the same narrative technique as that used on triumphal monuments, depicts all the steps in breadmaking: weighing the grain, grinding it, sifting it, preparing the dough, and baking. Each of these operations is witnessed by a togaed person, most probably Eurysacis.

Immediately outside the gate, between the Via Praenestina and the Via Labicana, is a monumental tomb, datable to between 40 and 30 BC, the trapezoidal shape of which is a result of the presence of even older sepulchral monuments that affected the available space.

The inscription on the monument relates that Marcus Vergilius Eurysacis was the owner of a breadmaking enterprise and that he was also a state contractor and probably collaborated with various magistrates or priests. His trade is confirmed by the urn bearing his wife, which is shaped like a trough for kneading bread.

▲ Porta Maggiore and the tomb of Eurysacis.

"Ostia is harborless on account of the silting up, which is caused by the Tiber . . . the merchant ships must anchor far out in the surge . . . a plentiful supply of tenders receive the cargoes" (Strabo)

Ports

From the most ancient times there was a port in the area of the Forum Boarium. Perhaps it was hardly more than a landing place where ships could be pulled ashore, but it was there, as early as the 6th century BC, that Rome's first true port arose. By 193 BC the installation was no longer capable of handling the city's commercial traffic, and work began on construction of a new port farther downstream, fitting out the area giving access to the river with the steps and ramps necessary to unloading goods and creating a vast open space destined to become a market and known as the Emporium.

The maritime port at the mouth of the Tiber had been made to handle large mercantile ships whose cargoes were unloaded onto smaller vessels to ascend the river to Rome. It offered little shelter to the ships, and access to the river port was difficult because of the continuous accumulation of detritus at the mouth of the river. Before the middle of the 1st century it had become necessary to create a more functional port complex, and under Claudius a new basin was dug to the north, served by two piers curving seaward and a large lighthouse; this complex, too, soon became unsuitable since its position made it subject to silting up, nor did it offer enough security for ships riding at anchor during storms. The problem was finally solved under Trajan with the digging of a second, more sheltered harbor, connected to the Claudian port by a canal with a lighthouse at the opening.

▼ Port of Trajan.

The Temple of Portunus is a clear sign of the existence of the ancient Tiber port, which although abandoned over the course of the 2nd century in favor of the structures built farther downstream, must have still been functioning in imperial times, at least as a terminal for small river ships coming from the Sabine hinterland.

In the Trajanic era, the area of the ancient port must have been occupied by storehouses and deposits, probably a reworking of the Horrea Aemiliana, Annona storehouses built in 142 BC by Scipio Aemilianus; remains of these structures were found during the work performed for the construction of the palace of the general registry office in 1936–37.

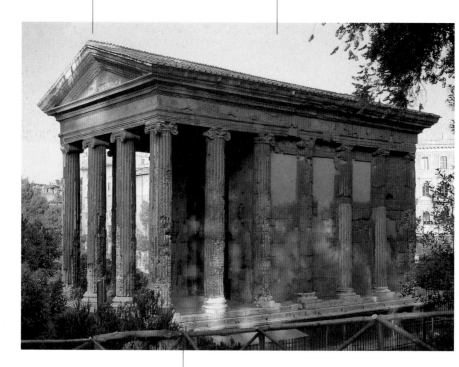

The Temple of Portunus, also known erroneously as the Temple of the Fortuna Virilis, stands on the embankment created during the reworking of the banks of the Tiber early in the 2nd century BC, while traces of the more ancient phases—from the 4th or 3rd century BC—were identified in excavations conducted in 1947.

▲ Temple of Portunus
in the Forum Boarium.

Scene of navigation with two ships in a sea densely populated by fish.

The earliest studies of Roman naval architecture date to the early 1930s when two gigantic ships from the age of Caligula came to light following the draining of Lake Nemi. These were flat-bottomed, sumptuously decorated vessels made for pleasure cruises on the lake.

The two ships were destroyed during World War II so it is no longer possible to examine the details of their construction, which were not taken into consideration at the time of the excavations.

The first underwater archaeological research dates to the 1950s, when new breathing apparatus was introduced; since then an enormous quantity of information has been obtained, with the investigation of many wrecks and the continuous discovery of new ships, even at great depths.

▲ Fresco from the Lungotevere di Pietra Papa, ca. 125–150, Palazzo Massimo, Rome.

For a long time, port structures represented the primary limit to maritime transport, since large ships quite often could not enter ports because of shallow bottoms and were forced to remain in the roadsteads, where they had to carry out slow operations of unloading cargo onto smaller ships.

The relief depicts a scene located in a crowded port and is dominated by the three large figures of Freeman, Freewoman, and Venus; the goddess should be interpreted as a metaphor for their voyage to and arrival in the world of the dead.

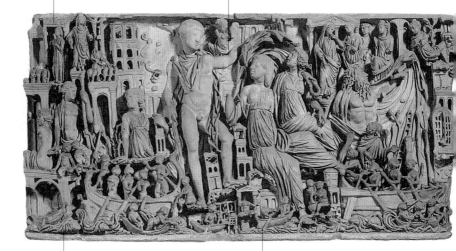

Because of the swampy conditions created by the mouth of the Tiber, the cargo ships that arrived at Ostia had to anchor in the open sea, often with disastrous results, as when two hundred ships were destroyed by a storm in 62.

Until the age of Trajan, Rome did not have a port suitable to its needs, and the ships of the Alexandrian fleet that served as grain ships for the capital were forced to use the port of Pozzuoli, which also had large storehouses for housing the foodstuffs.

▲ Front of sarcophagus, around the mid-3rd century, Musei Vaticani, Rome.

The three-story lighthouse indicates that the scene takes place in the waters immediately outside Rome's port of Portus.

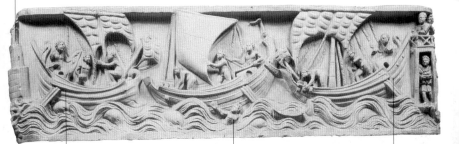

The hulls were built by covering the keel and framework of the ship with planking, but also with the opposite process, attaching the planking directly to the keel and inserting the skeleton of the framework. The planking could be held together with joints, with tongues held in place by wooden pins, or with stitching.

Particular attention was given to making hulls watertight; they were often dressed in lead sheeting held by nails before being covered with a layer of pitch.

The relief depicts stormy seas with a lively scene of a collision and the preparations to save a man overboard.

▲ Cast of the front of a sarcophagus, Museo della Civiltà Romana, Rome.

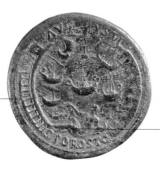

The coin, with a bird's-eye view of the port of Ostia, celebrated the completion of the complex begun under Claudius in 42.

The reclining figure of the Tiber indicates the close relationship between the maritime port of Ostia and the river navigation necessary to reach Rome.

Following somewhat recent excavations we know that the storehouses of Portus were abandoned in the 5th or early 6th century, but the port structures remained in use until at least the second half of the 9th century.

Recent studies have made possible identification of the statio marmorum, *the terminal for importations of marble located on the southern shore of the artificial canal of Fiumicino.*

▲ Sesterce of Nero, 64–67 (obverse), Palazzo Massimo, Medagliere, Rome.

▲Portus, portico from the Claudian age.

Many rough-hewn pieces of marble from different provenances have been found at the statio marmorum, *some marked with lead seals bearing indications of the management of the quarries and the control of the central power on commerce.*

"Appius Claudius laid together stones smoothed, leveled, and shaped at the corners, without mortar or other bonding material . . . and despite the time and the number of vehicles . . . their structure is not broken" (Procopius)

Consular routes and roads outside the city

During the archaic age Rome was connected to nearby towns by trails worn across fields that spread out in all directions over a radius of about twenty Roman miles and that, with the passage of time, came to assume the physical reality of roads. The most ancient road was the Salaria, which connected the territory of the Sabines with the mouth of the Tiber where the sheep-rearing tribes went for salt, a vital product not available elsewhere. The first paved road, the Via Appia, opened in 312 BC by the censor Appius Claudius Caecus, used the highly effective construction technique that made Roman roads so enduring.

From legal and administrative points of view, the roads outside the city of Rome were divided into those private *(viae privatae)* or military *(viae militares)*, primary public roads *(viae publicae)*, and secondary roads *(viae vicinales)*. The heavy financial burden of constructing the road network was originally paid out of the treasury and later also out of revenue from taxation. Various inscriptions tell of the high costs of road maintenance. In 182 BC, the repair of a somewhat worn-out twenty-mile stretch of road in an area of the Apennines cost fully 150,000 sesterces, an enormous sum if compared with the three sesterces salary of a workman in Rome at the middle of the 1st century BC.

Related entries
Bridges, Via Appia

▼ Via Appia.

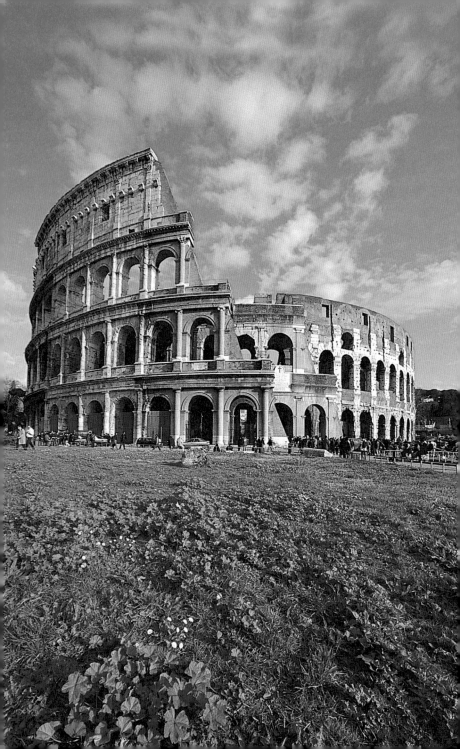

Sites and monuments

◀ Colosseum.

"Some of the ships of Antium were taken into the Roman docks, others were burnt and their beaks were fastened on the front of a raised gallery constructed at the end of the forum ... called the Rostra" (Livy)

Forum Romanum

Location:
On the slopes of the Palatine, between the Capitol and the valley of the Colosseum

Chronology
Site of a necropolis from the 9th to the 6th century BC; earliest constructions date to the end of the 7th century and beginning of the 6th; last construction is the Column of Phocas of 608 BC.

Function
Center of political and religious life throughout the republican period and symbolic center of the state during the imperial age

As early as the 9th century BC, the site on which the Forum Romanum came to stand, an unhealthy, marshy hollow crossed by the Velabrum, a small brook that emptied into the Tiber, was being used as a necropolis by the inhabitants of the surrounding hills. Around the end of the 7th century BC, the construction of the Cloaca Maxima led to the canalization of the stream and thus the reclamation of the area, which was also given a first flooring in beaten earth. In a short time the square of the forum became the center of the political, economic, and religious life of the city; there arose the first shops, the most ancient Roman cults had their centers there, and in the 6th century BC a complex was built for the meetings of citizens, senators, and magistrates. With the progressive monumentalization of the square, the original earthen floor was replaced by paving that was restored several times over the course of the centuries; the arrangement visible today dates to 9 BC, when the praetor L. Nevius Surdinus had the paving redone after a series of fires had devastated a large part of the forum.

The area was the site of building activity and active use for over a millennium, up until the Middle Ages, when the Forum Romanum

fell into complete neglect; overgrown with grass, it served as pastureland for cattle and was given the name Campo Vaccino. Many monuments were then still nearly intact—their destruction dates to the Renaissance, when the area was used as a quarry for building materials.

▶ Denarius of Octavian with the Curia Julia, British Museum, London.

Eyewitnesses, including Pirro Ligorio, relate that the destruction of the monuments was rapid and that buildings that were almost intact were demolished within weeks. Such important people as even Raphael and Michelangelo protested and expressed their dismay, but their voices went unheard; in a short time only a few remains were visible, and the area was again used as pasture.

The surviving columns of the Temple of the Dioscuri.

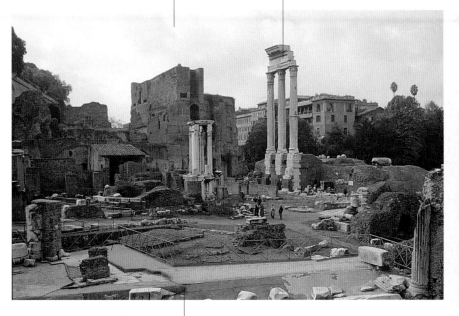

Early in the 16th century Pope Julius II decided to make use of the Forum Romanum as a quarry for materials to use—often after having transformed them into lime—in the many building projects that were part of his plans for the radical restructuring of the city.

▲ Forum Romanum.

The Column of Phocas is believed to have been the last monument erected in the forum, put there by the Byzantine exarch Smaragdus, in 608; a column with a fluted shaft topped by a Corinthian capital, it rests on a base that bears an inscription.

During the 4th and 5th century, Rome's central administration sought to preserve the function of the forum and to provide for the maintenance of its appearance as an area for public ceremonials.

The Curia Julia, built by Caesar to replace the earlier Curia Hostilia, directly bordered on the Forum Julium, of which it constituted an appendix.

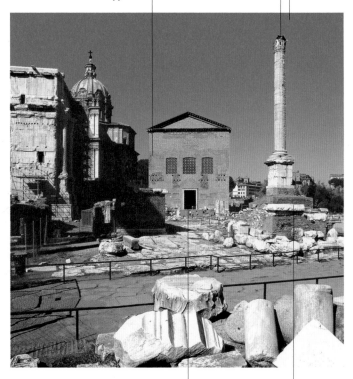

The bronze doors of the curia are a replica of the ones made during the age of Diocletian, which were brought to the Lateran in the 17th century and are visible today in the central portal of the church of St. John Lateran.

The Column of Phocas is probably nothing more than the reworking of an earlier work—perhaps from the Diocletian age—to which were added the inscription, a statue, and the stepped structure surrounding the base.

▲ Forum Romanum.

The enormous structure was erected on the site of a spice storehouse from the Flavian age (Horrea Piperataria); today, only its northern aisle remains. Of the eight Proconnesian marble columns that supported the central nave, one has survived and is visible in the Piazza di S. Maria Maggiore, where it was moved by Pope Paul V in 1613.

Late in the 4th century an apse decorated with rectangular niches was opened on the northern side of the basilica and, in line with it, a new entrance was opened on the Via Sacra porticoed with columns in porphyry and a long flight of stairs.

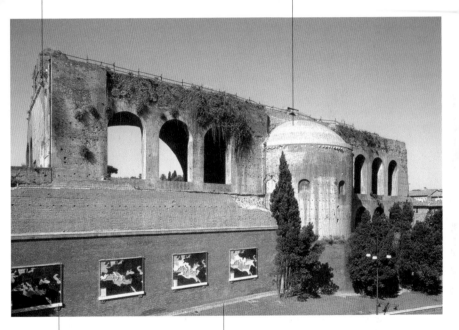

The basilica is also known as the Basilica of Constantine. A statue of Constantine, under whom work on the basilica was completed, was found in the western apse; it was there, in fact, in 1487, that the colossal acrolith of the emperor was found that is today located in the courtyard of the Palazzo dei Conservatori (see page 50).

The Basilica of Maxentius was probably the office for the legal activity of the city prefect, and the judges were probably located in the new apse. In that sense, the restoration might be related to the moment in 384 when the hearings were opened to the public.

▲ Basilica of Maxentius.

Curia Julia.

The only surviving basilica from the republican age is the Fulvia-Aemilia, built in 179 BC by the censors Marcus Aemilius Lepidus and Marcus Fulvius Nobilior: its current appearance is the result of numerous restorations conducted during the imperial age.

Temple of the Dioscuri.

Temple of Saturn.

Temple of Antoninus and Faustina.

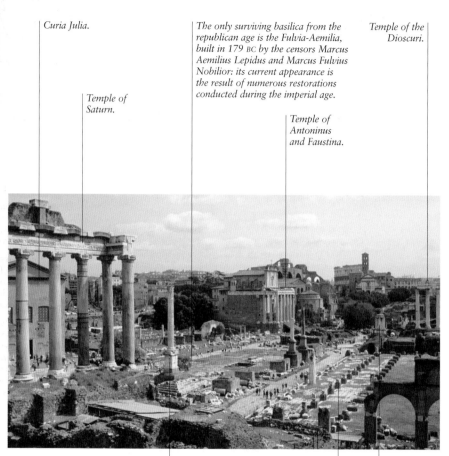

The Basilica Julia, started by Caesar in 54 BC, was completed by Augustus almost half a century later; its current appearance is the result of restoration work promoted by Diocletian.

Column of Phocas.

Alongside the round temple dedicated to Vesta, rebuilt in its contemporary appearance in 191 on the initiative of Julia Domna, wife of Septimius Severus, rose the House of the Vestals, arranged around a porticoed courtyard with ponds and fountains at its center; the numerous surviving statues of Vestals were probably originally located there.

▲ Forum Romanum.

"The construction of a forum was necessary considering the population and the number of cases: not being sufficient the two existing, there was the need for a third" (Suetonius)

Imperial Fora

At the end of the republican period, by which time Rome had become the capital of an empire that extended from Gaul to Syria and counted more than half a million inhabitants, the ancient Forum Romanum must have revealed itself as insufficient and inadequate to perform its functions as administrative and ceremonial center of the state. Julius Caesar began construction of the first complex outside the old square, of which he probably built a simple enlargement. The new complex of the Imperial Fora was built over a little more than a century and a half, through the reigns of several emperors, becoming a gigantic, unitary architectural organism created by the harmonious connection of a series

Related entry
Caesar

Location
Between the Forum
Romanum, the Capitol,
and the Quirinal

Chronology
From the middle of
the 1st century BC to
the end of the 5th
century AD

Function
Center of public life
in the imperial age
and site of state
celebrations and the
creation of political
power

of five monumental porticoed plazas. The urban arrangement came to involve roughly nine hectares of land, in good part of private ownership and already occupied by structures that had to be purchased and then demolished at costs that, although drawn out over time, must have been astronomical.

For several centuries, the Imperial Fora were the center of city life, site of the public and religious ceremonies by which the Roman state presented itself in majestic style to its citizens and to its subjects. The forums were eventually abandoned after the end of the 5th century, and the individual buildings met separate fates, some soon forgotten, others still being cited in the Middle Ages.

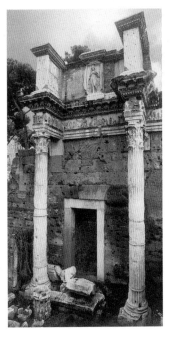

◄ Forum of Nerva.

Little is known of the events surrounding the Forum Augustum after the end of the ancient period, for the large-scale excavations performed during Italy's Fascist period almost completely erased all traces of the post-antique without assembling any documentation during the stages of demolition.

Temple of Mars Ultor (see page 106).

The Forum Augustum was dedicated in 2 BC when Augustus was given the title of pater patriae ("father of his country").

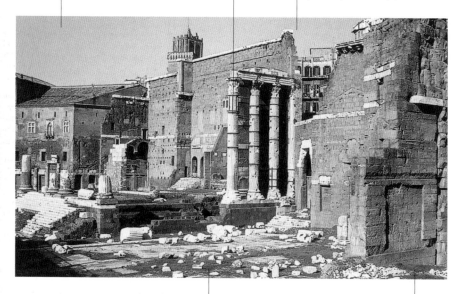

At the center of the short side of the Forum of Nerva stood the Temple of Minerva, demolished on the order of Pope Paul V in 1606. The square was opened in a space too narrow for the usual portico so the solution was adopted of setting the colonnade against the perimeter walls.

The Forum of Nerva—also called the Forum Transitorium since it connected the Forum Romanum with the district of Subura as well as the three already existing Imperial Fora—was built by Domitian and officially inaugurated by Nerva in 97.

▶ Aureus of Trajan, issued between 112 and 114, with depiction of the Forum of Trajan (reverse), Palazzo Massimo, Medagliere, Rome.

▲ Forum Transitorium and Forum Augustum.

"When he [Constantius II] came to the Forum of Trajan, a construction unique under the heavens and admirable even in the unanimous opinion of the gods, he stood fast in amazement" (Ammianus Marcellinus)

Forum and Markets of Trajan

The forum, probably originally planned by Domitian, was built by Trajan using the enormous financial resources derived from the spoils of the Dacian campaigns; the design was entrusted to Apollodorus of Damascus and required demolishing the ridge that joined the Quirinal and the Capitol. Recent excavations have substantially changed the traditional reconstruction of the layout of Trajan's complex, the façade of which was composed of a monumental pronaos, with large gray granite Corinthian columns leading to a small courtyard in which Trajan's Column stood, with libraries to its sides. Behind this stood the grand Basilica Ulpia, paved in colored marble and provided with two exedrae on its short sides. This was the site of civil and legal activity; from here, through three monumental entrances, one entered an enormous porticoed square paved in marble in which stood an enormous equestrian statue of Trajan.

The terraced slope of the Quirinal, remains of the excavation of the hill, became the site of the complex of brick buildings known as the Markets of Trajan, a structure used for a wide variety of activities, primarily of an administrative character. It is possible that there were also shops for retail sale, but the main function must have been that of a center for the state-directed distribution of foodstuffs, the final ring in a chain of distribution centers that had one of its headquarters in Trajan's new port at Fiumicino.

Related entries
Trajan and Apollodorus, Markets and storehouses, Ports, Ostia

Location
On the slopes of the Capitol and the Quirinal toward the Campus Martius

Chronology
Built between 107 and 113

Function
Distribution center and ceremonial center of the state

The historian *Ammianus Marcellinus* (see page 331) described the wonderment of Constantius II, a ruler accustomed to the architectural wonders of the East, when, during his visit to Rome in 357, he found himself facing the spectacle of the Forum of Trajan still perfectly intact.

The interior of the Basilica Ulpia was made striking by the use of an impressive number of columns in precious marble, gray granite for those of the lower order and cipollino for those of the upper order; in its side apses, columns in giallo antico were set against the walls.

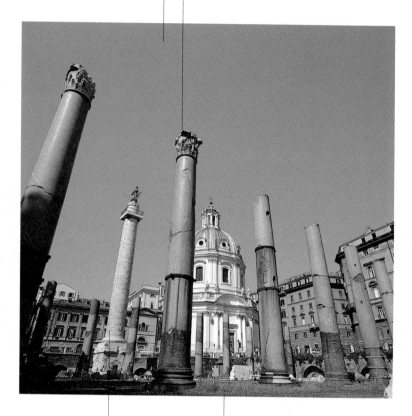

Trajan's Column.

▲ Forum of Trajan.

The sumptuous façade of the basilica included a colonnade in giallo antico with Corinthian capitals that supported an architrave decorated with a frieze of cherubs over which was an attic on which were placed statues of Dacian prisoners alternating with panels of weapons in relief.

Somewhere in the Forum of Trajan, perhaps in the east apse of the Basilica Ulpia, the ceremony of manumission—the freeing of slaves—was performed; it had originally been performed in the Atrium libertatis, but that had probably been destroyed to make room for Trajan's complex.

The vast exedra of the forum extends across the curving façade of the great hemicycle, from which it is separated by a road, paved with large stones, that was probably not open to traffic; facing onto this were the eleven rooms, frescoed and paved with mosaics, that were on the ground floor of the markets.

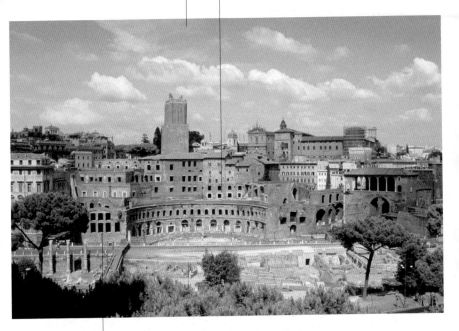

The central body, greatly transformed over the course of the Middle Ages, faced the steep section of the Via Biberatica (see page 301) and was articulated on three levels joined by flights of stairs.

▲ Markets of Trajan.

Composed of 18 large blocks of Luni marble resting on a dado base, the column was designed to indicate the original height of the hill (100 Roman feet, equal to 29.78 meters) that had been leveled for construction of the new forum.

The decoration consists of a continuous carved frieze, nearly 200 meters long and originally painted, illustrating the events in the two victorious wars Trajan led against the Dacians, in 101–2 and 105–6; the narration of the two campaigns is divided by a figure of Victory in the act of writing on a shield.

The frieze presents events of the war in detail, often schematized in a series of recurrent operations, and scenes demonstrative of universal values. The figure of Trajan appears no fewer than sixty times, and his only antagonist is King Decebalus.

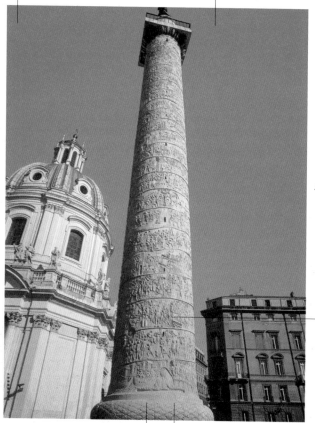

The column also served as the tomb of Trajan and his wife, Plotina; a door in the base gave access to the funerary chamber, which held a golden urn with the ashes of the emperor. Inside the marble column a spiral staircase, illuminated by small windows, led to the top of the monument.

In the narration, scenes of battles, sieges, speeches to the troops, and executions follow one another; there are also scenes of ritual sacrifice, the preparation of encampments, and the construction of bridges.

▲ Trajan's Column.

▶ Colosseum, detail of the external prospect.

"Titus . . . was styled the favorite and delight of mankind . . . He built an amphitheater at Rome and slaughtered five thousand wild beasts at the dedication of it" (Eutropius)

Colosseum

Construction of the Colosseum took ten years and began under Vespasian, who wanted to replace the amphitheater of Statilius Taurus, destroyed in the fire in 64, and also to return to the Roman people the vast area of the city that Nero had confiscated for construction of his palace. In transforming the area into a district for games and spectacles, Vespasian displayed a cunning talent for demagoguery, since it won his new dynasty the support of the urban plebeians.

The inauguration of the Colosseum, which took place when the building was not yet complete, was celebrated with entertainments that lasted one hundred days; the building was completed under Domitian with the construction of the last outer orders and the creation of the underground areas designed for services.

The amphitheater had to be repaired and rebuilt throughout the imperial period because of damage caused by earthquakes and fires, and when its use for spectacles came to an end, its physical structure gradually deteriorated.

The Colosseum was never completely abandoned. Between the 12th and 13th centuries it was incorporated in the fortress of the Frangipani family, and in the 16th century the arena was consecrated and used as a chapel. Between the 17th and 18th centuries, ideas changed concerning ancient monuments and the value of their preservation, and the amphitheater was no longer used as a quarry for building materials.

Related entries
The Flavians,
Amphitheater

Location
In the valley between
the Palatine, Caelian,
and Oppian hills

Chronology
Vespasian began
construction immediately
on his ascent to the
throne in 69; it was
completed in 80

Function
Site of gladiatorial
games *(munera)* and
hunts *(venationes)*

On August 23, 217, after it had been struck by lightning several times, a fire broke out in the Colosseum that devastated the wooden parts and the flooring of the amphitheater. So great was the violence of the fire that seven battalions of firemen from the city along with the sailors from the Misenum fleet were unable to put it out, and the monument suffered such grave damage that it remained unused for several years, until its complete reconstruction under Alexander Severus.

The Colosseum was large enough for a crowd of 50,000 (comparable to the capacity of a medium-sized modern stadium) to comfortably watch the spectacles, which went on for many hours and often over many days. An immense awning (velarium) operated by sailors from the fleet of Misenum, provided shelter and shade when needed.

▲ Interior of the amphitheater.

In the 8th century the Venerable Bede prophesied, "As long as the Colosseum stands, Rome shall stand; when the Colosseum falls, Rome shall fall; when Rome falls, the world shall end."

The seats reserved for the emperor, consuls, Vestals, and dignitaries were located on both sides of the shorter axis; the rest of the spectators took their places following an established hierarchical order. The humblest Roman citizens used the topmost ring of the building, from which they watched the games standing.

The arena had an elliptical shape, as is clearly visible today; its surface was originally covered by wooden flooring that hid from view the complicated warren of underground spaces and passageways necessary for the storage of scenery along with the cages for wild animals and the elevators and trapdoors used to lift men or animals to the surface or to retrieve them.

*"To the emperor . . . Constantine . . . [who] used his army to save the state
. . . from a tyrant . . . and from every kind of factionalism . . . the senate
and the people of Rome have dedicated this arch" (inscription on the arch)*

Arch of Constantine

Related entry
Constantine

Location
On the ancient Via
Triumphalis, between
the Circus Maximus
and the Colosseum

Chronology
Dedicated in 315

Function
The arch celebrates
the battle of Milvian
Bridge and
Constantine's tenth
anniversary as emperor

For a long time scholars believed the Arch of Constantine was the
admirable result of a collage blending original works with reliefs taken
from earlier monuments, all of them arranged to form a unitary archi-
tectural structure put together during the brief period—less than three
years—between the battle of Milvian Bridge and the celebration of the
decennalia, or tenth anniversary, of Constantine's rule. Detailed
restoration work carried out at the end of the 1980s brought to light
new information concerning the monument, and today there is a new
current of thought among specialists, according to which the arch is a
reworking of an arch that had been erected in honor of Hadrian during
the first half of the 2nd century. In the Constantinian age the attic level
with the inscription was added along with the decorative reliefs, but
not the Hadrianic roundels, which would already have been in place.

There is no complete agreement today on which is the correct
hypothesis, but according to both theories the monument clearly rep-
resents a synthesis of Constantinian propaganda, as is made clear
from the dedicatory inscription. The emperor, having restored the
empire through divine inspiration, associated himself with the wars
and triumphs of his most illustrious predecessors so as to provide
legitimacy to his own rule and to obtain the political support that was
necessary for the stability of the government.

▼ Roundels from
the Hadrianic age.

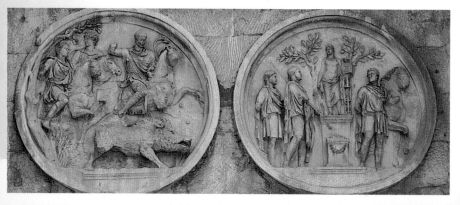

Dedicatory inscription from the senate and people to the emperor in memory of the battle of Milvian Bridge and on the occasion of the beginning of his tenth year of reign.

Statue of a Dacian prisoner.

Relief panel from the period of Marcus Aurelius.

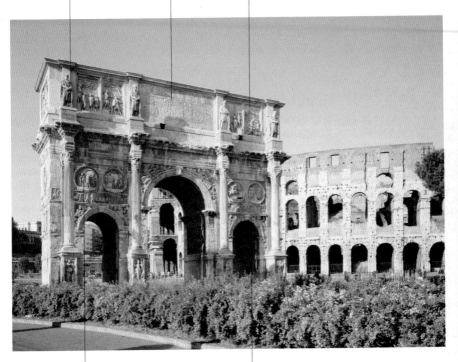

Roundels from the Hadrianic age; these may originally have been located on the entrance arch to a temple dedicated to Antinous, who appears several times, portrayed in scenes of hunting and sacrifice; according to another hypothesis, they were already in place on an older arch.

The continuous frieze is from the Constantinian age and wraps all of the arch above the smaller bays, narrating episodes of Constantine's victorious campaign against Maxentius.

▲ Arch of Constantine.

The panel on the right depicts the emperor's departure, the one on the left his triumphant return. The face of Marcus Aurelius has been refashioned to make it resemble Constantine.

A figure of Victory flies over the head of Marcus Aurelius with an outspread wreath.

Visible in the background of both panels is the Porta Triumphalis. In one panel it indicates the emperor's departure point, in the other it is symbolic of his victorious return to the city.

The panels from the age of Marcus Aurelius were probably originally located on a triumphal arch located on the slopes of the Capitol that likely celebrated the emperor's successes in his campaigns against the Germanic tribes.

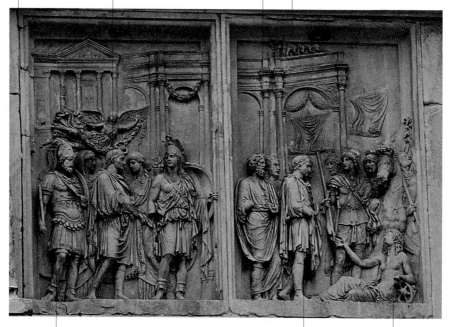

Mars stands to the left of the emperor, with Virtus *to the right, both of them inviting the emperor to enter through the Porta Triumphalis.*

Marcus Aurelius, dressed for traveling, is flanked by the genius senatus *and the* genius populi *and is accompanied by soldiers bearing insignia.*

The personification of a road invites the emperor to depart.

▲ Relief panels.

The hands and head of this figure, as of the others that frame the panels of Marcus Aurelius, are the work of an 18th-century restoration.

The Arch of Constantine is almost 25 meters high, and the central bay is 6.5 meters wide; its architectural layout is very similar to that of the Arch of Septimius Severus.

The statue, which depicts a figure dressed in the pants typical of barbarian tribes, was originally part of the decoration of the attic of the Forum of Trajan.

▲ Statue of Dacian.

The relief presents the final phase of the battle, when Constantine's cavalry destroyed the heavy infantry of Maxentius, driving them into the river, where many drowned.

A personification of the Tiber helps in the identification of the Milvian Bridge, over which Constantine advances, accompanied by Virtus *and* Victory.

It is possible that the design of this battle fought over billowing waves was later used as a model by the artisans who composed Christian works depicting the biblical episode of the passage of the Red Sea.

▲ Detail of frieze on the Arch of Constantine.

Suetonius repeats some of the popular verses mocking Nero and his palace: "Rome is becoming one house; off with you to Veii, Quirites! If that house does not soon seize upon Veii as well!"

Domus Aurea

Nero inherited Augustus's imperial palace on the Palatine and the splendid homes of Maecenas and the Lamia family on the Esquiline; his first plan was to transform his home into a royal palace worthy of a Hellenistic ruler and suitable for the reception of foreign monarchs visiting Rome by constructing a complex—the *Domus Transitoria*—that would unite the various buildings. When that structure was destroyed in the fire of 64, Nero conceived a new grandiose project to build a unitary architectural structure that would occupy roughly 80 hectares in a district that had been devastated by the fire. The design and creation of this were entrusted to the architects and engineers Severus and Celer, who made use of daring technical and structural experiments in the buildings. Only two years after work began, when the new palace was not yet finished, Nero moved in. Suetonius reports he was greatly satisfied, remarking,

"Good, now I can at last begin to live like a human being!" Construction of the sumptuous palace was not yet completed when Nero committed suicide. One of his immediate successors, Otho, spent 50 million sesterces on completion of the palace, but the short span of his reign made the expenditure useless. In a few years the *Domus Aurea* was abandoned, to be gradually taken down and dismembered.

◄ *Domus Aurea*, detail of vault of the Hall of Eagles.

Related entries
Virgil and Maecenas, Seneca and Nero, The Flavians, *Domus*, Garden, Colosseum

Location
The buildings occupied the Oppian up to the Esquiline and the Caelian, joining buildings on the Palatine

Chronology
Building began after the fire of 64; Nero was already living there in 66

Function
Nero's royal palace

In Greek mythology, Laocoön was a prince of Troy and priest of Apollo. When he saw the wooden horse he sensed the plot and called on the Trojan leaders to destroy it.

Poseidon, the divinity most adverse to the Trojans, intervened, sending two terrible sea serpents that wrapped themselves around the sons of Laocoön; the priest sought in vain to save them and perished with them.

The Trojans, convinced that the death of Laocoön was a sign from the heavens, ignored his advice and brought the horse into the city, thus bringing upon themselves their final defeat.

▲ Laocoön, from the Baths of Titus, marble replica of a Hellenistic bronze, Musei Vaticani, Rome.

The sculptural group, long held to be an original rather than an excellent replica, was found in 1506 inside a space in the Baths of Titus, and it is not possible to establish whether it ever belonged to the decoration of the Domus Aurea.

Pope Julius II, after asking Michelangelo and Giuliano da Sangallo for their opinions, bought the sculpture and had it brought to the garden of the Belvedere in a triumphal procession.

The great eye in the top of the dome provides abundant illumination to the Octagonal Hall and, by way of a brilliant architectural stratagem, provides light to the surrounding spaces as well.

The vault begins as an eight-sectioned cloister vault, but is transformed near the central eye into a hemispherical dome.

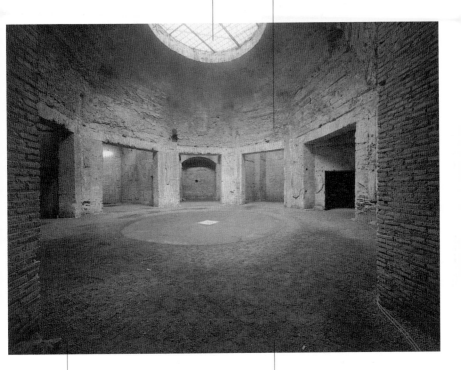

"Parts of the house were overlaid with gold and adorned with gems and mother-of-pearl. There were dining rooms with ceilings of fretted ivory, the panels of which could turn and shower down flowers and were fitted with pipes for sprinkling guests with perfume. The main banquet hall was circular and constantly revolved day and night, like the heavens." (Suetonius)

The room of the so-called Volta Dorata, one of the most important rooms in the pavilion on the Oppian, was a dining room with walls dressed in marble and its ceiling decorated in stuccoes covered in gold leaf that framed paintings with mythological scenes, known today only from 16th- and 17th-century paintings.

▲ *Domus Aurea*, Octagonal Hall.

The wall decoration is divided in three levels; visible in the upper two levels are airy architectural elements into which are inserted landscape scenes and small figures of animals.

Providing water to the Domus Aurea required construction of a special deviation of the Aqua Claudia that ran from Porta Maggiore along the slope of the Caelian; its solid arcades are still visible for long stretches from the Via Statilia to the Via di S. Stefano Rotondo and Piazza della Navicella.

The painted decoration on the lower level is far more elaborate, with theatrical niches and masks surmounted by fantastic animals; these alternate with small pictures framed by a complex frieze of sphinxes, birds, and griffons framing plant elements.

A colossal statue of Nero, more than 35 meters high, stood in the vestibule of the palace and was left there even after Vespasian began to eliminate all traces of Nero's megalomania, returning the valley to public ownership and beginning construction of the amphitheater, which took its name from the colossal statue.

▲ *Domus Aurea*, general view of one of the cryptoporticuses.

"Augustus was born just before sunrise on the ninth day before the kalends of October in the consulship of Marcus Tullius Cicero and Gaius Antonius in the Palatine quarter" (Suetonius)

Palatine

According to tradition, Romulus founded Rome on April 21, 754 BC, on the Palatine, using a plow to draw a deep line or furrow indicating its boundaries. A decade of excavations on the northern slopes of the hill and a reexamination of the elements already known have made possible the reconstruction of the earliest period of the city, identifying the moment at which, in the middle of the 8th century BC, the preurban settlement changed into a different kind of structure, that of a far more complex and articulated city. There are clearly visible traces of the demolition of an area of huts that took place, around 725 BC, to create the necessary space for the erection of a first circle of walls, a wooden palisade with an embankment in natural clay, soon replaced by a structure with greater solidity. The decision to establish this boundary line, looked upon as a sacred and symbolic boundary, must have been a deliberate political act, one that we can today identify as the foundation of the city.

With the passage of time the Palatine became the residential district of Rome's ruling class. The Palatine was the birthplace of Augustus, and when he became emperor he chose to continue living there, thus beginning the building activity of imperial palaces that, in the course of a century, led to the construction of an immense complex that was reworked and enlarged until by the end of the imperial age it occupied the entire hill.

Related entries
Romulus and Remus, Augustus and Livia

Location
At the center of the system of the hills that formed Rome

Function
Site of the foundation of the city, religious center, and location of the imperial palace

▼ Western nymphaeum of the *Domus Flavia*.

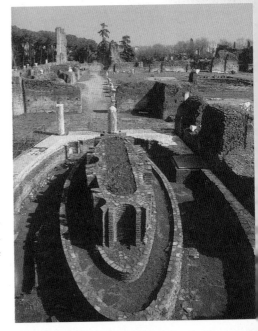

The Latin name of the Palatine, Palatium, *was first applied to the emperor's splendid home, but from that usage it made its way into all of Europe's languages, including English—palace—as the word we still use for an impressive, majestic building and also, in the broadest sense, for such a building when used as the headquarters of power.*

The great colonnaded peristyle was embellished by a body of water at the center of which stood a small temple on a high podium that could be reached by way of a small bridge held up on small arches.

The Domus Augustana, *the ruler's private home, was composed of an alternation of small, simple rooms with larger spaces arranged on two levels.*

▲ Upper peristyle of the
Domus Augustana.

At the center of the eastern side was a large hemicycle-shaped tribune resting on three spaces that faced the arena.

Domitian's private residence was connected to an enormous garden shaped like a stadium, 160 meters long and 48 wide, with one of the shorter sides curved, embellished by fountains and bounded by a two-story portico; the center was divided by a spina, the terminal elements of which are still visible.

In all likelihood the stadium or hippodrome in Domitian's palace served the functions of riding space and garden, based on the model of many villas that, as reported by Pliny the Elder, had a sort of private riding track—gardens in the shape of a circus that could also be used for riding.

▲ Palatine stadium.

On the side of the Palatine overlooking the Via Appia, Septimius Severus had a giant façade-nymphaeum built, the Septizodium, which according to ancient sources greatly impressed the inhabitants of Roman Africa—fellow countrymen of the emperor, who was a native of Leptis Magna—who arrived in Rome by way of the Via Appia.

The Septizodium was completely demolished on the orders of Pope Sixtus V between 1588 and 1589, and its marble was used in new constructions, including one of the chapels in the church of S. Maria Maggiore. Nothing remains of the splendid monument, but excavations carried out in recent years have made possible the reconstruction of its outline.

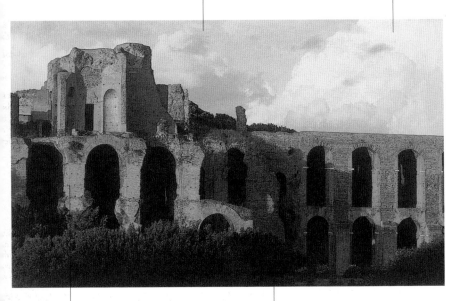

The Severan arcades, probably the most striking aspect of the southern slope of the hill today, were built as gigantic substructures for an artificial platform that was intended to make possible the enlargement of the palace even though the entire hill was by then taken up with buildings.

The palace that Septimius Severus had built stood on the artificial platform and today has almost completely disappeared.

▲ The Palatine seen from the Circus Maximus.

"A fire of an absolutely uncommon violence struck the city, devastating the Caelian . . . Caesar, however, intervened, distributing sums according to the damage suffered" (Tacitus)

Caelian Hill

The Caelian Hill was left outside the Servian Wall and for a long time was occupied only by religious buildings and tombs, later discovered at various times on the road running along the ridge of the hill. Around the end of the republican period a residential district arose in the area composed of modest houses with shops facing the road as well as luxury habitations, such as that of Mamurra, commander of Caesar's military engineers and the object of violent attacks from Catullus. The Caelian suffered the effects of a serious fire in 27, after which many buildings had to be rebuilt, but far worse was to come under Nero, with the Great Fire of 64: the district was almost totally devastated, and numerous areas were left without buildings, creating the premise for a radical urban transformation. Recent research has revealed that for nearly a century large tracts of the hill were occupied by blocks of apartment houses, with workshops and stores on the ground floor, and also by some large buildings that must have served primarily commercial and service functions. During the second half of the 2nd century, the urban fabric of the Caelian underwent yet another radical change, and the blocks—as was to happen shortly also in Ostia—were converted to single-family homes, often with only one story. Transformed and enlarged, these homes survived until the sack of the city in 410 and even later.

▼ Nymphaeum of the *domus* on the Caelian, detail of the fresco with Dionysus and Proserpine, end 3rd century.

In the upper level a series of cherubs harvest grapes and move amid grapevines, birds, and plant elements.

Numerous barracks were located on the Caelian, such as that of the firemen, near S. Maria in Domnica; that of the emperor's horse guard; and that of the provincial armies detached to Rome for special functions. The remains of the last-named barracks, known as the Castra Peregrina, are still visible today under the church of S. Stefano Rotondo.

▲ *Domus* on the Caelian, Room of the Genii, detail of fresco, second half 3rd century.

The images on the lower level alternate figures of birds with winged youths (the Genii), behind which extends a long garland of various flowers and fruits that recalls the passage of the seasons.

In 362, John and Paul were killed and buried, together with other martyrs, in the site where they lived, a large house with several floors that the owner, the senator Byzantius, had made available to a small Christian community. A few decades later the house was dismantled and in its place the church dedicated to John and Paul was erected.

Byzantius's home had been built in the 3rd century, unifying a house from the 2nd century arranged on several terraced floors with a small bath on the ground floor and an apartment house from the first half of the 3rd century, with workshops and a columned portico on the ground floor.

Excavations conducted over the last twenty years in the military hospital on the Caelian have brought to light numerous public and private buildings, among them a large domus built atop existing buildings at the end of the Antonine age, as can be deduced from the presence of a water pipe datable to 177.

In another area of the Caelian, inside the military hospital, a domus was found that had nearly 8,000 square meters of official meeting places, courtyards, rooms, baths, corridors, and service areas. This may have been where Commodus was living when he was killed. It was radically transformed in the 4th century by a thorough and luxurious restoration and may have become the property of the Symmachus family.

"For six months . . . the barbarians clung round that hill, making attempts by night as well as by day. Manlius . . . roused by the cries of a goose, hurled them from the top of the rock as they were climbing up at night" (Florus)

Capitol

▼ Remains of the substructure of the Temple of Jupiter.

As indicated by recent archaeological studies, the hill was being visited as early as the late Bronze Age by a community that carried out artisan activity related to metalworking. Its consecration as the site of the center of the civic cult took place during the final period of the Etruscan monarchs, when the Tarquins built a temple to the Capitoline triad (Jupiter Optimus Maximus, Juno, and Minerva) that was inaugurated in the first year of the republic. The appearance of the great temple can no longer be reconstructed, and what little remains of it, although impressive, has been incorporated in the structure of the 16th-century Palazzo Caffarelli. It is possible to hypothesize that its decoration culminated in a grandiose quadriga in painted terracotta that was produced, together with the cult statues, in the workshop of Vulca, a famous artist from the Etruscan center of Veii. Early in the 3rd century BC, the quadriga was replaced by one in bronze by the Ogulnii brothers, the aediles for that year, who also had the bronze she-wolf made that was placed in the Comitium.

Many of the principal events in the life of the Roman state took

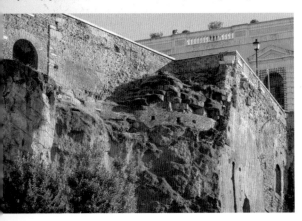

place on the Capitol. The ceremony of installing new consuls took place there every January 1, and the triumphal procession of victorious generals ended with the performance of sacrifices before the Temple of Capitoline Jupiter. Under Augustus the hill also became the seat of the military treasury, and from there governors set off for their provincial posts.

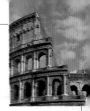

"He [Tiberius] dedicated certain temples . . . [including that] of Janus built in the vegetable market by Gaius Duilius, who gained the first Roman naval victory—over the Carthaginians—and won a triumph for it" (Tacitus)

Forum Boarium and Forum Holitorium

From the beginning of the city—and most probably even earlier—the plain between the Tiber and the hills above it assumed vital importance as a landing place and thus also as an important marketplace, since all the principal communication routes leading to the center of the peninsula met at that strip of land: the Tiber, navigable up to Orte; the road that joined Campagna with Etruria, exploiting the Sublicius Bridge at the height of the Tiber Island; and the Via Salaria, used by internal populations to get supplies of salt. The area was given an early arrangement in the period of the Etruscan kings, when Servius Tullius made the first attempts to organize the Tiber port and built two temples in that area, one to Fortuna and one to Mater Matuta (the sacred area of S. Omobono). The most intense building phase, however, dates to the 2nd century BC, after a calamitous period in which a fearsome series of fires and floods had repeatedly devastated the zone; the construction of the first warehouse for the storage of goods, the *Horrea Aemiliana*, probably dates to the end of the 2nd century BC; it was replaced in the imperial age by a complex of brick buildings.

Aside from the Temple of Portunus, still perfectly preserved, there are the remains of many shrines built in the area of the Forum Boarium and the Forum Holitorium and, in particular, alongside the church of S. Nicola in Carcere, which incorporates the podium and colonnade of the Temple of Juno Sospita.

Related entries
Markets and store-houses, Bridges, Ports

Location
The plain overlooking the Tiber

Function
Rome's first river port and market area

▼ Church of S. Nicola in Carcere.

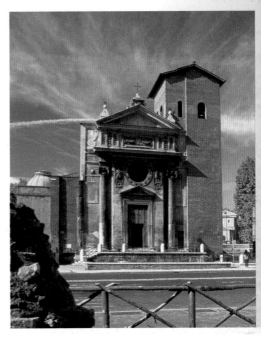

"The senate voted . . . the consecration of an altar to Pax Augusta in the Campus Martius and on this altar ordered the magistrates and priests and Vestal Virgins to make annual sacrifice" (Augustus)

Ara Pacis

Related entries
Augustus and Livia,
Virgil and Maecenas,
Temples and sacred
buildings

Location
In the Campus
Martius, to the west
of the Via Flaminia

Chronology
Site consecrated in
13 BC, inaugurated
January 30, 9 BC

Function
Celebratory altar

The *Ara Pacis Augustae* ("Altar of Augustan Peace"), a work of Greek sculptors, is the key to understanding the policies, ideology, and art of the Augustan period; it is the central monument of the Augustan program of constructions designed as dynastic propaganda. An impressive and richly decorated marble altar, it unites allegorical scenes of the birth of Rome and the myth of Aeneas, progenitor of the *gens* Julia, with the presentation of a long procession meant to evoke the official procession on the day the site of the altar was consecrated: behind the lictors and priests, among whom is Augustus himself in the dress of the pontifex maximus, parade all the members of the emperor's family, including the youngest children. No such procession ever took place, at least not in the form depicted, since in 13 BC, when the site was consecrated, Augustus was not yet pontifex maximus and, by the time of its inauguration, four years later, Agrippa was dead. It is thus clear that the relief, rather than depicting an actual event, is meant to capture, like an official photograph, all the members of the imperial family. The first blocks of the *Ara Pacis* came to light in 1568 beneath today's Palazzo Almagià, but only in 1879, after the discovery of the relief with Aeneas and of other important fragments, was identification of the monument made possible. Systematic excavations were conducted several times between 1903 and 1938 when, on the occasion of the two-thousandth anniversary of Augustus, the altar was reconstructed and located near the Mausoleum of Augustus.

▼ *Ara Pacis.*

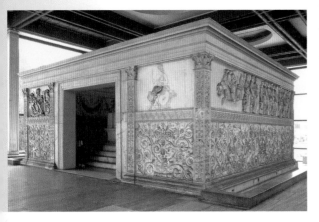

The blocks of the Ara Pacis *found in the 16th century met different fates: a good part were transported to the court of the grand duke of Tuscany, a large figural fragment was taken to the Louvre, another went to the Musei Vaticani, while many pieces with decorations of festoons were walled into the façade of the Villa Medici.*

Tellus (the Earth) is presented as a comely young woman holding two small children; beneath her throne are a cow and a sheep.

When the monument was restored in the 1930s the Florentine blocks were brought back and casts were made of the others. Pope Pius XII later donated the fragment in the Musei Vaticani to the city of Rome, and it was set in place on the altar.

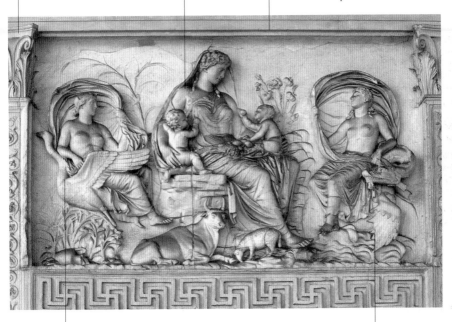

To the left, Air is seated atop a swan that spreads its wings as it rises in flight. The entire scene was probably understood as an allegory of Peace.

On the right is an allegorical figure of Water seated atop a sea monster.

▲ Relief with Tellus.

> *"About the same time took place the famous triumph over the Scordisci of Minucius, the builder of the porticoes which are famous even in our day"* (Velleius Paterculus)

Sacred area of the Largo Argentina

Related entries
Annona, Markets
and storehouses

Location
In the central area of
the Campus Martius

Chronology
From the end of the
4th century BC, with
restorations until AD 80

Function
Cultural complex

▼ Sacred area of the
Largo Argentina.

After his triumph over the warlike tribe of the Scordisci, celebrated in 107 BC, M. Minucius Rufus decided to unify an area of the Campus Martius in which three ancient temples already stood with the construction of a large portico—the Porticus Minucia Vetus—destined to become the center of Rome's grain dole, which had only recently been instituted. The most ancient of the three sacred buildings probably attested to the introduction to Rome of the Sabine cult of Feronia; it had been dedicated by Manius Curius Dentatus in 290 BC, after the Sabine War. Fifty years later, Q. Lutatius Catulus, after his triumph over the Carthaginians, had erected a temple to Juturna, and in 179 BC, M. Aemilius Lepidus had dedicated one to the Lares Permarini, protectors of sailors. The arrangement of the area concluded in 101 BC, with the building of a rotunda temple dedicated to "Fortune of the Present Day" (that of the *frumentatio*, the dole). To the east of the large complex of the Largo Argentina extends the Villa Publica, a large park in which was a temple, still partially visible in Via delle Botteghe Oscure, where the archives of the censors were kept with the lists of those with the right to receive the grain dole. In the imperial age a second porticoed square was built on the grounds of the Villa Publica, resulting in an immense complex destined to testify to the munificence and the generosity of the Roman state, which distributed grain to its people against the background of grand temples erected with plunder from defeated enemies.

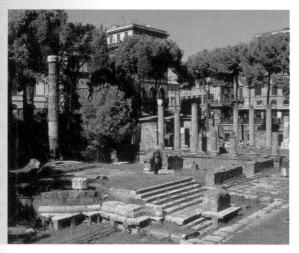

*"He often called on the leading citizens to improve the city . . .
thus many works were built by many citizens . . . by Agrippa
were built many and splendid monuments" (Suetonius)*

Pantheon

The construction of the Pantheon, the best preserved ancient build-
ing in all ´ Rome, was the work of Augustus's son-in-law Marcus
Agrippa, who promoted the overall rebuilding and reanimation of
the district. The temple's current appearance is the result of a com-
plete reworking carried out during the age of Hadrian and easily
datable thanks to the many maker's marks impressed in the bricks.
The original building was radically changed, even altering the ori-
entation of the façade and inserting the great rotunda; on the archi-
trave was placed the inscription, still legible today, attributing the
construction to Agrippa in the year of his third consulate. In 609
the Byzantine emperor Phocas donated the temple to Pope Boniface
IV, who transformed it into the church of S. Maria ad Martyres; as
with many other ancient monuments, this fate meant the salvation
of the building, which has survived to today practically intact,
although in a much different arrangement than the original, in
which the façade was
raised on several steps
and was preceded by a
large rectangular porti-
coed square.

Traces still visible on
the cement portion of
the building suggest that
the designer originally
planned to make a
higher pediment, which
certainly would have
made the relationship
between the circular
structure and the portico
harmonize better.

Related entry
Hadrian and Antinous

Location
In the central area of
the Campus Martius

Chronology
Built between 27 and
25 BC, completely
rebuilt between
AD 118 and 125

Function
Temple of the twelve
celestial divinities

▼ Pantheon.

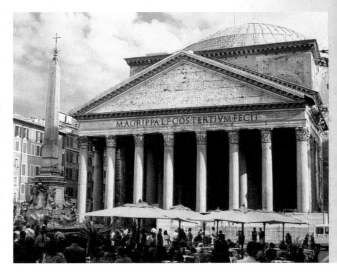

The Pantheon is dominated by the giant dome, which has a diameter of 43.30 meters and is the largest ever built in masonry; the circular opening at the top is nine meters wide.

The dome is decorated by five concentric rings of coffers that narrow toward the central opening, while the walls are animated by numerous niches that house the statues of the twelve celestial divinities to which the Pantheon is dedicated.

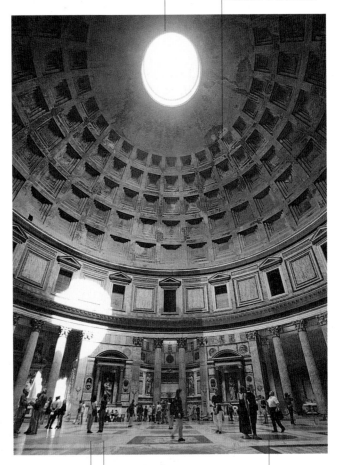

The four columns on the façade are in gray granite from the Mons Claudianus in Egypt's Eastern Desert; the interior columns are in red granite from Syene (Aswan).

▲ Interior of the Pantheon.

The monument's wonderfully harmonious appearance is a result of the proportions applied; the distance between the floor and the top of the dome is the same as its diameter, such making the internal space a perfect sphere.

The great bronze portal, although heavily restored, is perhaps still the original from the Roman age.

"I live over a pubic bath. Imagine the range of voices that irritate my ears . . . the hair plucker with his shrill, high-pitched voice . . . he's quiet only when he's plucking armpits and forcing his customer to shriek" (Seneca)

Baths of Diocletian

This bathing complex, the largest ever built in Rome, arose in one of the most densely populated areas of the city, and many buildings from earlier periods had to be demolished to make room for the new complex, as mentioned in the dedicatory inscription. The structure occupied an area of about 140,000 square meters, and the central building alone measured more than 250 meters by 180; according to ancient sources, the baths had room for up to 3,000 people at once, almost double the capacity of the Baths of Caracalla. Much of the baths has survived, incorporated and integrated in the modern urban structure: the central hall has become the church of S. Maria degli Angeli, which has its entrance in one of the apses of the *caldarium*, while some adjacent rooms have been incorporated in the Museo delle Terme, the garden of which preserves the façade of the principal building. The exterior enclosure of the baths is still clearly visible today, most of all in the outline of the great central exedra that forms today's Piazza della Repubblica and that must originally have been used as a theater. Not far from the Baths of Diocletian, between today's Via XX Settembre and Via Nazionale, arose a few years later another installation built by Maxentius and probably dedicated to Constantine. Nothing remains of these baths, which were smaller and more refined and probably served the well-to-do and that were also the last building of this kind to be built in Rome.

Related entries
Diocletian, Baths

Location
Between the Esquiline, Viminal, and Quirinal

Chronology
Built between 298 and 306

Function
Public baths

▼ Area between the *palaestra* and the *frigidarium*, Baths of Diocletian.

Among the primary difficulties faced by the managers of the baths was the supply of suitable combustible material, for not all types proved suitable. Olive wood, for example, gave off greasy smoke that ruined the decorations of the rooms, and smoke from darnel tended to give the bathers headaches and make them dizzy.

All the public baths had latrines, while only well-to-do Romans could afford private bathrooms; the citizens who inhabited the city's large apartment buildings collected their waste in containers that they then emptied into the street.

▲ Baths of Diocletian.

"Imagine a quarrelsome drunk . . . a man who loves to sing in the bath . . . the shouts of people selling drinks, sausages, pastries; each snack bar has its own huckster with his own recognizable jingle" (Seneca)

Baths of Caracalla

The Baths of Caracalla are the most grandiose and best preserved bathing complex from the imperial age. Built by Caracalla, who inaugurated the central building in 216, the baths were completed by his successors, Elagabalus and Alexander Severus. Construction of the enormous complex, which was designed to serve the needs of the less well-to-do social classes, required major urban projects, chief among them the creation of a special branch of the Aqua Marcia—that is, the Aqua Antoniniana—for the conduction of the water necessary for the function of the baths. The Baths of Caracalla, which could host up to 1,600 bathers at once, remained in operation for more than three centuries, during which they were restored several times by the emperors Aurelian and Diocletian and by the Ostrogoth king Theodoric; recent excavations in the underground areas have brought to light works of repair and restoration that date to the 5th century. The baths stopped working only when the Goths cut the aqueducts, depriving them of water.

Like many other monuments, the Baths of Caracalla were used in the Middle Ages as a quarry for building materials, such as in the 12th century, when three capitals from the eastern *palaestra* were removed and carted off to decorate the cathedral of Pisa. The baths suffered most in the middle of the 16th century, when Pope Paul III systematically stripped them for construction of his new Farnese Palace.

Related entry
Baths

Location
Between the slopes of the Small Aventine and the urban stretch of the Via Appia

Chronology
Inaugurated in 216, ceased to function after 537

Function
Public baths

▼ Piazza Farnese, fountain with granite tubs from the Baths of Caracalla.

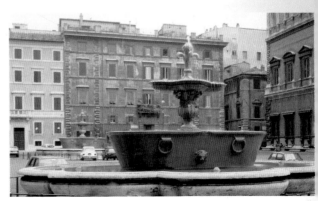

On the southern side of the area of the baths were located the storage tanks for water, eighteen interconnected rooms that provided storage for about 10,000 cubic meters, a reserve that probably served to cover the period of maximum usage.

The palaestra *was paved with polychrome mosaics, porticoed on three sides, and covered by a vault in its central area; the usual visit to the baths began in the* palaestra, *with gymnastic exercises that could be performed indoors or outside in the ambulacrum.*

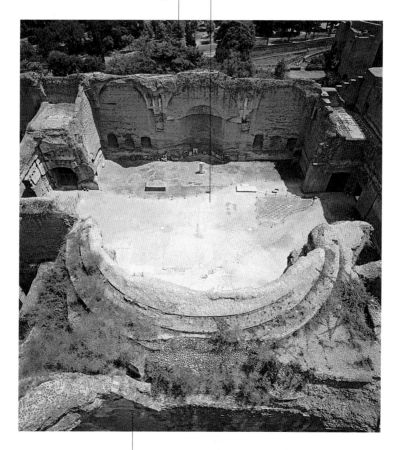

The complex must have required about 15,000 cubic meters of water daily, so the cisterns cannot have been used as a reserve supply kept on hand in case of problems with the aqueduct, since they would not have covered even an entire day's supply.

▲ Baths of Caracalla, eastern *palaestra*,

The statuary group is a Roman copy of a Hellenistic original from the 2nd century BC, a work by the sculptors Apollonius and Tauriscus of Tralles, today lost; Pliny the Elder mentions it at Rome in the collection of Asinius Pollio, who must have had it brought from Rhodes.

The twins Zethus and Amphion, Antiope's sons, having discovered the true identity of their mother, save her from the punishment to which Dirce had condemned her—being tied to a wild bull—and inflict the punishment instead on Dirce.

Excavations in the Baths of Caracalla, most of all during the 16th century, led to the discovery of part of the rich decoration of the baths and their furnishings, such as the two granite tubs that are today in Piazza Farnese.

In the foreground at left is Dirce, beneath the feet of the bull; to her side are the shepherd and the dog, and behind is Antiope. The myth of the punishment of Dirce, not dealt with to a great extent by the ancient sources, is an intricate tale of love, revenge, and family passions; the version known today is that given in Euripides' play Antiope.

Antiope, daughter of the king of Boeotia, bore two sons to Zeus, the twins Amphion and Zethus. To escape the wrath of her father, uncle, and aunt, Dirce, she left the children on Mount Cithaeron, where they were rescued by a shepherd.

▲ *The Punishment of Dirce* ("Farnese Bull"), early 3rd century, Museo Archeologico Nazionale, Naples.

"The Via Appia . . . extends from Rome to Capua. The breadth of this road is such that two wagons going in opposite directions can pass one another, and it is one of the noteworthy sights of the world" (Procopius)

Via Appia

The Via Appia, which exited Rome by way of the Porta Capena opposite the curved side of the Circus Maximus, is the oldest of the great Roman roads. Built in 312 BC during the Second Samnite War by the censor Appius Claudius Caecus, it joined Rome to Capua and officially confirmed the annexation of Latium and Campagna to the territory of Rome. The new artery provided permanent direct communication with the cities of the south, which were bellicose and turbulent but also rich, populous, and closely associated with the Greek world. Hardly more than fifty years later the Appian had been extended to the port of Brindisi, becoming one of the principal instruments of Roman expansion, first into the south of the peninsula and later in the direction of Greece and the Orient.

The paving of the Via Appia, an extraordinary feat that awakened the admiration of the Greek historian Procopius of Caesarea nine hundred years after its construction and that is still preserved for a long stretch across the Roman countryside, began in 295 BC and continued for more than a century and a half. The bed of the road, which was no less than ten meters wide up to Terracina, is highly recognizable up to Benevento, most of all in those stretches in which it is flanked by the remains of tombs, as in the first few kilometers outside Rome, an area for many centuries a favored haunt of poets, artists, and travelers.

▼ Via Appia.

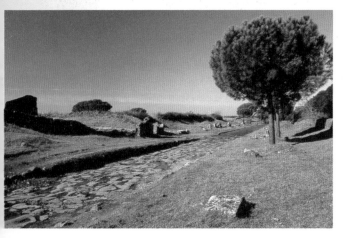

The great nymphaeum with its fountain must originally have included rich architectural decoration—of which several columns in cipollino marble remain—as well as statues and water displays.

Over the course of the Middle Ages the nymphaeum was transformed into a fortress that served defensive functions but also helped control traffic on the road. An interior view of a portico is on page 266, where there is also further information on the villa's original owners.

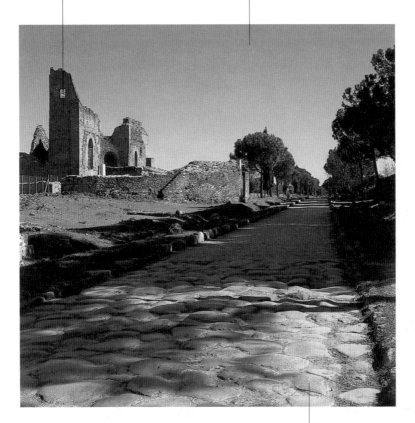

▲ Villa of the Quintili, nymphaeum and entrance of the villa following recent restoration work.

The paving, still perfectly preserved, of the Via Appia.

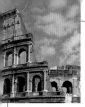

"As he [Hadrian] was himself wont to say, he would have sent away his wife too, on the ground of ill-temper and irritability, had he been merely a private citizen" (Historia Augusta: Hadrian)

Hadrian's Villa

Related entries
Hadrian and Antinous,
Villa, Garden

Location
On the slopes of the
Tiburtine mountains,
near modern Tivoli

Chronology
Built between 118
and 138

Function
Retreat for rest and
amusement of the
emperor Hadrian

▼ Maritime Theater,
Hadrian's Villa, Tivoli.

The site Hadrian chose for his luxurious, sprawling residence was already occupied by a villa from the republican period, and that structure was incorporated into one of the new buildings. Despite the complicated nature of the complex and its size—it occupied an area of about 186 hectares—it was without doubt a unitary project, as is made clear through analysis of the system of water supply and drainage, a system to which the emperor himself devoted much study during his stays in the capital. The splendor and richness of Hadrian's Villa awakened great admiration among the ancients, most of all because it included constructions that recalled famous buildings from all the provinces of the empire.

At the middle of the 16th century, when Cardinal Ippolito II d'Este asked the Neapolitan architect Pirro Ligorio to design a villa at Tivoli, Ligorio decided to draw inspiration from Hadrian's Villa and conducted excavations and research that brought to light the wealth and variety of the fountains and nymphaeums that decorated the complex, along with the refinement of the decorations and the incredible assortment of marbles of outstanding quality. Thus was born the marvelous design for the Villa d'Este as well as the systematic plundering of the furnishings and decorations from Hadrian's Villa that continued for more than three centuries, indeed until the unification of Italy, after which the great complex became state property.

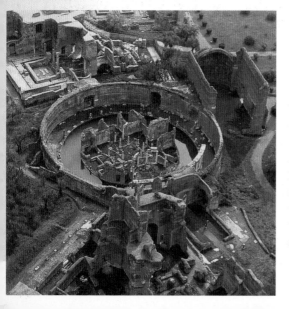

The portico, covered by a double-pitched roof, was designed for pleasant postprandial strolls, as indicated by an inscription found in the area in the 18th century.

The giant arcaded court enclosed a garden at the center of which was a pool that scholars have identified as the Poikile, which ancient sources claim Hadrian wanted built in imitation of the famous Athenian portico where the works by the leading Greek artists were collected.

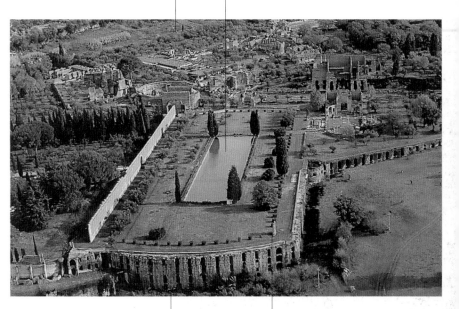

▲ Tivoli, Hadrian's Villa, arcaded court of the Poikile.

The high rear walls of the colonnaded portico cut off view of the landscape and created a sort of isolated garden around the pool, a rectangular body of water about 100 meters by 25 that must have created an atmosphere of peace and quiet.

Traces of the colonnade are still visible, and its outline has been repeated by box trees planted along the bases of the peristyle and trimmed to form cylinders.

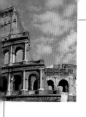

"The additions made by King Ancus were not confined to the city . . . and Roman dominion extended to the sea; at the mouth of the Tiber the city of Ostia was built; salt-pits were constructed all around" (Livy)

Ostia

Related entries
Seneca and Nero, Fleet, *Insula*, Markets and storehouses, Ports

Location
On the seacoast southwest of Rome

Chronology
From the 4th century BC until the end of the Roman age

Function
Rome's maritime port

▼ Signs for a *thermopolium*, 1st century, the Via di Diana, Ostia.

The first settlement at Ostia, early in the 4th century BC, involved fortifications that were part of a system of military control of the lower reaches of the Tiber, providing security for shipping, including vessels bringing supplies to Rome. This initial colony at Ostia grew quickly, gradually shedding its military function as it evolved into the city's commercial port. In the 1st century BC, homes for the well-to-do arose along the porticoed streets in the residential zone, houses with an atrium and, in some cases, a peristyle; the theater was built in the Augustan age, while the forum was erected in front of the new Temple of Augustus and Rome only in the beginning of the reign of Tiberius. Following the construction of the aqueduct the first bathing complexes were built, and the *Horrea di Ortensio*, the oldest large-sale commercial building, dates to the Julio-Claudian age.

Ostia's economic importance received a further boost with the creation of the port of Trajan and, during the rule of Hadrian, the port was restructured following an overall plan issued by the central power that resulted in the creation of a large district for services and residences. Ostia reached the height of its expansion during the Antonine age, becoming the distribution and administrative center of the entire port complex, while also remaining the river dock and the principal storage center for the goods that could not be immediately absorbed by the markets in the capital.

At the time of its founding, the new colony of Ostia was composed of about three hundred families, but it must have grown rapidly, for by the end of the 3rd century BC its walls were apparently no longer in use and instead had shops built up against them.

Between the end of the 2nd and beginning of the 1st century BC Ostia was given a new ring of walls that enclosed an area thirty times larger than the original settlement, although ample spaces inside the walls remained unused.

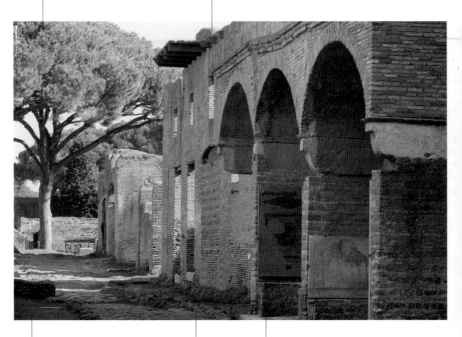

The walls of the colony included square towers on the sides of the three gates and small round towers on the four corners, while another tower oversaw the side overlooking the river, otherwise not fortified in order to not hinder traffic.

The ground level of the city was raised during the reign of Domitian to permit the installation of the solid foundations necessary for the new blocks of tall buildings that were built beginning in that period.

▲ Via di Diana, Ostia.

By the Antonine age, Ostia was slightly larger than Pompeii had been and only half the size of Lyons, but its population density was quite exceptional, counting about 50,000 people.

The necropolis remained in use from the age of Trajan through the Severan period, and its tomb typologies are extremely varied, from the chamber tombs with temple façades used by the well-to-do to the simple mounds or tumuli indicated by heaped amphorae or roof tiles for the poorest classes.

Characteristic of the Isola Sacra is the use of coffin tombs, halves of cylindrical brick coffins covered by red plaster and, sometimes, decorated with an aedicula-type façade.

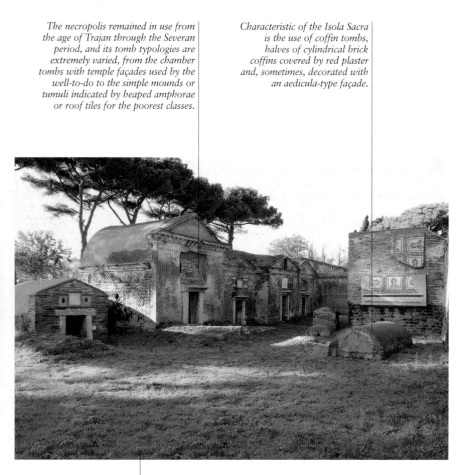

Districts of homes and commercial buildings soon arose in the area of the port and on the Isola Sacra, an artificial island that had been created following the work constructing the new harbors of Claudius and Trajan; here also was the necropolis, one of the most evocative in the Roman world.

▲ View of the necropolises on the Isola Sacra ("Sacred Island").

The creation of the sumptuous decorations required the use of different marbles—veined white, giallo antico, serpentine, porphyry, palombino, and granite—and colored vitreous paste.

A frieze of spiraling acanthus on a background of serpentine separates the area with geometric decoration from the upper strip, with its panels of lions attacking young deer.

The wall is decorated by a succession of regular panels framed with strips of rosettes, above which runs a frieze of small bucklers alternating with lozenges.

"Ostia is harborless on account of the silting up, which is caused by the Tiber . . . the merchant-ships must anchor far out in the surge . . . a plentiful supply of tenders receive the cargoes and bring back cargoes in exchange, making it possible for the ships to sail away quickly before they touch the river, or . . . they sail into the Tiber and run inland as far as Rome, 190 stadia [roughly 35 kilometers]." (Strabo)

The Porta Marina, excavated in 1938–42, is part of the 1st century BC ring of walls and owes its name to its nearness to the beach.

The recomposition of the entire decorative motif was made possible by a minute and patient work of restoration.

▲ Wall in *opus sectile* from a building outside the Porta Marina at Ostia, end 4th century, Museo Ostiense, Ostia Antica.

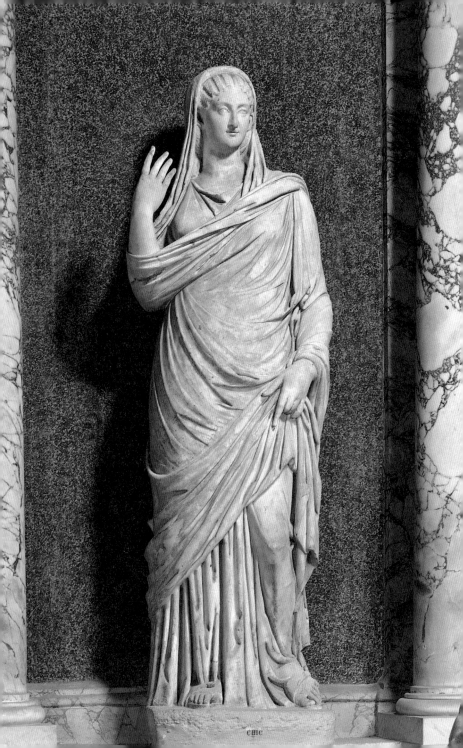

References

◀ Statue of a woman, 3rd century,
Galleria Borghese, Rome.

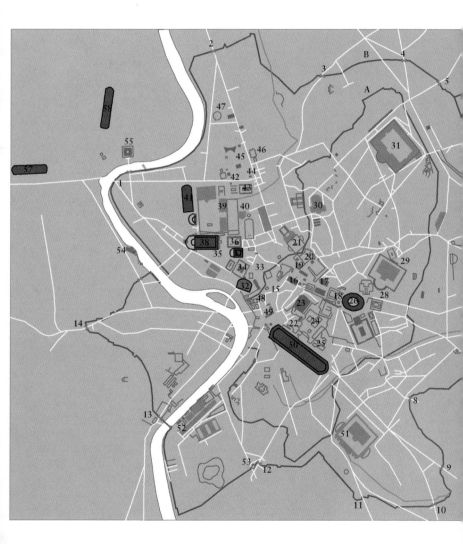

Rome's museums

Centrale Montemartini
Rome's first public power station has been an art museum since 1997; on display are more than four hundred sculptures from the Musei Capitolini, most of them from excavations from the late 19th century and the 1930s; the ancient works are displayed against the background of old power-station equipment.

Musei Capitolini
The Capitoline Museums have been reorganized and now include sections dedicated to the ancient remains of the Capitol, such as the structure of the Temple of Capitoline Jupiter, as well as new spaces, including the Tabularium, the gallery of which is open to the public.

Galleria Borghese
The museum located in the splendid Villa Borghese exhibits a rich collection of ancient works, most of all masterpieces of the 15th to 18th centuries; the museum is based on the collection of Cardinal Scipione (1579–1633).

Musei Vaticani
The vast papal collections include many sections of ancient art that include masterpieces of outstanding importance and great fame.

Museo della Civiltà Romana
This museum opened in 1955 in the EUR, the complex designed for the Exposition Universale of Rome in 1942; it presents the long history of Roman civilization by way of scale models of the city and its monuments, along with casts of reliefs from works in museums throughout the world.

Museo Nazionale Romano, Crypta Balbi
Located in an area of the city that has been the subject of study for nearly twenty years, this museum illustrates the transformation of the site from the Roman age to the 20th century; there are sections dedicated to aspects of late antique and Byzantine Rome; the government of the popes; and Rome's fora during the late Middle Ages (5th–10th centuries).

Museo Nazionale Romano, Palazzo Altemps
This splendid Renaissance palace, located only a few steps from Piazza Navona, displays masterpieces of ancient statuary collected over the course of the centuries by Rome's leading noble families.

Museo Nazionale Romano, Palazzo Massimo
The Museo Nazionale Romano (National Museum of Rome), founded in 1889, has been reorganized and is today divided among various branches across the city, but the hinge of the project is Palazzo Massimo. The exhibit includes works from as early as the 2nd century BC, many Roman copies of Greek statues, a large collection of imperial and private portraits from the Flavian age to Constantine, and several decorative arrangements from luxury residences. The underground areas include the collection of ancient, medieval, and modern coins and a collection of jewelry.

Museo Nazionale Romano, Terme di Diocleziano
The large buildings of the Baths of Diocletian house several displays, including an epigraphy department that illustrates the birth and spread of the Latin language, and a section on the development of Latin culture from the late Bronze Age to the Iron Age (ca. 11th–7th century BC), with particular reference to the territory of Rome.

Museo Palatino
Housed in a former convent, this museum exhibits the artistic culture of the imperial homes on the Palatine Hill, from Augustus to late antiquity.

Many special museums and displays are to be found in Rome and its environs; such institutions most often display artifacts found on the site. Notable among such sites are the Museo Ostiense at Ostia Antica, Hadrian's Villa at Tivoli, and the Villa of the Quintili on the Via Appia Antica.

Chronology

April 21, 754 BC: traditional date of the founding of Rome.

509 BC: the last Etruscan king is expelled from Rome; installation of the republic; after the attempt by Lars Porsena to reinstate Etruscan hegemony, Rome wins independence definitively from its powerful neighbors and signs its first treaty with Carthage.

499–493 BC: war against the cities of Latium and signing of a pact of reciprocal help with the Latin cities.

486 BC: the aristocracy assumes all power, excluding the plebeians from the direction of the state; conflicts between the patricians and the plebeians will continue throughout the century.

451 BC: a commission with ten members (decemvirs) creates the first written codification of Roman law, the Twelve Tables.

445 BC: abolition of the ban on marriage between patricians and plebeians; Rome moves toward a new oligarchy based on wealth.

396 BC: Rome conquers the powerful Etruscan city of Veii, beginning the conquest of Etruria.

387 BC: the Gauls occupy and sack Rome; immediately afterward the circle of walls today known as the Servian is erected.

367 BC: plebeians are admitted to the consulate and the *cursus honorum* is defined.

343–290 BC: Samnite wars and Latin wars; Rome subdues, destroys, or annexes the Latin cities and begins its southward expansion; the censor Appius Claudius opens the road from Rome to Capua later known by his name, the Via Appia.

280–241 BC: victorious war against Tarentum (Taranto) and Pyrrhus and final conquest of Etruria, with the destruction of several cities and the founding of new colonies in the conquered territories.

264–241 BC: First Punic War. Rome takes Sicily and Sardinia from Carthage.

230–228 BC: war against Teuta, queen of the Illyrians, and elimination of pirates from the Adriatic Sea.

225–221 BC: the Romans confront the Gallic tribes that have entered Etruria and begin the pacification of northern Italy; conquest of Istria.

218–201 BC: Second Punic War. At the conclusion of the war, fought in Spain, Italy, and Africa, Rome is ruler of the western Mediterranean.

200–168 BC: war against Macedonia and war against Antiochus III of Syria; following the victory at Magnesia, Rome is the sole naval power in the Mediterranean.

149–146 BC: attempted rebellion

of Macedonia and Third Punic War, at the end of which Carthage is razed and its ruins are sown with salt. In Greece, the Achaean League attempts a rebellion but is defeated; Corinth is destroyed, and all of Greece loses its independence.

145–133 BC: submission of the Iberian peninsula and acquisition of the kingdom of Pergamum, bequeathed to the Roman people by its king.

132–121 BC: the brothers Tiberius and Gaius Gracchus propose a series of agrarian reforms to redistribute public lands away from the control of the rich; first Tiberius and then Gaius, ten years later, are murdered, and their attempt fails, laying the basis for the future civil wars.

111–100 BC: Jugurthan War and political rise of Gaius Marius, who defeats the Cimbri and the Teutones.

91–88 BC: Livius Drusus proposes a series of social reforms but is assassinated; the problem of the citizenship of Italians becomes acute, leading to the outbreak of the Social War. Rivalry between Marius and Sulla for command in the war against Mithradates; Sulla marches on Rome with his army and begins the civil war.

87–79 BC: Sulla defeats Mithradates, Marius dies, and his followers are massacred by Sulla, who assumes the dictatorship and begins a series of constitutional

reforms. Sulla retires to private life.

77–70 BC: ascent of Pompey and Crassus, who, in 70 BC, both take on the position of consuls.

67–62 BC: Pompey subdues piracy and extends Roman rule over the Hellenized east. Cicero defeats the Catiline conspiracy.

60 BC: First Triumvirate, the private agreement among Pompey, Crassus, and Caesar.

58–52 BC: Caesar conquers Gaul. Death of Crassus.

52–50 BC: Pompey, ally of the senate, is the ruler of Rome.

49–48 BC: Caesar marches on Rome with his army; Pompey flees and is defeated at Pharsalus.

45–44 BC: Caesar, dictator for life, is assassinated on the Ides of March in 44 BC.

44–42 BC: Second Triumvirate, of Antony, Octavian, and Lepidus, defeats the murderers of Caesar at Philippi.

42–31 BC: rivalry among the triumvirs; Antony marries Cleopatra, queen of Egypt, and becomes ruler of the east. Octavian and the senate declare war against him and defeat him at Actium. The long period of the civil wars ends, the armies are demobilized, the veterans receive land, and Octavian receives the support of the ruling class.

27 BC: Octavian is proclaimed *princeps* by the senate and receives the title of Augustus, which confers greater power on him than that possessed by all the other state magistrates combined.

25–15 BC: submission of the Alpine populations.

17 BC: celebration of the Saecular Games, marking the end of the war and the beginning of peace.

AD 2–4: deaths of Gaius and Lucius Caesar, grandsons of Augustus and his designated heirs.

14: death of Augustus, succeeded by Tiberius, son of his wife Livia from her first marriage.

23–31: creation of the barracks of the Praetorian Guard; in 26 Tiberius retires to Capri, leaving Rome in the hands of Sejanus, Praetorian prefect, who rules in such an authoritarian manner that he is deposed and put to death in 31.

41: the Praetorians kill Caligula and acclaim his uncle Claudius emperor; during his reign he favors the extension of Roman citizenship and permits the first provincials in the senate.

64: Great Fire in Rome.

68: revolts in Gaul and Spain. Nero, declared a public enemy, flees and kills himself, ending the Julio-Claudian dynasty; his death is followed by a year of insurrections and disorder.

69–96: the Flavian dynasty, with Vespasian and his sons, favors the emergence of the rich and learned middle class; conquest of Jerusalem in 70.

79: eruption of Vesuvius, destroying Pompeii, Herculaneum, and Stabia.

80: another major fire at Rome.

88–96: Domitian gains the support of the armies with bounties, and Italy enters an economic crisis that the emperor seeks to alleviate with measures in favor of Roman products. After various foiled plots, Domitian is killed.

96: the senate proclaims Nerva emperor in a movement to end hereditary succession.

101–106: Trajan conquers Dacia.

117: death of Trajan, succeeded by Hadrian, who renounces the policy of expansion and reinforces Rome's borders; he spends little time at Rome and much in Greece.

138–161: with Antoninus Pius the empire enjoys a long period of peace; intellectual life prospers, and legislation becomes more humanitarian.

161–166: wars of Marcus Aurelius against the Parthians; the returning troops spread a violent epidemic of plague to the west.

176: after the long wars against

the Germanic tribes of the Quadi and Marcomanni, Marcus Aurelius returns to Rome and names his son Commodus as successor, putting an end to succession by adoption.

189: revolt of the Roman plebeians, reduced to misery by the economic crisis; Rome's armies are in control of the empire.

192: Commodus is killed in a palace plot.

193: Septimius Severus, born in Africa, proclaims himself a descendent of the Antonines and installs an authoritarian government; Italy is militarized. Over the coming years he reinforces the empire's borders and on his death leaves a solid empire with an efficient military.

212: Caracalla, after having begun a move toward monetary reform, issues the *Constitutio Antoniniana*, which extends Roman citizenship to all free inhabitants of the empire.

217–235: the murder of Caracalla is followed by a period of disorder during which Rome is ruled by two nephews of the sister-in-law of Septimius Severus.

235–283: period of anarchy during which Rome is ruled by a series of emperors selected by the troops; economic and social crises. The Sassinid Empire threatens the eastern borders, and in 260 the emperor Valerian is captured. Between 270 and 275 Aurelian constructs a new series of walls to protect Rome.

283–305: Diocletian sets in motion a profound political and institutional transformation of the empire, with the strong centralization of power at Nicomedia, new capital of the empire; institution of the tetrarchy with the sovereign defined as *dominus et deus* ("master and god").

306–337: rule of Constantine who, in 313, with the Edict of Milan, proclaims freedom of worship throughout the Roman Empire. In 330 he founds a new capital at Constantinople.

337–351: years of uprisings and unrest in the empire.

364: the first groups of barbarians are admitted within the borders of the empire.

379: with the Edict of Thessalonica (380), Theodosius proclaims Christianity the official religion of the empire, and in 391 he prohibits every form of pagan worship. Treaties are made with the barbarians. On the death of Theodosius the empire is divided into East and West.

395–476: Arcadius, eldest son of Theodosius, rules in the East; Honorius, youngest son, rules in the West, under the guidance of the Vandal general Stilicho, who succeeds in holding back the barbarians, but soon barbarian rule replaces Roman rule in outlying areas. Alaric I takes Rome in 410; and the city is sacked by Vandals in 455; in 476, Odoacer deposes the last Western emperor, sending the insignia to Constantinople and ending a government that for decades had been in the hands of generals of barbarian origin.

General index

Bibliography

The literature on ancient Rome is vast and increases yearly; in addition to the many works of popular interest there are reports based on recent archaeological research. The brief list given here includes a few classical works along with more recent publications of a historical or archaeological character. Any one of these works can serve as the introduction to the subject, and most include bibliographical references that will help the interested reader in the further exploration of the subject.

Adembri, Benedetta. *Hadrian's Villa*. Milan: Electa, 2000.

Arnott, Peter. *The Romans and Their World*. New York: St. Martin's, 1970.

Balsdon, J.P.V.D. *Romans and Aliens*. Chapel Hill: University of North Carolina Press, 1979.

Beard, Mary, and John Henderson. *Classical Art from Greece to Rome*. Oxford: Oxford University Press, 2001.

Beard, Mary, John North, Simon Price. *Religions of Rome*. 2 vols. Cambridge: Cambridge University Press, 1998.

Boardman, John., ed. *Oxford History of Classical Art*. Oxford; New York: Oxford University Press, 1993.

Boardman, John, Jasper Griffith, Oswyn Murray. *Oxford History of the Roman World*. Oxford; New York; Oxford University Presws, 1991.

Carcopino, Jérôme. *Daily Life in Ancient Rome*. New Haven and London: Yale University Press, 1940.

Coarelli, Filippo. *The Colosseum*. Translation by Mary Becker. Los Angeles: J. Paul Getty Museum, 2001.

------. *The Column of Trajan*. Translation by Cynthia Rockwell. Rome: Editore Colombo in collaboration with the German Archaeological Institute, 2000.

Deiss, Joseph Jay. *Herculaneum*. New York: Harper & Row, 1985.

Elsner, Jas. *Imperial Rome and Christian Triumph*. Oxford: Oxford University Press, 1998.

Gabucci, Ada. *Ancient Rome: Art, Architecture, and History*. Translation by Thomas M. Hartmann. Los Angeles: J. Paul Getty Museum, 2002.

Giardina, Andrea, ed. *The Romans*. Translation by Lydia G. Cochrane. Chicago: University of Chicago Press, 1993.

Grant, Michael. History of Rome. New York: Charles Scribner's Sons, 1978.

Grimal, Pierre. *The Civilization of Rome*. Translation by W. S. Maguinness. London: Allen and Unwin, 1963.

Hölscher, Tonio. *The Language of Images in Roman Art*. Translation by Anthony Snodgrass and Annemarie Künzl-Snodgrass. Cambridge; New York: Cambridge University Press, 2004.

Le Glay, Marcel, Jean-Louis Voisin, Yann Le Bohec. *A History of Rome*. Translation by Antonia Nevill. Cambridge, Mass.: Blackwell, 1969.

Potter, T.W. *Roman Italy*. Berkley and Los Angeles: University of California Press, 1990.

Scheid, John. *An Introduction to Roman Religion*. Translation by Janet Lloyd. Bloomington: Indiana University Press, 2003.

Shelton, Jo-Ann. *As the Romans Did*. Oxford: Oxford University Press, 1988.

Strong, Donald. *Roman Art*. New Haven and London: Yale University Press, 1995.

Watson, G. R. *The Roman Soldier*. Ithaca, NY: Cornell University Press, 1969.

AKG-Images, Berlin, 28, 334
Araldo De Luca, Rome, 22, 273
Archivio Mondadori Electa, 322, 336, 337/Arnaldo Vescovo, 34, 332, 360/Schiavinotto, Rome, 335
Arnaldo Vescovo, Rome, 32, 34, 39, 87, 192, 229, 221, 297, 302, 310, 326, 327, 352, 353, 356, 357, 366
Biblioteca Accademia di Francia, Villa Medici, Rome, 154
Biblioteca Apostolica Vaticana, Vatican City, 67
British Museum, London, 62, 324
Comune di Roma, Soprintenden-za ai Beni Culturali: 13, 25, 40, 50, 55, 88, 89, 101, 106, 107, 121, 122, 133, 141, 148, 158, 159, 167, 168, 176, 181, 193, 198, 204, 206, 219, 230, 231, 257, 265, 278, 290, 291
Foto Vasari, Rome, 18, 19, 37, 307, 309, 328, 333, 338, 339, 340, 341, 363
Giovanni Rinaldi, Rome, 15, 31 above, 41, 43, 110, 114, 234, 252, 254, 277, 312, 314, 347, 354, 355, 371, 372
Musei e gallerie pontifice, Vatican City, 26, 38, 49, 85, 208, 209, 213, 228, 264, 304, 318, 344

© RMN, Paris, 229
© Scala Group, Florence, 90, 123, 286, 294, 295, 306, 373, 374
Soprintendenza Archeologica di Rome, 10, 11, 16, 17, 20, 21, 23, 24, 27, 29, 31 below, 36, 42, 44, 45, 46, 48 above, 51, 52, 54, 57, 58, 60, 61, 64, 68, 69, 73, 74, 75, 76, 79, 81, 82, 83, 86, 92, 93, 94, 95, 96, 97, 98, 99, 100, 102, 103, 104, 105, 108, 109, 112, 113, 115, 116, 117, 118, 119, 120, 125, 126, 128, 129, 130, 131, 132, 134, 135, 136, 137, 138, 139, 140, 143, 144, 145, 147, 150, 151, 152, 153, 155, 156, 157, 160, 161, 162, 164, 166, 169, 170, 171, 173, 174, 175, 177, 178, 179, 180, 181, 186, 188, 190, 191, 199, 200, 201, 202, 203, 205, 207, 210, 211, 215, 216, 217, 222, 223, 227, 242, 243, 244, 245, 247, 248, 249, 250, 252, 258, 260, 261, 262, 263, 267, 269, 272, 275, 276, 280, 281, 284, 285, 287, 288, 289, 292, 293, 317, 320 above, 331, 348, 349
Soprintendenza per I beni archeo-logici di Ostia, 30, 149, 165, 184, 185, 189, 197, 246, 274, 279, 298

This volume was printed and bound in Spain, by Artes Graficas Toledo, S.A.U., in the year 2007.